Magritte and Contemporary Art

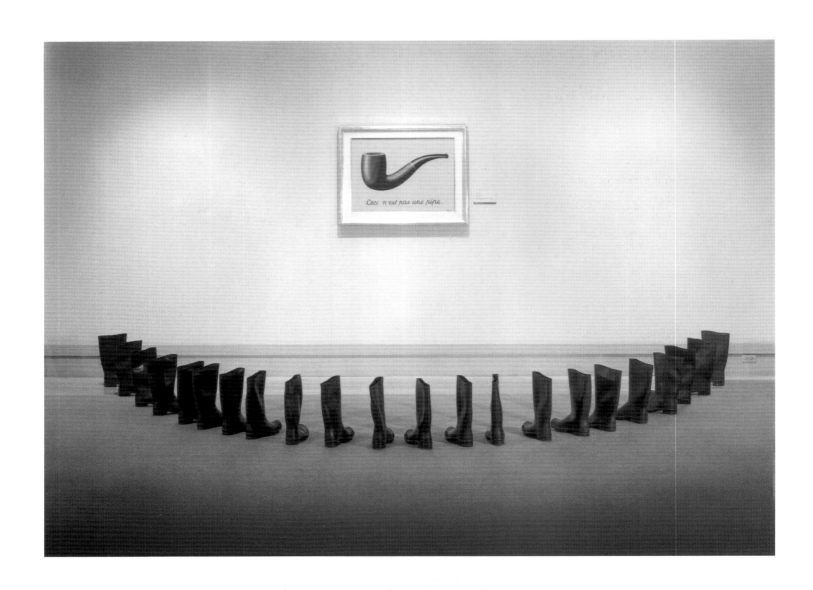

Eleanor Antin, *This is not 100 BOOTS*, 2002

Magritte and Contemporary Art: The Treachery of Images

Stephanie Barron

Michel Draguet

with the assistance of Sara Cochran

essays by

Richard Armstrong

Stephanie Barron

Roberta Bernstein

Sara Cochran

Michel Draguet

Thierry de Duve

Pepe Karmel

Theresa Papanikolas

Noëllie Roussel

Dickran Tashjian

Lynn Zelevansky

Los Angeles County Museum of Art and Ludion
with the collaboration of the Magritte Foundation, Brussels

This catalogue was published in conjunction with the exhibition *Magritte and Contemporary Art: The Treachery of Images*, held from November 19, 2006, to March 4, 2007, at the Los Angeles County Museum of Art. The exhibition was made possible with the support of the Magritte Foundation.

This exhibition was organized by the Los Angeles County Museum of Art and is presented by Lexus.

It was supported in part by the National Endowment for the Arts and the Frederick R. Weisman Philanthropic Foundation.

In-kind support for the exhibition was provided by The Beverly Hilton.

Copublished by Ludion and the Los Angeles County Museum of Art.
Printed in China.

Los Angeles County Museum of Art
5905 Wilshire Boulevard, Los Angeles, California 90036
www.lacma.org

Ludion
Muinkkaai 42, B-9000 Ghent, Belgium

Distributed by
D.A.P./Distributed Art Publishers, Inc.
155 Sixth Avenue, New York, New York 10013
(800) 338-2665
www.artbook.com

For the Los Angeles County Museum of Art:
Project manager: Sara Cody
Editors: Nola Butler, Sara Cody, and Thomas Frick
Supervising photographers: Peter Brenner and Steve Oliver
Rights and reproductions: Cheryle T. Robertson and Piper Severance
Proofreader: Dianne Woo

For Ludion:
Designer: Tony Waddingham
Production coordinators: Marianne Thys and Lut Ausloos

ISBN 90-5544-621-1 / 978-90-5544-621-6 (hardcover)
ISBN 0-87587-196-8 (paperback)
Library of Congress Control Number: 2006930377

Contents

Foreword

In 1968 LACMA hosted the landmark exhibition *Dada, Surrealism, and Their Heritage*, which had been organized by the Museum of Modern Art. It featured ten canvases by Magritte, including one that would, a decade later, become one of LACMA's most popular acquisitions—*The Treachery of Images (This Is Not a Pipe)* (1929). This endlessly provocative painting, which succinctly portrays the paradoxes of visual and verbal representation, was the impetus for the current exhibition.

Magritte and Contemporary Art: The Treachery of Images places in juxtaposition more than sixty paintings and gouaches by René Magritte and a similar number of works by postwar artists, demonstrating that the legacy of this classic modernist is very much alive. Examining the Belgian surrealist's work in relation to that of more recent artists, including Jasper Johns, Robert Gober, Vija Celmins, and many others, triggers an invigorating reconsideration of both—especially in identifying the deeper tenets of Magritte's art in a world where his imagery and technique have been so pervasively and gratuitously subsumed into our everyday culture of commercial advertising.

Today we are surrounded by images that vie for our attention through their surprising or "surreal" constructions, yet very few deserve and reward our careful reading and rereading—the sense made on the edge of non-sense—as do the images and objects of Magritte and those of the other artists presented together with his in this exhibition. The magic of Magritte's surrealism is found not only in its provocative inventiveness, but also in its invitation to us to use our eyes and minds to "read" art more closely—and to apply our critical facilities to the world around us as well. The value of that intention is perhaps never better expressed than in *The Treachery of Images*, which is why it has become such an icon not only of art, but of our human capacity to use our sense of irony to explore deeper truths.

Particular thanks are due to artist John Baldessari, who shared his creative insights into Magritte's art by collaborating on the installation of the artworks in LACMA's galleries. It has been a privilege to witness his inventive and playful sense of humor and depth of visual understanding as he helped situate works by Magritte together with works by thirty other artists.

Organizing such an exhibition relies upon the cooperation of institutions and private collectors as well as the collaboration of many museum colleagues. Our thanks to the Magritte Foundation, and especially to its president, Charly Herscovici, for his inestimable help with many aspects of the project. Michel Draguet, director of the Musées Royaux des Beaux-Arts de Belgique in Brussels, has been generous with loans from his museum. His collaboration with LACMA, both in coorganizing the exhibition and contributing to this catalogue, is much

appreciated. And we express our profound gratitude to all of the lenders (listed on page 252) for sharing their works with the public.

An exhibition of this ambition needs a patron, and in this case, Lexus has made this project possible through their generous sponsorship. Lexus was particularly interested in how historical influences are remade in the present, and how an artist, John Baldessari, might collaborate with us to recontextualize this Belgian modern master's work in present-day Los Angeles.

We are grateful as well to the National Endowment for the Arts for their support for the exhibition and to the Federal Council on the Arts and the Humanities for an indemnity that helped to defray the cost of insurance for this project. The insurance and shipping for such a show are a significant part of the budget, and the subvention from the Arts and Artifacts Indemnity Program has been critical. Federal support of exhibitions, through direct grants and through assistance with insurance, is increasingly essential. Without such important U.S. government programs it would be extraordinarily difficult to mount exhibitions of this nature. The museum's Wallis Annenberg Director's Endowment Fund and the Frederick R. Weisman Philanthropic Foundation have provided important additional assistance.

Finally, I am grateful to LACMA's senior curator of modern art, Stephanie Barron, whose enthusiasm, tenacity, and imagination have brought this stimulating exhibition to fruition.

MICHAEL GOVAN

CEO and Wallis Annenberg Director,
Los Angeles County Museum of Art

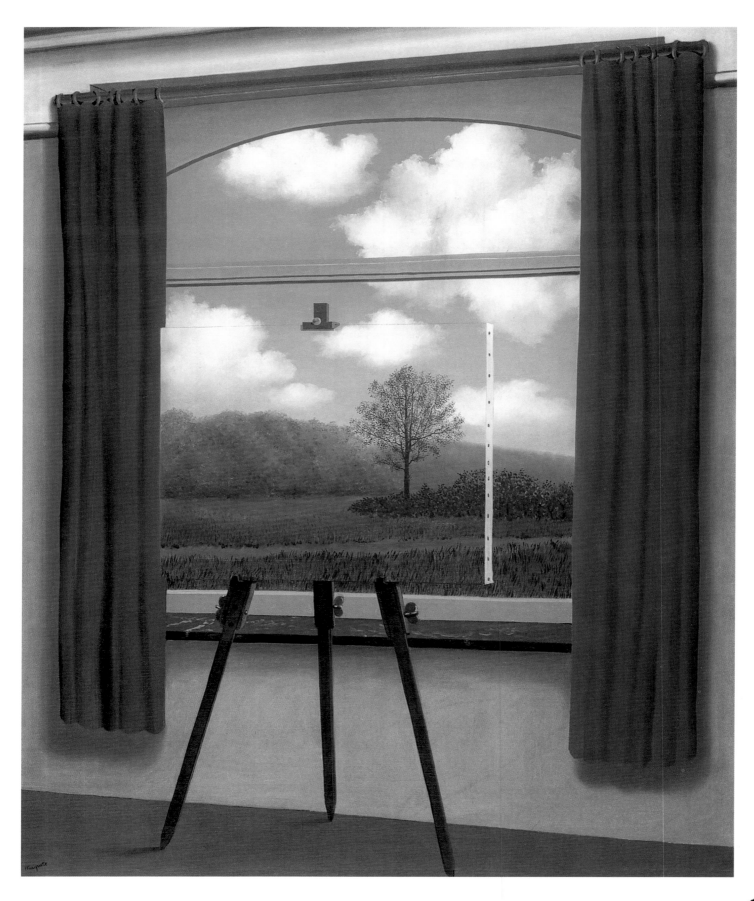

Magritte, *The Human Condition*, 1933

Enigma: The Problem(s) of René Magritte

STEPHANIE BARRON

The art of René Magritte has had an influence far exceeding the confines of the art world. Imagery adapted from his paintings has been widely disseminated for more than half a century through advertising, cartoons, film, book jackets, and popular music. For an unsuspecting public, the source may be unfamiliar. His work has continued to appeal to modern audiences hungry for the puzzling conjunctions of the everyday and the fantastic, painted with a flat (and misleading) literalness, that fill his many paintings and gouaches. Though Magritte has widespread popular appeal, stemming mostly from the appropriation of his imagery by mass culture, his artistic reputation for many years lagged well behind his public recognition.[1] The inscrutable nature of Magritte's work—coded, self-referential, and incongruous— has, however, intrigued several subsequent generations of artists. His refusal to explain, his steadfast dismissal of psychological interpretations, and the enigmatic titles of the paintings themselves have all fueled speculation about the meaning of his art.

In her pioneering English-language monograph, Suzi Gablik saw Magritte as a precursor, setting out the chain of problems whose solutions led to the collapse of the conventional devices of illusionistic representation.[2] She described him as a prophet, in whose paintings one could find the basis for much of the provocative and seminal work by Jasper Johns and Robert Rauschenberg in the 1950s and 1960s. Magritte became a crucial link between the disjunctions of cubist collage and the replacement of illusionism by now-historic objects such as *The Bed* (1955) by Rauschenberg and Johns's *Painted Bronze* (1964). In fact Magritte's work has appealed to a number of artists who have acquired his works: Rauschenberg, Johns, Andy Warhol, Roy Lichtenstein, Saul Steinberg, Konrad Klapheck, Pierre Alechinsky, and Jeff Koons. Yet Magritte himself at first dismissed pop art as a joke, derivative of dada and without artistic merit: "Are we permitted to expect from pop art anything more than sugar-coated dadaism?"[3] He was indifferent to connections that were drawn at the time between his work and that of the pop artists. As Sarah Whitfield put it, "They wanted to revolutionize art, while he wanted to break with it."[4]

Discussion of Magritte's significance for and position in postwar art has continued during the past thirty years, especially in the context of exhibitions.[5] The 1996 Magritte exhibition organized by Didier Ottinger underscored Magritte's continued relevance by inviting five contemporary artists—Robert Gober, Sturtevant, Michael Snow, Robert Racine, and Joseph Kosuth—to situate their own work within a selection of Magritte's. Gober, Sturtevant, and Snow chose preexisting works; Racine and Kosuth created works specifically for the exhibition. Kosuth's installation ~nloyed hovering black cloud-thoughts containing words like "classification,"

Marcel Broodthaers, *The Error*, 1966,
eggshells and oil on canvas,
99.7 × 69.2 × 5.7 cm, private collection,
courtesy Peter Freeman, Inc., New York

"tautology," and "paradox" in white letters. These were hung on blue walls amid several of Magritte's word-and-image paintings of the 1920s.[6]

The present exhibition assembles a group of iconic Magritte paintings and gouaches displaying his most influential themes, and brings them together with works by thirty postwar artists. While some of the artworks reveal either a direct visual link with or an homage to specific Magritte images (such as those by Eleanor Antin, Vija Celmins, Douglas Huebler, and Sherrie Levine), others glean from Magritte the seeds that fuel or enhance their particular pictorial inventions (including Richard Artschwager, Marcel Broodthaers, Robert Gober, Jasper Johns, Jeff Koons, Joseph Kosuth, Roy Lichtenstein, Raymond Pettibon, Ed Ruscha, and Jim Shaw). Magritte's work was widely accessible in New York from the 1950s until his death in 1967, culminating in a major retrospective at the Museum of Modern Art in 1965. Not only were there almost yearly exhibitions in New York, but his work was shown throughout the country. New York gallerists Sidney Janis and Alexander Iolas featured him in commercial exhibitions, and both Johns and Rauschenberg acquired works by Magritte that they still own. Of all the artists of the postwar generation who absorbed the spirit of Magritte it is Johns who displays the closest links. MoMA added signature paintings to their collection, which came to be widely known. Pop artists were certainly well acquainted with his oeuvre. Magritte's conjunctions of unrelated items, his serialization of images, and his interest in everyday objects connect him further to those artists who draw on popular culture for subject matter, from Johns and James Rosenquist to Jeff Koons's celebration of commonplace items by painstakingly transforming them into highly polished icons. Magritte's alterations of scale, in paintings such as *Personal Values* (1952), *The Anniversary* (1959), and *The Listening Room* (1958), occur also in numerous works by Claes Oldenburg, whose colossal sculptures are among the hallmarks of pop art, and in Vija Celmins's occasional larger-than-life-size objects from the 1960s. For Richard Artschwager there is little interest in replication per se: rather, in his furniture surrogates he transforms familiar objects with painted faux finishes. Roy Lichtenstein's interest in trompe l'oeil and transformation led to a connection with Magritte's work.[7] In a group of self-portraits in which a T-shirt supports a rectangular mirror-head, Lichtenstein is referring to Magritte's familiar image of a bowler-hatted man whose face is covered by an incongruous object.

Though Magritte was dismissive of their work, it was in fact the pop artists who contributed most to the rising esteem for him in the United States during the 1960s. Critic Max Kozloff, reviewing MoMA's Magritte retrospective, wrote in *The Nation* that after Johns and pop art "Magritte seemed more profound and liberating than before."[8] A few months later in *Artforum* he published "Surrealist Painting Re-examined," in which he found new interest in the work of Magritte, Masson, Dalí, and Ernst, because it "simultaneously denies intrinsic significance to mere artifacts like pictures and assemblages, and yet presents them as models of an interior cosmos."[9]

This installation, designed by John Baldessari, proposes connections between Magritte and a number of postwar artists by placing their works in relation to one another, though more imaginatively than simply relying on obvious pairings. In some cases there are indeed specific paintings by Magritte that have been an inspiration for a particular contemporary work, but in most cases it is a broader shared sensibility behind the imagery that has led to the inclusion of the contemporary artists.

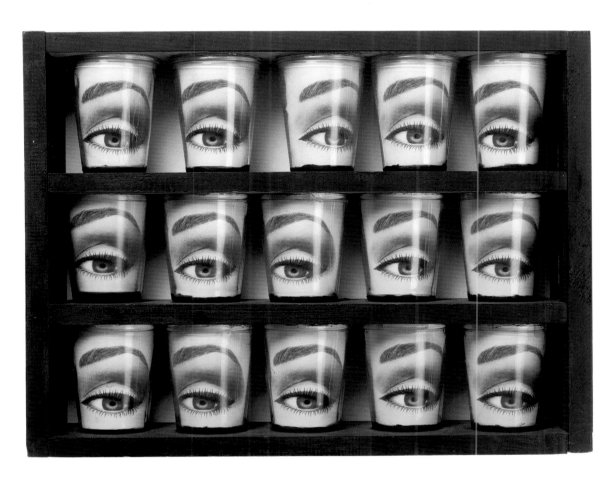

Marcel Broodthaers, *Shelves with Jars and Eyes*, 1966

To enhance our examination of the contemporary connection to Magritte's work, we have invited five authors to discuss particular relationships: Jasper Johns (Roberta Bernstein), Richard Artschwager (Richard Armstrong), Ed Ruscha (Lynn Zelevansky), Vija Celmins (Sara Cochran), and Robert Gober (Pepe Karmel). Their discussions of and/or interviews with these artists provide depth and nuance to our exploration.

It was as a result of philosopher Michel Foucault's groundbreaking essay "Ceci n'est pas une pipe" (1968) that Magritte's work, most particularly that of the disjunctive word-and-image paintings, found new appreciation from an audience eager to grapple with philosophical and analytical approaches to his striking oeuvre.[10] That pivotal text and the subsequent discourse between Foucault and Magritte highlighted the Belgian artist at a crucial moment in the development of conceptual art. Magritte thus joined Duchamp as an important precursor to the art of the 1970s. Along with his visual production, his voluminous writings have provided a rich source for philosophers, artists, and critics. (It is therefore quite surprising that Magritte's *Écrits complets* is not yet available in English.)

For conceptual artists of the late 1960s and 1970s such as Mel Bochner, Douglas Huebler, Joseph Kosuth, and John Baldessari, Magritte's work provided visual and conceptual triggers. Kosuth's "definition" paintings clearly are intimately connected with the concerns of Magritte's word-and-image paintings. Bochner emphasized analytical thought in his work but denied that words were more objective than other visual forms. *Language Is Not Transparent* (1970) might be described as Bochner's manifesto, much as Magritte's *This Is Not a Pipe* could be said to stand for much of his work. For Bochner there is the implication that linguistic meaning is as transient and unstable as the painted support that drips away behind the words.

For artists in the 1980s a renewed interest in surrealism was combined with the legacy of pop art to allow an appreciation of the (until then) little-known period *vache* paintings when they were included in the influential *Westkunst* exhibition in 1981. The essay by Noëllie Roussel explores the impact these pictures had on a generation of younger artists.

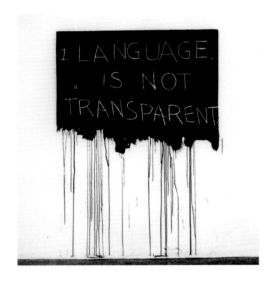

Mel Bochner, *Language Is Not Transparent*, 1970

René Magritte (1898–1967) was born at the end of the nineteenth century in Lessines, Belgium.[11] When he was thirteen he suffered a tragic shock when his mother drowned herself in the nearby river Sambre. When the body was recovered seventeen days after her suicide, her face was covered by a nightgown, which had become wrapped around her head. Yet when asked in 1968 if his mother's suicide had marked him, Magritte responded by lashing out, "Psychology doesn't interest me. It claims to reveal the flow of our thoughts and emotions; its efforts are contrary to what I know; it tries to explain mystery. The only mystery is the world. Psychology concerns itself with false mysteries. It is impossible to say whether my mother's death had any influence or not."[12] By the time he was fifteen Magritte had met the woman who would become his wife, Georgette-Marie-Florence Berger (1901–1986).

Magritte began his art training at the Royal Academy of Fine Arts in Brussels during World War I, coming under the influence of one of the leading Belgian abstract artists, Victor Servranckx. Other than through reproductions he was essentially cut off from exposure to contemporary European art. Following his academic studies, Magritte began the first of the commercial jobs that would

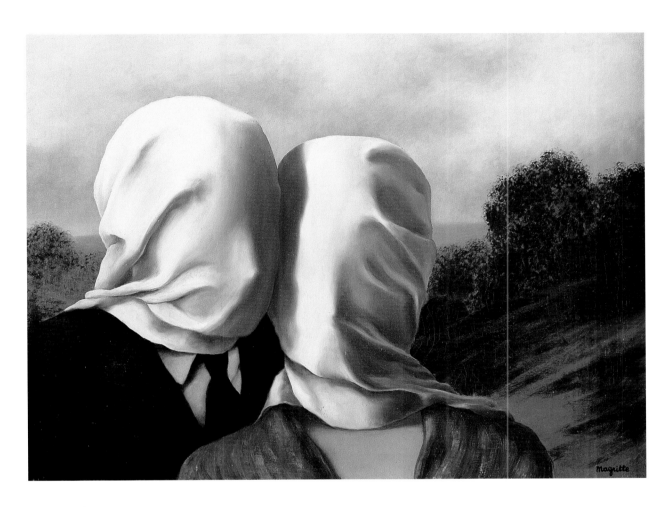

Magritte, *The Lovers*, 1928

Giorgio de Chirico, *The Song of Love*, 1914, oil on canvas, 73 × 59.1 cm, The Museum of Modern Art, New York

engage him for years to come, designing for a wallpaper company and later doing interior decorating, posters, and advertising.

In Brussels Magritte encountered a group of like-minded creative people with whom he would maintain lifelong friendships, including the poet, musician, and artist E. L. T. Mesens (1903–1971), the writer Marcel Lecomte (1900–1966), and the critic and art dealer Camille Goemans (1900–1960). He also met Filippo Marinetti, Theo van Doesburg, Eric Satie, and Tristan Tzara, and was exposed to futurism, dada, and de Stijl firsthand in both Brussels and Paris. However, Magritte's early painting was nonfigurative, a generally undistinguished pastiche of popular cubist and futurist vocabulary. In 1923 Magritte was profoundly influenced by a reproduction of Giorgio de Chirico's 1914 *Song of Love*. By 1925 he had begun to incorporate the visual language and ideas of de Chirico's absurd conjunctions of objects, and painted his earliest surrealist work. Magritte's first one-man show, consisting of sixty-one works, was shown in 1927 at Galerie Le Centaure in Brussels to almost universally hostile critical response.

By 1927 Magritte, already married to Georgette, had decided to move to Paris to be closer to the surrealist circle gathered around André Breton and Paul Eluard. It would be a transformative two-year stay. The couple settled, however, not in the capital but in the suburb of Le Perreux-sur-Marne, where Magritte produced more than two hundred paintings. He eschewed the surrealists' eccentric lifestyles, public flourishes, and overtly sexual escapades in favor of a seemingly bourgeois existence. His painting too seemed flat, deadpan, straightforward, rather than embellished by collage, frottage, and other surrealist inventions. He set up his easel not in a special atelier but in a confining corner of his home, where casual visitors would inevitably interrupt him.

Although Magritte was sometimes claimed by the surrealists, and has been included in many surrealist exhibitions during the past fifty years, he resisted their experiments and techniques, including dream imagery and automatism, maintaining that he did not believe in the subconscious.[13] Later he said, "My paintings are the opposite of dreams, since the dream does not have the significance we ascribe to it. I can work only in lucidity."[14] Yet some of his images share the surrealists' attraction to sexual and brutal themes. *The Titanic Days* (1928), for example, is a violent image of an attempted rape. Magritte said of this image: "I have treated this subject, this terror that grips the woman, by means of a subterfuge, a reversal of the laws of space, which serves to produce an effect quite different from what the subject usually affords. It's roughly like this: the man seizes the woman; he is in the foreground; necessarily therefore the man conceals parts of the woman, the part where he is in front of her, between her and our vision. But the discovery lies in the fact that the man does not overlap the outline of the woman."[15] As a result, it's almost as if the painting depicts a rape of the image itself from within.

In *The Rape* (1934), a particularly compelling transformation painting, Magritte takes up one of the themes favored by the surrealists.[16] Here a woman's face metamorphoses into her body, with breasts replacing eyes and a pubic triangle where her mouth should be. The result is a disturbingly erotic image. When this work was first put on public display in Brussels in May 1934, it was placed behind a velvet curtain, so provocative was it thought to be. What makes it shocking, however, is not the transgressive sexuality of the image per se, but the witty and cheerful manner in which Magritte painted it. In another transformation painting, *The Philosopher's*

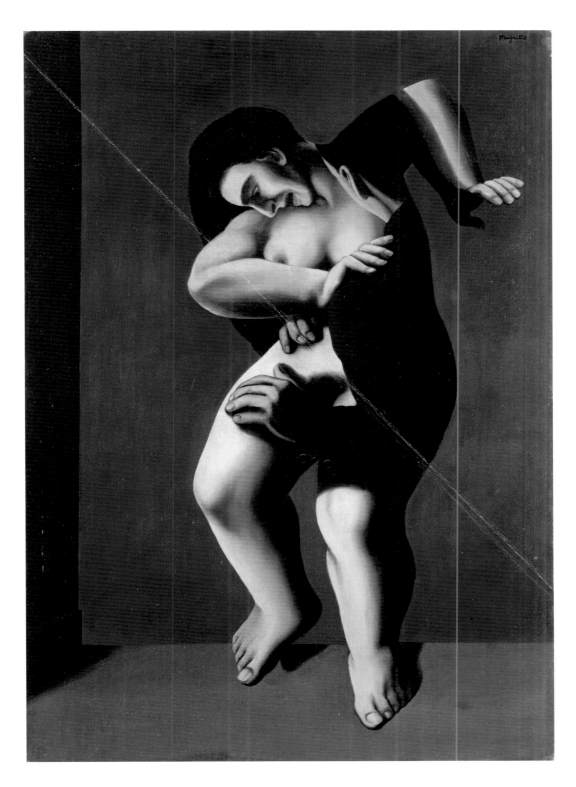

Magritte, *The Titanic Days*, 1928

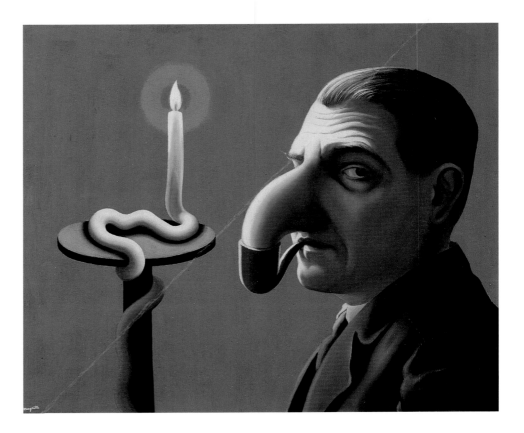

Magritte, *The Philosopher's Lamp*, 1936

Lamp (1936), a man's waxy funnel-shaped nose is stuffed into his pipe. Next to him is a sinuously coiling, then erect, lit candle. (The connecting link between the two, we might conjecture, would be the hidden penis.) Although Magritte claimed to have no interest in any Freudian interpretation of his work, it is difficult not to note the phallic references. While the concept of the lamp may suggest the age-old connection between knowledge and light, art critic Jack Spector has drawn connections between the nose (and mucus) and the candle through etymology and French idiomatic expressions in subtle and convincing ways.[17]

It was during Magritte's stay in Paris that some of his most haunting images emerged. He often juxtaposed unrelated pedestrian objects and motifs in unnerving sequences that confuse and confound. When he introduced abstract forms or objects joined together with a concept or a word, it came not from the surrealists' interest in automatism and the unconscious, but rather from his fascination with the arbitrary relationship between objects, images, and names. Magritte's word-and-image paintings have their origin in children's textbooks, and are similar to examples used in Ferdinande de Saussure's Course in General Linguistics (given between 1906 and 1911 and published in 1916), of interest because Saussure was the first to propose the concept of the arbitrary nature of the linguistic sign. In two works called *The Interpretation of Dreams* (1930, 1952), for example, Magritte divides the canvas into six parts, each containing a carefully painted object beneath which is written in schoolbook script a noun (with its article) that is totally unrelated to the object it supposedly captions.

The following year Magritte published some of these word-and-image combinations in surrealist magazines such as the Belgian *Variétés* and the French *La révolution surréaliste*. In the December 1929 edition of the latter, which contained Breton's second surrealist manifesto, Magritte published "Les mots et les images," a three-column illustrated text composed of gentle, perplexing drawings combined with simple yet startling captions. "Sometimes the name of an object takes the place of an image," and "Any shape whatever may replace the image of an object."[18] This important text is virtually an instruction manual for the word-and-image paintings that appeared between 1927 and 1929. It is essential to an understanding of Magritte's work and would form the foundation of his appeal to a new generation of artists after the war.

Magritte, *The Interpretation of Dreams*, 1952

The most famous of this group of paintings is certainly *The Treachery of Images (This Is Not a Pipe)* (1929, p. 28). Deceptively simple, it presents the image of a pipe and then below it a text that undermines the assumptions behind such representation. Of course a painted pipe is not a real pipe, but rather a depiction of a pipe: "Ah, the famous pipe. I've been criticized enough for it! And yet, can it be stuffed with tobacco, my pipe? No, it can't be, it's just a representation. So if I had written, 'This is a pipe' below the picture, I would have been lying."[19] But with the inscription asserting that "this" is *not* a pipe Magritte undermines our experience. The language has an arresting effect, focusing attention on itself as a locus of meaning.

By 1929 Magritte had fallen out of favor with the surrealist leaders, and his Paris gallerist faced hard economic times. With Georgette homesick, in 1930 the Magrittes decided to return to Belgium, settling in a rented apartment in a suburb of Brussels. For support Magritte once again took up work as a commercial artist and window dresser, while continuing to produce paintings and gouaches. Eventually reconciled with the Parisian surrealists, he participated in surrealist exhibitions and publications in both Belgium and Paris. By 1933 Magritte had begun to describe in letters his new method of working: to search out "solutions" for "problems" posed by various objects. In public lectures—London in 1937 and Antwerp in 1938—he discussed various new works and explained his intentions. He established that the simple object was the crux of his work, and that he sought to give familiar objects disturbing meaning through displacement, transformation, metamorphosis, and "false denomination":

> In the course of my researches, I became certain that the element to be discovered, the unique feature residing obscurely in each object, was always known to me in advance, but that my knowledge of it was, so to speak, hidden in the depths of my thoughts. As my researches had necessarily to arrive at a single correct answer for each object, my investigation took the form of trying to find the solution of a problem with three points for reference: the object, the something linked to it in the obscurity of my consciousness and the light into which this something had to be brought.[20]

The core of the Antwerp lecture was devoted to an illustrated discussion of sixteen "problems," each resolved by a specific painting: "the problem of the door" (*The Unexpected Answer*, 1933); "the problem of the window" (*The Human Condition*, 1933); "the problem of the locomotive" (*Time Transfixed*, 1938); "the problem of the mountain" (*The Domain of Arnheim*, 1938); "the problem of fire" (*The Discovery*

of *Fire*, 1934 or 1935); "the problem of the woman" (*The Rape*, 1934); "the problem of shoes" (*The Red Model*, 1935); and nine other such "problems": tree, forest, sea, sand, light, rain, horse, dog, and "the redskin." Magritte tried to show that a specific image provided a unique "solution" to a particular "problem." These images take on a personal meaning not easy to penetrate, and form the basis of the vocabulary that would continue to characterize his work.

In *The Human Condition* Magritte combines two of his favorite themes: "the problem of the window" and the painting within the painting. In his Antwerp lecture he commented: "I placed in front of a window, seen from inside a room, a painting representing exactly that part of the landscape that was hidden from view by the painting. Therefore, the tree represented in the painting hid from view the tree situated behind it, outside the room. It existed for the spectator, as it were, simultaneously in his mind, as both inside the room in the painting, and outside in the real landscape."[21] Using the surrealists' principle of collage, Magritte brings together the jarring contradiction inherent in the two-dimensional representation of three-dimensional space. Done in a flat, uninflected style, without the exacting verisimilitude of trompe l'oeil painting, *The Human Condition* explores the artifice of illusion: is it the view through the window that is in fact "real," while the image on the canvas is a representation of that reality? Does it matter? Both are drawn from the artist's imagination. One representation has no a priori status as more real than another.

In *Time Transfixed* Magritte explores "the problem of the locomotive" by depicting one arrested while speeding through a fireplace into an immaculate domestic space. Perhaps the imagery was inspired by Magritte's strong impression of de Chirico's paintings from the 1910s in which the juxtaposition of trains and clocks evokes a feeling of the cessation of time. Or perhaps, as Lawrence Weschler suggests, there is more than a coincidence between the image Magritte painted in 1938 and a photograph of a train that overshot the terminus at Gare Montparnasse in Paris on October 22, 1895, and literally collapsed onto the sidewalk.[22] Uncannily suspended, Magritte's locomotive is a scary, funny, or miraculous intrusion, and thoroughly unforgettable whatever one's point of view.

In 1966 Joseph Cornell would find inspiration in this painting for a collage, *Untitled (Time Transfixed)*,[23] following the death of his brother Robert at age fifty-four from cerebral palsy. For Cornell, the odd conjunction of the train and fireplace was poignantly literal, as his brother had been confined to a wheelchair with little to distract him other than his model trains and his shortwave radio.[24]

In *The Domain of Arnheim*, as Magritte wrote to English surrealist collector Edward James, he wanted to follow the example of Roland Penrose, who had stopped using color to depict objects in his collages. Magritte in this painting worked completely in grisaille, casting a stark shadow onto the window casement. The painting draws its title from a short story by Edgar Allan Poe, a favorite author, in which an enormously wealthy man was able to rearrange his own garden landscape to suit his fancy, or as Magritte remembered it, to "move mountains so that the sun appears according to a specific wish."[25] Magritte referred to the painting in his explanation of "the problem of the mountain" and continued treating the motif—a mountain peak whose shape is that of an eagle's head and outstretched wings—in later paintings and gouaches.

The Red Model was Magritte's exploration of "the problem of the shoe," about which he said, "Thanks to *The Red Model* people can feel that the union of the

Magritte, *The Domain of Arnheim*, 1962

Magritte, *The Annunciation*, 1930

human foot with the leather shoe is in fact, a monstrous custom."[26] This particularly haunting image is one that Magritte repeated several times.

Magritte preferred titles that were not tied to specific imagery. According to scholar David Sylvester, he began to search for a title while working on a painting, and often turned to his friends for suggestions.[27] Frequently titles were changed within weeks of being applied. He once wrote, "I think the best title for a painting is a poetic title. . . . A poetic title is not a sort of indication that tells one, for instance, the name of a town whose panorama the painting represents or the symbolic role attributed to a painted figure. . . . The poetic title has nothing to teach us; instead it should surprise and enchant us."[28] In fact Magritte later expressed dissatisfaction with the title *Time Transfixed*, the common English translation of *La durée poignardée* (which literally means "ongoing time stabbed by a dagger"). The surrealist poet Paul Nougé, a friend of Magritte's, probably supplied the title *The Annunciation* (1930), in which several favorite motifs are present: shapes resembling chess pieces or balusters, a curtain, jingle bells, and cut-out paper patterns. Set amid theatrical-looking rocks and foliage, the whole landscape has a make-believe quality. *The Glass Key* (1959) went through ten trial titles before Magritte settled upon the name by which it is known today. Finding the right title was akin to creating a collage, in which the juxtaposition of concept and image was equivalent to the traditional joining of disjunct visual elements.[29]

In 1940, shortly after the Germans invaded Belgium, Magritte left Georgette and traveled to France, where he remained for three months before returning home. During the Occupation, Magritte painted works depicting plaster casts, such as *Deep Waters* (1941), in which a giant bird looks intently at a woman whose head is of plaster. There is an ominous quality to the painting, a sense of absolute lifelessness, a palpable feeling that the artist found himself at an aesthetic dead end.

By 1943 Magritte had begun to paint pictures that were aggressively in search of happier subject matter. He described it as "a search for the bright side of life, the whole traditional range of charming things, women, flowers, birds, trees, the atmosphere of happiness."[30] His work went through a radical transformation that would last until the end of the decade, and which would separate him from all but his closest supporters. He began by adopting a subject and palette familiar to the impressionists: a nude female bather executed in rosy tones. Breaking from the cool and precise painting of his past, he now attempted to make more traditionally agreeable pictures in the face of the misery of life under the Occupation. "Since the start of this war, I have had a strong desire to achieve a new poetic effectiveness which would bring us both charm and pleasure," he recalled in a letter to fellow Belgian artist Pol Bury in 1945.[31] In one group, he imbued animals with human characteristics: *A Stroke of Luck* (1945) depicts an absurd, sad pig dressed up in a suit, apparently on his way to a cemetery. With its sweetness and reliance upon the aesthetic of the unfashionable late Renoir, this and similar examples of his "sunlight surrealism," which occupied him until 1947, are fascinating, subversive, and disturbing. When exhibited, they met with unfavorable critical response.[32]

For a brief time in 1948 Magritte introduced a new style in which he tried to push this sunlight surrealism even further, in extravagantly comic paintings suffused with bold, strident colors. This group of works, comprising fifteen paintings and ten gouaches, was presented at a show in Paris that was also despised by the critics.[33] The subjects resemble popular cartoons, caricatures, even the figures of James Ensor.

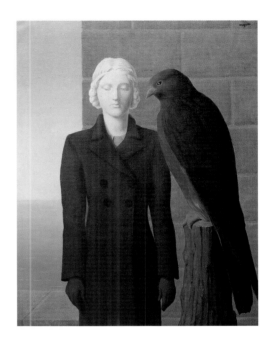

Magritte, *Deep Waters*, 1941

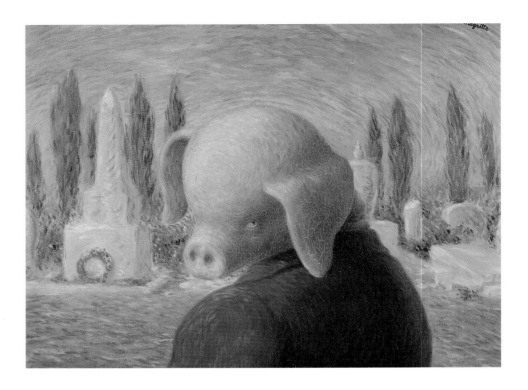

Magritte, *A Stroke of Luck*, 1945

The paintings are brash, and their style starkly departs from the artist's earlier flatness. As Magritte's early biographer Louis Scutenaire recalled, "Never for a minute was there any question of putting together pictures done in one or other of the styles which had won recognition. . . . The overwhelming purpose was not to delight the Parisians but to scandalize them. . . . 'We'll give them an eyeful!' said Magritte delightedly, 'with an incendiary preface?'"[34]

The Cripple (1948) contains familiar Magritte vocabulary—the clock and the pipe—but here they have been skewed into a cartoon and painted with thick impasto. This new way of painting Magritte dubbed *vache* (literally "cow," but colloquially "rotten"), a play on the word *fauve*, applied to Matisse's paintings in the early part of the century (literally "big cat," but used by early critics to mark him as a "wild beast"). In the aggressively erotic *The Pebble* (1948), one of the last of the *vache* paintings, Magritte echoes the late Matisse through the simple line, the patterned background, and the sensuality of the woman licking herself.

The artist's paintings and gouaches from the 1940s were critically scorned. Only a few of his staunchest supporters rallied their enthusiasm; the surrealists reviled them. Magritte reflected on the controversy that the *vache* paintings provoked in a letter to Scutenaire: "I would rather like to pursue and intensify the 'manner' that I tried out in Paris. I have a tendency to slow suicide. But there's Georgette and the disgust I experience in being 'sincere.' Georgette prefers the carefully finished painting 'of yore,' so above all to please Georgette in future I shall exhibit the old kind of painting. I'm sure I'll find a way now and then of slipping in some good hefty joke."[35]

Magritte, *The Pebble*, 1948

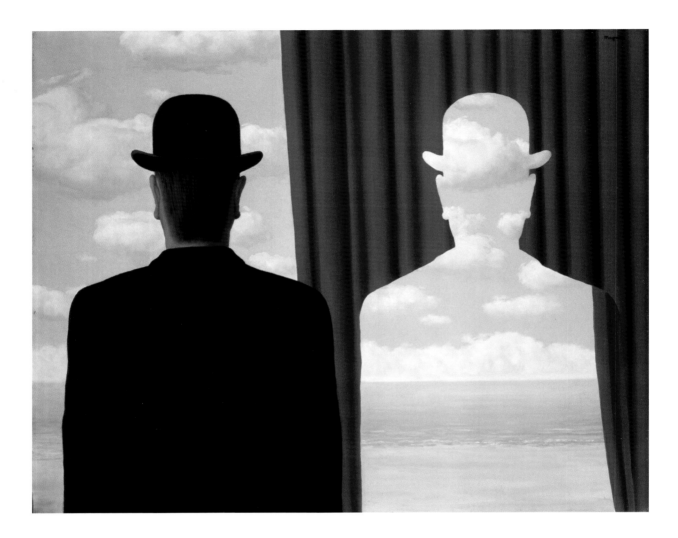

Magritte, *Decalcomania*, 1966

None of the *vache* paintings were sold, and until Magritte died, nineteen years later, only one was included in an exhibition. Only recently have they begun to be favorably regarded. Kasper König showed nine of them (none owned by institutions) in the highly regarded 1981 *Westkunst* exhibition in Cologne, thus introducing this unfamiliar body of work to a new generation of artists.

In the early 1950s Magritte turned away from these critically and commercially unrewarding *vache* and "sunlight" pictures, as he had promised in the letter to Scutenaire, and returned to a more familiar and commercially successful style. Beginning in 1952 he painted several images in which grossly oversize objects dominate a domestic space: *Personal Values* (1952), *The Listening Room* (1952 and subsequent versions), *The Anniversary* (1959), and *The Tomb of the Wrestlers* (1959). In *Personal Values* the blue sky becomes wallpaper in an airless bedroom filled with personal objects rendered in differing scales, achieving a collagelike effect. The gargantuan comb rests in the corner, propped up on a Lilliputian bed; a giant wineglass sits in the foreground; a Brobdingnagian shaving brush rests precariously on top of a mirrored armoire, and a bright pink match lies on the oriental carpet. Painted in bold, flat colors, the work marked a return for Magritte to the stark images of his Paris years. The painting confounded Magritte's New York dealer Alexander Iolas, however, who said that looking at it made him ill. He begged the artist to explain it to him. Magritte first lay to rest Iolas's criticism that it had been painted hastily, revealing that he had worked on it for two months.

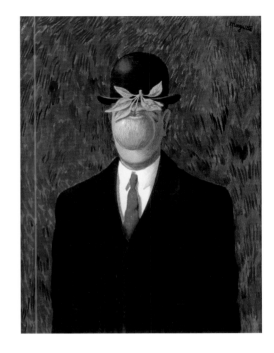

Magritte, *A Taste for the Invisible*, 1964

> In [*Personal Values*], the comb (and the other objects as well) has specifically lost its "social character," it has become an object of useless luxury, which may . . . leave the spectator "feeling helpless" or even make him ill. A painting that is truly alive should make the viewer feel ill, and if viewers do not feel ill it is because 1) they are too coarse or 2) they are so used to feeling ill in this way that they take it for pleasure. . . . Contact with reality . . . always produces this feeling. . . . Furthermore, all the reasons in the world are powerless to make anyone like anything.[36]

One of the most celebrated Magritte motifs is the man in the bowler hat, often thought to be a self-portrait. (Magritte was frequently photographed wearing a similar hat.) But in these images the face of the man—dressed in a dark suit, white shirt, and natty tie—is commonly blocked by an apple, a bird, or a pipe, or else the entire body is seen from behind. In other examples the man is seen in silhouette or is represented only by separate floating eyes, nose, and mouth. Very little of a personal nature is revealed, and the bowler hat adds to the anonymous quality: he ends up being the sum of his haberdashery. In *Decalcomania* (1966) the figure on the left turns his back to us, while the one on the right is empty; his elegant silhouette is all that we are offered. Patrick Waldberg described the artist himself as follows: "Average height and build . . . conservatively dressed in dark clothes, neatly collared and tied, and wearing a hat in the currently popular style, he went unnoticed in a crowd. . . ."[37]

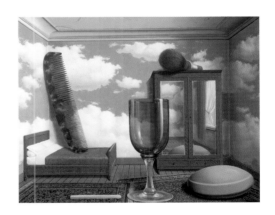

Magritte, *Personal Values*, 1952

The last major Magritte exhibition during his lifetime opened in New York in December 1965 at the Museum of Modern Art, and brought new attention to his work from contemporary New York artists. It toured the United States during 1966. It was on the occasion of this show that Magritte and his wife visited New York

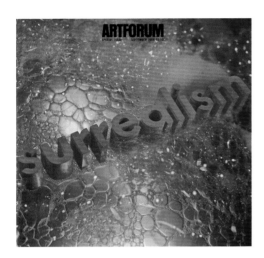

Ed Ruscha, *Surrealism Soaped and Scrubbed*, cover of *Artforum*, Sept. 1966

and Houston, and were widely celebrated in the media. *Esquire* and *Life* both ran illustrated articles, "This Is Not a Magritte" and "The Enigmatic Visions of René Magritte" respectively.

The 1960s witnessed a renewed interested in surrealism in the United States. A 1966 issue of *Artforum* (with a striking cover by the young Ed Ruscha, who was in charge of production for the then Los Angeles–based magazine) devoted an entire issue to the movement. Important articles by Max Kozloff, Lucy Lippard, Robert Rosenblum, Roger Shattuck, William S. Rubin, Sidney Tillim, Annette Michelson, Nicolas Calas, and Jerrold Lanes offered new appreciation of the surrealists. Kozloff's article, which began with a half-page image of Magritte's *The Treachery of Images*, quotes the artist: "There are objects which get along without names" and "Sometimes a word serves only to designate itself." Finding such ideas radically subversive, Kozloff wrote, "If words become only things, stripped of their denotative function, then images too can be things, and things (objects) might just as well be conceived of as images. . . . In labeling his picture 'Ceci n'est pas une pipe' Magritte underlines the intolerable yet heuristic reversibility of his processes."[38]

In August 1967 Magritte died at his home in Belgium from advanced pancreatic cancer. Seven months later the Museum of Modern Art opened the major exhibition *Dada, Surrealism, and Their Heritage*, organized by curator William S. Rubin. That exhibition, which traveled to LACMA and the Art Institute of Chicago, included ten paintings by Magritte. It was widely acclaimed and contributed to the increasing appreciation of Magritte's work in the United States.

Magritte wanted to be considered as a man who thought and who communicated his thoughts through painting. "I think as though no one had ever thought before me," he once said.[39] His provocative images and words continue to confound, prod, amuse, and frighten us. By making his thoughts visible, they continue to surprise and inspire artists.

Notes

1. Sarah Whitfield, *Magritte*, exh. cat. (London: Hayward Gallery/ The South Bank Centre, 1992), 11.
2. Suzi Gablik, *Magritte* (London: Thames & Hudson, 1970).
3. René Magritte, "Declaration de René Magritte lors d'une interview de la television belge," in René Magritte, *Écrits complets*, ed. André Blavier (Paris: Flammarion, 1979), no. 183; translation in Gablik, *Magritte*, 72.
4. *Magritte* (London 1992), 17; see also January 1963 interview by Jean Nyens in Magritte, *Écrits complets*, 605.
5. See *Magritte*, exh. cat. (Montreal: Museum of Fine Arts, 1996); *René Magritte: Die Kunst der Konversation*, exh. cat. (Düsseldorf: Kunstsammlungen Nordrhein-Westfalen, 1996); *Magritte*, special issue of *Louisiana Revy* (Louisiana Museum of Modern Art) 39, no. 3 (August 1999); Siegfried Gohr, *Magritte*, exh. cat. (San Francisco: Museum of Modern Art, 1999); Daniel Abadie, *René Magritte*, exh. cat. (New York: D.A.P., 2003); *Magritte: The Key to Dreams*, exh. cat. (Ghent: Ludion in association with Basel: Fondation Beyeler and Vienna: BA-CA Kunstforum, 2005); and Gablik, *Magritte*. A good example of a publication that links the work of a particular contemporary artist to Magritte's imagery is *Roy Lichtenstein: Conversations with Surrealism*, exh. cat. (New York: Mitchell-Innes & Nash, 2005); see particularly "Lichtenstein and Surrealism," by Charles Stuckey. See also *René Magritte en de hedendaagse Kunst / René Magritte and Contemporary Art* (Ostend: Museum voor Moderne Kunst, 1998), which includes no Magritte objects but focuses on contemporary art (mostly European) related to his work.
6. Joseph Kosuth, *L'essence de la rhétorique est dans l'allégorie*, 1996; installation view published in *Die Kunst der Konversation* (Düsseldorf 1996), 214–15.
7. Diane Waldman, *Roy Lichtenstein*, exh. cat. (New York: Guggenheim Museum, 1993), 243–49.
8. Max Kozloff, "Epiphanies of Artifice," *The Nation*, January 10, 1966, 55–56.
9. Max Kozloff, "Surrealist Painting Re-examined," *Artforum* 5, no. 1 (September 1966), 5–9.
10. Michel Foucault, *This Is Not a Pipe*, trans. James Harkness (Berkeley: University of California Press, 1983).
11. This abbreviated recounting of Magritte's life is indebted to the comprehensive chronology in David Sylvester et al., *René Magritte: Catalogue Raisonné*, 5 vols. (Antwerp: Mercatorfonds and Houston: The Menil Foundation, 1992–97), and to the biography (based on the same source) by Sarah Whitfield in Abadie, *René Magritte* (New York 2003).
12. Jean Stévo, "Le surréalisme et la peinture en Belgique," *L'art Belge*, January 1968, 61; translated in Sylvester, *Catalogue Raisonné*, vol. 1, 9.
13. Magritte, letter to André Bosmans, August 10, 1962, in Magritte, *Écrits complets*, 573.
14. Interview by Henry Lemaire, 1962, in Magritte, *Écrits complets*, 567.
15. Sylvester, *Catalogue Raisonné*, vol. 1, 277. See also Pia Müller-Tamm, *René Magritte: Les jours gigantesques* (Berlin and Düsseldorf: Kulturstiftung der Länder and Kunstsammlung Nordrhein-Westfalen, 1996).
16. A drawing of *The Rape* served as the cover for the Breton publication *Qu'est-ce que le surréalisme?* (1934).
17. Jack J. Spector, "Magritte's *La lampe philosophique*: A Study of Word and Image in Surrealism," in *Dada/Surrealism* 7 (1977), 121 ff.
18. Magritte's relationship with the French surrealists was a complicated matter and has been described more fully in several texts. See William S. Rubin, *Dada, Surrealism, and Their Heritage*, exh. cat. (New York: Museum of Modern Art, 1968); Sylvester, *Catalogue Raisonné*; and the essay by Dickran Tashjian in this volume.
19. Magritte, interview by Claude Vial, 1966, quoted in *Écrits complets*, 643.
20. Sylvester, *Catalogue Raisonné*, vol. 2 (1993), 17.
21. Magritte, "La ligne de vie" (1938), in Louis Scutenaire, *Avec Magritte* (Brussels: Lebeer Hossmann, 1977), 90; see *Magritte* (London 1992), no. 62.
22. Lawrence Weschler, *Everything that Rises: A Book of Convergences* (San Francisco: McSweeney's, 2006), 56–59. English surrealist collector Edward James commissioned the Magritte painting; the fireplace and mirror depicted were the ones in James's London home.
23. Joseph Cornell, *Untitled (Time Transfixed)*, c. 1966, collage, 30.8 × 22.9 cm, Art Institute of Chicago.
24. See Deborah Solomon, *Utopia Parkway: The Life and Work of Joseph Cornell* (New York: Farrar, Straus, Giroux, 1997), 300–6.
25. Sylvester, *Catalogue Raisonné*, vol. 2, 262.
26. Gablik, *Magritte*, 124.
27. Sylvester, *Catalogue Raisonné*, vol. 1 (1992), 73.
28. Magritte, "Question du titre," unpublished ms. quoted in A. M. Hammacher, *Magritte* (New York: Harry N. Abrams, 1974), 27.
29. David Sylvester, *Magritte: The Silence of the World* (Houston: The Menil Foundation and New York: Harry N. Abrams, 1992), 233–35.
30. *Magritte* (London 1992), no. 86.
31. Sylvester, *Catalogue Raisonné*, vol. 2, 91.
32. Breton condemned Magritte's sunlight surrealism in the catalogue of a surrealist show at the Galerie Maeght, Paris: André Breton, "Devant le rideau," in *Exposition internationale du surréalisme: le surréalisme en 1947*, exh. cat. (Paris: Galerie Maeght, 1947).
33. Galerie du Faubourg, Paris, 1948, catalogue text by Louis Scutenaire.
34. Scutenaire, *Avec Magritte*, 109–11, 113, trans. in Sylvester, *Catalogue Raisonné*, vol. 2, 160, 162.
35. Sylvester, *Catalogue Raisonné*, vol. 2, 167.
36. Magritte to Iolas, October 24, 1952, trans. in Sylvester, *Catalogue Raisonné*, vol. 3 (1993), 192.
37. Patrick Waldberg, *Magritte: Peintures* (Paris: L'Autre Musée/ La Différence, 1983), 17.
38. Max Kozloff, "Surrealist Painting Re-examined," *Artforum* 5, no. 1 (September 1966).
39. Magritte, *Écrits complets*, 684, trans. in *Magritte* (London 1992), 21.

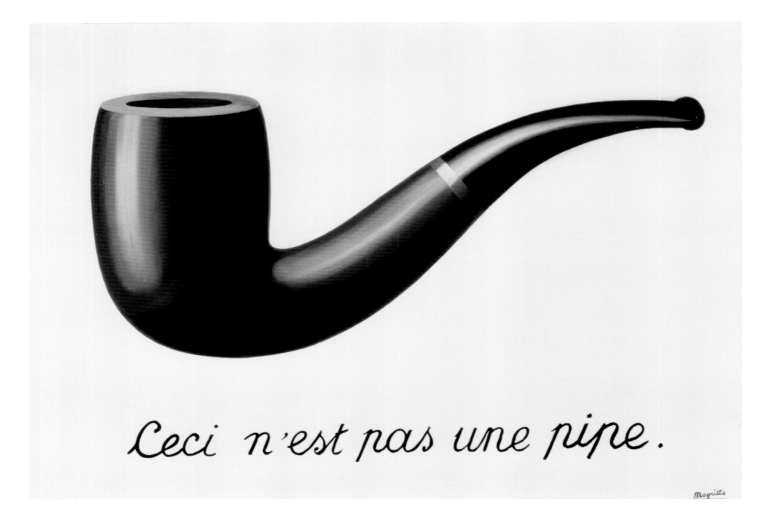

Magritte, *The Treachery of Images (This Is Not a Pipe)*, 1929

The Treachery of Images: Keys for a Pop Reading of the Work of Magritte

MICHEL DRAGUET

The last likeness unravels. No longer are there ordinary things.
—Paul Nougé [1]

René Magritte's work and thought continue to have a central place in today's artistic debate despite his voluntary, and nearly suicidal, retrenchment from contemporary praxis in 1948, expressed in what he called his *vache* period of deliberately unsympathetic painting.[2] Denigrating the explorations of Jean Dubuffet,[3] rejecting the affiliation claimed by the pop generation,[4] Magritte isolated himself in a marginality that was hostile to the present. His critique of pop makes the point: "[Pop artists] came to the mistaken conclusion that they must show the poetry of today's world. That is where their error lies. They want to express today's world, although it is just a transitory state, a fad; and poetry does not concern passing things. Poetry is the feeling of the real, of what it has that is most permanent."[5]

Yet Magritte, like Duchamp before him, contributed decisively to the development of what would become known as postmodern theory. At the heart of the historical avant-garde, the singularity of his undertaking can be situated in his categorical refusal to abandon representation under the seductive influence of new aesthetic codes. This choice was greatly sustained by the momentum of surrealism, from its postromantic valorization of the unconscious to its investment in the object situated in the light of desire.

At the beginning of the 1920s Magritte rejected the development of a nonfigurative formalism in favor of creating images whose primary meaning would remain their readability. Historians have not paid much attention to this question, although treating it situates Magritte directly in the arena of mass culture, which he will oppose to the elitist developments of abstraction. While still an art student, in 1918 Magritte created his first poster, for the Derbaix company's beef stew. This poster shows Magritte dealing with the juxtaposition of text and image in a manner that he will continue to develop over the rest of his career. Later he will refer to his advertising activity—illustrations, book covers, and brochures—as "idiotic work." At the same time that he made his start in advertising, Magritte began an apprenticeship as a painter-decorator, enabling him to grasp the difference between the efficacy of the image as discourse and the visual reality of the image. Between 1918 and 1925 he shuttled between these two modes, depending on whether he was executing large-scale posters or drawing designs for wallpaper for the Peters-Lacroix firm, where he collaborated with the nonfigurative painter Victor Servranckx. From this point on he would try to detach himself from painting as such in order to define himself as an inventor of images practicing the "art of painting." During

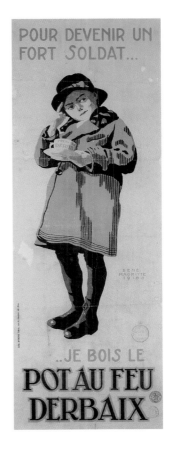

Magritte, advertisement for Derbaix stew, 1918

these early years Magritte was also part of the avant-garde circles of Belgian art. He presented himself as a fashionable poster artist with a sensitivity to cubo-futurist vocabulary. His work participated in the "modernolatry" of urban life, with its cortege of fancy cars and elegant ladies.

But this experience lasted only a short time. Magritte did not share the belief that abstraction would impose itself as a new language. His reflections on pure painting inclined him away from such ideas. In "L'art pur, défense de l'esthétique" (Pure Art: A Defense of the Aesthetic)[6]—a short treatise he wrote with Servranckx in 1922—he described how an artwork must function by "triggering AUTOMATICALLY the aesthetic sensation in the spectator."[7] By opposing artwork/life to function/theory, Magritte attributed a vital impulse to the image, one that could be characterized as dadaist: "A painting hanging on the wall can be a factor of disorder; this disorder is only an appearance; it is caused by life; it is inevitable, destined; at its heart there is order: a law."[8]

Being the elegy of natural disorder and of the law under which apparent discontinuity unites the work and reality, "pure art" is singularly distinct from appeals to the purely visual. To systematic form Magritte opposes the extended image, considered as a universe unto itself, a spiritual universe detached from social conventions, and thence from the decorative instrumentation of a kind of painting that tends not to signify anything but itself.[9] To the primacy of form, Magritte substitutes the primacy of meaning: the *idea* will define a new philosophy of the image. As an autonomous entity it can be "reproduced a million times over thanks to the progress of color photogravure"[10] without any loss to be mourned. From this moment on, Magritte's work in painting and advertising can be distinguished from his merely decorative work. The opposition between painting and poster is not to be sought in the concept of multiples. "Pure" painting and the pragmatism of advertising both refuse the prestige to which masterpieces aspire.[11] For Magritte, the specificity of the unique work of art—and thus its deepest meaning—is to be found in the social inscription of the image in the world: an image that is unique, hence precious, and that resides in a single place. This singular status transforms the image into its own ornament, and contrary to Walter Benjamin's theory of "aura," thus reduces its significance. That the work of art becomes a cult object attests to this. Magritte makes the point by interrogating his reader: "Do you believe that the decorative aspect of a work of visual art interests the person who is looking at a reproduction during an airplane trip?"[12]

The question is not innocent. When the work of art is not hanging on elitist walls, it is projected, mediated, for the length of an everyday journey. Magritte no longer associates the autonomy of the work with its functionality, but with its efficacy— much greater in a magazine than in a museum, a place Magritte himself always disliked going. Being independent of reality, the work can go forth in its infinite reproducibility. Reintegrated into its social context, it does not lose the aura that, for Magritte, doesn't come from the material culture to which Walter Benjamin remains indebted, but rather from the outburst of an idea in perpetual recomposition.

Magritte substitutes for avant-garde doctrine an emancipated conception of painting as such. In an undated letter to his friend E. L. T. Mesens, he sums up his position in a slogan : "Down with visual art—long live simply painting."[13]

The path chosen by Magritte includes literature, not as an artistic genre but as a laboratory of ideas. It is through writing that his ideas take shape, often in the form

of dialogues. These include collaborative works with Paul Nougé—a strange poetic catalogue of 1927 for the furrier Samuel; a parody of spelling manuals, *Clarisse Juranville*, several months later; and the extensive exchange of letters, which will play a determining role in the elaboration of the artist's imaginative universe.[14] This dynamic dialogue, which passes from the written to the image seemingly without interruption, concerns the evolution of the kind of modern painting that Magritte discovered thanks to Mesens. The works of Giorgio de Chirico and Max Ernst steer his own work toward a form of the imagination under the sign of dismemberment and recomposition. Between 1925 and 1927 Magritte experimented with the logic of collage, which determined his conception of surrealism in painting. He discussed this in 1938 in a lecture entitled "La ligne de vie" (The Line of Life), where he associated the practice of collage—latent in his conception of advertising posters—with the "overwhelming effect" of an image that no longer obliges the artist to demonstrate sincerity and sentiment. Rejecting the traditional function of the painted image, Magritte claims its tools: drawing, brush, and color. Scissors and glue bring life to a universe born from selection and reuse; the work is that of critical reserve through cutout, and poetic deviation by collage. Thus Magritte concludes that the image can do without everything that traditionally endows painting with prestige.

The practice of collage is less a way of amputating reality than of revealing what is hidden beneath appearances. The collaboration with Nougé on the catalogue for Samuel demonstrated this, as their correspondence acknowledges when the poet writes to the painter in his new Paris home: "What I find most interesting is the function you attribute to these pieces of cut-up paper, an inexplicable object that serves to *hide*, indeed to suggest more strongly than the image everything that it conceals, *because one cannot admit that it conceals nothing*. This, my friend, seems to be the sign of a new direction that cannot but bring you back to the unknown, or if you prefer, the unpredictable. I would be surprised if you do not make some important discoveries shortly."[15] Indeed, these discoveries would soon emerge from the combined effect of writing and painting.

Words in Perspective

The relationship that links image to text constitutes a determining element in Magritte's work once he abandons the rhetoric of the avant-garde. Magritte's answer to the nonfigurative idiom (which, beginning with art deco, defines a period) is a hesitant exploration of the link between writing and painting that then allows for its deconstruction. From this perspective every painting becomes "an infernal machine."[16]

The Treachery of Images (This Is Not a Pipe) is the culminating point of this exploration. Painted in 1929, after a project published in the magazine *Variétés* in January of that year, it was exhibited for the first time in 1933, at the Palais des Beaux-Arts in Brussels. This work synthesized investigations linked to Magritte's word-and-image painting practice. Magritte shows himself to be extremely parsimonious. His paint handling is perfectly smooth, giving the image a kind of transparence that calls attention to its obviousness. In both the figure and the accompanying caption, the artist has erased all evidence of his hand, endowing the representation with the universal quality proper to an advertised object. This encounter between image and text makes clear the shared requirement of depersonalization.[17] Through numerous references to the practices of Salvador Dalí and Joan Miró—the clear palette and concise gesture

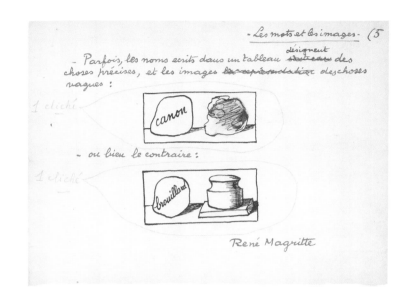

Magritte, *Words and Images* (fifth sheet), 1928

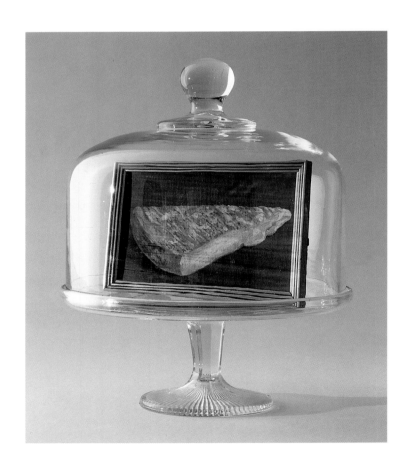

Magritte, *This Is a Piece of Cheese*, 1936 or 1937, oil on canvas board in gilded wooden frame on glass pedestal under glass dome, height: 31 cm, diameter: 25.2 cm, The Menil Collection, Houston

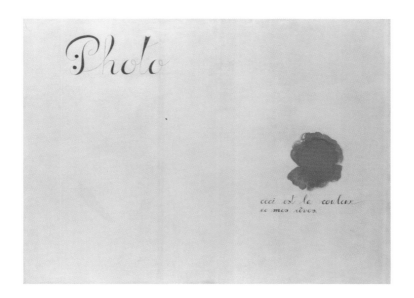

Joan Miró, *Photo: This Is the Color of My Dreams*, 1925, oil on canvas, 96.5 × 129.5 cm, The Metropolitan Museum of Art, New York, The Pierre and Maria-Gaetana Matisse Collection, 2002

compete with Dalí on the terrain of illusionism,[18] while the composition itself harks back to *Photo: This Is the Color of My Dreams*, painted by Miró in 1925—this work served as a tool for penetrating the surrealist circle to which Magritte then aspired.

The Treachery of Images plays on the contrast between what is seen as obvious and what the text finally comes to deny. The evidence refutes the written demonstration. What is said not to be a pipe has no alternative formulation—"If this is not a pipe, what is it, then?"—other than a long demonstration in the manner of Michel Foucault. The latter concentrated on the distance which separates the thing itself (one notes that the pipe in question had never been used) from its representations—figure or caption—in the spirit of Magritte himself, who announced in "Les mots et les images": "You see images and words differently in a painting." This contrast distinguishes between the operations of the linguistic field and those of pictorial space. Neither the word *pipe* nor the figure of the object referred to by the word *ceci* are in and of themselves pipes. The use that would justify the object in everyday reality remains forbidden to them. Yet only use defines an object in its reality. This principle—neglected by Foucault—alludes in some sense to the work being done by Duchamp as of 1915 in the readymade.

Such a practice enters Magritte's oeuvre in 1936 with *This Is a Piece of Cheese*. Identity, henceforth affirmed by recourse to the demonstrative pronoun *ceci*, is here founded exclusively on use. Thus, Magritte simultaneously highlights objectivity and the quality of the object by enclosing the representation—along the lines of the 1929 pipe but lacking any caption—in a covered cheese dish. The assertion arises from the same game of codifications as the bottle rack transformed into an art object by the artist's placement of it, which leads one to interpret the object's identity based on its function. While Duchamp articulated his undertaking around an intention that captures an already constituted object, Magritte remains faithful to his own logic. The only object present harkens to the mechanics of identification: the cheese dish confirms the object's identity. It is its proof. But at the same time it alludes to a virtuality: a representation that functions like a word made visible, and not

like the thing itself. Whereas *The Treachery of Images* remained exclusively centered on the denunciation of representation, and through that, of language, *This Is a Piece of Cheese* narrows the only path available for defining the object: the conventions of use. Thus Magritte reduces the efficacy of the readymade to a language event whose character seems arbitrary. In Magritte's presentation, the sense attached to use cannot be confined to the limits of a convention. On the contrary, he tries to reveal the sense of the object in a process of poetic deviation, which his painted work unceasingly explored from the 1930s onward.

The experience synthesized in *The Treachery of Images* will find its theoretical formulation in December 1929 in the twelfth issue of *La révolution surréaliste*, where "Les mots et les images" appears as one of Magritte's major contributions to the art of the twentieth century. Creating an inventory of the kinds of relationships that link text and image, he ends up demonstrating the impossibility of having confidence in language. Not that language is opaque and forbids all obvious correlation to representation. On the contrary, it is its very transparence—the mimetic question that the paintings had been evoking since 1928—that drives Magritte to inextricably link communication and prevarication.

"Les mots et les images" was methodically constructed. The possibility of passing from one zone to another is granted by the formula stating that "the words are of the same substance as the images." Eighteen key ideas are thus developed in a report fixing theory on the side of the text and demonstration on the side of the image. In some cases, an assertion achieves its revolutionary development only through the test of the image. That is the case with the first example, a leaf renamed "cannon." The poetic dimension does not reside in the programmatic statement, but in the poetic rerouting practiced by Magritte. In other cases, the image makes itself an illustration, and Magritte declares: "There are objects that do without a name." It can also happen that the image constitutes the locus of theoretical formulation. In this case—demonstrated in the next-to-last and last propositions—Magritte anchors his statement in a subtle reading of avant-garde discourse. When he affirms that "the names written in a painting designate precise things and the images vague things," he stigmatizes abstraction's aspiration to the formless. The word thus becomes the mimetic reference, even though earlier in the text Magritte evoked the possibility of matching any word with any form. But this illusion of reality becomes abstract when it is confronted with an object seized in its cold objectivity. Against the static quality of spoken language—embodied here by "cannon" and "fog"—is the gap that opposes the biomorphic blot to photographic rendering. From 1928 on, Magritte's interest focused on the meaning of mimetic representation. Here he affirms its conventional aspect—"Everything tends to make one think that there is little relation between an object and that which represents it"—as a prelude to the radical denial that is revealed in *The Treachery of Images*.

The Invention of the Object

The explosion created by the confrontation between the visible and the readable permitted the recomposition of the image in its poetic form. Henceforth, the sense of the image is completely changed by a praxis of painting that Magritte intends to define. As of 1933 it becomes the theater of a dialectical questioning in which the image visually resolves problems posed according to a methodology not unrelated to the logic of advertising.[19] *Elective Affinities* (1933) opened the way for this method,

as Magritte explains in a lecture delivered in London in February 1937: "There exists a secret affinity between certain images; this is true equally for objects and for the representing images. Here is a demonstration: We know the bird in the cage; interest is heightened if the bird is replaced by a fish or a shoe; but if these images are surprising, they are unfortunately accidental, arbitrary. It is possible to obtain a new image that will resist examination by what it possesses that is definitive, just. That is the image of an egg in a cage."[20]

Magritte, *Elective Affinities*, 1933, oil on canvas, 41 × 33 cm, private collection

Using this principle, Magritte situates the meaning of the image in the dialectical surmounting of the object. One's gaze wants to go beyond the obvious, to a mysterious point that renders perceptible its reason for being, to a first cause, a fundamental logic as irrefutable as a truth buried in the depths of humanity: something so evident that consciousness itself occults it and that it would take an image to reveal. Up to this point Magritte had cultivated strangeness under the influence of his poet friends; gradually he would come to a more philosophical inflection in his work. It is less a question of deconstructing the language than of exhuming from each object (even though he recognizes that it doesn't work with every one) a predestined meaning whose resolution would not reside in the thing itself but in the deployment of the thought process. A method becomes clear: identify "predestined" objects, whose particularity is that when they are put into a relationship a heretofore occulted signification would spring forth. Magritte linked this notion of "obvious poetry" to a form of philosophical introspection: "This element I was looking for, this obscure aspect of each object—I had in the course of my reflection acquired the certitude that I would always recognize it in advance, but that this knowledge was somehow lost in the depths of my thoughts. As this reflection must result in only one exact answer for each object, my investigations resembled the pursuit of the solution of a problem for which I had three givens: the object, the thing attached to it in the shadows of my consciousness, and the light where this thing must arrive."[21]

The results of these investigations are known: they span from *Elective Affinities* to *The Dominion of Light* (1954). Nonetheless, it is interesting to observe how this poetic redistribution, founded upon the central experience of *The Treachery of Images*, will develop in the works to come. Beyond the reference to the photographic practice of double exposure as discussed by David Sylvester,[22] Magritte pursues his work of undermining representation in three gouaches bearing the single title *Objective Stimulus* (1939). He no longer does this by opposing the word to the object it fails to match, but by superposing on the thing in its visual obviousness its reduced, but identical, double. The table on the table, the painting on the painting, the sculpture on the sculpture, the pot on the pot, the apple on the apple operate as if two assertions added together cancel each other out. The accumulation betrays the surface effect and deprives the object of all concrete presence. The operation does not affect reality, but only its representation. It is the banality of the chosen object that constitutes its power of fascination and its "virtue of provocation."[23] This is how the doubling works: by denying assertion through repetition and by reinforcing the surface effect of the entire representation. The image becomes a screen spread across the void. Things there are absent and resemblance closes the loop in a lie.

In 1956 Magritte returned to his "problematology" of images with a series of gouaches entitled *The Place in the Sun*. These works no longer foreground the distance that separates the word from the thing it is supposed to match, but they restore a distance seemingly annulled in the 1939 *Objective Stimulus* variations.

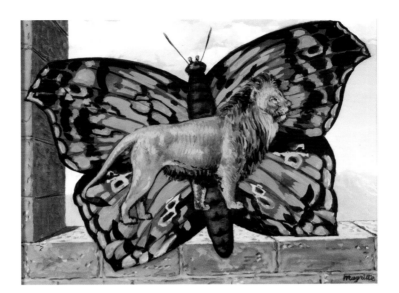

Magritte, *The Place in the Sun*, 1956,
gouache on paper, 15 × 19.6 cm,
private collection

Magritte juxtaposes motifs: a plum on a pear, an open door on a closed door, a lion
on a butterfly, a seated woman on the back of a chair. He explains his process to
his friends Mirabelle Dors and Maurice Rapin: "I had a little idea: instead of writing
an unrelated name under an object, I thought to try something like painting a plum
on a pear or some other object: a locomotive for example, on a prone lion."[24]

Anonymity and the Multiple

Cinema, an integral part of urban modernity whose icons advertising is always
multiplying, occupied an important place in Magritte's discourse on multiplicity.
In the collective unconscious being constituted, cinema appears as a means of
expression that brings together the marvelous aspects of invention with popular
entertainment. The magic of motion, the reinvention of narrative, and the pleasure
that film affords all attract Magritte. When American cinema crosses the Atlantic
between the wars, he is enthusiastic about romantic comedies and westerns. He
is particularly fascinated by Charlie Chaplin, whose characters mix realism and
expressivity, irony and critique. The cinematic imagination and technique are based
on the principles of montage. This fact would seem to incite collage to operate in
a similar manner in order to generate narrative. Clearly Magritte is sensitive to
cinema's acceleration of movement and to its multiplicity of viewpoints, which
allow many sensations to be evoked simultaneously. When an idea becomes gesture
it is deployed over time. The home movies that Magritte makes starting in 1956
follow this lead: they are humorous declensions of banal events from the daily life
of friends and acquaintances. Magritte exalts insignificance as many of his pictorial
compositions become the locus of the intimate festivities immortalized on celluloid.
Thus cinema brought to Magritte the possibility of depicting an image in articulated
shots. From this came the feasibility of deconstructing the montage of any image to
recompose it according to a different intellectual point of view or even remodulating
the thematic elements. Inspired by Raoul Hausmann, Magritte began to make his
paintings as a kind of montage from a "static film." But he was not, like Hausmann,
just trying to "retain a relationship to the life of the times and to create a new unity
which would rip away from the chaos of this warring and revolutionary period a

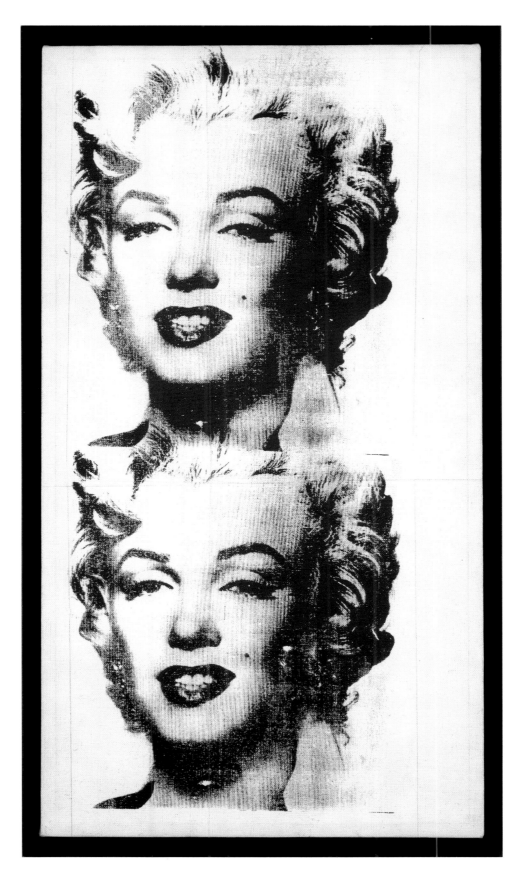

Andy Warhol, *Two Marilyns*, 1962

Magritte, *Golconda*, 1953, oil on canvas, 80.7 × 100.6 cm, The Menil Collection, Houston

reflective image which would be optically and conceptually innovative."[25] Magritte detached himself from the visual questioning of the avant-gardes. His conception of the "reflection-image" remains based on the principle of language deconstruction that supports mimetic representation. It is not a matter of affirming syncope and rupture, but of recomposing an illusion by placing it in the foreground. He creates an illusion so perceptible that it would close itself around its own circularity. In other words, a negation of everything that representation reveals of the tautological.

Starting in 1936 one can observe a coincidence between Magritte's interest in popular culture and his need to produce images to meet the demands of his exhibition schedule.[26] Thus it would seem that his exploitation of variants owes a lot to the development of his career in the United States. He begins to pay attention to themes and their variations. More and more gouaches are made in parallel to paintings on canvas. Regularly Magritte denounces the idea that these gouaches are mere copies.[27] From this period on, he transforms his correspondence into a podium from which he defends the work and explains the ideas that stimulate each new variation. Before the development of today's mass photographic reproduction, these gouaches constituted an essential aspect of the work's dissemination, particularly since Magritte was not at first widely reproduced in books and catalogues. As a savvy adman, he is quite conscious of what he is doing, even if he regularly bemoans having to give into Iolas's persistent demands that he rework images from the past, an undertaking many of his friends criticize.[28]

The prolific production of gouaches that characterizes the 1950s and 1960s goes hand in hand with the serious commercialization of Magritte's work by Iolas. This entails an industrialization of his output that does not, however, change anything

in his creative spirit. On the contrary, it gives Magritte's work that "promotional effectiveness" already evident in the 1920s. Magritte finds a twofold advantage. For one, the increase in sales considerably improves his lifestyle without in any way affecting the poetic substance of his enterprise. Furthermore, his newly acquired comfort accompanied a new form of subversion conditioned by the massive distribution of the image. This can be observed in the iconography Magritte adopts in subsequent works such as *Golconda* (1953) or *The Month of the Grape Harvest* (1959). Of course, this aspect of his work was not always readily perceived by the artist's own circle.

In July 1962, on the occasion of Magritte's retrospective in the Belgian city of Knokke, a pamphlet titled *Grande baisse* (Great Bargain Sale) is published. It stigmatizes the disparity between the discourse articulated around the principle of mystery and the commercial orchestration of the images: "From mystery to mystery, my painting is beginning to resemble merchandise delivered up to the most sordid speculations. My pictures are now being bought in the same way one would purchase land, a coat, or jewels. I have decided to put an end to this undignified exploitation of the mystery by making it accessible to all purses. . . . I call attention to the fact that I am not a factory and that my days are numbered. Art lovers are invited to submit an order immediately. Let it be known: there will not be enough mystery for everyone."[29]

This anonymous[30] pamphlet met with the approval of many, including André Breton, who congratulated Magritte, thinking he was its author. It describes a kind of assembly-line production of works in various mediums and formats, notwithstanding that for Magritte each variant is supposed to induce a deepening of the initial idea and sometimes even a genuine reorganization of the subject. Exact copies were secondary to him and for all intents and purposes negligible. He refutes the criticism that he "furnishes copies of his most popular paintings, he who always hated painting as a manual skill and who had even stated that if he ever became rich, he would only paint the pictures he really felt like making."[31] He no longer gives pride of place to rarity, that central element of art commerce, in order to integrate the parameters of a postmodern communication substituting for the unique image (which hence became precious) the infinitely multiplied image of its reproduction.

Thus Magritte's practice conserves its coherence independently of its mass circulation; indeed, because of it. It is founded on a fundamental contrast opposing the surface effect of the multiplied image to the profundity of the image as considered in its poetic principle. Magritte attributes value neither to the practical exercise of painting nor to the hypothetical quality linked to the status of the unique work. The value of the image is measured not according to the manner of its making but with regard to the imagination that is freely available at the time of its creation. It is simply the visible vehicle of the idea. Whether or not the artwork is industrially produced—as proposed in the avant-garde circle frequented by Magritte at the beginning of his career—its pertinence is not affected. This position is perfectly coherent with regard to Magritte's perfect understanding of the persuasive techniques inherent to the advertising image. It is from this stance that he defies the "efficacy" of the monumental formats that impose themselves in such an authoritarian manner on the viewer's consciousness. Magritte chooses to challenge monolithic vastness with repetition and variation. He pays no heed to the value of the original; for all he cares it can disappear.

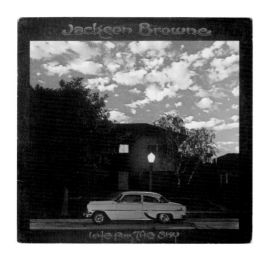

Album cover, Jackson Browne, *Late for the Sky*, 1974, Asylum Records

This attitude is in the air. In October 1964 Magritte receives from Ivanhoe Trivulzio of Milan a letter (written at Pierre Alechinsky's behest) proposing that he participate in an action aiming to "democratize" art. The proposal is to make a painting, publish it in an edition of several thousand posters, and then destroy the original in front of an official witness.[32] Two years later Magritte would become interested in a procedure that leads him along a similar path: "kamagraphy." Magritte, along with Max Ernst and Henri de Waroquier, was invited to participate in an experiment founded on the invention of the chemist Henri Cocard, a friend of the art dealer Raymond Nidrécourt. The simple procedure did not involve already completed paintings, but rather works to be made, as the artwork had to be integrated into the creative process from the beginning.[33] As Magritte explained: "Two hundred copies would be exhibited with similarly reproduced paintings by Max Ernst, Chirico, etc., in the main cities of Europe and America. Thanks to this invention impecunious museums will be able to have rooms full of modern paintings they could only dream about until now. Similarly for art lovers."[34]

Magritte followed this procedure to create a variation of *The King's Museum* (1966), whose multiples would be reproduced in *Paris Match*. He finds the technique all the more inspiring as it does not perturb his means of expression. The painting was sold to Nidrécourt, whom Magritte introduced to Harry Torczyner as "that industrialist devoted to the love of graphics (Kama—Hindu god of love),"[35] and then sacrificed to allow a "democratic" distribution of the work.

The process would be abandoned, even though Magritte's growing recognition made his works the object of more and more numerous and varied forms of reproduction. Although he refused to accept it, his ideas were often co-opted by advertising, and after his death there would be a mass diffusion of his images on posters, cards, books, and all sorts of commercial objects. So many aspects of his work seem to have already explored this realm. After all, his paintings sometimes seem like the matrices—and how precious—of now familiar images. If the aspect of overuse tends to annoy today's art amateur, this familiarity does guarantee their efficacy, the efficacy Magritte claimed when he declared that there was nothing behind the "visible image." When considered as an object, any painting masks a slice of reality—behind the colors, the canvas; behind the canvas, the wall; behind the wall, the ocean. Thus, the "visible image" hides nothing, since it unties itself poetically from reality. Even when multiplied indefinitely, the image remains irreducible.

Thus, Magritte's negative perception of pop art finds closure in the *mise en abîme* of his own situation. The question is not so much about the reality of his work as it is of its social inscription in a world in the process of globalization. One can interpret Magritte as a melancholy critic of pop in its "neo-dada" perspective when he writes: "Pop art is a kind of son of dada, but without the same freedom that dada had at the time."[36] This statement betrays regret at no longer being able to combine avant-garde and social protest and also the feeling that pop is somehow involved in a complacent form of imitation bereft of authenticity. Perhaps this work is necessarily insincere, as Marcel Broodthaers seemed to indicate in his inaugural oeuvre. But Magritte cannot bring himself to accept it, even if he had already affirmed that modern art had come to an end with Picasso.[37] Instead, he situated himself in an indistinct space placed under the sign of imitation and verisimilitude.

Translated from the French by Rachel Stella

Notes

1. Paul Nougé, *Le Catalogue Samuel* (1927; facsimile repr. Brussels: Didier Devillez Editeur, 1997), n.p.

2. For more on this subject, see Michel Draguet, *Magritte tout en papier: Collages, dessins, gouaches* (Paris: Hazan, 2006), chap. 4.

3. Magritte wrote to Louis Scutenaire, "As for Dubuffet, one now sees it clearly: false notes from beginning to end. Value based only on an imbecilic snobbism. He'd be even better off showing used toilet paper assembled under glass according to his fancy; it would certainly make a few aesthetes drool." Magritte to Scutenaire, December 1949 or January 1950, Centre de Recherches René Magritte–ULB, Brussels.

4. Magritte systematically refers artistic enterprises of pop art—whose English branch had received support from E. L. T. Mesens—to their origins in dada. By August 1964, in the columns of the magazine *Rhétorique*, he criticizes the "phoniness" he perceives in pop; reprinted in Magritte, *Écrits complets*, ed. André Blavier (Paris: Flammarion, 1979), 594. The question of the object appears at the heart of a comparison that Magritte refuses less from conviction than from his wish not to be assimilated with any kind of trendiness.

5. M.-F. Fryns, "'Pop' art et poésie avec René Magritte," *Beaux-Arts*, January 20, 1966, 6.

6. The history of this text is discussed in David Sylvester et al., *René Magritte: Catalogue Raisonné*, vol. 1 (Antwerp: Mercatorfonds and Houston: The Menil Foundation, 1992), 35–36.

7. Magritte, "L'art pur, défense de l'esthétique" (1922) in Magritte, *Écrits complets*, 13.

8. Ibid., 16.

9. This aspect is to be reconsidered in the general framework of the history of abstraction between the wars, where in countries such as France, Italy, and Belgium nonfigurative language is mixed with the rhetoric of art deco.

10. Magritte, "L'art pur," 18.

11. As Georges Roque has pointed out, for Magritte advertising became "objectionable as it brought him into contact with the main schemas of representation that he would always try to overcome in his paintings." Georges Roque, *Ceci n'est pas un Magritte: Essai sur Magritte et la publicité* (Paris: Flammarion, 1978), 14.

12. Magritte, "L'art pur," 18.

13. Magritte to E. L. T. Mesens (c. 1923), Centre de Recherches René Magritte–ULB, Brussels.

14. I have treated this issue in detail in *Magritte, tout en papier*.

15. Paul Nougé to René Magritte, November 1927, in Nougé, *René Magritte (in extenso)* (Brussels: Didier Devillez Éditeur, 1997), 139.

16. Ibid., 145.

17. Regarding the magazine *Correspondance*, the composer André Souris remarked: "The writing . . . was curiously uniform and seemed to result from a voluntary depersonalization in the case of [Lecomte, Magritte, and Nougé]. It was characterized by an extreme concision, an allusive, precious, sometimes sibylline and slightly disturbing tone." André Souris, "Paul Nougé et ses complices," in *Entretiens sur le surréalisme* (Paris–La Haye: Mouton, 1968), 434.

18. Magritte met Dalí in the spring of 1929 during his stay in Paris for the filming of *Un chien andalou*. As a freelancer for the Barcelona paper *La Publicitat*, Dalí mentioned Magritte several times. In August of the same year, the Magrittes rented a place in Cadaqués with Goemans and his companion Yvonne Bernard, as well as Gala and Paul Eluard, not far from the Dalí family's summer home. Miró and Bunuel visited. It was during this trip that Gala left Eluard for Dalí, whose meticulous technique could be seen influencing Magritte's *Threatening Weather* (1929) (see Sylvester, *Catalogue Raisonné*, vol. 1, no. 313). In October Goemans opened a gallery in Paris at 49, rue de Seine. The first exhibition presented the artists he had under contract: Arp, Dalí, Tanguy, and Magritte. There would only be three more exhibitions: Arp in November, then Dalí. The following year, he organized an exhibition of collages with Aragon.

19. This point is central to the thesis developed by Georges Roque in *Ceci n'est pas un Magritte*.

20. Magritte, "Conférence de Londres" (1937), in *Écrits complets*, 97.

21. Magritte, "La ligne de vie" (1938), in *Écrits complets*, 111.

22. Sylvester, *Catalogue Raisonné*, vol. 4 (1994), 39.

23. Ibid., 59.

24. Magritte to Mirabelle Dors and Maurice Rapin, February 14, 1956, Centre de Recherches René Magritte–ULB, Brussels.

25. Raoul Hausmann (1931), quoted in *Dada* (Paris: Musée National d'Art Moderne, Centre Georges Pompidou, 2005), 260.

26. I explain this development in relation to gouache works in *Magritte, tout en papier*, chaps. 3 and 5.

27. See, for example, besides the correspondence with Harry Torczyner, Magritte's letter to the collector Barnet Hodes dated August 16, 1962, Centre de Recherches René Magritte–ULB, Brussels.

28. "Des Magritte en cher, en hausse en noir et en couleurs" was the formula of Marcel Duchamp in *Magritte* (New York: Hugo Gallery, 1951).

29. *Grande baisse* (1962), Centre de Recherches René Magritte–ULB, Brussels.

30. In fact, the text was written by Marcel Mariën. Magritte was not very happy about the whole episode. Suspecting Mariën, he wrote him a sarcastic message: "My dear Mariën, I take advantage of this empty moment to wonder if your heavy humor and doubtful French are enough for others to follow your trail as you have? Without any remarkable mystery, despite any downturns which might be announced, find my signature going up." Magritte to Marcel Mariën, July 14, 1962, in Magritte, *La Destination: Lettres à Marcel Mariën* (Brussels: Les Lèvres Nues, 1977), no. 278.

31. Marcel Mariën, *Le radeau de la mémoire: Souvenirs déterminés* (Paris: Pré-aux-Clercs, 1983), 191.

32. See Magritte, *Lettres à André Bosmans 1958–1967* (Paris: Seghers, 1990), 389, n. 1.

33. The weekly magazine *Paris Match* described the new process: "A prepared canvas (the back is a plastic sheet covered with conduction points) is given to the artist, who may work on it in any fashion: with oils, or glue, with a brush or a palette knife, in washes, impasto—just as he wishes. When the work is dry it goes through forty-two operations destined to homogenize it with a layer of special translucent resin and then gently baked for twenty-four hours at a temperature of 180° Celsius. At that point nothing is left of the original, which is destroyed, but the machine is able to produce two hundred fifty canvases which are exactly identical to each other and to the original." J. Borgé et N. de Rabaudy, "Le rêve de Malraux 'Le musée imaginaire' devient réalité," *Paris Match*, November 19, 1966, 146.

34. Magritte to Harry Torczyner, October 3, 1966, in *L'Ami Magritte* (Antwerp: Mercatorfonds, 1992).

35. Ibid.

36. M.-F. Fryns, "'Pop' art et poésie," 6.

37. Cited in Magritte, *Écrits complets*, 643.

Magritte with LouLou at a rodeo, Simonten, Texas, 1965

Magritte's Last Laugh: A Surrealist's Reception in America

DICKRAN TASHJIAN

It was an auspicious beginning for Magritte. What better place than the Julien Levy Gallery to have his American premiere? Levy was an up-and-coming impresario of surrealism, having organized the first New York survey of surrealism in 1932, and subsequently exhibiting Max Ernst and Salvador Dalí in his Manhattan gallery. Levy thus sported impeccable credentials for Magritte, who always took an intense interest in the details of his exhibitions. Although circumstances kept the two apart, the young dealer probably learned of the Belgian painter through common acquaintances among the surrealists. At the very least, he must have certainly noticed Magritte's work in the pages of *La révolution surréaliste*, a journal that was readily available in Paris and Manhattan. After some preliminary correspondence, dealer and painter agreed upon a one-man show in January 1936.[1]

Upon unpacking the twenty-two canvases Magritte had chosen for the exhibition, Levy was disappointed to discover that many of the paintings were smaller versions of previous work. Given their transatlantic arrival, Levy's bone of contention was rendered moot, but it nonetheless hinted at a Magritte largely unknown in America at the time. The invisibility of his complicated intellectual and artistic life in Europe increased the odds of misinterpretation when he came before the American public, his contradictions concealed by the respectability of his iconic bowler and chesterfield coat.

Levy would not have known that commercial considerations were secondary for Magritte in duplicating images for his American debut. The painter was mainly interested in conceptual problems that led to solutions on canvas. Thus visualization of the same idea could take variant forms. (For example, the smaller, 1935 version of *The Rape*, which Levy received, is a mirror image of the 1934 original.) In this vein Magritte was closer to the conceptual orientation of Marcel Duchamp or Man Ray than to the Freudian orthodoxy of the surrealist group and their leader, the poet André Breton. Duchamp and Man Ray, however, knew enough to keep a friendly distance from this group, whereas Magritte was so eager to join them that he and his wife, Georgette, moved from Brussels to a Paris suburb in September 1927. Their stay did not meet expectations, however, as Magritte hovered on the margins of the closely knit surrealists. Annoying obstacles and squabbles drove an exasperated Magritte home by mid-1930.[2]

Such aggravations simply masked fundamental differences between Magritte and Breton. The painter was not a fellow traveler—that is, a surrealist in all but official sanction, which in any case was not forthcoming from Breton for several years. Nor was he a notorious self-publicist like Salvador Dalí, who was shamelessly eager for commercial ventures. ("Avida Dollars," as Breton anagrammatically christened him.)[3]

Magritte, *The Rape*, 1934

Magritte, *The Discovery of Fire*,
1934 or 1935

By contrast, Magritte thrived in a murky zone where his identity papers were never quite in order, at least not to the satisfaction of Breton, who was the final arbiter. Magritte painted under the banner of surrealism nonetheless, even as he deviated from its tenets.

At the same time, Levy may have felt that the ambiguities that marked Magritte's avant-garde identity in Europe were best left behind to avoid confusion in marketing the newcomer to an American audience. Levy thus presented the painter as nothing other than a surrealist. Magritte collaborated in establishing this guise. For the exhibition flyer, he sent Levy a poetic homage by Paul Eluard, translated by Man Ray, along with a statement about his paintings by Paul Nougé, a prime mover of surrealism in Belgium. This supporting cast served to validate Magritte's surrealism. Levy designed an economical layout on a single blue sheet centrally illustrated with Magritte's *Man with Newspaper* (1927). To the left of the illustration, the short, cascading lines of Eluard's poem ("stairs of the eye," "the silhouettes of mirrors") reverberate against the titles of the paintings listed on the right. In the lower part of the sheet, Nougé's eloquent statement invites the viewer to participate in the process of "creating bewildering objects." Even a casual observer would have sensed that Magritte was a painter among poets: his enigmatic titles (*The Alphabet of Revelations* [1929], *The Discovery of Fire* [1934 or 1935]) claimed poetry of their own. And poetry was considered an essential albeit largely undefined quality of surrealism.

Entering the gallery, a viewer faced a bewildering array of images on display, just as Nougé had forecast. The paintings conveyed the thematic concerns that Magritte would so mysteriously visualize throughout his life. From the humor of *Perpetual Motion* (1935) to the violent double entendre of *The Rape* (1935) and the shock of *The Red Model* (1935), unforgettable images assaulted the unsuspecting visitor. New York critics responded with mixed reviews. A veneer of sophistication did not conceal a fear of being duped. The most strident reviewer dismissed Magritte as a "dullard" with a "pedestrian mind" and indicated that surrealism was old hat, in "a very lively state of decay." Another writer conceded that the paintings were certainly

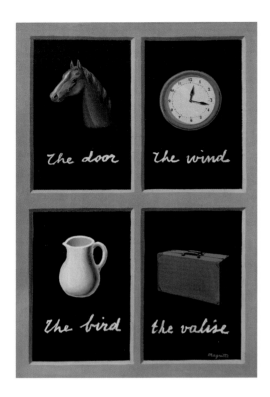

Magritte, *The Interpretation of Dreams*,
1935, oil on canvas, 41 × 27 cm, collection
of Jasper Johns

bewildering, but in the end Magritte was "merely entertaining." In the *New York Times*, Edward Alden Jewell refused to be tricked by Magritte "the prestidigitateur," with his "sly, horrendous shocks." He jettisoned the painter's "whole bag of tricks without batting an eyelash."[4]

The exhibition gained its greatest notoriety from a full-page feature in the *American Weekly*, a tabloid blaring the disparaging headline: "Crazy Paintings by Another Sur-realist Artist." The accompanying article caught on to Magritte's humor, but it set him up as a jokester if not a joke by putting words in his mouth to "explain" his paintings. Underlying the spoof, however, was a felt need to make sense of Magritte's images. All the critics understandably employed the familiar template of Freudian psychoanalysis—"the inexhaustible fields of magic, waking hallucinations, perversions, and just plain dreams," as the *New York Sun* put it.[5] Given the critical response, Levy was perhaps prudent in avoiding a more nuanced view of Magritte's surrealism.

Even so, Levy offered a new slant on Magritte by insisting that he trafficked in metaphor.[6] As a consequence, paintings with images and words came to the fore. The *American Weekly* showed *The Interpretation of Dreams* (1935), with each quadrant framing an image accompanied by a word that does not correspond: a horse ("the door"), a clock ("the wind"), a pitcher ("the bird"), and a suitcase (correctly labeled "the valise"). Faced with these incongruities, the reviewer could well imagine the Tower of Babel looming behind the painting. The *Times* critic Jewell seemingly accepted *The Interpretation of Dreams* but balked at *The Treachery of Images* (1935). He countered its inscribed disclaimer, "This is not a pipe," with Gertrude Stein's mantra, "A rose is a rose is a rose." Although Magritte's trope took on a life of its own, almost twenty years passed before American critics would seriously explore his play with words and images again.

The prospect of strengthening Magritte's presence in New York was ironically undercut by the visual spectacle at the Museum of Modern Art in December 1936. *Fantastic Art, Dada, Surrealism* was a sweeping survey where, if one can imagine it, a Magritte represented by no less than seven paintings was overshadowed by his fellow surrealists—Dalí, Ernst, and Hans Arp among them. It was surprisingly easy to lose Magritte among so many artists. The static that the press had directed earlier toward Magritte was now amplified against an entire movement. Adding to the frenzy was Dalí, who shrewdly manipulated publicity upon arriving in New York. Dalí's manic energy took him everywhere—from the cover of *Time* and the pages of *Vogue* to the windows of Bonwit Teller on Fifth Avenue.[7] Magritte did not stand a chance against Dalí's media blitz. From the first instance, critics made unfavorable comparisons, mesmerized as they were by the Spaniard's antics, on and off the canvas.[8]

Levy gave Magritte a follow-up exhibition in January 1938, but it was a diminished affair, with only sixteen paintings, including five from the first show. His press release for the follow-up perpetuated the idea that Freudian theory could unlock meaning, whereby Magritte supposedly painted "the fantasies of the subconscious." And despite ranking the Belgian as one of the leaders of surrealism in Europe, Levy further undermined Magritte by exhibiting him with someone who sketched patients at Bellevue psychiatric hospital. At one stroke Levy gave credence to those who considered the surrealists escapees from an insane asylum. Jewell tempered his *New York Times* review by claiming that *The Voice of the Air* (1928) was

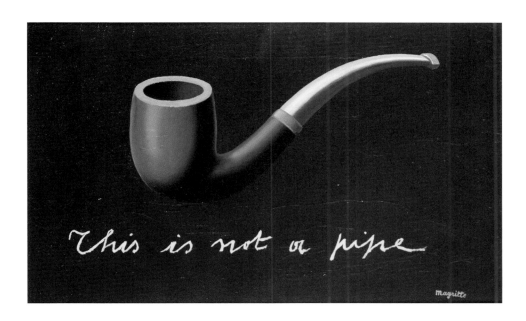

Magritte, *The Treachery of Images*, 1935

"the best thing by the artist that has yet been shown in America," but only because the painting was on loan from MoMA.[9]

By the end of the decade, Levy had sold few Magrittes. Transactions occurred mainly among a small coterie of surrealists—among them Kay Sage, who purchased *The Unexpected Answer* (1935). In 1941 he sold the 1935 version of *The Interpretation of Dreams* and *The Discovery of Fire* to Peggy Guggenheim. Earlier, MoMA had purchased *The False Mirror* (1929) from Man Ray, who conveyed to E. L. T. Mesens, Magritte's Parisian dealer, that "his 'eye of sky' is hanging in my apartment and it sees many things! For once, a picture sees as much as it is seen itself." Man Ray later wrote to Magritte, "Your paintings have reversed the usual procedure: before one can look at them, they are already scrutinizing the distracted onlooker."[10] Asserting that they saw "eye to eye," Man Ray shared visual affinities with his friend. Beyond their mutual fascination with eyes, both painted objects and body parts floating in the sky in defiance of gravity.

Almost a decade passed before Magritte would have another solo exhibition in the United States. By 1940 he had virtually disappeared, swallowed up by Nazi Germany's invasion of Belgium at the start of World War II. Isolated in Brussels, he anxiously sat out the war and survived its depredations under Nazi occupation.[11] Back in Manhattan, where the surrealist émigrés had regrouped to escape the death trap of occupied Europe, Peggy Guggenheim opened Art of This Century, a gallery featuring surrealist work. In his preface to Guggenheim's catalogue, Breton included an incisive discussion of Magritte, whose paintings he admired despite their contretemps of a decade before. In what was his first, albeit brief, commentary on Magritte, Breton generously acknowledged the painter's departure from surrealist orthodoxy for a "deliberate" procedure, "the reverse of automatic." Magritte "approached painting in the spirit of 'object-lessons' . . . [to] put the visual image on trial." The painter, he claimed, conceived "each picture as posing an entirely new problem."[12] For the first time, then, thanks to Breton's disclosure, the American audience learned of Magritte's conceptual inclinations.

Magritte, *The Voice of the Air*, 1928

Those inclinations could have led to a severe breach with the surrealists—others had been "excommunicated" for lesser offenses—but they were glossed over in the catalogue by illustrating Magritte's *Interpretation of Dreams* next to Breton's *Portrait of the Actor A. B.* (poem-object, 1941), an assemblage that integrated the verbal and the visual. It was a way of suggesting détente between Magritte and Breton. Even more striking would be the image of *The Red Model* (1935) on the cover of Breton's *Le surréalisme et la peinture*, a collection of essays published in 1945 by Brentano's bookstore in New York. Magritte was conspicuous by his absence from the text, but the cover image spoke volumes nonetheless. Here, apparently, was a surrealist who, denied admission to the club, left his shoes at the door.

Magritte gained his own forum in *View*, an American journal that shared affinities with surrealism. Its December 1946 issue was devoted to surrealism in Belgium. In "Lifeline" Magritte declared his urge to transform life through provocative images of objects "represented with the appearance they have in reality . . . [but] situated where we never find them." While he acknowledged the play of dreams and the unconscious, he preferred to establish "contact between consciousness and the external world." Ultimately, he sought a "pictorial experience which puts the real world on trial" so as to enter "an infinity of possibles [*sic*] now unknown to life."[13]

View's Belgian issue was a prelude to Magritte's postwar debut at the Hugo Gallery in January 1947. Among the forty-five paintings on display were *The Red Model* (1935) and *A Stroke of Luck* (1945). Alexander Iolas, a young Greek who had abandoned ballet to run the gallery, turned for catalogue copy to the poet and critic Parker Tyler, an associate editor of *View*. Tyler offered the highest praise: "The works of this painter might be meditated forever as mysteries, and in this full abyss one might find the love everlasting to look at them." Magritte's titles, however, set a snare for Tyler, who saw them as "verbal clues," rendering the imagery "hieroglyphic." The paintings became "charades" with meanings for the viewer to puzzle out. *Alice in Wonderland* (1946), with its anthropomorphic tree, became a "sexual charade," readily understood in Freudian terms.[14] Although Magritte conceded that the essay was "likeable," he risked surrealist heresy by rejecting Tyler's Freudian interpretations as "banal."[15]

Magritte's second exhibition at the Hugo Gallery, in May 1948, traveled in September to the Copley Galleries in Beverly Hills, California. (Although his gallery closed after only six months, William Copley became something of a West Coast Levy, exhibiting a roster of surrealists—Max Ernst, Joseph Cornell, and Man Ray.)[16] A pattern of dissemination was set, as Magritte infiltrated the United States beyond Manhattan. He would eventually gain national exposure in diverse venues, from the Renaissance Society at the University of Chicago to Gump's department store in San Francisco, from museums and galleries coast to coast and points in between. At the same time, Magritte maintained a strong presence in Manhattan, thanks to Iolas, who became his agent and exhibited him regularly.

After World War II, through the 1950s, reviews revealed a gradual sea change in attitudes toward Magritte. The occasional rant surfaced, and some reviewers were perfunctory, their brevity standing in for negative assessment, as though the surrealist label explained everything. By 1951, however, Magritte had become a "well-known Belgian surrealist," apparently for no discernible reason beyond longevity. But as one reviewer finally realized in 1957, "To classify Magritte simply as

Magritte, *Alice in Wonderland*, 1946, oil on canvas, 146 × 114 cm, private collection

Brochure for *Magritte: Word vs. Image* exhibition, Sidney Janis Gallery, New York, 1954

'Surrealist' is to relegate him, which is easier than to evaluate him as a painter or to wait for the laugh—the last one."[17] Discarding a comfortable category, however, left critics in extremely unfamiliar territory, marked only by the paintings themselves. The paintings remained a difficult challenge, flaunted by Magritte, who seemed eager to have the last laugh.

Fresh ways of understanding Magritte surfaced along with his reemergence after World War II. Robert M. Coates reviewed Magritte's 1948 exhibition at the Hugo Gallery for the *New Yorker*. Author of *The Eater of Darkness*, a novel written under the spell of the Parisian dadaists in the 1920s, Coates had a reserve of empathy for Magritte. Even as he recognized the painter's "extraordinary technique," something that many reviewers doubted, he understood Magritte's refusal to get caught up in the eye-dazzle of "retinal" painting, as Duchamp once dismissed the pyrotechnics of the paintbrush. Coates simultaneously identified Magritte as a "mature" thinker of "large concepts" and praised the poetic feeling of the paintings.[18] He neglected, however, to explain how the conceptualist and the poet were reconciled in Magritte.

Poetry, of course, is associated with metaphor, and from the moment of Magritte's debut in America, Levy had pointed to metaphor as a key to the paintings. Metaphor, however, is first cousin to symbol, and Magritte not only vented displeasure at Freudian symbolism, he also denied the presence of symbols in his work. "I hate symbols as much as I hate tradition," he confessed to *Time* magazine's Brussels correspondent in 1947. "Symbols are what you learn at school, but to be a surrealist, as I am, means barring from your mind all remembrance of what you have

seen, and being always on the lookout for what has never been seen." Magritte the surrealist apparently sought an innocent eye, which, deliberately averted from the past, would offer fresh images of the world from one blink of an eyelid to the next. Where was the poetry in that self-renewing gaze at a constant present? *Time* could only resort to insult, calling Magritte a "dour little Belgian."[19]

These issues came to a head in March 1954, when Sidney Janis opened at his gallery in New York *Magritte: Word vs. Image*, the first American exhibition to offer a thematic approach to the paintings. Suggested by E. L. T. Mesens, Magritte's Parisian dealer, the show was based on a series of drawings, each accompanied by the artist's brief commentary, titled "Les mots et les images," which had been previously published in *La révolution surréaliste* in December 1929. Appearing in *La révolution* with Breton's "Second Manifesto of Surrealism," "Les mots et les images" could be considered Magritte's own sly manifesto, posing questions about metaphor, poetry, and representation. Mesens translated the 1929 text, which Janis printed along with the original sketches in an accordion-fold catalogue for the exhibition.[20]

The show concentrated on twenty-one paintings executed between 1928 and 1930, when Magritte was grappling with the problem of the relationship between word and image. The canvases in the exhibition visualized that relationship, making clear that conceptualizing and painting went hand in hand for Magritte. Even though the theme (and the paintings) dated back twenty-five years, the exhibition retrieved and made accessible an important aspect of Magritte's work. It revealed the painter in a new light and dislodged him from the ranks of orthodox surrealism. At a time when abstract expressionism was ascendant and representational painting was suspect or dismissed, Magritte's imagery could no longer be considered "mysterious" in some vaguely surrealist fashion, or merely "representational." The paintings had shifted into the realm of the visually conceptual and were no less mysterious for their dislocation if not abandonment of discursive meaning.

Although Magritte appeared to have stated the theme simply enough, the paintings themselves testified to its labyrinthine complexity; taken in the aggregate, the paintings presented seemingly endless permutations of word and image, often in cross reference, throughout the gallery. A viewer would certainly have sympathized with the woman depicted in *The Subjugated Reader* (1928), originally titled *The Agitated Reader*, as though Magritte were anticipating the reactions of viewers confronted by his word-and-image paintings. Here was the earlier, 1930 version of *The Interpretation of Dreams*, with six images inscribed with incongruous labels, parodying a child's primer by undoing the reading lesson, de-schooling a child for primal vision. Here, too, was *The Literal Meaning* (1929), this version (of the three in the exhibition) enigmatically bearing the phrase "*femme triste*" on an oval panel, perhaps a mirror-less mirror, leaning up against a wall of faux stone. In other variations, *The Palace of Curtains* (1929) shows two panels, one includes the word "*ciel*," the other depicts sky, while *The Blue Body* (1928) shows "*arbre*" and "*canon*" inscribed onto an ocean within an irregularly shaped frame. And, of course, topping these disjunctions was *The Treachery of Images* (1929), with its now-infamous phrase, "Ceci n'est pas une pipe."

At first glance, words in Magritte's paintings appear to be evidence of automatic writing welling up from his unconscious. But the options unfolded in the exhibition catalogue suggest to the contrary that Magritte had devised his own vocabulary, hardly dictated by the unconscious. Implicit in the sequence of possibilities was

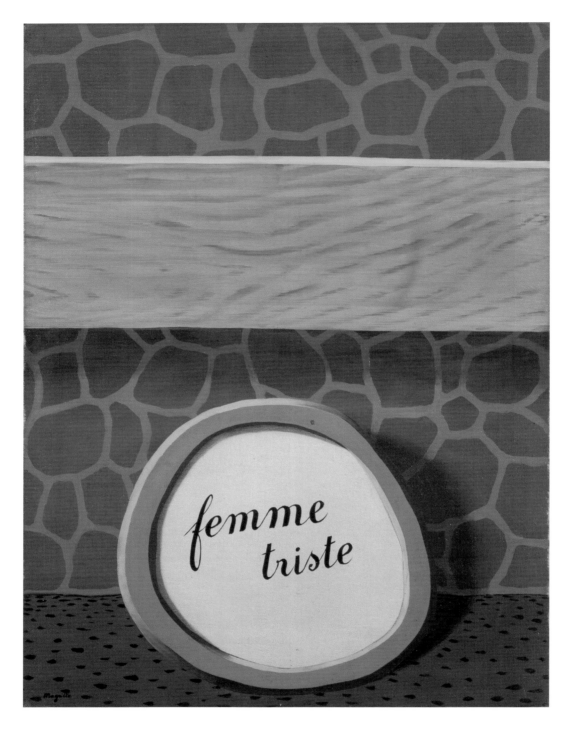

Magritte, *The Literal Meaning*, 1929

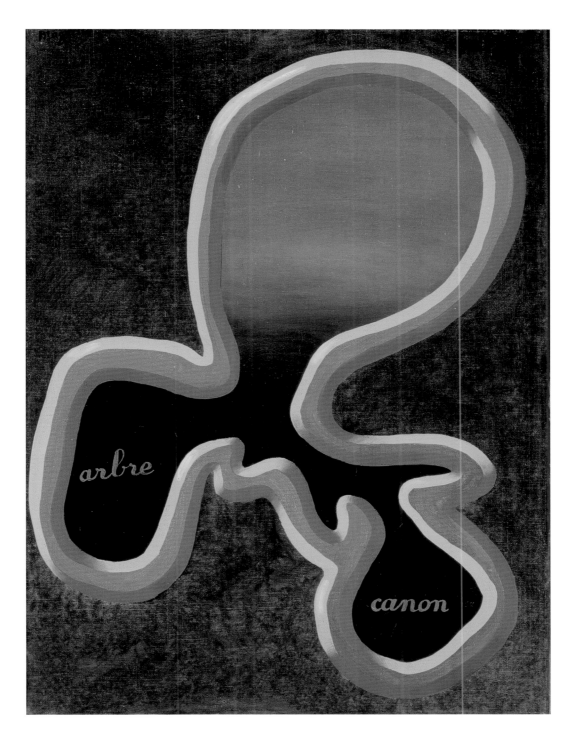

Magritte, *The Blue Body*, 1928, oil on canvas, 73 × 54 cm, private collection

Magritte, *The Empty Mask*, 1928,
oil on canvas, 73 × 92 cm, Kunstammlung
Nordrhein-Westfalen

the painter's assertion of autonomy, a freedom to manipulate words and images. Inscriptions found, say, in *The Empty Mask* (1928) could disappear, only to be replaced by their corresponding images, as in *The Six Elements* (1929). The sketches, white on black ground in the foldout, suggest chalk on a blackboard, which Magritte had actually used in giving a lecture at the London Gallery in 1937. *Word vs. Image* revealed his mind at work, its ad hoc processes, coordinating the gesture of sketching on the board to visualize yet another relationship between word and image.[21] In this respect, Magritte, no less than Jackson Pollock, who notoriously engaged in pouring paint on his canvases, was conceptually *in* his carefully constructed paintings.

Magritte's disjunctions dramatically contrasted the arbitrary connection between word and image, image and object, word and object—a connection ordinarily sealed (congealed, he might have said) by social convention. His disjunctions established a radical tension between word and image (hence "word" *versus* "image" in the English translation), such that the juxtapositions become indecipherable. These negations, however, were a misdirection that silently transformed the visual representation of recognizable elements into an opaque presentation before the viewer's eyes. In short, the image re-presented nothing but itself.

Magritte performed his conceptual sleight of hand according to the dynamics of metaphor set forth in the first "Manifesto of Surrealism" (1924). Breton had claimed that the juxtaposition of two "distant realities" was all the more poetic as their distance increased.[22] Skeptical of Breton's conviction that such juxtapositions could arrive only from the unconscious, Magritte achieved maximum distance by deliberately seeking disjunctions of word and image that jettisoned all logic for nondiscursive imagery, rendering it purely metaphoric, immune to interpretation.

No wonder, then, that some critics simply did not get it. Although the *New York Times* critic acknowledged that the Janis exhibition raised the problem of pictorial interpretation, he preferred to sidestep complexities for the ease of applying the surrealist or dada label. In *Art News*, Thomas B. Hess was somewhat more perspicacious by aligning the word paintings with the French poet Arthur Rimbaud's "alchemy of verbs" and their subsequent derangement. He dismissed this plausible connection, however, as out-of-date and characterized Magritte as "droll but peripheral."[23]

In *Art Digest*, however, Robert Rosenblum understood the "diabolical inevitability" of the artist's "surrealist grammar." If Magritte had become "our teacher," with a "didactic program," then what Rosenblum learned inside the gallery was hardly reassuring, for the disjunction of word and image suggested meaning beyond grasp, "concealed forever." Magritte's subversions, Rosenblum realized, were all the more disturbing because his "substitutes . . . are just as susceptible to foolish conventions as our own dictionaries, and that, of course, is quite to Magritte's point, too." Magritte's onslaught allowed no escape, not even for himself. Beyond the logic of his "surrealist dictionary" (presumably a reference to the fold-out catalogue), Rosenblum praised the "utter detachment and matter-of-factness" of Magritte's paintings. His highest accolade came as he left the gallery: "It is almost a relief to be back in a familiar world." But even East Fifty-seventh Street did not provide lasting consolation: "Magritte's lesson is so potent that, if properly learned, we will never take this familiar world quite so for granted again."[24]

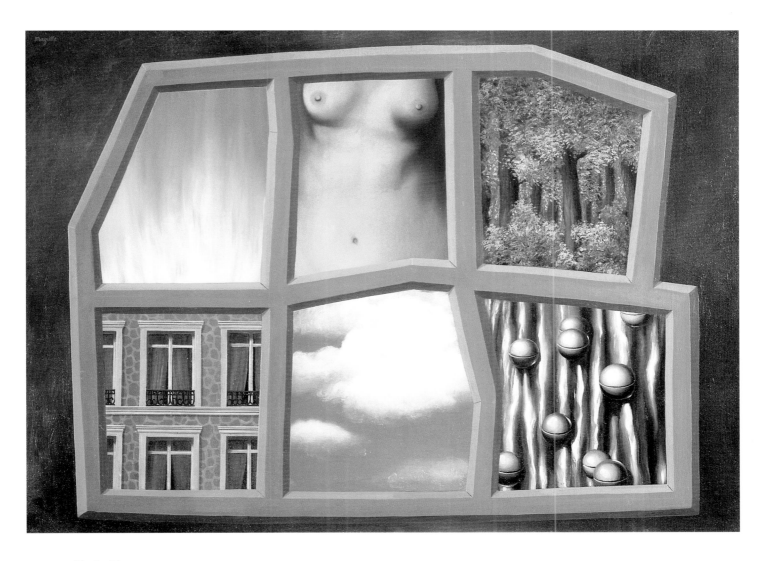

Magritte, *The Six Elements*, 1929

Installation views of *René Magritte in America* exhibition, Dallas Museum for Contemporary Arts, 1960–61

By 1960 Magritte's paintings began to appear in unlikely outposts, especially in Texas. Two energetic curators who had started out in San Francisco temporarily broke the dominance of Manhattan. Jermayne MacAgy was director of the Contemporary Arts Association in Houston in 1959 when her former husband, Douglas MacAgy, became director of the Dallas Museum for Contemporary Arts. John and Dominique de Menil, major collectors of Magritte in Houston, were crucial in realizing the MacAgys' curatorial aspirations for Magritte. Curators and collectors joined forces over winter 1960–61, when *René Magritte in America*, the painter's first retrospective in the United States, opened at the Dallas Museum for Contemporary Arts, followed by its showing at the Museum of Fine Arts, Houston.

Douglas MacAgy selected the works in the exhibition, a task facilitated by the de Menil family, Alexander Iolas in New York, and Harry Torczyner, an international lawyer who had become close to Magritte through collecting his art.[25] After the exhibition closed in Dallas in January, Jermayne MacAgy reinstalled it at the Museum of Fine Arts, Houston. She erected wall panels to create an intimate enclosure within a spacious gallery and to provide more wall space for the eighty-two works on exhibit. Scattered throughout the galleries were what appear to be large rocks, possibly made of papier-mâché, perhaps to point to Magritte's interest in boulders, as in *The Glass Key* (1959). Her installation, however, seems to have been less whimsical than the one in Dallas, which included an alcove for a table bearing Magritte's painted wine bottles. If the tableau hinted at a still-life place setting, the giant apple of *The Listening Room* (1952) loomed behind to disrupt such a possibility, pushing any thought of Cézanne out of the room. Elsewhere in the galleries were two *torchères* (tall stands for candlesticks) crowned with bowlers perched on Styrofoam heads. They stood at attention before Magritte's *The Sirens' Song* (1952), which presents a man in a bowler looking out to sea with his back to the viewer.

Although Jermayne MacAgy did not design the handsome catalogue, its compact dimensions and interplay of transparent overlays lived up to the innovative catalogues she had done for the Contemporary Arts Association and for the

University of St. Thomas.[26] Magritte contributed a brief statement that confirmed the primacy of "resemblance" for the human mind in perceiving the mystery of the world. For Magritte, the mental act of resembling was a metaphoric process central to the act of painting, "the art of resemblance." In the end, the viewer was left with the mystery, *"namely a group of figures which imply nothing."*[27] Hence the caption for his "pen-drawn vignette," the frontispiece for the catalogue: "This is not a derrick," a witty deference to a familiar Texas landmark, exotic to his eye, and defamiliarized for local vision.

Douglas MacAgy's catalogue essay offered the first major American analysis of Magritte's enterprise as a painter. Cognizant of Magritte's assertion that "my paintings say *nothing*," MacAgy concentrated instead on the painter's ideas and attitudes underlying his efforts. In dense prose that verged on the abstract, he traced Magritte's "conceptual vision" back to the late nineteenth century and noted the "nihilistic" surgery the painter performed in dislocating his otherwise banal images for their "poetic recognition." While acknowledging Magritte's nineteenth-century connections might have served to placate the catalogue's conservative audience, MacAgy's greatest contribution was to clarify the artist's relationship to surrealism. Magritte, he claimed, "drew inspiration from the association when it seemed congenial and calmly pursued his personal course when it was not."[28] Magritte's public persona began to gain some of the complexity that animated the private painter.

Two more large exhibitions quickly followed *René Magritte in America*. In 1962 *The Vision of René Magritte* was mounted at the Walker Art Center, Minneapolis, thanks to the efforts of Harry Torczyner. The exhibition catalogue was notable for exposing Magritte's scornful dismissal of psychoanalysis: "Perhaps psychoanalysis is the best subject to be treated by psychoanalysis." Two years later, acting as chair of the art department at the University of St. Thomas, Dominique de Menil organized *Magritte* for the Arkansas Art Center in Little Rock. The catalogue included Breton's belated appreciation of Magritte: "Europe may well envy America this vast retrospective of his work, which, with a truly clairvoyant brush, sweeps across the whole expanse of the world of today."[29]

Despite their significance, this concentration of large-scale exhibitions was soon overshadowed by Magritte's late-1965 retrospective at the Museum of Modern Art, simply titled *René Magritte*, tacitly acknowledging the artist's name recognition. In 1941 MoMA had ignored Magritte in favor of Dalí, Miró, and de Chirico, each of whom received major exhibitions. Now, after a quarter-century of neglect, the museum tried to make amends by mounting a retrospective. Cultural hegemony was not to be denied, as Manhattan once again became the center of attention. Although the retrospective might have lacked the panache of the Dallas installation of *René Magritte in America*, it was hardly a lackluster affair. MoMA displayed a full range of Magritte's paintings, always an intense visual occasion when seen together but heightened in this exhibition by the presence of *The Human Condition* (1933), *The Liberator* (1947), *Time Transfixed* (1938), *Elementary Cosmogony* (1949), and *Memory of a Journey* (1951), paintings that confuse our sense of perception, disrupt our domesticity, or take us into an alien realm.

James Thrall Soby's essay for the catalogue offered a docent's tour of the exhibition, moving from one painting to the next, methodically categorizing each one. Soby was a competent guide, certainly, but he failed to equip a viewer with

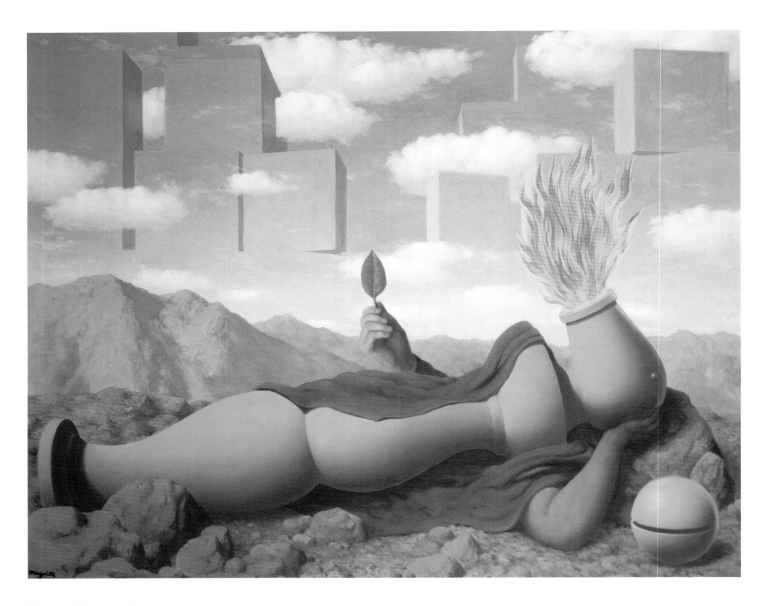

Magritte, *Elementary Cosmogony*, 1949

Magritte, *The Imp of the Perverse*, 1927

Sabena Airlines timetable and schedule of fares, 1966–67, incorporating Magritte's *Sky Bird* (1966)

the underlying principles of Magritte's project, as MacAgy's rigorous but rewarding essay had done. Whereas the New York press ignored the Texas exhibitions, John Canaday of the *New York Times* wrote a long notice and then a full Sunday review of the retrospective.[30] In January 1966, Magritte and his wife, Georgette, along with LouLou, their Pomeranian, flew in from Brussels for the opening. (Magritte gave Sabena Airlines an image from a recent oil painting, *Sky Bird* [1966], to use as an advertising logo in exchange for permitting LouLou to ride among the passengers rather than with the luggage.)[31]

Dalí, who was having his own Manhattan exhibition at the conservative Gallery of Modern Art in Columbus Circle, "tried to steal the show" at Magritte's opening. Dalí was most likely anxious because his reputation had severely declined while Magritte's was rising. As *Newsweek* succinctly put it, "Magritte is much more difficult to understand than Dalí . . . and he is certainly a more genuine, original and profound artist." Magritte survived Dalí's theatrics and enjoyed dinner and a round of fetes in Manhattan. He was interviewed by Grace Glueck for the *New York Times*, wandered the streets of the city with Georgette (and LouLou), and visited the house of Edgar Allan Poe, whose writings Magritte admired.[32] (See *The Imp of the Perverse* and *The Domain of Arnheim* for paintings whose titles refer to short stories by Poe.)

Houston managed to steal Magritte from Manhattan. In mid-December Magritte, Georgette, and LouLou took a charter flight to visit John and Dominique de Menil in "western country," as he later described it. Interviewed by the Houston press, he acknowledged local hospitality by alluding to the doubting St. Thomas: "I conclude that the people at St. Thomas University want to see me to be sure I am not a myth." "Royally entertained" by the de Menil family, he thoroughly enjoyed himself at a rodeo, where he traded his signature bowler for a "real" cowboy hat and hoped to meet John Wayne.[33] Magritte had clearly entered into the spirit of

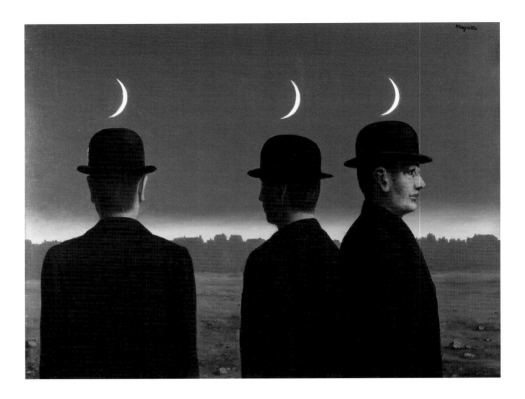

Magritte, *The Masterpiece or the Mysteries of the Horizon*, 1955

an America imagined by his generation of Europeans. It was as though he were symbolically completing a rite of passage into the American art world. The outcome of this cultural metamorphosis would soon become evident.

In the meantime, with MoMA's imprimatur, the retrospective went on the road to New England, and then traveled across country, finally landing on the campus of the University of California, Berkeley, in October 1966. Peter Selz, director of the Berkeley Art Museum, hung the exhibition so that upon entering the Powerhouse Gallery, viewers were immediately disoriented by *The Treachery of Images*. Magritte delivered a new image for a poster, MoMA apparently having depleted its stock. For the obligatory lecture series, Roger Shattuck, a professor at the University of Texas, gave a talk titled "René Magritte Framed" before an overflowing crowd of more than seven hundred. Magritte, however, came snapping at Shattuck's heels, having gotten wind of his speculations about the word-and-image paintings. Torczyner donned his lawyer's robes and mockingly proposed "a Consumers' Union to protect artists, art lovers and above all art students, from being fed false theories about artists." Undaunted, Shattuck posed for the *Daily Californian* before *The Masterpiece or the Mysteries of the Horizon* (1955), where he joined the three figures of the painting.[34] Students were seen wearing Magritte buttons. The excitement of the exhibition spilled onto a campus still in the throes of the Free Speech movement.

That the retrospective readily traveled while Magritte's out-of-town exhibitions remained local events was simply the most obvious sign of MoMA's cultural capital. It was due, however, not to the Manhattan newspaper reviews, the catalogue essay, nor even the retrospective itself; it was, rather, a result of the cultural buzz that MoMA could generate, amplified by the concentration of exhibitions focusing

on Magritte beginning in 1960. The buzz was picked up by the mass media and scattered throughout popular culture. Magritte buttons were the least of it in light of a Derby chair, a label for Zapple wine "reminiscent of the surrealist René Magritte," or a *Harper's Bazaar* article on weight reduction methods, illustrated by Magritte's erotically charged *Liaisons Dangereuses* (1936).[35]

The *New York Times* routinely reproduced Magritte paintings in the Book Review; *The Liberator* (1947), for example, illustrated a review for a novel by Michel Bataille. *The Murderer Threatened* (1927), a scenario depicting death and impending murder, is illustrated in Carol Hill's novel, *Let's Fall in Love*, a send-up of James Bond thrillers, replete with "steamy erotic passages."[36] (Line drawings of a bowler decorate the start of every chapter.) At the other end of the literary spectrum, a number of children's books featured Magritte paintings, mainly to initiate an appreciation of modern art. They indicate the degree to which Magritte has been acculturated, beginning with childhood.[37] But perhaps the most pervasive sign of Magritte in the air, or more properly in this instance, on the air, has been the CBS logo, erroneously assumed to be based on *The False Mirror* (1929).[38] This is *not* a Magritte, indeed.

Magritte's playful transformation at a Texas rodeo celebrated a reception that was a long time coming. He had emerged from thirty years of obscurity to gain celebrity status. What could be more American—but at what cost? Could Magritte remain enigmatic in the glare of such exposure? Even so, no one was more exotic than Magritte—a Belgian, not a Frenchman, and above all, not a bohemian. By the 1960s a bourgeois artist seemed as mysterious as one of Magritte's own paintings. The inevitable response of the mass-circulation magazines (such as *Esquire* and *Life*) was surprisingly refreshing. *Esquire* titled its feature, "This Is Not Magritte," a witty variant of "This Is Not a Pipe," which was rapidly becoming a preferred title for academic books and articles on Magritte.[39] *Life*'s pictorial effectively montaged Magritte in a "neat dark suit" against color reproductions of his paintings. He became a whimsical docent, on one page stretched out beneath a painting, on another, standing in front of three successive images of *Golconda* (1953) as his bowler soars through the air.[40]

Esquire and *Life* had been trumped three years earlier by *Harper's Bazaar*. Picking up where it had left off with the surrealists in the 1930s, *Bazaar* cobbled together an astonishing blend of puffery with a genuinely informative article. As though anticipating *Esquire*'s mythic male, Magritte was cast as a ladies' man in *Bazaar*. Although seen wearing a tuba on his head, he was described as being eyed by "the provocative woman" who, "reading in bed . . . devours our inquiry" into his art. Suzi Gablik, a young artist and critic who had spent eight months living in the Magritte household in 1959, wrote *Bazaar*'s inquiry, characterizing Magritte as a "mystery painter." Her essay offered a succinct biographical account of Magritte as contrarian and traced his genealogy as a painter, as he "became an eternal truant" from surrealism.[41] She stressed the semantic blank of his paintings, which resist interpretation, *any* interpretation—all written with grace and charm, sufficient to seduce that provocative woman in bed with Magritte.

Esquire's article featured the montages and double exposures of Duane Michals (as did MoMA's invitation to the opening of the retrospective and its catalogue cover, at Magritte's request). Michals had first come across Magritte in *Harper's Bazaar* and gained an invitation through a friend of Gablik's to meet the painter at his home in Brussels. (Magritte's apparently mundane domestic life in Brussels had become a

William Golden, logo for CBS Television, 1952

Magritte, *The False Mirror*, 1929, oil on canvas, 54 × 81 cm, The Museum of Modern Art, New York

Duane Michals, *Magritte with Hat*, 1965

source of astonishment, perhaps no less than his paintings.) In August 1965 Michals stayed at a hotel near Magritte's home and photographed the artist every day for a week. The young photographer found the paintings "consistently amazing because they contradicted [my] assumptions about the logic of the world." Most importantly for his own art, Michals became "freed . . . to reinvent photography from just documenting reality to actually question[ing] the nature of reality."[42]

The resulting book, *A Visit with Magritte*, begins at the front entrance of 97 rue des Mimosas, where we are greeted by Magritte. Moving through a muted interior, we finally reemerge on the street, as Magritte's house recedes into the distance. In between, we have followed Michals's unobtrusive camera from page to page: a series of close-ups transforms Magritte into a prestidigitator, his open hand concealing his face, a bowler balancing on his head. Multiple Magrittes appear superimposed as he hides beside and behind his paintings. Magritte sits at his desk, and then naps on his green sofa. (Images unexpectedly alternate between black and white and color.) Turning to the last page we come upon a rakish Duane Michals, wearing a bowler, in echo of Magritte's pose elsewhere in the silent narrative. The painter and the photographer have become linked through the camera's lens, which reveals a palpable domesticity containing the uncanny sensibility of Magritte, still a mystery despite his exposure. As Michals tersely explains, "Something wonderful had to come to an end," as Magritte continues to turn his back on us.[43]

Notes

I want first to thank Stephanie Barron for asking me to take on Magritte, whom I had egregiously dodged in previous research, despite admiration for his painting. One doesn't often get second chances. My thanks to Sara Cochran and Nola Butler, who have been enormously helpful in keeping the essay accurate and literate. The challenge of research was greatly eased by the generous efforts of several individuals: Jacqueline Allen, archivist, Dallas Museum of Art; Beth Bahls, Pace/MacGill Gallery; Geraldine Aramanda, archivist, Menil archives, The Menil Collection, Houston, Texas; Stephanie Cannizzo, curatorial associate, Berkeley Art Museum, UC Berkeley; Marie A. Difilippantonio, curator of the Julien Levy Archive, Newtown, Connecticut; Kathryn Wayne, fine arts librarian, UC Berkeley.

Finally, Renée Riese Hubert, my late colleague and friend, displayed a quiet intelligence and determination that led me through the mysteries posed so genially but oh so deceptively by that other René, Magritte.

1. For Julien Levy's account of his experiences as an art dealer, see *Memoir of an Art Gallery* (New York: G. P. Putnam's Sons, 1977). Levy offered a brief discussion of Magritte's methods, emphasizing the juxtaposition of image and word, in his collection of surrealist writing and visual art, titled *Surrealism* (New York: The Black Sun Press, 1936), 22. Also see Ingrid Schaffner and Lisa Jacobs, eds., *Julien Levy: Portrait of an Art Gallery* (Cambridge: MIT Press, 1998). The Levy-Magritte correspondence leading up to the 1936 exhibition is in the Julien Levy Archive, Newtown, Connecticut.

2. Magritte's dustup with Breton, which precipitated his return to home territory by mid-1930, occurred over a religious pendant of Georgette's. The story is told in David Sylvester et al., *René Magritte: Catalogue Raisonné*, vol. 1 (Antwerp: Mercatorfonds and Houston: The Menil Foundation, 1992), 111–12. I am greatly indebted to the editors of the catalogue raisonné, without whom this essay could not have been written.

3. According to Ian Gibson, Breton's anagram for Dalí appeared in a footnote in the second edition of Breton's *Anthology of Black Humour*, c. 1948. See *The Shameful Life of Salvador Dalí* (New York: W. W. Norton, 1998), 507.

4. "Magritte, Surrealist at Levy Gallery," *New York Post*, January 25, 1936; "René Magritte," *New York Herald Tribune*, January 8, 1936; Edward Alden Jewell, "Show Lists Works of Surrealist Art," *New York Times*, January 8, 1936. These review clippings were found in Levy's scrapbooks in the Julien Levy Archive.

5. "Crazy Paintings by Another Sur-realist [*sic*] Artist," *American Weekly*, March 1, 1936; *New York Sun*, January 11, 1936.

6. Jewell, "Show Lists Works of Surrealist Art."

7. For an account of the response to *Fantastic Art, Dada, Surrealism* at MoMA, as well as Dalí's stunts in New York, see Dickran Tashjian, *A Boatload of Madmen: Surrealism and the American Avant-Garde, 1920–1950* (New York: Thames & Hudson, 1995), 50–90.

8. Jewell, for example, claimed that Dalí could "paint like an angel" (*Art Digest* 11, no. 7 [January 1, 1937]: 7), whereas Magritte's "canvases are for the most part arid with respect to those qualities we call esthetic" ("Show Lists Works of Surrealist Art").

9. Julien Levy, press release for the 1938 Magritte exhibition, Julien Levy Archive; E. A. Jewell, "Canvases Shown by René Magritte," *New York Times*, January 8, 1938.

10. Magritte, letter to Mesens, July 12, 1933, in Sylvester, *Catalogue Raisonné*, vol. 1, 342; Man Ray, "My Dear René," in *Magritte: Paintings, Drawings, Gouaches*, ed. Philip M. Laski (London: Obelisk Gallery, 1961), 31. Man Ray exhibited with Magritte in *Trois peintures surréalistes: René Magritte, Man Ray, Yves Tanguy* at the Palais des Beaux-Arts in Brussels, December 1937.

11. While Dalí was enjoying a second season at the New York World's Fair in 1940, Magritte was fleeing the invasion of the Nazis and their subsequent occupation of Brussels. Although Georgette refused to leave, the painter joined a chaotic exodus to Paris, where he ran into Peggy Guggenheim, who was maniacally buying art one step ahead of the German invasion. Desperate for cash, he sold her a later version of *The Voice of the Air* (1931). On foot, by bicycle and train, Magritte eventually made his way back to Brussels, where he continued to paint, and even managed to find a dealer, who gave him a clandestine exhibition; it was a dangerous business, necessitating self-censorship because of the status of Magritte's paintings as "degenerate art" under the Nazi regime. For a full account of Magritte during the war (from which I have sketched the main events), see Sylvester, *Catalogue Raisonné*, vol. 2 (1993), 80–91.

12. "Genesis and Perspective of Surrealism," in *Art of This Century*, ed. Peggy Guggenheim (New York: 1942), 22–23.

13. "Lifeline," trans. Felix Giovanelli, *View* 7, no. 2 (December 1946): 21–23. Note that Magritte has the "real world" on the docket, not the image, as Breton had indicated. The discrepancy, however, is moot because Magritte questioned both image and reality. Magritte also contributed the cover to this issue of *View*, which was titled "Surrealism in Belgium."

14. Magritte decided not to exhibit *Alice in Wonderland* at the Hugo Gallery, but Tyler evidently saw the gouache on the premises and commented on it in his essay.

15. "René Magritte," brochure (New York: Hugo Gallery, April 1947). See also Magritte, letter to Iolas, April 21, 1947, in Sylvester, *Catalogue Raisonné*, vol. 2, 143. For a brief account of Iolas and the Hugo Gallery, see David Sylvester, *Magritte: The Silence of the World* (Houston: The Menil Foundation and New York: Harry N. Abrams, 1992), 266; Theresa Papanikolas, "Alexander Iolas: The Influence of Magritte's American Dealer," this volume. Magritte had wanted a full-blown catalogue, with illustrations as well as an introduction by Jacques Wergifosse, a young French poet whom the painter had met in 1944. Wergifosse's introduction was held up at U.S. Customs, so Parker Tyler was brought on board. Despite Magritte's objections to the essay that was substituted, Tyler was not an unreasonable alternative. He had written a short introduction for *An Exhibition of the Fantastic in Modern Art*, presented by *View* at the Hugo Gallery in November 1945, and earlier he had mentioned Magritte in an essay on "The Erotic Spectator," locating the experience of seeing in "the eye of the libido" (*View*, series IV, no. 3 [October 1944]: 74–77, 83).

16. See Sara Cochran, "Passing the Hat: René Magritte and William Copley," this volume.

17. "René Magritte," *Art News* 50, no. 2 (April 1951): 45; "René Magritte," *Arts Magazine* 31, no. 8 (May 1957): 54.

18. Robert M. Coates, "The Art Galleries," *New Yorker*, May 15, 1948, 60–61. Coates was inspired by the pulp fiction character Fantomas, whom Magritte also admired, for *The Eater of Darkness* (New York: Macaulay, 1929). During the 1920s, the Parisian dadaists, then surrealists (including Magritte), were fascinated by American popular culture. See Dickran Tashjian, *Skyscraper Primitives: Dada and the American Avant-Garde, 1910–1925* (Middletown: Wesleyan University Press, 1975), 116–42.

19. "Be Charming," *Time*, April 24, 1947, 75.

20. Mesens's English translation is problematic in itself: "word vs. image" indicates an opposition of elements, whereas "les mots et les images" describes a juxtaposition. Moreover, "words," in the plural, suggests the multiplicity of Babel, in contrast to the Word as Logos. Against the divine order and absolute meaning of the Logos, Magritte sets the anarchy of words, disrupting their conventional meanings and deconstructing their underlying social contract.

21. Magritte found this impromptu approach to appearing before an audience rather challenging. See Sylvester, *Catalogue Raisonné*, vol. 2, 53–54. This suggests the degree to which he planned the word-and-image paintings. The images were not automatic in the surrealist method.

22. "Manifesto of Surrealism" (1924), in André Breton, *Manifestoes of Surrealism*, trans. Richard Seaver and Helen R. Lane (Ann Arbor: University of Michigan Press, 1969), 20–21, 36–37. For a clear exposition on metaphor, see Philip Wheelwright, *Metaphor and Reality* (Bloomington: Indiana University Press, 1978). Magritte's juxtaposition of elements is a kind of metaphor that Wheelwright describes as "diaphor" (78–86). Wheelwright further sees metaphor in all its forms as intrinsic to the human mind, offering a perspective on reality. Magritte's juxtapositions create a dissident, dissonant perspective, which is indeed disturbing.

23. Howard Devree, "Art of Magritte at Janis Gallery," *New York Times*, March 3, 1954; Howard Devree, "Symbol and Vision: In Four New Shows Artists Illustrate the Problem of Interpretation," *New York Times*, March 7, 1954; Thomas B. Hess, "René Magritte," *Art News* 53, no. 2 (April 1954): 42–43.

24. Robert Rosenblum, "Magritte's Surrealist Grammar," *Art Digest* 28, no. 12 (March 15, 1954): 16, 32. *Word vs. Image* at the Janis Gallery looked forward obliquely to *Secret Affinities: Words and Images by René Magritte*, a 1976 exhibition at the Institute for the Arts at Rice University in Houston, Texas. The words were Magritte's, but the exhibition was not thematically focused, offering instead a survey of his paintings.

25. Torczyner was also president of the Belgian Art Foundation in the United States, an organization that would have smoothed the entry of paintings through U.S. Customs. For insight into their friendship, see *Magritte/Torczyner: Letters Between Friends*, trans. Richard Miller (New York: Harry N. Abrams, 1994); Michel Draguet, "Harry Torczyner, Magrittean Ambassador to America," this volume.

26. Magritte was included in the following catalogues for thematic exhibitions at Jones Hall Fine Arts Gallery of the University of St. Thomas: *Persona Grata: An Exhibition of Masks from 1200 B.C. to the Present* (Houston: 1960); *Art Has Many Faces: The Artistic Fascination with the Cube* (Houston: 1963); *Out of this World: An Exhibition of Fantastic Landscapes from the Renaissance to the Present* (Houston: 1964), which was the last catalogue Jermayne MacAgy designed before she died. Dominique de Menil maintained MacAgy's standards: see *Constant Companions: An Exhibition of Mythological Animals, Demons and Monsters, Phantasmal Creatures, and Various Anatomical Assemblages* (Houston: 1965); *Unromantic Agony* (Houston: 1965).

27. "Statement by the Artist," in *René Magritte in America*, exh. cat. (Dallas: Dallas Museum for Contemporary Arts, 1960), n.p.

28. Douglas MacAgy, "About the Art of Magritte," in *René Magritte in America* (Dallas 1960).

29. Statement by Magritte, in *The Vision of René Magritte*, exh. cat.

(Minneapolis: Walker Art Center, 1962), n.p.; André Breton, "The Breadth of René Magritte," in *Magritte*, exh. cat. (Houston: University of St. Thomas, 1964), n.p. Breton aptly quoted Dore Ashton, who at a symposium on pop art in 1963 asserted, "Metaphor is as natural to the imagination as saliva to the tongue" ("A Symposium on Pop Art," *Arts Magazine* 37, no. 7 [April 1963]: 39). For a short discussion of Breton on Magritte, see Simon Watson Taylor, "André Breton and René Magritte," *Studio International* 177, no. 908 (February 1969): 69–70.

30. See John Canaday, "Art: Retrospective for René Magritte," *New York Times*, December 15, 1965; John Canaday, "The Quiet Necromancer," *New York Times*, December 19, 1965. Sarah Whitfield succinctly traces the growth of Magritte's reputation in the United States, and she indicates that Soby came to appreciate Magritte by the mid-1960s (*Magritte*, exh. cat. [London: South Bank Centre, 1992], 11–23).

31. Sylvester, *Catalogue Raisonné*, vol. 3 (1993), 132. According to Georges Roque, who has traced Magritte's career as a commercial artist, Sabena had commissioned Magritte for a logo in 1965. *Sky Bird* (1966) took to the air and even appeared on the airline's tickets. See Roque, *Ceci n'est pas un Magritte: Essai sur Magritte et la publicité* (Paris: Flammarion, 1983), 174–75. Sabena also took out a full-page color advertisement on the inside back cover of *Arts Magazine* (January 1966). This advertisement simply displayed a full illustration of *The Married Priest* (1961) to commend Belgium as a cultural destination for tourists.

32. Roger Shattuck, "This Is Not Magritte," *Artforum* 5, no. 1 (September 1966): 32; "The Square Surrealist," *Newsweek*, January 3, 1966, 57; Grace Glueck, "A Bottle Is a Bottle," *New York Times*, December 19, 1965. I have found no account in the New York press of Dalí's behavior at Magritte's opening other than Shattuck's brief remark in his essay for *Artforum*.

33. "Surrealism Goes to Texas," press release, December 15, 1965; Ann Holmes, "Artist Wants John Wayne Chat," *Houston Chronicle*, December 19, 1965; Magritte, interview by Eleanor Kempner Freed, "Painter of Paradox," *Houston Post*, December 19, 1965. In Houston, Dominique de Menil arranged a small exhibition of Magritte's paintings drawn from local collectors, and Magritte spoke informally with the students at St. Thomas University. This information can be found in the Menil Collection archives. For a brief account of Magritte's trip to New York and Houston, see Sylvester, *Catalogue Raisonné*, vol. 3, 132.

34. Shattuck's photograph appeared along with a brief interview in "Surrealist Scholar Shattuck Analyzes Magritte," *The Daily Californian*, October 17, 1966. Torczyner made his mock proposal to William Seitz, director of the Rose Art Museum at Brandeis University, where Shattuck had initially spoken; he then revised it for publication in *Artforum*. (Torczyner, letter to Seitz, September 22, 1966.) Material about the exhibition at Berkeley can be found in the Magritte file of the archives of the Berkeley Art Museum.

35. Rita Reif, "Furniture: 'Its Own Madness,'" *New York Times*, May 14, 1974; Jane Leek, "Pop Wines Prime the Youth Palate," *Los Angeles Times*, September 19, 1971; Edward Maisel, "Take Inches from Your Waist," *Harper's Bazaar*, April 1967, 164–67, 171, 187.

36. Christopher Lehmann-Haupt, "Machineries of Sex and Love," *New York Times*, April 18, 1974; Carol Hill, *Let's Fall in Love* (New York: Random House, 1974).

37. Children's books include Michael Garland, *Dinner at Magritte's* (New York: Dutton's, 1995), a work of fiction that takes a bored little boy into Magritte's home for dinner with Dalí; Angela Wenzel, *Now You See*

It—Now You Don't: René Magritte (Munich: Prestel, 1995); Catherine Prats-Okuyama and Kimihito Okuyama, *Le Double Secret: René Magritte* (Paris: Centre Georges Pompidou, 1985); Douglas and Elizabeth MacAgy, *Going for a Walk with a Line* (New York: Doubleday, 1985). All these books illustrate Magritte's paintings and attempt to explain them to children.

38. The CBS eye, which bears a marked resemblance to Magritte's *The False Mirror*, was designed by William Golden in 1952. Torczyner pointed out the similarity to Magritte, who did not think that a lawsuit was justified. See Sylvester, *Catalogue Raisonné*, vol. 1, 342. The most recent (and clever) appropriation of Magritte can be found in the 1999 remake of *The Thomas Crown Affair* (MGM), which involves several men in bowlers invading the Metropolitan Museum of Art to return a stolen Monet.

39. "This Is Not Magritte," *Esquire*, February 1966, 100–103. The trend might have begun with Shattuck's 1966 *Artforum* article, followed by Roque in 1983. An extended exploration of Magritte's *Treachery of Images* was conducted by Michel Foucault in *This Is Not a Pipe* (Berkeley and Los Angeles: University of California Press, 1983).

40. "The Enigmatic Visions of René Magritte," *Life*, April 22, 1966, 113–14, 117, 119. In 1959 *Life* magazine had traveled to Brussels to do a three-page color pictorial about Magritte. The brief text emphasized mystery set against the artist's "middle-class home" ("A Painter's World of Fantasy," *Life*, September 7, 1959, 8–10).

41. "The Editor's Guest Book," *Harper's Bazaar*, November 1963, 127, 129; Suzi Gablik, "René Magritte: Mystery Painter," *Harper's Bazaar*, November 1963, 146–49, 190–91. Gablik's important monograph on Magritte was published in 1970.

42. These statements came from some questions I posed to Duane Michals via Pace/MacGill Gallery, New York, September 2005.

43. Duane Michals, *A Visit with Magritte* (Providence: Matrix, 1981), n.p. Magritte's own photography has been most recently considered in Patrick Roegiers, *Magritte and Photography*, exh. cat., trans. Mark Polizzotti (Ghent and New York: Ludion and D.A.P., 2005). For an account of another home inhabited by Magritte, see Jan Ceuleers, *René Magritte, 135 Rue Esseghem, Jette-Brussels* (Antwerp: Pandora, 1999).

Magritte, *The Rape*, 1945

Alexander Iolas: The Influence of Magritte's American Dealer

THERESA PAPANIKOLAS

On February 25, 1950, art dealer and impresario Alexander Iolas (d. 1987), who was determined to cement René Magritte's reputation in the United States as a surrealist master, pressed the painter to send him only "magnificent material," which, he promised, would guarantee the long-overdue recognition of the artist's "genius."[1] Magritte responded by reminding his dealer that his chief concern was neither magnificence nor genius, but the mundane particularities of business, a rejoinder that speaks volumes about their two-decades-long relationship.[2] Flamboyant, idealistic, and prone to flights of fancy, Iolas instinctively understood the subtleties and whims of American artistic taste, and he was uniquely able to direct the proper, meticulous, and perpetually businesslike Magritte toward subject matter and style that would please his New York audience. Magritte balanced his dealer's hyperintuitivism by offering persistent—and at times insistent—reminders about the practical realities of what he perceived to be a primarily contractual arrangement. Their long collaboration, however, reinvigorated the artist's career, pushing him to create the caliber of work that helped shape his fortunes in America.

"For me, each exhibition is like a ballet premiere," Iolas once said. "I do not regard the gallery as a commercial profession. It is an . . . artistic profession. . . . I am not an art dealer just to sell paintings. The collectors are friends of mine, who fall in love with everything I do or see."[3] Former principal dancer with the Monte Carlo ballet, the Egyptian-born Greek was a polyglot who cultivated his "artistic profession" through his art galleries in New York, Paris, and Milan, and through his carefully constructed persona as exemplar to art world luminaries, purveyor of beauty, and shaper of public taste.[4] He owed his success not only to his uncanny ability to recognize quality work, but also to his talent for connecting with artists and collectors on a personal level, serving as mentor, friend, adviser, and mediator. His natural gregariousness formed the cornerstone of his entire enterprise, which began with the purchase of a painting by Giorgio de Chirico after a chance encounter with the artist, evolved into an impressive personal collection (which included works by Paul Cézanne, Auguste Renoir, Henri de Toulouse-Lautrec, Fernand Léger, Pablo Picasso, and Max Ernst), and culminated in the sale of that collection to finance his first gallery.

The Hugo Gallery opened on East Fifty-fifth Street in Manhattan in 1945 with the blessing of its namesake, the dowager Duchesse de Gramont Maria Hugo; the support of cosmetics mogul Elizabeth Arden; and the financial backing of the collectors John and Dominique de Menil. The gallery's blue velvet walls became a New York showcase for interwar European art—particularly surrealism, which was then giving impetus to the new generation of painters who would go on to develop

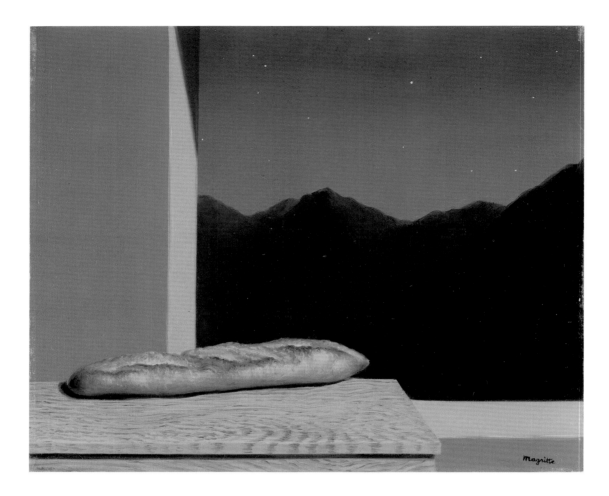

Magritte, *The Future*, 1936, oil on canvas, 54 × 65 cm, private collection

abstract expressionism. But even as artists like Max Ernst, Victor Brauner, Jean Fautrier, and Magritte served as inspiration, surrealism itself was little known in the United States. It was Iolas who seized the opportunity and raised the movement's profile by encouraging his surrealist artists—particularly Magritte—to expand upon those aspects of their styles that most appealed to American tastes.

Iolas's considerable influence over Magritte—as well as Magritte's savvy, and at times cantankerous, openness to being influenced—was apparent from their initial encounter in 1946. The year before, an agent had left five quasi-impressionist gouaches from Magritte's "Renoir" period at the Hugo Gallery, and Iolas invited the artist to exhibit his work.[5] Their complex, often contentious, and wholly collaborative dynamic is revealed in their earliest correspondence. Magritte (mistakenly addressing his response to "Madame Hugo") proudly accepted the invitation and announced his intention to be fully involved in the planning of his show by attaching a checklist, a manuscript by French poet Jacques Wergifosse for the catalogue, and suggestions about catalogue layout and paper stock.[6] Iolas, for his part, made every effort to accommodate his newest charge, even though the checklist and manuscript were held up in U.S. Customs. In the end, Magritte's first Hugo Gallery exhibition—which opened in the spring of 1947—included only the five gouaches, supplemented by a handful of works from the collections of Magritte's friends Alex Salkin and Claude Spaak. Iolas also published an exhibition catalogue with an essay by art critic Parker Tyler, which replaced Wergifosse's missing manuscript.

The events and missteps surrounding this first exhibition sparked debate between artist and dealer over how best to present and publicize Magritte's work. Magritte expressed concern that his work was misunderstood, and he took issue with Tyler's essay: "I do not agree for an instant with the meaning he ascribes to my paintings. . . . The same goes for his commentaries on the titles: a title like 'Smile,' for example, is neither gratuitous nor arbitrary: the painting, because of what it evokes, makes the spectator smile and the title find its justification."[7] Iolas reassured Magritte that the exhibition had "awakened great interest in your work in our country," but he also explained that Tyler's lukewarm critique spoke not to the work's quality but to its failure to satisfy the proclivities of its audience.[8] Americans, he elaborated, were simply not ready for the exuberant color and loose brushwork of Magritte's Renoir style; instead, they preferred the tightly conceived meditations on the semiotics of mundane reality that had made the artist famous. "Poetic painting of very fine quality is essential," Iolas wrote.

> This alone will sell, and this is what I ask of you. The people who liked your painting from before 1940 unanimously find it more poetic and superior to those five paintings that I returned to you, and they are therefore inclined to want the former. Believe me as a friend and great admirer that I only wish to establish your work at the place it is now due. Do not worry about doing business; I will do that for you the moment I have paintings on a par with *The Red Model* [and] *The Future*. . . . I do not ask you to copy old paintings, but to perpetuate [those paintings'] poetic and mysterious quality, which in their tight technique are much more "Magritte" than those in Renoiresque color and technique, which everyone thinks are outmoded.[9]

Magritte, in turn, promised to send his finest work to New York, even as he defended his Renoir style as being simply ahead of its time:

> You will have the works on a par with *The Red Model* and that will please your visitors. The period you call "Renoiresque" is over and the paintings of this period will be much sought after "later." But this experience has served to bring a lot of issues to the surface and as a result, you will be able, among other things, to compare the new works with the old ones.[10]

Respectful of Iolas's talent for anticipating what viewers wished to see, Magritte complied with his dealer's advice on this and other stylistic matters over the years, but he was adamant in his refusal to compromise his artistic integrity. When important patrons such as John de Menil, for example, requested replicas of his best-known paintings, Magritte delivered but was quick to point out that these new works were "not merely copies, but creations that correct what in the old paintings was imprecise and insufficient."[11] And when Iolas attempted to commission specific genres—once even going so far as to invite the artist to share "any ideas [you might have] about dazzling roses" to please "a very important lady here who loves roses"—the artist raised questions about his dealer's priorities: "Your judgments of my works, do they depend on the works' ability to attract a buyer? I ask you this because, until now, you have advised me not to send paintings with roses, and now you are asking for one because a lady likes roses?"[12] At times, Magritte sent Iolas works that did not meet his dealer's approval. *Personal Values* (1952), for example, "derailed" poor Iolas, who called the work

> a painting that is quickly painted and whose color . . . nauseates me. I am so depressed I cannot get used to it. . . . I would be very grateful if you could write to me about this painting because it disarms . . . and confuses me, and I don't know what I like. Be an angel and explain it to me.[13]

Magritte responded to this and all criticism by patiently attempting to set Iolas straight; arguing (in this case, unsuccessfully) that *Personal Values* was not a failure but a masterpiece, precisely because it was so disquieting:

> In my painting, the comb (and the other objects as well) has lost its "social character." It is now just an object of useless luxury, which can, as you say "disarm" the spectator and even make him sick. This is exactly the proof of the painting's effectiveness. A real, living painting makes the spectator sick, and if the spectator is not sick, it is because 1. they are too crude, or 2. they are used to this malaise and take pleasure in it (my paintings of 1930–32, anyone?).[14]

Iolas and Magritte's lively correspondence added spark to an already fruitful working relationship that endured until the artist's death in 1967. Iolas inspired Magritte to create some of his most important work, and he publicized the artist's talent through ever more spectacular exhibitions at his galleries in New York and abroad, ensuring ample publicity and easy availability for prospective buyers. Magritte counterbalanced Iolas's idealism with levelheadedness: articulating the merits and drawbacks of his dealer's often impractical agenda; tracking

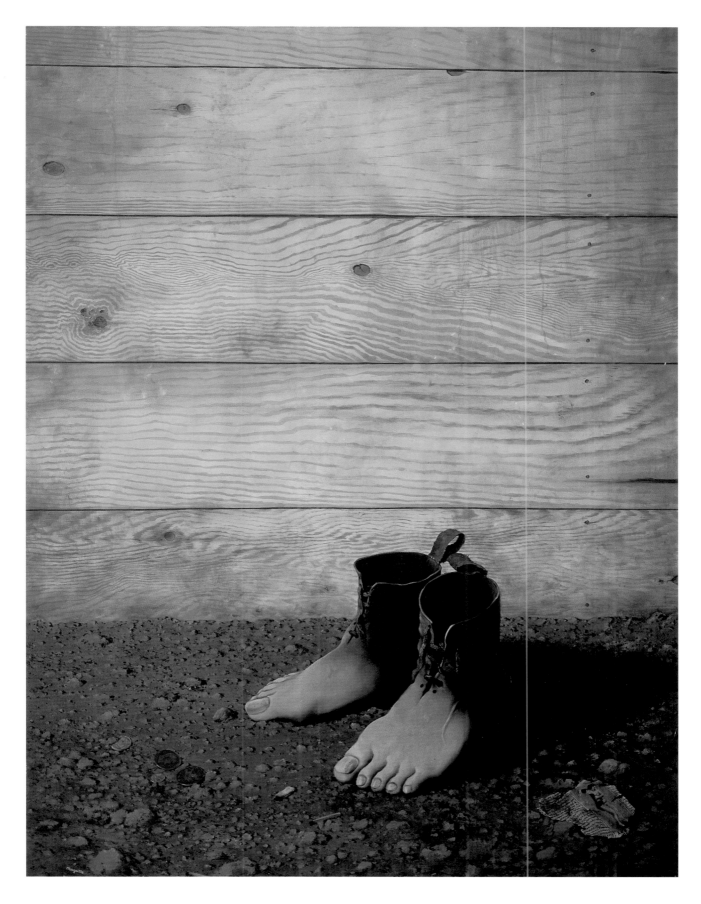

Magritte, *The Red Model*, 1937

Magritte and Alexander Iolas, December 1965

the inventories, checklists, and sales figures for each exhibition and financial exchange; expressing dismay at Iolas's reluctance to compensate him and apparent unwillingness to discuss business. At one point, Magritte, desperate to protect his legal interests, even went so far as to enlist the lawyer, collector, and purchaser of *Personal Values* Harry Torczyner to keep him abreast of Iolas's activities during the long, anxious intervals between letters.

Yet Iolas's abiding interest in Magritte had more to do with artistic posterity than with financial gain, for he insisted that the only reason he expected the artist to cater to the whims of his audience was because doing so would bring him the fame and fortune that was so rightfully his. "If I attempt to make it clear to you about the American public," he once told Magritte, "it is so that you succeed and make your mark with the next exhibition; it must be sublime and astonishing. And I am more than sure that you will work miracles . . ."[15] That Iolas was successful in bringing out Magritte's inner miracle worker is beyond question, for the works that automatically spring to mind when we think of Magritte—*The Future* (1936), *The Red Model* (1937), *The Eternally Obvious* (1948)—exist in our shared psyche, as well as in American collections both public and private, thanks in large part to the tireless efforts of Alexander Iolas.

Alexander Iolas, Marcelle Hoursy (Harry Torczyner's wife), and Magritte at the opening of the exhibition *René Magritte* at the Museum of Modern Art, New York, 1965–66. *The False Mirror* is in the background.

Notes

1. Alexander Iolas, letter to René Magritte, February 25, 1950. Magritte's correspondence with Iolas is housed in the Menil Collection archives, Houston, Texas. I would like to thank archivists Geraldine Aramanda and Diane Roberts for making it available to me. All translations are mine unless otherwise indicated.
2. Magritte, letter to Iolas, February 28, 1950.
3. Alexander Iolas, 1968 interview with French *Vogue*, cited and translated in Sevasti Eva Fotiadi, "Alexander Iolas: Analysis of a Collector" (master's thesis, University of Leicester, 2001), 7.
4. For biographical details about Iolas, see Fotiadi, as well as David Sylvester, *Magritte: The Silence of the World* (Houston: The Menil Foundation and New York: Harry N. Abrams, 1992).
5. For more on Magritte's dealers, see Sylvester, *The Silence of the World*.
6. Magritte, letter to "Madame Hugo," January 2, 1947.
7. Magritte, letter to Iolas, April 21, 1947.
8. Iolas, letter to Magritte, May 5, 1947.
9. Iolas, letter to Magritte, November 21, 1947.
10. Magritte, letter to Iolas, November 27, 1947.
11. Magritte, letter to Iolas, October 19, 1959. John de Menil requested a second version of *Dominion of Light* (1952) after donating the first to the Museum of Modern Art, New York, in 1951. See Iolas, letter to Magritte, June 23, 1952.
12. Iolas, letter to Magritte, February 25, 1950; Magritte, letter to Iolas, March 2, 1950, reprinted in Daniel Abadie, "René Magritte and Alexander Iolas: The Art of Conversation," trans. Caroline Beamish, in *Magritte*, exh. cat. (New York: D.A.P., 2003), 271.
13. Iolas, letter to Magritte, October 15, 1952.
14. Magritte, letter to Iolas, October 24, 1952.
15. Iolas, letter to Magritte, January 18, 1950.

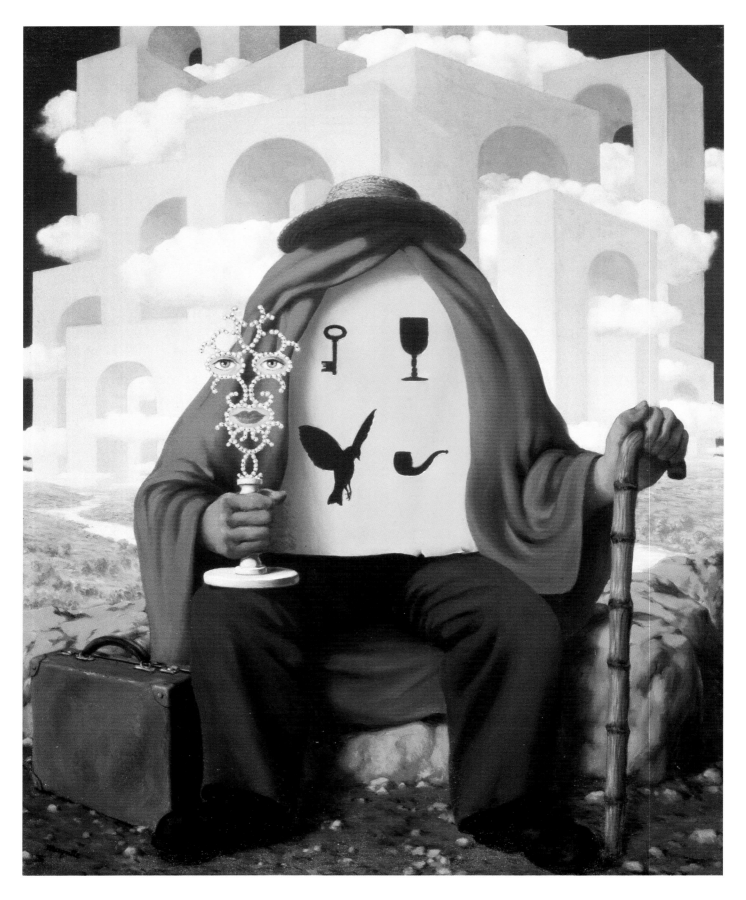

Magritte, *The Liberator*, 1947

Passing the Hat: René Magritte and William Copley

SARA COCHRAN

René Magritte's first exhibition in Southern California was organized in 1948 by William Copley (1919–1996) and held at the Copley Galleries in Beverly Hills. Copley ran the gallery with his brother-in-law John Ployardt. In the 1940s, by his own account, Copley knew nothing about art. In contrast, Ployardt was an active and erudite artist who made his living as an animator for Walt Disney, a job he hated. Ployardt called himself a surrealist and he encouraged Copley to look at life differently. Copley felt an immediate affinity for surrealism. He stated that his discovery of it changed his life because its positive engagement with chance happening and the absurd explained certain elements in his own life that puzzled him: the genteel family that raised him, the war, and even why he had spontaneously decided to go to his prom at Yale without shoes.[1]

An orphan, Copley had been adopted by the wealthy family of a newspaper baron and former congressman. He married Ployardt's sister almost immediately after leaving the army at the end of World War II. Independently wealthy but with no clear vision of his future, Copley was searching for meaning in his life. Los Angeles of the 1940s was not a center for the selling of art, but it was home to a few serious collectors, the most important of whom was Walter Arensberg. Nevertheless, despite their lack of experience in art dealing in particular and business in general, Copley and Ployardt decided to open a gallery, financed entirely by Copley and specializing in surrealism. They were convinced that Hollywood— a place where reality and make-believe collided in spectacular ways—would be a natural environment for the movement. However, they were unaware that New York dealer Julien Levy had tried and failed to bring surrealism to the West Coast six years previously.[2]

Flush with enthusiasm, Copley and Ployardt set out to meet the nearest bona fide surrealist: Man Ray. The photographer had fled Paris in advance of the German invasion in 1940 and returned to the United States, settling in Los Angeles. When Copley and Ployardt met Man Ray, he was living in semihibernation on Vine Street in Hollywood.[3] Their visit was difficult at first but Man Ray eventually warmed to them and to their project. He encouraged them to go to New York to meet Marcel Duchamp and to Sedona, Arizona, to meet Max Ernst. Duchamp, in turn, introduced them to a number of important individuals such as the artists Roberto Matta, Arshile Gorky, Yves Tanguy, and Joseph Cornell, and the dealers Curt Valentin, Pierre Matisse, and Alexander Iolas. Iolas, who was Magritte's main dealer in the United States from 1948 until the painter's death in 1967, became Copley and Ployardt's close collaborator. His gallery also specialized in surrealism, showing works by Ernst, Matta, Tanguy, Cornell, and Victor Brauner.

Exterior view of Copley Galleries,
Beverly Hills, California

Installation view of Magritte exhibition,
1948, Copley Galleries, Beverly Hills,
California

Returning to Los Angeles, Copley and Ployardt rented a bungalow on North Canon Drive in Beverly Hills, hired Igor Stravinsky's daughter-in-law as a secretary, and opened their gallery in September 1948 with an exhibition of seventeen oil paintings and twelve gouaches by Magritte. All of the works came to them through Iolas's Hugo Gallery. The majority were recent works from 1947 and 1948 that had been shown at the Hugo Gallery in May 1948. There were a number of important paintings, such as *Philosophy in the Boudoir* (1947), *The Rights of Man* (1947), and *The Eternally Obvious* (1948). The Los Angeles exhibition also included six oil paintings dating from the mid-1920s to the late 1930s that were on consignment with Iolas from the collector Claude Spaak.[4] For the exhibition invitation, Copley and Ployardt created a white card with dye cuts of signature motifs from Magritte's work, including a bird, a leaf, a key, and a pipe. They also produced a catalogue for the exhibition, which contained a print by Magritte. They sold two paintings to the wealthy local collector Stanley Barbie the day after the opening, but this was the only sale they made during the exhibition.[5] In fact, only one other painting sold during their next five exhibitions, which featured works by Tanguy, Cornell, Man Ray, Matta, and Ernst. In the late 1940s Los Angeles was still not ready for surrealism. The gallery closed after only six months of operation. Later in life, Copley bluntly recalled the reaction to their gallery and its six groundbreaking exhibitions: "We were almost totally ignored. We were attacked by most of the critics. And totally unattended. . . . And it was a damn fool thing to do—I mean business-wise, and every other way. When I go back to California now, I am treated as a person who has insight. Which I must say I lap up. It's a lot of nonsense. I didn't know what I was doing. I was enjoying it very much, but it . . . was suicide business-wise. There was no interest whatsoever."[6]

Despite its short existence, Copley Galleries had a tremendous influence on Copley's life. It allowed him to meet and befriend some of the most important artists of his time. It inspired him to take up painting and it provided the opportunity to form the cornerstone of his remarkable personal collection.[7] From the Magritte exhibition, he acquired *Free Love* (1937), *Treasure Island* (1942–43), and *The Liberator* (1947)—which he donated to LACMA, then called the Los Angeles County Museum

of History, Science, and Art, in 1952. Copley insisted, however, that he began his collection more by default than by design. In an interview in 1968, he explained that he was compelled to acquire works from each show as a result of contracts with the artists: "I started collecting at that time because each artist that I showed, again I suppose it was bad business judgment, but I guaranteed 10 percent of the sales. And those I didn't sell, I would buy 10 percent of the show myself. Which turned out to be the basis of my collection. I could [have made] up what I lost on the gallery by selling one picture. But I didn't know what I was doing . . . at the time."[8]

In 1951 Copley accompanied Man Ray and his wife, Juliette, when they returned to Paris. Copley spent the next decade in France. Through his close friendships with Man Ray and Duchamp, he immediately found himself at the heart of the Parisian art world—mixing with a diverse community of individuals, from André Breton and Max Ernst to Jean Tinguely and Meret Oppenheim. During this period, he also befriended British and American pop artists, such as Richard Hamilton, Eduardo Paolozzi, and Andy Warhol.

William Copley, *Interior*, 1965, watercolor and gouache on paper, 25.5 × 29 cm, Collection Helmut Klewan

Around the time Copley opened his gallery in Los Angeles, he himself had discreetly begun painting.[9] However, once in France, he concentrated on art.[10] The work he produced had a bright comic-strip style and was blatantly erotic—female nudes were prevalent. He used a variety of motifs, from the details of everyday life in France to the clichés of the Wild West, and often incorporated delicate lace collage elements. He had his first exhibition at the Galerie Nina Dausset in Paris in 1953, and three years later Alexander Iolas gave him an exhibition in New York—which shifted their relationship from one of professional colleagues to that of artist and dealer. The influence of surrealism on Copley's work was evident. He drew on Magritte's problematic juxtapositions, Duchamp's enigmas and word games, and Ernst's use of formal patterns and sense of fantasy. His work also reflected contemporary developments, especially pop art's blurring of the boundaries between popular culture and high art imagery. Bridging pop art and the historical movements of surrealism and dada, Copley's painting resonated with his time. In 1966 the Stedelijk Museum in Amsterdam held his first museum exhibition, and the Centre Pompidou in Paris followed suit in 1980. His work was also included in *Documenta* 5 (1972) and *Documenta* 7 (1982) in the important presentation of contemporary art held every five years in Kassel, Germany.

Magritte, Marcel Duchamp, Max Ernst, and Man Ray holding the catalogue for Copley's 1966 retrospective at Stedelijk Museum, Amsterdam

Copley finally met Magritte on a trip to Brussels in the early 1950s. The two had corresponded for some time but despite the down-to-earth tone of Magritte's letters, Copley was disconcerted by the meeting.[11] First of all, there was Magritte's appearance. The artist's deliberately banal guise mirrored his flat, deadpan painting style, but Copley, who had associated with the flamboyant French surrealists, was unprepared for this quiet bourgeois of Brussels in a three-piece suit. He was also unnerved by the way Magritte painted in the dining room of his comfortable and unassuming house like an amateur painter. It was as though Magritte were trying to pass unnoticed. Yet this seeming reticence was in contradiction to what Copley knew to be Magritte's high opinion of his own work. In fact, Copley related that Magritte saw nothing strange in his painting and that he sincerely considered himself to be the greatest living painter of his time.[12] Copley came to realize, however, that, as with Magritte's deceptively prosaic painting style, his nondescript exterior was merely a conceit that heightened the moments of shock he choreographed in his everyday life.[13] Copley continued to acquire works by Magritte, and the two men remained close

William Copley, c. 1970

friends for the rest of the Belgian painter's life.[14] Copley also supported Magritte in other ways. In 1957 a foundation founded by Copley published the first English-language monograph on Magritte, with a statement by the artist and a translation of Louis Scutenaire's essay from 1948.[15]

Looking at Copley's paintings, it is obvious that Magritte was a great influence. Copley admired Magritte's work for what he called its sense of poetic metaphor, which he defined as something far stronger and more interesting than simple analogy.[16] Copley explained that Magritte's poetic use of imagery allowed him to create an autonomous world with an alternative logic in which signs and motifs could take on completely new meanings. Copley appreciated that Magritte's painting was a place of other questions and other answers. Working in his bold and direct cartoon style, Copley portrayed his own capricious world, which is inhabited by enforcing policemen, sensuous naked women, and a faceless man in suit and bowler. The figure of the bowler-hatted man dominates Copley's work as both an anachronism and a rebel. Like Magritte's original version, which is most often interpreted as a veiled self-portrait, Copley's man in a bowler is an enigma. He lives outside of the everyday world and its morality, always evading the figures of authority who want to control him. But it was Copley's personal adoption of the bowler hat that was perhaps his greatest homage to the Belgian surrealist: by embracing this trapping of bourgeois banality, Copley tacitly signaled his final understanding of the ironic nonconformity of Magritte.

Notes

1. William Copley, "Portrait de l'artiste en jeune marchand de tableau," in *Paris–New York 1908–1968*, exh. cat. (Paris: Centre Georges Pompidou, 1991), 135.

2. Ibid., 137.

3. Man Ray described this existence as a masterful inactivity that allowed him to pass unnoticed. Ibid., 138.

4. David Sylvester et al., *René Magritte: Catalogue Raisonné*, vol. 2 (Antwerp: Mercatorfonds and Houston: The Menil Foundation, 1993), 158.

5. Copley gave several amusing accounts of this sale. It seems that Barbie arrived at the gallery drunk and continued drinking there with Copley and Ployardt. He eventually selected two works and paid for them with a check, which to Copley's surprise did not bounce. Copley was convinced that after Barbie sobered up the next day he would forget that he had bought the paintings. When the gallery closed, Copley hesitated to send the paintings to him. Copley, interview by Paul Cummings, January 30, 1968, Archives of American Art, Smithsonian Institution.

6. Copley, interview by Cummings.

7. An insurance inventory of 1965 for the Copley art collection lists fifteen works by Magritte among a wealth of other works by artists such as Francis Picabia, Max Ernst, Man Ray, Giorgio de Chirico, and Yves Tanguy. In April of that year, the Museum of Modern Art included the Copleys' New York apartment on a tour of outstanding private collections in the city. The William and Noma Copley Foundation and Collection Records, 1954–65, special collections, Getty Research Institute, Los Angeles.

8. Copley, interview by Cummings.

9. In 1951, before leaving for France, Copley showed a few paintings at Royer's Book Shop in Los Angeles.

10. Copley discussed the importance of living in Paris to the development of his painting style, saying that he enjoyed challenging his friends' sense of morality and good taste. See the conversation with Allan Jones published in *William N. Copley*, exh. cat. (New York: David Nolan Gallery, 1991), 9.

11. Copley, *Paris–New York*, 147.

12. Ibid.

13. Magritte's impeccable appearance of respectability was at odds with his embrace of vulgarity, in particular, his love of dirty jokes and pranks. Copley relates one memorable incident in which Magritte, at one of their first meetings, pinched Copley's second wife Noma's breast. Ibid., 148.

14. In 1957, for example, Copley acquired the iconic painting *The Treachery of Images* (1929), which the Los Angeles County Museum of Art bought from the Sotheby Parke Bernet sale of Copley's collection in New York in 1978.

15. Founded in 1954, the William and Noma Copley Foundation gave grants to young composers and artists, including Edward Kienholz, Mark di Suvero, Lucas Samaras, Larry Bell, Etienne Martin, Leon Golub, and Christo. The monograph on Magritte was the first in a series of publications about contemporary artists. After his return to the United States in 1963, Copley continued working with contemporary art. In 1968, he founded the magazine *SMS* in New York. In all, *SMS* published six portfolios, highlighting the work of Christo, Walter de Maria, Richard Hamilton, La Monte Young, Alain Jacquet, Ray Johnson, Meret Oppenheim, Enrico Baj, Joseph Kosuth, Arman, John Cage, On Kawara, Roy Lichtenstein, Bruce Nauman, Yoko Ono, Lawrence Weiner, Richard Artschwager, Diter Rot, Claes Oldenburg, and Bernar Venet, among others.

16. Copley, interview by Cummings.

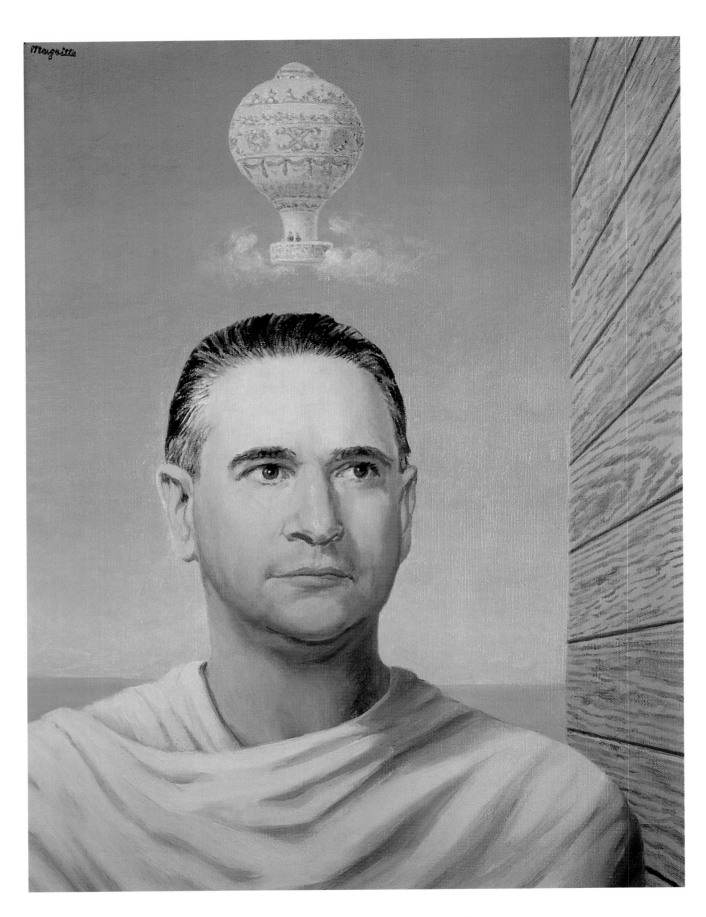

Magritte, *Harry Torczyner, or Justice Has Been Done*, 1958, oil on canvas, 40 × 30 cm, private collection

Harry Torczyner, Magrittean Ambassador to America

MICHEL DRAGUET

In October 1957 Magritte met Harry Torczyner (1910–1998), a Belgian lawyer based in New York who was interested in poetry and art. Torczyner would become an important collector of Magritte's work and would publish a major monograph about the artist in 1977. The two men shared certain affinities from the start. Magritte gave Torczyner a copy of the Comte de Lautréamont's *Les chants de Maldoror* (1927) with his illustrations from the mid-1940s. Torczyner had read the book in his youth and felt that it had changed his life; it was a fitting background for their first encounter.[1] Torczyner had been living in New York since 1940 and was a recognized expert in international law; he also wrote poetry and was involved in the surrealist milieu. He discovered Magritte's work and acquired his first gouache, *The Healer*, in 1947. Magritte had been officially represented in America by Alexander Iolas's Hugo Gallery since 1948; Torczyner appeared in the artist's life at a time when he was trying to make headway in the New York scene. A rich correspondence testifies to the bond between the two men, as does Magritte's portrait of the lawyer as an "aerial dialectician." Magritte's new friend in America soon became a faithful accomplice.

By 1959 the close friendship between Magritte and Torczyner allowed the painter to confide that he had misgivings about Iolas's distribution and promotion of his work. In a letter written on January 24, 1959, Magritte dreams of a "cultural offensive," which would involve favorable comparisons of his work with that of other major figures of surrealism whose careers seemed more successful. Magritte called upon Torczyner to intercede on his behalf—to encourage museum curators to exhibit his work, to solicit publishers to include him in their anthologies, and to find journalists and critics to write articles about him. In short, Magritte expected Torczyner to represent and defend him in the United States. The New York lawyer fulfilled this mandate with qualities that Magritte hesitated to attribute to his dealer, Iolas.

In his efforts to publicize Magritte's work, Torczyner went so far as to solicit Marcel Duchamp to write a text that Iolas published in the catalogue of the Hugo Gallery exhibition of March 1951.[2] The correspondence between Torczyner and Magritte testifies to Magritte's disappointment with Duchamp's ironic epithets. Torczyner was also responsible for Magritte encountering Suzi Gablik, a young artist and art historian who wrote an important monograph about the artist.[3] A man about town, Torczyner facilitated Magritte's worldly connections. He helped broker several commissions with large American firms such as the Container Corporation of America (letter of June 26, 1960).[4]

Torczyner's collection of works by Magritte was built with care and distinction. Their correspondence constituted an arena for the lawyer to study his Belgian

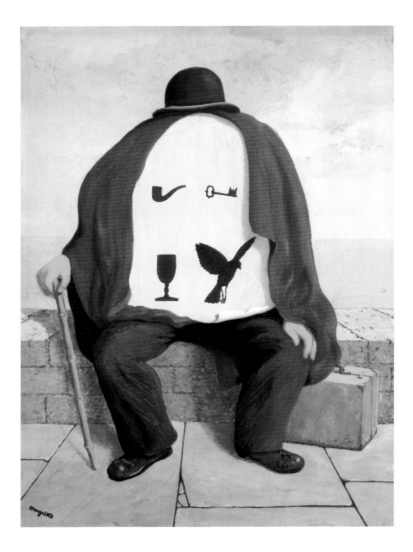

Magritte, *The Healer*, 1946, gouache on paper, 47.1 × 34 cm,
Estate of Harry Torczyner

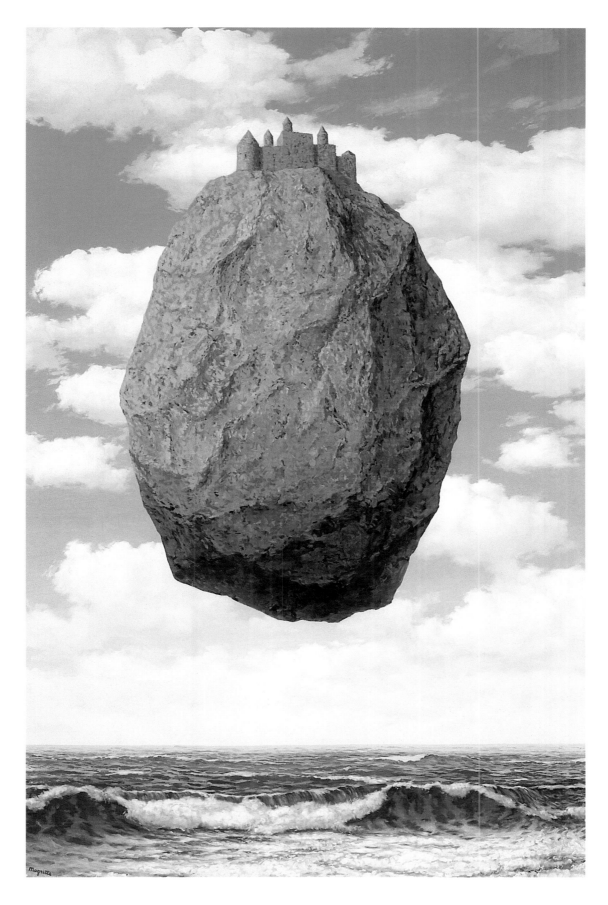

Magritte, *The Castle in the Pyrenees*, 1959, oil on canvas, 200.3 × 130.3 cm, The Israel Museum, Jerusalem

friend's art. Torczyner made use of this privileged position to acquire such important works as *Personal Values* (1952), and even to directly intervene in the genesis of *The Castle in the Pyrenees* (1959). Through his letters, Torczyner entered the laboratory of the painter's ideas and situated himself as one of Magritte's "substantial allies." Magritte was never to regret the confidence he placed in Torczyner. Their correspondence covered everything from illicit reproductions of the works to finding titles for certain paintings, from requests for financial advice to the discussion of philosophical issues. Torczyner became one of Magritte's closest advisers and confidants.

Thus he was to intervene more and more frequently in the business affairs between Magritte and his American dealer. In a letter of October 18, 1960, Magritte called on his "magnificent and magisterial ambassador" to learn what his dealer was up to since Iolas himself was so often negligent about sharing information. Magritte had expressed his frustration with Iolas before, on May 2, 1959, when he wrote, "from here to New York is some ways apart, and I have no idea what is going on in Iolas's mind." Throughout his correspondence, Magritte seems terribly ill-informed about the initiatives taken by his dealer. Iolas is tardy about payments, withholds collectors' contact information, and provides no details about paintings in his care that have supposedly been destroyed (letter of June 10, 1959). He even neglected to inform Magritte about upcoming exhibitions of his work at the Hugo Gallery.

Tension between the two mounted, and Iolas did not approve of the lawyer's interference in Magritte's American projects. Torczyner took advantage of his position as Magritte's representative to deftly and parsimoniously pressure the dealer. In September 1960 Torczyner offered to negotiate with other galleries willing to give Magritte a contract, which Iolas had consistently refused to do. And yet, despite his misgivings, Magritte was unable to break with Iolas and the $10,000 that he received from him every year (letter of September 8, 1960). In the same letter Iolas noted that the sum could be greatly increased if Magritte decided to paint "seriously," that is to say if he were willing to accept the collaboration of specialists capable of "doing the heavy work." Always wary of monopolistic tendencies, Torczyner followed all of Iolas's doings and recounted them to Magritte. On May 26, 1962, he wrote to his friend: "The work of a living artist is not always well served by the existence of a monopoly, particularly if this monopoly doesn't reach the ranks of those who desire the master's work. [Iolas] makes no effort except when pressured by others to place the work of the master in front of the eyes of as vast an audience as possible." Though difficult to quantify, Torczyner's actions undoubtedly contributed to "remobilizing" Iolas, to the point where, according to the lawyer himself, the men began to form a veritable "ménage à trois."

Indeed, Torczyner was invested with a kind of permanent diplomatic mission, which made his New York office a virtual "Magrittean embassy" (letter of February 18, 1959). On Magritte's request, Torczyner devoted himself particularly to the promotion of the work through publications and exhibitions. If Iolas's gallery was Magritte's main outpost in America, Torczyner was the emissary, contributing his diplomatic ability and his connections to the cause. *René Magritte in America*, the exhibition that traveled from Dallas to Houston during winter 1960–61; the Albert Landry Galleries exhibition in Manhattan in 1961; the Walker Art Center show in Minneapolis a year later; *Magritte* in Little Rock, Arkansas, in 1964; and the retrospective at the Museum of Modern Art in New York in 1965 all

Cover of Torczyner's *Magritte: Ideas and Images*, 1977

mobilized his forces, whether to locate lenders or to convince new venues of the interest of a project.

Torczyner's actions would be decisive also in terms of publications. Besides the help and support he gave Suzi Gablik in 1960, Torczyner took up the pen himself in *Magritte: Ideas and Images* (1977). For this, he took advantage of the clues provided by their extensive correspondence to arrive at a detailed analysis of the work. Two years later, Torczyner brought out a new essay, *Magritte: The True Art of Painting*, in which he discussed the imaginary universe of Magritte in thematic terms.[5] And in 1992, he decided to make his correspondence with Magritte public, thus providing an essential element for understanding the work.[6]

Translated from the French by Rachel Stella

Notes

1. Harry Torczyner, *Magritte: Ideas and Images* (New York: Harry N. Abrams, 1977), 10.
2. Marcel Duchamp, "Des Magritte en cher, en hausse, en noir et en couleurs," in *Magritte*, exh. cat. (New York: Hugo Gallery, 1951).
3. Suzi Gablik, *Magritte* (London: Thames & Hudson, 1970).
4. Magritte's correspondence is found at the Centre de Recherches René Magritte–ULB, Brussels.
5. Harry Torczyner, *Magritte: The True Art of Painting* (London: Thames & Hudson, 1979).
6. Harry Torczyner, *L'ami Magritte: Correspondance et souvenirs* (Antwerp: Mercatorfonds, 1992). A concise, English-language edition was published in the United States as *Magritte/Torczyner: Letters Between Friends*, trans. Richard Miller (New York: Harry N. Abrams, 1994).

Magritte, *The Listening Room*, 1952

A Deliberate Accident: Magritte in the Collection of John and Dominique de Menil

THERESA PAPANIKOLAS

> However well parenthood is planned, children are what *they* are, not what parents decide. Like children, treasures of a collection are what *they* are. Complex sets of circumstances brought these treasures into the family: a chance encounter, a visit to an artist or dealer, a glance at an auction catalogue, a successful bidding, and, of course, a favorable moment for spending. This somehow unsystematic approach was our way of collecting. Nothing was excluded from consideration, yet deep inclinations existed. Constraints, too: price and availability.[1]

When Dominique de Menil (1908–1997) penned these words in 1987, it was to celebrate the opening of the Menil Collection, the Houston museum built to house the vast art collection that she and her husband, John (1904–1973), had spent the better part of their adult lives amassing. Born and raised in Paris, John and Dominique de Menil came to America in 1941 to escape Nazi Europe, making Houston their home so that John could oversee the affairs of the family oil business, Schlumberger, Ltd.[2] Their Philip Johnson–designed house on San Felipe Road—a modernist anomaly in the tony neighborhood of River Oaks—became a destination for artists and intellectuals from all over the world. Their collection—housed in their home, at the University of St. Thomas (whose art department they founded), and later at the Institute for the Arts (which they established at Rice University)—made modern art accessible to a new audience.

Intimate yet grand, planned yet full of surprises, the Menil Collection is a microcosm of its patrons' methodology of acquisition: to welcome the intangibles of circumstance, coincidence, intuition, emotion into the predictable and studied domain of the informed decision, and to collect only that which resonated with their own aesthetic sensitivity. Their awareness that chance could coexist with and even complement what was predetermined was a sensibility they shared with the surrealists, whose works form the core of their holdings. That this same sensibility motivated the surrealists' self-proclaimed kinship with the art of disparate and far-reaching cultures is mirrored in the antiquities, Byzantine art, tribal art, and European old masters that the de Menils acquired to complement and augment their modernist works. At once intellectually rigorous and developmentally organic, the de Menils' collection found its parallel in the personal relationships that the couple formed with the artists and experts whose advice they routinely solicited and whose work received their unconditional support: among them the artists Marcel Duchamp, Max Ernst, and Jim Love; the Dominican priest Father Marie-Alain Couturier; the art dealer Alexander Iolas; the curators Jermayne MacAgy and Walter Hopps; and the scholars William Camfield and David Sylvester. Late in life, Magritte

Living room of the de Menil home, 1982, with *The Glass Key* in the background

Dining room of the de Menil home, 1963, with three Magritte paintings in the background

became the beneficiary of this generosity, for not only did the de Menils collect some of his most important work, but they also organized exhibitions that served as much to publicize his achievement as to educate his public.

Marcel Duchamp sparked the de Menils' interest in Magritte and legitimized it with his own high regard for the artist; Iolas, who both catalyzed and cultivated the de Menils' fascination with surrealism, guided them in collecting Magritte's work; and Sylvester ensured that their purchases were shrewd ones. Today, the Menil Collection boasts fifty-four of the artist's oil paintings, sculptures, drawings, and gouaches, including the iconic *Eternally Obvious* (1930), *The Rape* (1934), *This Is a Piece of Cheese* (1936–37), *The Fair Captive* (1949), *The Treachery of Images* (1952), *The Listening Room* (1952), and *The Glass Key* (1959). This impressive array of work speaks as much to the de Menils' zeal for acquisition as to their abiding interest in the artist's critical fortune, for it formed the centerpiece of two important Magritte retrospective exhibitions, organized by Dominique in the 1960s and 1970s, that cast the artist in a French surrealist light.

In organizing these shows, Dominique de Menil drew impetus from Jermayne MacAgy (1914–1964). One of the first women in the United States to earn her Ph.D. in art history, MacAgy had come to Houston from the California Palace of the Legion of Honor in San Francisco to serve as the first director of Houston's Contemporary Arts Museum and, later, as chair of the art department at the University of St. Thomas, Houston, and curator of its teaching collection.[3] As a curator, MacAgy had pioneered the thematic exhibition, and she specialized in exploring overarching ideas—the figure, the "primitive," the contemporary—as expressed in the art of cultures that were geographically and chronologically diverse.[4] After MacAgy's untimely death in 1964, Dominique inherited her mentor's curatorial responsibilities and perpetuated her spirit, continuing to organize exhibitions whose meaning was in the sum of their individual parts.

Among the first such projects was the 1964 exhibition *Magritte*, commissioned by Winthrop Rockefeller as a collaborative project between the University of St. Thomas and the Arkansas Art Center in Little Rock. With more than one hundred paintings and gouaches, this was the largest exhibition of Magritte's work in the United States to date, and it covered the full spectrum of the artist's career, from his

Magritte, *The Glass Key*, 1959

lesser-known abstractions of the early 1920s to familiar compositions such as *The Lost Jockey* (1952), *Dominion of Light* (1954), *The Treachery of Images* (1952), and *Act of Faith* (1960).[5] Magritte himself contributed the ink drawing *Rock of the Wind* (1964) to the catalogue, and André Breton, the founder of surrealism, wrote the essay. To be sure, Magritte was less involved with French surrealism in the late 1920s, and his careful, controlled, and deliberate approach to making art ran counter to the surrealists' emphasis on the spontaneous, the uncanny, and the subconscious. Nevertheless, Breton described the artist in surrealist terms, casting Magritte as a visionary who operated in that liminal zone between sensory experience and abstract thought, the no-man's-land between wakefulness and dreams:

> This half-closed, half-open eye—his eye—which, functioning at peak sharpness, hunts, and then focuses on, the instant when dream vision teeters on the brink of wakefulness, when waking perception, too, stumbles at the gates of sleep. Those objects—the most familiar—are we not overlooking them . . . when we confine them strictly to their utilitarian role? Yet if we pass on to another frame of reference, it is certain (and psycho-analysis gives ample evidence of this) that most of these same familiar objects contribute to the symbolic elaboration which furnishes the stuff of dreams.[6]

Breton's words were echoed in the exhibition plan, which juxtaposed groups of works not so much to invite contemplation of their often hilarious and always thought-provoking conceptualism, but more to suggest a mysterious, profoundly moving, and strangely conversant poetic tension between the ordinary objects that populated them. Dominique de Menil described this approach in a letter to Magritte:

> Neither telegram nor letter could ever express the emotion that I felt while living for a few days in the intimacy of about 100 of your works. . . . We did a very sober installation, putting each painting in relief. Some were hung alone. Others were grouped in twos and threes, in such a way that those with practiced ears understand a sublime duet or the murmur of an indecipherable message. . . . It completely mystified us.[7]

Unable to attend the show, Magritte responded that he "would have loved to have seen it, but [was nevertheless] enchanted by what you have told me about it."[8]

The poetic mystery of Magritte's work was also the focus of the 1976 exhibition *Secret Affinities: Words and Images by René Magritte*. By that time, the now-widowed Dominique de Menil had severed ties with the University of St. Thomas and shifted operations to the Institute for the Arts at Rice University. Not quite as comprehensive as the Arkansas show, *Secret Affinities* was still monumental, with forty-eight paintings and sculptures, including reiterations of the Arkansas checklist and more recent additions to the collection, such as *The Rape* (1934), *The Listening Room* (1952), and *Golconda* (1953). This intimate and accessible installation brought order to these disparate subjects: works were arranged in small clusters at eye level on walls painted in soothing gray tones, and, as in Arkansas, placed so as to resonate and suggest relationships with one another.[9] Wall texts consisted of cloud-shaped panels on which quotes from Magritte—such as "people who look for symbolism fail

to grasp the inherent poetry and mystery of the image"—were set in cursive type that mimicked his handwriting. These suggested keys for unlocking the "secret affinities" between the works, offered up by the artist himself.[10] Magritte's words dominated the catalogue, which contained quips and quotations, explanations of titles, and notes from a conversation with Dominique de Menil in which Magritte discussed his favorite philosophers (Plato, Descartes, Heidegger), denied his works their shock value, and spoke of mystery as a remedy for defeatism:

> [about having children] I don't have enough confidence in life. I always expect the worst. The minute you are in the cradle you are ready for dying. . . . Everything that happens tends to make us defeatist. Defeatist, that's too strong a word. . . . Fortunately there is mystery. We know nothing, and that's heartening. Mystery allows hope and despair. Since it is a question of the absolute, one may have hope.[11]

That conversation took place in 1965, during Magritte's first and only visit to the United States. Accompanied by his wife, Georgette, their dog, LouLou, and Iolas, Magritte stopped in Houston after attending the opening of his retrospective exhibition at the Museum of Modern Art, New York. Hosted by the de Menils, the artist was honored with a reception by the Arts Association of the University of St. Thomas. Denizens of Houston high society, newly interested in Magritte's work thanks to the accessibility of the de Menils' collection and the success of the Arkansas show, turned out for the reception in droves. Slyly referring to his university associates, Magritte explained the reason for his visit: "St. Thomas the Apostle had to see in order to believe. I conclude that the people at St. Thomas University want to see me to be sure I am not a myth."[12]

Indeed, Magritte's presence in Houston put a human face on the collection the de Menils had so painstakingly put together. Assembled as much as an educational tool as a reflection of personal taste, this collection existed less for private enjoyment than for public edification, and the bulk of its contents were acquired specifically to enrich the teaching collections of the universities of St. Thomas and later Rice. Thus, works by Magritte such as *The Telescope* (1963), whose cloud-filled windows open onto a void that Dominique de Menil considered "an evocation of exploration [fit] for an educational institution,"[13] were purchased for their didactic associations and scrutinized under the microscope of Dominique's expertise:

> The left side is closed and through the glass one sees a beautiful though monstrous seascape. The right side is half open and one discovers that there is no sea, no sky, only black nothingness. The sky and the sea have been painted on the glass, one first thinks. A glance at the top of the right side of the window reveals that the glass is clear. Then . . . there is one answer, no possible explanation. All our certainties are shattered. We know only that we do not know.[14]

Dominique de Menil was interested in contextualizing Magritte's work art historically. She posited, for example, that the ambiguous relationship between painting and subject in *The Fair Captive* (1949) was "antedated" by a page in the Da Costa Hours (illuminated by Simon Bening, c. 1515), because the illumination, like the gouache, contained "a frame held . . . in front of the landscape."[15]

Magritte and Dominique de Menil at a rodeo, Simonten, Texas, 1965

But she was also humble enough to defer to the experts—Alexander Iolas and David Sylvester—who routinely advised and alerted the de Menils when important works entered the market. Indeed, the de Menils collected Magritte's work not so much in direct consultation with the artist as in dialogue with those who knew the most about him. Thus, Iolas, who specialized in making the artist's best work available to American collectors, extended this courtesy to the de Menils and offered such significant paintings as *The Fair Captive* (1949), *The Force of Circumstance* (1958), and *The Fanatics* (1963). Sylvester, who spent a quarter century in the Menil Foundation's employ as author of the five-volume catalogue raisonné of Magritte's work, generously imparted his hard-won (and often-unsolicited) scholarly expertise and negotiated the purchases of such masterworks as *Nocturne* (1925), *The Literal Meaning* (1929), and *The Eternally Obvious* (1930).[16]

A critic and scholar famous for his essays on Picasso and Magritte, Sylvester had published extensively on subjects ranging from midcentury artists and movements—such as Henry Moore and abstract expressionism—to film, literature, and cricket by the time he received the catalogue raisonné commission in 1967. His own vast and perpetually rotating collection did not include a single Magritte, which lent legitimacy to his advice. It implied that he was motivated less by a need to validate his own expertise than by a desire to see that the artist's most important works found their way into the proper hands. He kept his ear to the ground, alerting the de Menils at the slightest suggestion of the availability of new works: when fellow critic Roland Penrose, for example, hinted that he wished to liquidate the Duchampian *This Is a Piece of Cheese* (1936 or 1937), Sylvester immediately secured right of first refusal for Dominique de Menil. When *The Rape* (1934) came on the market in 1976, he tracked down Dominique's assistant with fanatical zeal, declaring the painting's asking price to be the "bargain of the decade" and weighing in that

it would be a "terrible pity if the foundation . . . doesn't make the purchase. It is a staggering opportunity."[17] He had an uncanny and consistent ability to assess a work's real value, and he made the de Menils aware of such undervalued works as *The Dead Bird* (c. 1926), which, he proclaimed, was "a great Magritte. . . . In a year or two, as the result of the impact which works of this period . . . are making, the market value may well be considerably higher."[18] And more often than not, he was right.

"It was very late before we would admit we were collectors," Dominique de Menil once said, and indeed she and John surrounded themselves with authorities— MacAgy, Iolas, and Sylvester—who enriched their collection and enhanced their expertise by operating varyingly as mentors, advisers, go-betweens, and spies.[19] When it came time to build a museum to house her treasures, Dominique envisioned an edifice that would embody this same spirit of goodwill and collaboration, and she commissioned Renzo Piano to design a structure of wood on a scale that was more human than monumental, an approachable yet grand building full of natural light, an intimate respite from the challenges of Houston's unforgiving climate and chaotic city streets, a place for people to gather and quietly contemplate the mysteries of her collection.[20]

Notes

1. Dominique de Menil, foreword to *The Menil Collection: A Selection from the Paleolithic to the Modern* (1987; repr., New York: Harry N. Abrams, 1997), 7. I would like to thank Geraldine Aramanda and Diane Roberts of the Menil Collection archives for so generously assisting me with my research for this essay.

2. For background on the de Menils, see Marguerite Johnson, "The de Menils: They Made Houston a More Beautiful Place in Which to Live," *Houston Post*, January 9, 1977, and Walter Hopps, introduction to *The Menil Collection*, 9–13.

3. Up until MacAgy's appointment, the Contemporary Arts Museum (then known as the Contemporary Arts Association) was run by a group of individuals interested in contemporary art who held exhibitions at locations around Houston. With MacAgy's appointment, the CAA became a bona fide museum. For more on the history of the Contemporary Arts Museum Houston, see *Finders Keepers*, exh. cat. (Houston: Contemporary Arts Museum Houston, 1997).

4. See Hopps, introduction to *Menil Collection*, 11.

5. The exhibition's catalogue contains a full checklist. See *Magritte*, exh. cat. (Little Rock: Arkansas Art Center, 1964), n.p.

6. André Breton, "The Breadth of René Magritte," trans. W. G. Ryan, in *Magritte* (Little Rock 1964), n.p.

7. Dominique de Menil, undated letter to Magritte. All translations are mine unless otherwise indicated.

8. Magritte, letter to Dominique de Menil, May 21, 1964.

9. Installation photographs of *Secret Affinities* can be found in the Menil Collection archives in Houston.

10. These quotations were reprinted in the exhibition's catalogue. See *Secret Affinities: Words and Images by René Magritte*, exh. cat. (Houston: Institute for the Arts, Rice University, 1976), 9.

11. "Listening to René Magritte," trans. W. G. Ryan, in *Secret Affinities*, 22.

12. "Surrealism Goes to Texas," University of St. Thomas press release, December 15, 1965.

13. From Dominique de Menil's undated notes on the painting in the Magritte master file, Menil Collection, Houston. I am grateful to Mary Kadish for making this file available to me.

14. Ibid.

15. Dominique de Menil, letter to Mary Jane Victor, May 7, 1983.

16. David Sylvester et al., *René Magritte: Catalogue Raisonné*, 5 vols. (Antwerp: Mercatorfonds and Houston: The Menil Foundation, 1992–97).

17. Elsian Cousins, undated note to Dominique de Menil.

18. David Sylvester, letter to Dominique de Menil, January 22, 1975.

19. Quoted in Hopps, introduction to *Menil Collection*, 11.

20. Dominique de Menil discussed her plans to build a museum in a conversation with Iolas that took place on June 3 and 8, 1977. Transcription, April 10, 2001, Menil Collection archives, Houston.

Marcel Broodthaers, *Rue René Magritte Straat*, 1968

This Wouldn't Be a Pipe:
Magritte and Marcel Broodthaers

THIERRY DE DUVE

Anyone inquiring about the posterity of Magritte's work in that of Marcel Broodthaers will inevitably come upon the interview by Irmeline Lebeer[1] in which Broodthaers sharply separates himself from surrealism in general and André Breton in particular. He goes on to say, "It is not so easy to deal with the Magritte of 'This is not a pipe.' One might say he was still too Magritte. That is to say, he wasn't 'This is not a pipe' enough. Thus, it was with this pipe that my adventure began."

Broodthaers's adventure was complex and magnificent, and Magritte's pipe played a role that the following remarks do not intend to dissipate in a cloud of smoke. Knowing that Broodthaers made no less than eight films between 1968 and 1972 showing the pipe in question, including one titled *This Wouldn't Be a Pipe* (1970), it is clear that a few pages of commentary will not be able to exhaust the *subject* ("subject" and "figure" being hardly the least enigmatic of the words indicating the praxis of an artist known for his *eulogy of the subject* and who gave form, without ever explaining it, to a *theory of figures*). Magritte lovers will pardon me, I hope, for restricting my attention to a Magritte less "Magritte" than "This is not a pipe." As for Broodthaers fans (and count me among them), may they pardon me for focusing exclusively upon a very particular Broodthaers, the one who had the genius to cross Magritte with Duchamp.

In 1968 Broodthaers created, at his home in Brussels, the Musée d'art moderne, Département des aigles. It went through many incarnations, one of the last being the Section of Figures in Düsseldorf in 1972. There Broodthaers, in his self-appointed role as museum director, brought together in the city's Kunsthalle about three hundred objects in an exhibition known as *The Eagle from the Oligocene to the Present*. Some of the objects were recognized works of art, while others, such as beer bottles, military emblems, and advertising images, were simply objects taken from material culture. All of these images of eagles were borrowed from either public or private collections. Each was accompanied by a label in one of three languages stipulating, "This is not a work of art."[2] In the catalogue, Broodthaers specifies that these labels "illustrate an idea of Marcel Duchamp and of René Magritte." On two facing pages he juxtaposes the photograph of Duchamp's urinal and a reproduction of Magritte's *The Treachery of Images* (1929), and he advises his readers to consult a then little-known text by Michel Foucault, "Ceci n'est pas une pipe."[3] Two years later Broodthaers confirmed in the Lebeer interview: "'This is not a work of art' is a formula obtained by the contraction of a concept by Duchamp and an antithetical concept by Magritte."[4]

Such a contraction has the simplicity of those luminous ideas that mask the complexity of the thought underlying them: "This is a work of art" + "This is not

Marcel Broodthaers and Magritte, 1967

Marcel Broodthaers, Musée d'art moderne, Département des aigles, Section des figures, 1972

a pipe" = "This is not a work of art." Broodthaers borrows from Magritte in order to deny Duchamp. One is surprised by the borrowing, since Broodthaers had no need to pass through Magritte in order to invert the operation that consecrates a readymade. In a note on *The Green Box*, Duchamp had already proposed the ironic idea of the "reciprocal readymade: using a Rembrandt as an ironing board."[5] Indeed, he put it into practice several times in his own work, for example in 1950, when at Sidney Janis Gallery he exhibited a urinal similar to the 1917 version photographed in a prone position by Alfred Stieglitz, but this time placing the object in a "normal" position, and low enough "so little boys could use it."[6] Instead of using a Rembrandt as an ironing board, Duchamp used a Duchamp as a urinal. However, Broodthaers did not use a Magritte as a pipe. His operation is something else. It is poetic and it is political: he used it "to decorate Duchamp's urinal with the emblem of an eagle smoking a pipe." He recounted this in the Lebeer interview, adding, "I believe that I have emphasized the authority principle which makes the symbol of the eagle into the colonel of art."[7] The catalogue in which this interview is published also reproduces, twice, the image of a "dead general [who] smokes an extinguished cigar."[8] The parallel with a "colonel of art" smoking a pipe is obvious.

Under Broodthaers's gaze Magritte's pipe acquires a political significance: the colonel of art is dead and the pipe extinguished. In other words, the eagle is discharged. No doubt Magritte's 1949 *The Domain of Arnheim* is the piece that provoked Broodthaers to print "Ô mélancolie, aigre château des aigles" (O melancholy, bitter castle of the eagles) under the only image (a landscape with a castle) containing no representation of an eagle. The paintings that precede and announce *The Domain of Arnheim* have significative titles: *The Precursor* (1936) and *The Call of the Heights* (1943). Typically of Magritte, insofar as the bird is confounded with the peaks it flies over, the works have retained too much of their evocative power to keep the fractured eagle on the broken pane from staying at the top. That is to say, in *The Domain of Arnheim* Magritte is too "Magritte" and not enough the author of "This is not a pipe." Too much an "artist," and not "sociologist" enough.[9] Broodthaers will not make this mistake. He knows that the artist is irremediably compromised, all the more so because the art world in which he evolves is the totally institutionalized post-Duchampian art world, more or less cynical and thoughtless, which has aligned itself with this single circular rule: a museum is an art museum if it contains art, and everything that an art museum contains is automatically art. In order to break the vicious circle of this tautology, Broodthaers dubbed himself museum director: only in a parody of power could the artist's fundamental lack of power be demonstrated.

Around 1970 many artists became conscious of the institutional character of art. For many of them this was a consequence of Duchamp's gesture; and many reacted through a practice that took as its explicit subject the power to name art. Broodthaers has often been associated with such conceptual work. This is a huge misunderstanding, perhaps encouraged by Broodthaers himself, who as a subtle dialectician always knew how to play with the reception context of his work (from 1964 to 1968, pop art; from 1968 to 1972, conceptual art; and from 1972 to the end of his life, the shamanistic enterprise of Joseph Beuys) in order to submit it to his biting irony. The dogma of conceptual art maintains that the concept has replaced the art object, and that artistic practice has taken a linguistic turn, prefigured by Duchamp and bolstered by the Magritte of 1927–30, the very Magritte of *The Treachery of Images*. This linguistic turn is quite real, but it has been greatly misinterpreted. It is

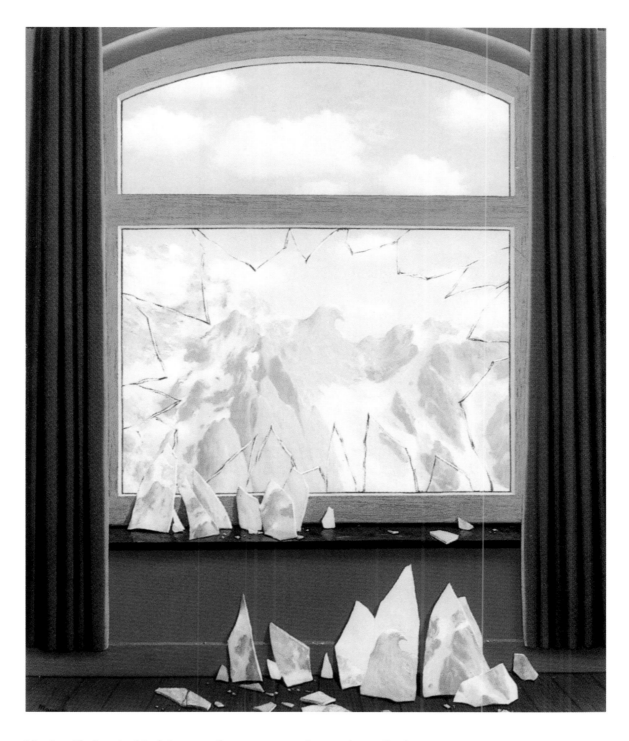

Magritte, *The Domain of Arnheim*, 1949, oil on canvas, 100 × 81 cm, private collection

thing [θiη] n. Chose *f.;* objet *m.; the big things in the room,* les gros objets de la pièce. ‖ Pl. Vêtements, habits *m. pl.;* affaires *f. pl.* (clothes). ‖ Pl. Outils, ustensiles *m. pl.* (implements); *tea things,* service à thé. ‖ Jur. Pl. Biens *m. pl.; things personal,* biens mobiliers. ‖ Comm. *It's not the thing,* ça ne se fait pas, c'est passé de mode; *the latest thing in hats,* chapeau dernier cri. ‖ Fig. Chose *f.; as things are,* dans l'état actuel des choses; *for one thing,* tout d'abord, et d'une; *for another thing,* d'autre part, et de deux; *it's just one of those things,* ce sont des choses qui arrivent; *it would be a good thing to,* il serait bon de; *not a thing has been overlooked,* pas un détail n'a été négligé; *the thing is to succeed,* la grande affaire (or) le tout c'est de réussir; *that's the very thing,* c'est juste ce qu'il faut; *to expect great things of,* attendre monts et merveilles de; *to make a good thing out of,* tirer profit de. ‖ Fam. Etre *m.* (person); *poor little thing,* pauvre petite créature. ‖ Fam. Truc, machin *m.* (thingumabob). ‖ Fam. *How are things?,* alors comment ça va?; *not to feel quite the thing,* se sentir patraque; *to know a thing or two,* connaître le bout de gras, être à la coule.

Joseph Kosuth, *Definition ("Thing")*, 1968

Marcel Broodthaers, *Pense-Bête*, 1964,
books and plaster, whereabouts unknown

most often seen as the discovery that "art is a (visual) language system determined
. . . in a manner very analogous to the Saussurian model"; "the proposal inherent
in conceptual art was to replace the object of spatial and perceptual experience by
linguistic definition alone."[10] When Broodthaers covered the remaining copies of
his book *Pense-bête* in plaster, he buried his noncareer as a poet, and it was to make
an object, not a concept. When, ten years later, his "Belgian pop art" period equally
buried, he is asked whether there are still any objects of this period he is partial to.
He answers, "Yes, a few. They are poetic, that is to say guilty in the sense of 'art as
language' and innocent in the sense of language as art."[11] They are poetic and not
conceptual. Guilty in the eyes of those who cultivate art as language and who, like
Joseph Kosuth, profess that "works of art are analytic propositions" that "express
definitions of art," and conclude that art is a tautology.[12] And innocent for those
who understand the poet to whom occurred "the idea of finally inventing something
insincere" after he asked himself if he too could not "sell something and succeed in
life," for this poet never ceased to practice rhetoric, that is to say language as art.[13]

Before rushing to claim that in Düsseldorf, in 1972, Marcel Broodthaers
submitted some three hundred objects bearing eagle imagery to the test of the
reciprocal readymade, one must first ask—contracting Duchamp and Magritte—why
he preferred the iconography of the eagle to that of the pipe or the men's fountain.
Also, one should remember that, in the second volume of the show's catalogue,
Broodthaers revealed that the "concept of the exhibition is based on the identity of
the eagle as idea and of art as idea."[14] Keeping all this in mind, one must ask why
he borrowed "This is not a pipe" from Magritte in order to deny Duchamp's "This is
art." Each of the exhibited objects is too overtly accompanied by a label making it
a reciprocal readymade for there not to be something funny going on. The negation
does not apply in the same fashion to the objects that are recognized works of art
and to those that are not. The former seem to have their artistic status denied; the
latter are accompanied by a warning, as if their simple presentation in the context
of Broodthaers's fictive museum made them run the risk of being inevitably dressed
up as art. And the labels don't have the discretion we expect of museums: they are

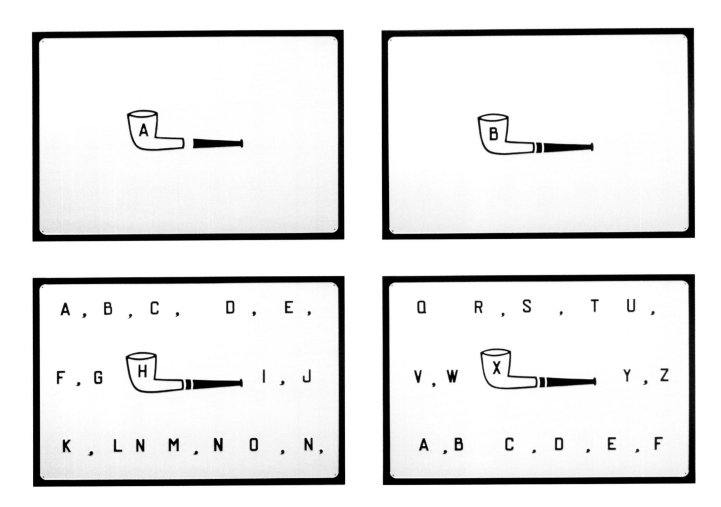

Marcel Broodthaers, *4 Pipes Alphabet*, 1969

black, their material (engraved plastic) and their graphic style are inappropriate. They make no mention of title, artist, or provenance; they merely cite a number referring to the catalogue where this information can be found. They are punctured by two screw holes, yet they are not attached to the object, seeming instead to have been detached in order to be exhibited on their own. Their obsessive repetition, in three alternating languages, is what should provide a clue—a clue that we might as well read self-referentially. Perhaps it is these labels, as much as the associated objects, that are submitted to the test of "Rembrandt as an ironing board."

It seems to me that Broodthaers understood better than anyone that any object, as long as it is presented in and by the post-Duchampian art world where tautology reigns, is as automatically accompanied by an invisible label saying "This is art," as an image of a pipe is accompanied by an invisible label saying "This is a pipe." Better than the conceptual artists who confuse name and concept, Broodthaers has understood that Duchamp's gesture with the readymade was to reduce the artwork to the statement that names it as such. Moreover, he also understood that Magritte's gesture in *The Treachery of Images* was to have reduced representation to presentation. The perception of this equivalence is a stroke of genius. It is also that which makes the qualitative jump (if I may be permitted this old Marxist expression) between his "Belgian pop art" phase and his "Museum of Modern Art" phase, which opened May 30, 1968, with the occupation of the Palais des Beaux-Arts in Brussels. Nothing records this qualitative jump better than the Lebeer interview, in which the conversation slides from engaged art to indifferent art. Broodthaers suggests that one creates indifferent art "from the moment that one is less of an artist, when the necessity of doing puts its roots down in memories alone. I believe that my exhibitions have depended on, and still depend on, the memory of a period when I experienced the creative situation in a heroic and solitary manner. In other words, it used to be: read this, look at this. Today: allow me to present to you."[15]

It would be a mistake to see Broodthaers's indifferent art as a refusal of political engagement. It is a certain kind of political engagement—in the mode of May 1968, or like the occupation by artists of the Palais des Beaux-Arts—the ineffectiveness of which Broodthaers observed between May 30 and September 27, 1968. This is the date a bona fide official of the post-Duchampian art world, museum director Johannes Cladders, inaugurated Broodthaers's Musée d'art moderne, Département des aigles. Occupying the Palais des Beaux-Arts could only last for a time. The institution always gets the upper hand. Art in the street, the multiple, viewer participation as called for by the kinetic art of the period—these are not viable alternatives for museum art. Broodthaers understood the profoundly tragic and wholly institutional sense of Kosuth's tautology. Making art had become a sort of war game played exclusively between artists, dealers, and curators, the public remaining on the sidelines. Either the artist and the curator engage in a game of one-upmanship to see who will have sway over the other (Daniel Buren would prove to be a great master of this game), or the artist, publicly demonstrating his bad faith and insincerity, usurps the role of curator and plays the power game in order to make it clear that this must be rescinded. Innocence at the price of cunning perversity. The artist as a museum director? Yes, that is to say as the master of ceremonies: "Allow me to present to you. . . ."

One could extract a whole ethical theory of the museum from Broodthaers's endeavor. It starts with the following observation: every last thing that has

Marcel Broodthaers, *A Magritte Picture*, 1967

successfully introduced itself into a museum or art gallery bears an invisible label stating *This is art*. Such is the post-Duchampian finding, the one that apparently leads to the tautology of the institutional theory of art. But the ethical theory would immediately introduce the following corrective: the statement is between quotation marks. This is Magritte's lesson according to Broodthaers. When a museum *presents* something as art, it is as if it were saying "Here is a case of 'This is art.'" Coming from a museum, the statement "This is art" does not transform the thing presented into art; it cites it as already called art. The phrase in quotation marks becomes autonymous (self-naming). That is exactly what Magritte accomplishes in *The Treachery of Images*.

Let us, in the manner of François Recanati, consider two opposed theories of language.[16] The first, which he calls representationalism, upholds that linguistic signs are transparent and that their meaning resides entirely in their denotation. They represent what they present and, conversely, they fade behind the thing presented/represented. The second theory, which corresponds more or less to pragmatism, maintains that linguistic signs are by turns transparent and opaque, or simultaneously one and the other, and that denotation, which is the transitive function of signs, is also, and necessarily, reflexive. Like Recanati, I opt for the second theory. To be brief, I support this assertion with a well-known Chinese proverb: "When a wise man points at the moon with his finger, an imbecile looks at the finger." The representationalist approves, yet does not understand that he is the imbecile. The pragmatist seizes the pedagogic value of the aphorism and understands that in order to know that the finger points to the moon, he has first to have looked at the finger. The theory of representationalism, which acknowledges only the transitivity of signs, thus forbids the reflexivity that the pragmatic theory allows. For the pragmatic theory, in the statement "Socrates has eight letters" the word "Socrates" presents itself while continuing to refer to the Greek philosopher. In the representationalist theory, the statement is stripped of meaning, since a philosopher is not made of letters. It only makes sense if it is written "Socrates" (with the word in quotation marks), so that it is not the name of the philosopher, but the name of his name. John Searle has made fun of this theory, which doesn't allow for the self-reference of signs yet allows for infinite regress of the names of names, by proposing to call the name of Socrates's name by the word "John." Thus "John has eight letters" would be a valid statement, since it would be equivalent to "'Socrates' has eight letters." Searle's humorous move is a typically Magrittean one. Numerous are the alphabet paintings where Magritte, acting dumb, plays at radical representationalism and rebaptizes names to make us believe that the things have forgotten theirs.[17]

The difference between "John has eight letters" and "'Socrates' has eight letters," says Recanati, is that in the first statement the word "Socrates" is *represented*, while in the second it is *presented*. Representationalist theory pretends not to make this distinction although, when pushed, sees itself obliged to admit it. "A word-between-quotation-marks is thus not the proper name of the word, it is the word itself, exhibited or shown. . . . The only objects which we *must* represent if we wish to speak about them are the ones which cannot be introduced in the flesh into a discourse: for all other objects it ought to be possible to present them, to produce them, rather than to represent them."[18] This is clearly the case for words. Why would I need to call the Greek philosopher's name "John," since it is sufficient for me to

pronounce "Socrates" to evoke it in the flesh (the name, not the philosopher)? And why not extend this possibility to objects? Recanati goes on to quote Carnap: "For example, we can adopt the rule that instead of the word 'match,' we will always place a match on the paper."[19] And why not, from then on, extend it to images? "A word can take the place of an object in reality," writes Magritte, adding, "An image can take the place of a word in a proposition."[20] In all of these cases and others (an object for a word, an image for an object, etc.), the expression is used as its own designation. Recanati quotes Carnap again: "An expression used in this way is called *autonymous*."[21] Thus, an autonymous expression, whether it be the word "match" (in quotation marks), or the match on a paper, or the image of the pipe that the match lights, is a sign that presents itself. The quotation marks are merely an optional convention of language, making the self-presentation of the sign manifest. Needless to say, Magritte, who loved to play with autonymy, usually makes do without the quotation marks, or rather catches us in the trap of their transparency. He knows very well that they are there. He only applies himself so virtuously to scrupulous representation in order to hide from us the fact that he believes in it only when it is reduced to presentation.

The quotation marks are a display device. The word *this* is a display device. A base under a statue, a frame around a painting, a spotlight shining on an object, a white wall in a museum, all are for display purposes. All these devices, some linguistic others not, are pointing fingers, deictics. A photograph is simultaneously an index (trace) of the thing presented and an index (finger) pointing at this thing in the real world, and is therefore also a display device. Similarly for a drawing or a painting, particularly if it has the photographic style so dear to Magritte. Here then is *The Treachery of Images* (note that the deictic "here" and the title of the painting are display devices as well). A drawing represents a pipe in its absence, accompanied by a statement that denies that it has to do with a pipe. Let us engage in the most childish, commonsense reading, that is to say, let us be as logical as Alice.[22] Logic doesn't like contradictions, and common sense, which is spontaneously representationalist, backs off from the paradoxes of self-referentiality. It reads the word "this" as referring to the lines in the form of a pipe that hover over the statement and answers immediately that a drawing is not a pipe. But how does representationalist common sense know that this is a drawing? According to representationalists, a sign doesn't have the right to present itself. To present the drawing of a pipe, there ought to be another, in the manner either of "'Socrates'" or of "John." If it is "John," nothing precludes representing the drawing of a pipe by a formless cloud on which is written "pipe." But why "pipe," since "horizon" or "person bursting with laughter" (as in *The Living Mirror*, 1928) are just as adequate for the task, having neither more nor less relation to the drawing of a pipe than "John" does to the name of Socrates? And if it is "'Socrates,'" why take the trouble to draw the pipe twice? Nothing precludes the drawing of a drawing of a pipe (like the name of a name) from being rigorously identical to the initial drawing. Magritte having been perverse enough not to paint quotation marks around his drawing, we must conclude that the drawing is the quotation marks and that the representationalist theory is wrong.

Magritte, ever perverse, made the counter-proof in another drawing, which Michel Foucault exploited with unrivaled brio, where *The Treachery of Images*—the whole painting—is presented/represented on an easel. In this case no doubt is

possible: an easel is a display device, the equivalent of a pair of quotation marks. The right theory, if we must remain representationalists, is thus "'Socrates.'" But why then the apparition above the easel of that "outsized, floating, ideal pipe—simple dream or idea of a pipe," as Foucault put it?[23] No doubt because self-referentiality is inevitable. Try for yourself to keep a drawing of a pipe from presenting itself, surround it with quotation marks as big as an easel. You'll see, it will pop back up in the sky of ideas with no other quotation marks than the mere fact that it declares itself drawn. The more you hold fast to the transparency of signs, believing you can anchor them thus to the real, the more their reflexive opacity will take revenge upon you. And reciprocally, the more you doubt the real and multiply the quotation marks around quotation marks, the less you will preclude the drawing of a drawing of a drawing of a pipe from *being* a pipe. Or as Foucault said, the idea of a pipe.

Ideas are not ordinarily presentable. Being invisible, they cannot be shown. The imbecile can stare as long as he likes at the fingertip, but he'll never find the idea of the moon. So what is Broodthaers doing in Düsseldorf? The subtitle of the exhibition states clearly: *Marcel Broodthaers Shows an Experimental Exhibition of His Museum of Modern Art, Department of Eagles, Section of Figures*. Each word counts, starting with *Marcel Broodthaers Shows:* What does he choose to show? An *Experimental Exhibition*, a test. What is being tested? The presentation itself. The walls of the exhibition are full of paintings and images, stands, vitrines, all rather old-fashioned and with a kind of Museum of Natural History connotation much too exotic to be overlooked in the context. Together, these display devices present objects that each present an image presenting an eagle that presents?—no, that represents?—no, that *presentifies* "the concept of the exhibition," itself "based on the identity of the eagle as idea and of art as idea." This identity is revealed in the second volume of the catalogue (published after the exhibition was well under way) and is undoubtedly addressed to naive spectators who imagined that they would be treated to the thematic concept of the eagle in all its declensions: "The eagle in art, in history, in ethnology, in folklore. . . ." "Public, how blind you are!" rants Broodthaers.[24]

The public is blind, of course: ideas, we have already noted, are not visible. Nonetheless there exists a procedure that, although unable to make them presentable, at least makes them representable. This procedure, known from classical rhetoric, is allegory: just as a blindfolded woman holding scales represents the idea of justice, so an eagle represents the idea of power. More than one empire has made use of such an image: with one or two heads, the eagle is imperial. But Broodthaers doesn't stop there. He warns us in the subtitle that the Department of Eagles belongs to *his* Museum of Modern Art, and hence we are in neither a museum of natural history nor an imperial museum but rather in that of an artist who has captured the idea of the museum in general to turn it into an allegory of his own conception of art. Even the most novice viewers of conceptual art can no longer imagine that images might be subsumed under the concept of art just as those majestic birds can be subsumed under the eagle concept. "The eagle as idea" is to "art as idea" what Broodthaers the museum director is to Broodthaers the artist. Just as Magritte undertook scrupulous representation the better to hide from us that he no longer believed in it except when it is reduced to presentation, so Broodthaers goes out of his way to make us believe that art answers to the most carefully hierarchized taxonomy (Museum, Department, Section) the better to rub our noses in the brutal formula equating the idea of art and the idea of power.

It is this very equation that he denies about three hundred times in a row by accompanying each object presenting the image of an eagle with a sign warning "This is not a work of art." Broodthaers does not pull us out of the ambiguities inherent to deictics any more than Magritte does by *drawing* the word *"ceci"* as carefully as he *writes* the outline of his painted pipe. It is not impossible, in Broodthaers's case, that "this" refers back to itself, or to the black plastic sign on which it is engraved. Nor is it ruled out that it refers to the object that the sign accompanies, or to the image of the eagle born by the object. You may decide for yourself. In "art as language" the objects, in this case, the eagles, are guilty, but they are innocent "in language as art." That is to say, in figurative speech, in the language of rhetoric. One must read the subtitle of the exhibition to the very end in order to acquaint oneself with this rhetoric manipulating the allegory of allegory whose secret Broodthaers possesses. It is the Section of Figures in the Department of Eagles in his Museum of Modern Art that Broodthaers chooses to *present* in Düsseldorf. There he pretends to *represent* the equation "art/eagle = power," stressing again and again that the equation in question concerns an idea that is not his own, and thus he *presentifies* his thought.

Marcel Broodthaers, Musée d'art moderne, Département des aigles, Section des figures, 1972

Magritte wrote to Michel Foucault: "Only thought has the power of resemblance. It resembles while being what it sees, hears, or knows. It becomes what the world offers to it. It is as invisible as pleasure or pain. But painting adds a new difficulty: there is thought that sees and that can be visibly described. *Las Meninas* is the visible image of Velázquez's invisible thoughts. Does that mean that the invisible is sometimes visible? On condition that thought is constituted exclusively of visible figures."[25] For Magritte thought is presentable and the figures of the visible world are its display devices. This must have been written by the kind of Magritte who is a bit too "Magritte" and not quite enough "This is not a pipe," a Magritte who one way or another underwrites his thoughts about resemblance (as a resembling thought) with a theory of figures that can make use of any material so long as it draws from the world of visible appearances. Broodthaers will correct this: "A theory of figures can only serve to give an image of a theory. But the fig. as theory of the image?"[26] "Figure" versus "Fig.": an idea presented figuratively for Magritte becomes for Broodthaers an idea presentified as figures. Thus, as surely as an easel or a pair of quotation marks, the abbreviation "Fig." followed by a numeral or letter is a display device, a deictic, and like all deictics it is reflexive before being transitive. For Broodthaers it is most often exclusively reflexive, for example in the book *Charles Baudelaire, je hais le mouvement qui déplace les lignes*, 1973 (Charles Baudelaire: I Hate the Movement that Shifts the Lines), where the abbreviation "Fig.," followed by a numeral (0, 1, or 2) or a letter (always A), is repeated to fill all the space on the page normally occupied by an illustration, while the words of Baudelaire's poem "La beauté" drip one by one onto the bottom of the page, where one expects to find the caption. Broodthaers comments: "The numerals 1, 2, 0 appear as figures. And the abbreviations Fig. seem wrong in their sense."[27]

Broodthaers said "mal dans leur sens" (wrong in their sense) as if he had said "mal dans leur peau" (uncomfortable in their skin). Deictics presenting themselves whereas they are meant to present images must indeed feel disoriented. Numerals that "appear as figures" can only feel the loss of the world when they see themselves taking the place of the "figures that the world of appearances offers to us"—as Magritte said, ever confident with the offering. *O melancholy, bitter castle of the eagles*, will we never escape self-referentiality? Words with or without quotation

Marcel Broodthaers, *Charles Baudelaire: I Hate the Movement that Shifts the Lines*, detail, 1973

marks, images on easels or not, objects accompanied by invisible labels stating "This is art" or highly visible signs denying them such an identity. Are all these signs that present themselves hence condemned to bear the spleen of a world they no longer know how to represent? What chance has art to present thought, and what chance has presentified thought to speak of the world, poetically and politically? "I use the object as a zero word," said Broodthaers.[28] "Fig. 0" sometimes has a different status from "Fig. 1," "Fig. 2," or "Fig. A." That is the case in Düsseldorf, where "Fig. 0" identifies the only image that does not represent an eagle—the aforementioned landscape with castle—the image specifically captioned *Ô mélancolie, aigre château des aigles*. "Fig. 0" is the lever of Archimedes for Broodthaers: it serves him to lift the world, even when he has no fulcrum. Now that Broodthaers's work has joined Magritte's in the museum, the question is whether Broodthaers, museum director that he was, succeeded in escaping the tautological reification that the post-Duchampian museum reserved for him. "Fig. 0." is perhaps for us, his viewers, the finger one must look at to see the moon in the sky.

Translated from the French by Rachel Stella

Notes

1. Marcel Broodthaers, interview by Irmeline Lebeer, "Dix mille francs de recompense," in *Marcel Broodthaers*, exh. cat. (Brussels: Palais des Beaux-Arts, 1974), 64. Though questions and answers were both by Broodthaers, the interview was published under the name of Irmeline Lebeer and is referred to here by that name.

2. *Der Adler vom Oligozän bis Heute: Marcel Broodthaers zeigt eine experimentelle Ausstellung seines Musée d'Art Moderne, Département des Aigles, Section des Figures*, exh. cat., 2 vols. (Düsseldorf: Städtische Kunsthalle, 1972).

3. Michel Foucault, *This Is Not a Pipe*, trans. James Harkness (Berkeley: University of California Press, 1983).

4. Broodthaers, interview by Lebeer, 68.

5. Marcel Duchamp, *Duchamp du signe* (Paris: Flammarion, 1975), 49.

6. Sidney Janis, letter to William Camfield, cited by Camfield in "Duchamp's Fountain: Aesthetic Object, Icon, or Anti-Art," in *The Definitively Unfinished Marcel Duchamp*, ed. Thierry de Duve (Cambridge: MIT Press, 1991), 156.

7. Broodthaers, interview by Lebeer, 68.

8. Ibid., 64.

9. Ibid. "Or that of sociological reality. That is what Magritte was always reproaching me for. He thought I was more of a sociologist than an artist." This was Broodthaers's answer to the question whether the world where the table and the egg and the mussel and the pot meet is the world of the imagination.

10. Claude Gintz, "L'art conceptuel, une perspective: Notes on an Exhibition Project"; Benjamin Buchloh, "From the Aesthetic of Administration to Institutional Critique (Some Aspects of Conceptual Art, 1962–1969)"; both in *L'art conceptuel, une perspective*, exh. cat. (Paris: Musée d'art moderne de la Ville, 1969), 20, 41.

11. Broodthaers, interview by Lebeer, 64.

12. Joseph Kosuth, "Art after Philosophy," parts 1 and 2, in *Idea Art: A Critical Anthology*, ed. Gregory Battcock (New York: Dutton, 1973).

13. Broodthaers had his first exhibition in 1964, at the Galerie Saint-Laurent, in Brussels. The invitation announcement included this text: "I also began to wonder if I could not sell something and succeed in life. I have been a good-for-nothing for some time now. I am forty years old. . . . The idea of inventing something insincere crossed my mind, and I immediately set to work. Three months later I showed my work to P. Edouard Toussaint, the owner of the Galerie Saint-Laurent. He said, 'But this is art, and I would be pleased to show it all.' Alright, I answered. If I sell something, he'll take 30 percent. Apparently these are quite normal conditions, as certain galleries take as much as 75 percent. So what is it? In fact, they are objects. Marcel Broodthaers."

14. *Der Adler vom Oligozän bis Heute*, vol. 2, 19.

15. Broodthaers, interview by Lebeer, 66.

16. François Recanati, *La transparence et l'énonciation* (Paris: Seuil, 1979).

17. "Word-paintings" is what David Sylvester called the forty-some paintings realized during Magritte's Paris sojourn from September 1927 to July 1930, where the artist combined words and figures. These fall into three categories: "There are the ones where the words accompany figurative forms, the ones where they accompany abstract or semiabstract forms, and the ones where they accompany both sorts of forms." David Sylvester, *Magritte: The Silence of the World* (Houston: The Menil Foundation and New York: Harry N. Abrams), 210.

18. Recanati, *La transparence*, 68, 70.

19. Ibid., 70.

20. "Les mots et les images" is an illustrated text published in *La révolution surréaliste* in 1929, and reproduced in René Magritte, *Écrits complets*, ed. André Blavier (Paris: Flammarion, 1979), 60–61.

21. Recanati, *La transparence*, 70.

22. I am referring to the episode in *Through the Looking Glass* where Alice resists with all her logical common sense the representationalism (we could even call it nominalism) of the White Knight, who tries to lead her into infinite regress by ceaselessly renaming the title of a song with a new title, then another, etc. A personal memory also comes to mind. When my daughter (coincidentally named Alice) was five or six and she was learning to read, I showed her a postcard of *The Treachery of Images*. She sounded out "Ce . . . ci . . . n'est . . . pas . . . une pi . . . pe," and said, "But it is a pipe." I answered, "So smoke it," and she smiled sheepishly: "It's a drawing of a pipe."

23. Foucault, *This Is Not a Pipe*, 16 (translation modified).

24. *Der Adler vom Oligozän bis Heute*, vol. 1, 16.

25. Letter of May 23, 1963, reproduced in Foucault, *This Is Not a Pipe*, 57–58, and in Magritte, *Écrits complets*, 639.

26. This is written on the back of a work consisting of two cut-out numbers, the 0 and 1 of the binary code often parodied by Broodthaers and which just as often in his work indicate the "fig." See Dirk Snauwaert, "The Figures," in *October* 42, Fall 1987, 134.

27. Broodthaers, interview by Labeer, 66.

28. Ibid., 64.

Jasper Johns, *Canvas*, 1956

René Magritte and Jasper Johns: Making Thoughts Visible

ROBERTA BERNSTEIN

I produce pictures in which the eye must "think" in a completely different way from the usual one. —René Magritte[1]

I am interested in the idea of sight, in the use of the eye . . . in how we see and why we see the way we do. —Jasper Johns[2]

The aspects of things that are most important for us are hidden because of their simplicity and familiarity. (One is unable to notice something because it is always before one's eyes.) —Ludwig Wittgenstein[3]

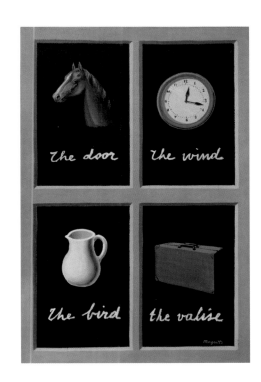

Magritte, *The Interpretation of Dreams*, 1935, oil on canvas, 41 × 27 cm, collection of Jasper Johns

Both René Magritte and Jasper Johns present commonplace things in unexpected ways that make us think differently about what we usually take for granted. Magritte aimed to enliven the ordinary world with a sense of poetic mystery by eliciting a spellbinding fascination from the most familiar things. This may be accomplished by ignoring the rules of gravity, as in *Familiar Objects* (1927–28), or through disarming juxtapositions, fusions, and changes in scale, as in *Personal Values* (1952). Johns, like Magritte, used what he described as "things which are seen and not looked at, not examined"[4] to rivet the viewer's attention to what is commonly overlooked. While Johns has remained a literalist in his manner of presenting familiar objects, many of his works have roots in the illogic of dada and surrealism. By presenting elements from daily life in the context of art, Johns endows them with uncertain, shifting meanings, whether flat objects and signs such as flags, targets, alphabets, and numbers or common household and studio items. A 1953 page of sketches by Magritte that Johns owns reveals an assortment of devices Magritte employed to create enigmatic icons out of ordinary things. Among them are objects—fork, chair, coat hanger, book, shoe—that Johns had used in his own work by the time he acquired the drawing in 1965.[5] The connection between the two artists is deeper, however, than the similar kinds of objects that attracted their eye. It rests on their mutual fascination with how the eye and mind work together and with the paradoxes and ambiguities inherent in visual perception.

Johns first saw Magritte's painting at the exhibition *Magritte: Word vs. Image*, held at the Sidney Janis Gallery in March 1954.[6] This exhibition included more than twenty word-and-image pictures, among them *The Treachery of Images* (1929), the painting that would become the best known example of Magritte's use of familiar items and words to unsettle the connections between an object, its image, and its name. In a review of the exhibition, Robert Rosenblum commented upon the innovative way Magritte "paints objects with utter detachment and matter-of-

Magritte, *Familiar Objects*, 1928, oil on canvas, 81 × 116 cm, private collection

factness." He further observed how Magritte's use of "new principles of vocabulary and syntax [is] not only striking visually; it enforces the disarming simplicity of his attack on the basic principles of common sense."[7] In March 1954 Johns was still several months away from beginning his first *Flag* painting. He had recently been introduced to Robert Rauschenberg by Suzi Gablik, an artist and writer who had met Rauschenberg at Black Mountain College in the early 1950s. It is possible to imagine that Johns, Rauschenberg, and Gablik may have been impressed by the same qualities in Magritte that Rosenblum noted. Within a year of the Janis Gallery exhibition, both Johns and Rauschenberg were challenging the hegemony of abstract expressionism with works that were similarly seen to be emotionally detached and shocking in their innovative manner of presenting common things. Each would affirm their interest in Magritte by acquiring examples of his work, beginning in the 1960s.[8] Gablik would later publish a major monograph on Magritte in which she compared his work to that of Johns, Rauschenberg, and other American artists of their generation.[9]

Johns's art is replete with references to artistic predecessors and writers with whom he identifies, including Marcel Duchamp, Pablo Picasso, Matthias Grünewald, Hart Crane, and Samuel Beckett. Although Magritte is one of the artists with whom Johns has most often been compared, Johns has not included specific Magritte references in his art, nor has he spoken extensively of his interest in Magritte as he has of other artists.[10] There is, however, a profound connection between them that rests on their examination of the relationship between seeing and thinking that remains at the core of each artist's work. Magritte's use of images and words to "render thoughts visible" established a strong link between his painting and Duchamp's conceptual art. In a 1960 review of a translation of Duchamp's notes for *The Large Glass*, Johns wrote of Duchamp's "brilliantly inventive questioning of visual, mental, and verbal focus and order."[11] It is likely that Johns became more aware of the connections between his own work and Magritte's around the same

Magritte, *Page of Sketches*, 1953,
pencil on paper, 26.7 × 21.6 cm,
collection of Jasper Johns

time he discovered Duchamp's in 1959. That year there were two important Magritte exhibitions in New York galleries, and Duchamp contributed a short text for the invitations.[12] Six years later, Johns met Magritte for the only time when Magritte came to New York to attend the opening of his 1965 retrospective at the Museum of Modern Art. Around the same time, Johns acquired *The Interpretation of Dreams* (1935) and *Page of Sketches* (1953), and he received as a gift from Magritte *The Two Mysteries*, a 1965 drawing in ballpoint pen of the "ceci n'est pas une pipe" motif (see *The Two Mysteries*, 1966).[13]

While Magritte's pipe became his signature image for investigating the paradox of object versus image, Johns's *Flag*s established his own paradoxical position on the relationship of art and reality. Leo Steinberg was the first to articulate the way Johns's early paintings of flat objects and signs take Magritte's conceptualized approach to illusionism one step further. As Steinberg notes, "You can't smoke Magritte's pipe, but you can throw a dart at a Johns target or use his painted alphabets for testing myopia."[14] Magritte invented an array of devices to exploit what Gablik describes as "the ambiguity which exists between a real object, one's mental image of it, and the painted representation."[15] Magritte articulates this key philosophical premise in a statement about *State of Grace* (1959), a painting in which a bicycle rests on a large cigar that floats in space. He writes, "Painting has no thickness: thus my painting with the cigar, for example, has no perceptible material thickness. *The thickness of the cigar is in the mind. . . . It is not a cigar one sees, but the image of a cigar.*"[16] In his early encaustic paintings, Johns builds upon Magritte's paradox of object versus image. His *Flag*s, *Target*s, and *Number*s are not illusions

Jasper Johns, *Figure 7*, 1955

Jasper Johns, *White Flag*, 1960

Magritte, *The Human Condition*, 1948

of reality like Magritte's pipes and cigars, yet they are not the found objects that they initially appear to be. Johns raises awareness that perception is "in the mind" through the ambiguous and undetermined nature of these painterly versions of otherwise familiar things. In his Sculp-metal and painted bronze sculptures, Johns further destabilizes the boundary between art and reality by closely simulating three-dimensional objects such as lightbulbs, flashlights, and ale cans.

Both Magritte and Johns employ motifs that specifically question the viability of the metaphors of paintings as windows or mirrors revealing or reflecting the real world. Magritte uses what David Sylvester called "the pictured picture" to play with the "ambiguities in the relation between the depicted and the real."[17] Sometimes these appear in the form of framed pictures. In *The Six Elements* (1929), for example, the oddly configured frame counteracts the seductive illusionism of the six disparate "elements" pictured within its compartments. In *The Salon of Mr. Goulden* (1928–29), which shows four framed views of the sky hanging on a wall, Magritte purposefully creates doubt as to whether these frames contain pictures, windows, or mirrors. His images of canvases resting on easels raise the same ambiguity regarding appearance and reality. In *The Human Condition* (1933), the painting on the easel represents a landscape that at first appears unequivocally identical to the one viewed outside the window. Yet by revealing the canvas edge tacked onto the stretcher, Magritte reminds us that the painting's surface is not a transparent plane. Here, what Magritte called the "hidden visible"—that which is hidden from view *behind* the canvas—becomes the key to unraveling the picture's meaning. Johns owns a gouache and pencil drawing (both from 1948) of a variation on *The Human Condition* where the canvas is on an easel set in a cave entrance that opens onto a mountain landscape.

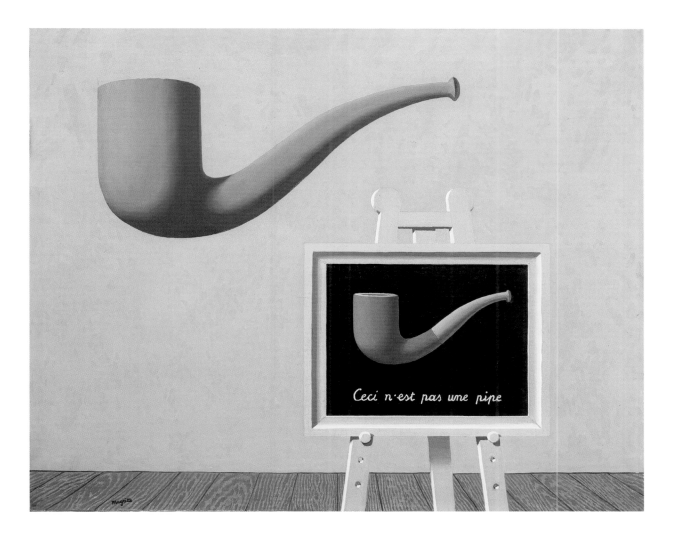

Magritte, *The Two Mysteries*, 1966

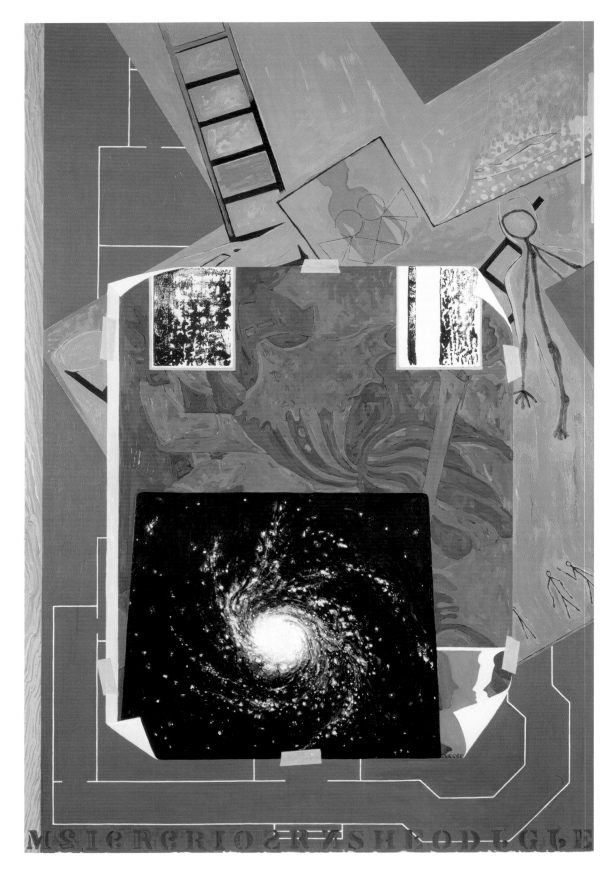

Jasper Johns, *Mirror's Edge*, 1992, oil on canvas, 167.6 × 111.8 cm, private collection

It is this kind of logical yet uncanny examination of the artwork as object that coincides with Johns's own interests. In his early works Johns used real canvases placed atop or hinged onto larger ones to expose the painting's canvas-on-stretcher construction. His first was *Canvas* (1956), where the exposed stretcher bars appear to frame a smaller rectangle within a larger one. This results in an ambiguous construction, with surfaces both hidden and exposed, that dispels the fiction of the canvas as a transparent window to reality. Johns's use of real objects attached to canvases establishes a literal basis for his paintings that distinguishes his approach from Magritte's enigmatic illusionism. In Magritte's *The Two Mysteries*, one pipe is contained within a picture frame while a larger one floats outside it in an undefined space. In Johns's paintings, objects adhere to the surface or obey the laws of gravity, as do the broom and cup that hang from hooks in *Fool's House* (1961–62). Shifts in scale occur only with flags, numbers, and other flat things that retain their integrity as symbols or signs in whatever size they are rendered. In many of his later works, Johns sometimes utilizes a quasi-representational, layered space that evokes the ambiguous nature of how reality is pictured in art, employing devices from trompe l'oeil still life, cubism, and surrealism. In *Mirror's Edge* (1992), for example, Johns presents an array of images atop one another to reveal how space and time can simultaneously expand outward and shrink inward. These images include a galaxy, drawings by Barnett Newman, tracings after a Grünewald figure, imagery from Johns's *The Seasons*, and the floor plan of the house where Johns spent much of his childhood. The wooden frame at the "mirror's edge" functions like Magritte's canvas edge as a reminder of the fictional status of these "pictured pictures."

Another area of interest shared by Magritte and Johns is the relationship of language to visual perception, and both artists' work has been examined in light of the semiotics of Charles Sanders Peirce, the linguistic structuralism of Ferdinand de Saussure, and the analytic philosophy of Ludwig Wittgenstein.[18] Both are closest to Wittgenstein, whose philosophical propositions explore the relationship of language to thought and to the world. Although there is no evidence that Magritte knew of Wittgenstein's ideas firsthand or at all, there is a correspondence in his paintings to Wittgenstein's examination of naming "as a *queer* connexion of a word with an object."[19] Gablik writes of the similarity of Magritte's and Wittgenstein's preoccupations with language "to the point where even the images they use often correspond."[20] The same can be said of Johns, who discovered Wittgenstein in 1961 and proceeded to read all of his writings.[21] In his series *The Interpretation of Dreams*, Magritte used pictures with captions arranged as if taken from the page of a school child's primer. Johns owns a variation with words in English rather than French. Magritte relies on our expectation that pictures and words function as surrogates for things represented. Yet the "incorrect" captions make us aware that this relationship is arbitrary and mysterious. As Magritte writes in his 1929 essay "Les mots et les images," "Everything tends to make one think that there is little relationship between an object and that which represents it."[22]

Like Magritte and Wittgenstein, Johns concentrates on how words function in our perception of reality. Among his earliest works are the paintings *Tango* (1955), *The* (1957), and *Tennyson* (1958), where isolated words evoke nonspecific, unseen things. In 1959 Johns introduced color names in *False Start*, *Jubilee*, and *Out the Window*. In *False Start*, words naming the painting's colors are scattered across the surface, but Johns provokes us to question what we see, since words are situated

Jasper Johns, *Fool's House*, 1961–62, oil on canvas with objects, 182.9 × 91.4 cm, Collection Jean Christophe Castelli

Jasper Johns, *Four Panels from "Untitled 1972,"* 1974

over colors that differ from their names ("blue" on orange or "white" on yellow) and letters painted in colors different from the ones they spell out ("white" in red letters or "yellow" in blue). Beginning in 1961, Johns used handwritten or stenciled words to label objects. Sometimes words are written on objects; other times words point at objects with arrows, as with the broom, towel, stretcher, and cup in *Fool's House*. While Magritte's captions purposefully clash with our expectations, Johns's always match objects with words with which we normally associate them. This underscores Johns's commitment to using only real objects or their traces, rather than images of things. At the same time, since the object's function shifts within the artwork (i.e., the broom becomes a paintbrush), the words take on an unfamiliar relationship with reality, reminding us that words themselves are a form of representation.

While Magritte and Johns are most frequently associated with the conceptual realism of their renderings of familiar objects, the human figure plays an essential role in the work of each. This aspect of their art reveals a shared attitude in their impersonal yet striking and inventive presentation of the human figure. The emotionally detached and anonymous casts in Johns's *Target with Four Faces* (1955) recall the generic bowler-hatted men that recur in Magritte's paintings, as those found in *The Masterpiece or the Mysteries of the Horizon* (1955) or *The Month of the Grape Harvest* (1959).[23] Johns's tracing of his own cast shadow, first used in *Summer* (1985) and then repeated in each version of *The Seasons*, has contradictory qualities of concreteness and insubstantiality, as do the transparent silhouettes found in Magritte's works of the 1960s, such as *Decalcomania* (1966) and *The Grand Quarry* (1964).

Dada and surrealism are replete with fragmented figures that serve as precedents for Johns.[24] However, it is specifically Magritte's illusionist fragments that are closest to Johns's veristic plaster and wax casts of faces, hands, legs, torsos, and other body parts. Both artists present body fragments as if they are inanimate objects, and both evoke an unsettling eroticism or psychological charge even while reminding the viewer of the figure's illusory status as representation. Johns's most graphic use of fragmented body parts is found in his *Target with Plaster Casts* (1955), *Watchman* (1964), and the large-scale painting *Untitled* (1972) and its related prints and drawings, where the casts sometimes appear as tracings and are sometimes photographically reproduced, as in a 1974 lithograph. The wax casts, found in the painting's right panel, are larger and more realistically rendered than those in his early *Targets*, and, as a result, their presence is more overtly jarring. They include a face, torso, feet, leg, knee, and buttocks, and give the impression that we are looking at a female nude that has been broken into pieces.[25] Instead of placing the casts in boxes as he had in his early *Targets*, Johns attached them to boards, and this manner of display can be seen on the one hand as objectifying them and, on the other, as enhancing their disturbing visceral and psychological impact.

Magritte plays with this same ambivalence between reality and illusion in his paintings with isolated body parts, including the feet in the many versions of *The Red Model* and *The Six Elements* (1929). In *The Eternally Obvious* (1948), Magritte divides a figure into segments and encloses them in separate frames. While the frames disrupt the image's verisimilitude, the nude, like Johns's broken figure, remains disturbing and erotically charged.[26] Several paintings in which Magritte combined fragmented figures with stone walls provide revealing precedents for the unsettling, disjunctive imagery in Johns's *Untitled*, where the panel of casts is juxtaposed with panels of

Magritte, *The Eternally Obvious*, 1948

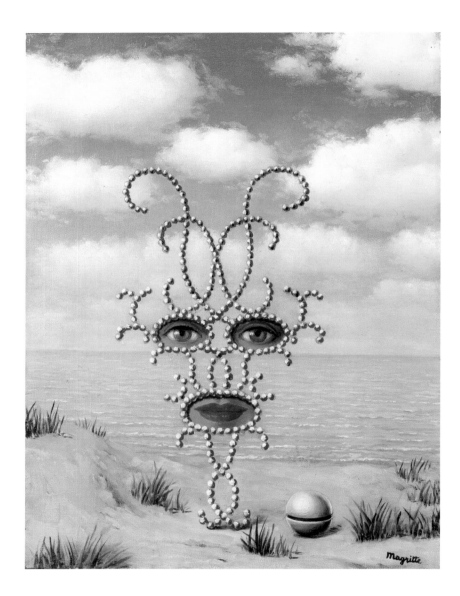

Magritte, *Sheherazade*, 1950

Jasper Johns, *Montez Singing*, 1989–90

Magritte, *Page of Sketches*, 1967,
ink on paper, dimensions unknown,
private collection

flagstones and stripes. A striking concurrence of imagery is found in Magritte's *The Literal Meaning* (1929), a canvas owned by Rauschenberg, that includes a "sad woman" represented by the words *"femme triste"* written across an ovoid canvas that leans against a stone wall crossed by a wooden board.[27] Magritte also did paintings of nudes embedded in stone walls, including *The Acrobat's Rest* (1928), where the figure is cropped into parts and distorted, and *The Elusive Woman* (1927–28), where an intact nude is flanked by four gigantic hands.

In 1985, Johns introduced a mysterious face with disembodied facial features that resembles a number of surrealist works, including ones by Magritte. In Magritte's *The Liberator* (1947) and *Sheherazade* (1950), a woman's eyes and mouth are surrounded by an ornate framework embellished with pearls, while the rest of the face has vanished into the surrounding air. In other paintings by Magritte, the eyes, nose, and mouth appear to be suspended in landscape settings. These enigmatic images of Magritte's are recalled in Johns's works, such as *Montez Singing* (1989–90), where the facial features are arranged within a rectangular frame and the background shifts from a flattened piece of stretched out skin to solid wall to an abstracted landscape/seascape. The lips double as the distant mountain peaks seen across the lagoon from Johns's home in St. Martin, while the cloth hangs as if attached to a flat surface by trompe l'oeil nails. In a page of sketches from 1967, Magritte invented pictures of faces laid out within rectangles that very closely foreshadow Johns's images. Johns's rectangular face was in part derived from the distorted profile in Picasso's *Woman in Straw Hat* (1936) and in part from his memory of a drawing by a schizophrenic child he had seen decades earlier.[28] Its resemblance to Magritte's imagery is just one of the many instances where similar motifs result from the shared values behind both artists' use of objects, words, and figures to address the enigmatic aspects of how we perceive the world. Understanding these connections enriches our understanding of Magritte and Johns and establishes a sense of the complex and lively interaction of artistic ideas that can occur from one generation to the next.

Notes

1. Quoted in David Sylvester, *Magritte: The Silence of the World* (Houston: The Menil Foundation and New York: Harry N. Abrams, 1992), 129.

2. Quoted in *Jasper Johns: Writings, Sketchbook Notes, Interviews*, ed. Kirk Varnedoe (New York: Museum of Modern Art, 1996), 135.

3. Ludwig Wittgenstein, *Philosophical Investigations*, trans. G. E. M. Anscombe (Oxford: Basil Blackwell and Mott, 1953, 1958), 73.

4. Walter Hopps, "An Interview with Jasper Johns," *Artforum* 3, no. 6 (March 1965): 34.

5. See n. 13 below.

6. Roberta Bernstein, "An Interview with Jasper Johns," in *Fragments: Incompletion and Discontinuity*, ed. Lawrence D. Kritzman (New York: New York Literary Forum, 1981), 287. In a recent conversation with the author, Johns confirmed that this was the first exhibition of Magritte's work he had seen, although he may have seen his work earlier in reproductions.

7. Robert Rosenblum, "Magritte's Surrealist Grammar," *Art Digest* 28, no. 12 (March 1954): 32. Rosenblum would later write reviews and essays on Johns's art.

8. Johns presently owns seven works by Magritte: one painting, *The Interpretation of Dreams* (1935) [unfortunately not available for this exhibition due to a prior loan commitment—ed.], and six works on paper in various media that he either purchased or received as gifts. In addition he owns an original Magritte letter. The first Magritte he acquired was a small sketch received as a gift around 1960. Rauschenberg presently owns six Magrittes: two paintings—*The Literal Meaning* (1929) and one of the five canvases (depicting a pair of breasts) of *The Eternally Obvious* (1954)—and four works on paper. This information was acquired by the author from the inventories of the artists' collections.

9. In 1959–60, Gablik spent eight months living with the Magrittes researching her monograph, which was published in 1970.

10. I discuss Johns's relation to his artistic predecessors, including Magritte, in "'Seeing a Thing Can Sometimes Trigger the Mind to See Another Thing'" in Kirk Varnedoe, *Jasper Johns: A Retrospective*, exh. cat. (New York: Museum of Modern Art, 1996).

11. Jasper Johns, "Duchamp," *Scrap*, no. 1 (December 23, 1960), 4. Johns's relationship with Duchamp has most recently been examined in the exhibition and catalogue by Dorothy Kosinski, *Dialogues: Duchamp Cornell Johns Rauschenberg*, exh. cat. (Dallas: Dallas Museum of Art and New Haven and London: Yale University Press, 2005).

12. The 1959 Magritte exhibitions in New York were at Iolas's Hugo Gallery and the Bodley Gallery. There was also an exhibition at the Hugo Gallery in 1957.

13. Information about these acquisitions is from a recent conversation the author had with Johns. Johns's *Page of Sketches* (1953) was acquired in a trade with Gablik in 1965. Johns gave Gablik a small *Flag* painting in exchange for the Magritte sketches.

14. Leo Steinberg, "Jasper Johns: The First Seven Years of his Art," in *Other Criteria: Confrontations with Twentieth-Century Art* (New York: Oxford University Press, 1972), 42. Originally published in *Metro*, nos. 4/4 (May 1962) and in Steinberg, *Jasper Johns* (New York: George Wittenborn, 1963).

15. Suzi Gablik, *Magritte* (Greenwich: New York Graphic Society, Ltd. and London: Thames & Hudson, 1970), 96.

16. Ibid., 106.

17. Sylvester, *Silence of the World*, 72.

18. For a perceptive discussion of this aspect of Magritte's work, see Frederik Leen, "A Razor Is a Razor: Word and Image in Some Paintings by René Magritte," in *Magritte 1898–1967*, exh. cat. (Ghent: Ludion, 1998). Magritte's surrealist approach to the arbitrary relationship between objects, words, and images echoes Peirce's analysis of icon, index, and symbol, Saussure's study of signs, signifiers, and signified, and Wittgenstein's linguistic propositions. Each examined the relationship of language and reality in preceding decades, and in the case of Wittgenstein, overlapped chronologically with Magritte's word paintings. According to Leen ("A Razor Is a Razor," 34), Magritte's word paintings "gave expression within the world of art to the fundamental changes that were occurring in the ideas about the way our knowledge and understanding of reality are formed." Wittgenstein has been evoked in connection with Johns in nearly every major study of his art. Fred Orton in *Figuring Jasper Johns* (Cambridge: Harvard University Press, 1994) examines Johns's work in light of the structural linguistics of Roman Jakobson. Magritte's work is studied from this perspective by Randa Dubnick in "Visible Poetry: Metaphor and Metonymy in the Paintings of René Magritte," *Contemporary Literature* 21, no. 3, Art and Literature (Summer 1980): 407–419.

19. Wittgenstein, *Philosophical Investigations*, 19.

20. Gablik, *Magritte*, 96.

21. See Roberta Bernstein, *Jasper Johns' Paintings and Sculptures 1954–1974: "The Changing Focus of the Eye"* (Ann Arbor: UMI Research Press, 1985), 92.

22. See the translation of this essay in Gablik, *Magritte*, 138–39.

23. Johns told me that the first work of Magritte's he wanted to purchase was *The Month of the Grape Harvest* (1959), a painting that shows a crowd of bowler-hatted men looking into an empty room from outside a window. This was in 1961, when Johns had an exhibition at the Galerie Rive Droite in Paris, the same gallery where Magritte had shown recent works in 1959. Johns decided the painting was too expensive for him to purchase at the time, but his interest in this work is revealing of the appeal of the anonymous-looking repeated figures in Magritte's works. An undated sketch Johns owns shows a bowler-hatted man seen from behind—the same motif as *The Intimate Friend* (1960).

24. Johns's first *Targets* were associated with surrealism because of the illogical and unsettling juxtaposing of the target design with body fragments. *Target with Plaster Casts* (1955), with diverse body parts set in boxes and painted in an array of colors, was selected by Duchamp for inclusion in the final *International Exhibition of Surrealism*, which opened in Paris in 1959.

25. The parts were actually cast from four different figures, male and female.

26. For other Magritte erotic nudes, see *The Titanic Days* (1928), *Attempting the Impossible* (1928), and *The Rape* (1934). Robin Adele Greeley, in "Image, Text and the Female Body: Rene Magritte and the Surrealist Publications," *Oxford Art Journal* 15, no. 2 (1992): 48–57, discusses the problematic of Magritte's images of female nudes.

27. *The Literal Meaning* was reproduced in Gablik's 1970 monograph. Rauschenberg owned the painting by 1964; it can be seen hanging on his studio wall in a photograph taken that year by Dan Budnick. Johns remembered Rauschenberg's acquiring it when they were in Paris in 1961 when Johns had an exhibition at the Galerie Rive Droite. However, it is listed as still belonging to E. L. T. Mesens in a 1962 exhibition.

28. The drawing is titled *The Baby Drinking the Mother's Milk from the Breast* in Bruno Bettelheim, "Schizophrenic Art: A Case Study," *Scientific American*, April 1952, 31–34.

Magritte, *Perspective: Manet's Balcony*, 1950

René Magritte and Richard Artschwager: Personal Values

RICHARD ARMSTRONG

By the time of Richard Artschwager's birth in 1923, René Magritte was well into his first years as a young painter. His evolving style was indebted to Fernand Léger, Robert Delaunay, and the theories of purism—Le Corbusier and Amédée Ozenfant's flattened, geometricized, anatomical vision of the machine age. It was also the year that Magritte first saw a reproduction of Giorgio de Chirico's painting *The Song of Love* (1914)—an arresting amalgam of a carved classical head, a sphere, and a large glove situated inside an archetonic landscape. The painting catalyzed Magritte's artistic development and de Chirico's work remained a touchstone throughout his long career.

After spending his boyhood in Washington, DC, where his émigré father worked as a research scientist (his mother a trained amateur painter), Artschwager moved with his family to southern New Mexico seeking a milder climate for the tubercular elder Artschwager. There, the German-speaking household added Spanish to its linguistic repertoire, and young Richard adapted quickly to both the landscape and the culture of the American Southwest. He demonstrated an aptitude for drawing, but entered Cornell University (his father's alma mater) in 1941 intending to follow his father's path as a scientist. Magritte, by contrast, seems to have had less in common with his parents—his father a commercial tailor and businessman, his mother a milliner and housewife whose suicide in 1912 greatly changed the family dynamic. The young Belgian's aptitude for drawing led him to the Academy in Brussels, ending his provincial isolation in the bleak regions around Charleroi, and he connected with the capital's emerging avant-garde.

Cornell ended Artschwager's isolation and World War II further changed his circumstances, obliging him to ship out to England, France, Germany, and (by war's end) Vienna, where he served in the counterintelligence corps. After marrying, he returned to Ithaca, graduating in 1948 with a degree in physical science and with profound doubts about his suitability to be a scientist. With his wife's prodding, he decided in favor of becoming an artist, and they moved to New York. There, he studied for a year with Ozenfant, an early instance of Magrittean serendipity. It proved characteristic of Artschwager that he chose Ozenfant's instruction over that of the widely popular Hans Hofmann, whose downtown school was attracting so many veterans. Artschwager's attraction to the rationalism of Ozenfant, in contrast to the expressionist fury of Hofmann, is akin to Magritte's lifelong aversion to aesthetic flamboyance of any kind—both the Belgian and the American artist being among the most reticent artists of the twentieth century. Though somewhat more histrionic in tone than Artschwager would allow himself, Magritte wrote (in response to postwar art) a comment that is revelatory of both artists' disdain

Edouard Manet, *The Balcony*, 1868–69, oil on canvas, 169 × 125 cm, Musée d'Orsay, Paris

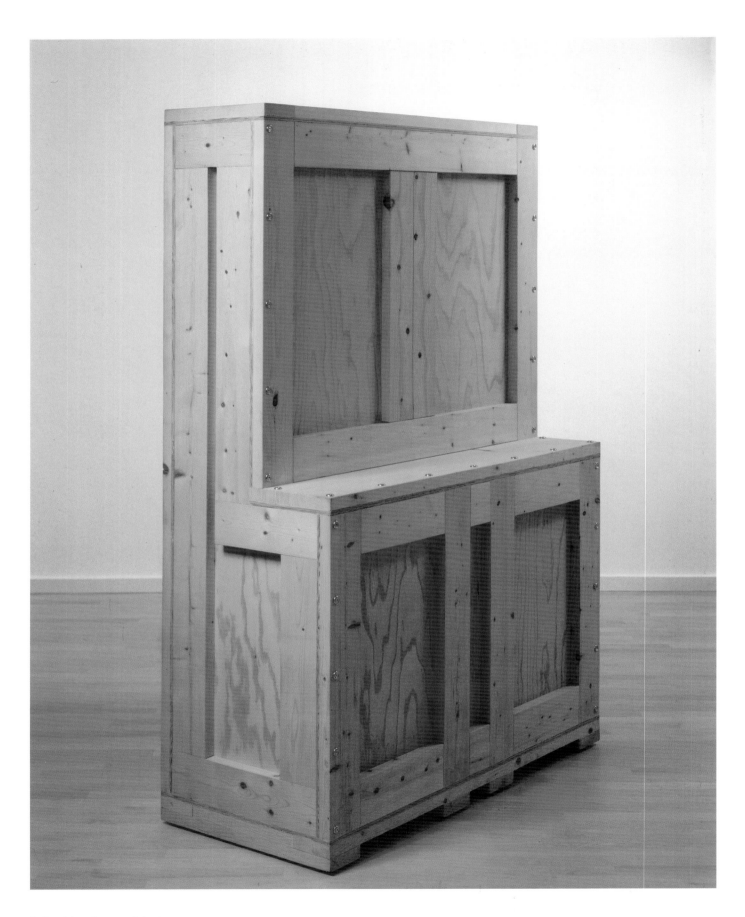

Richard Artschwager, *RA-26*, 1995

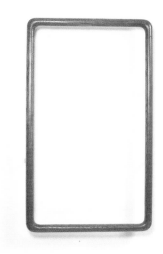

Richard Artschwager, *Handle*, 1962

Magritte, *The Delights of Landscape*, 1928, oil on canvas, 54 × 73 cm, Foundation for Investment in Modern and Contemporary Art

for excess: "An ever-prevalent stupidity manifests itself of late in the supposition that painting is now being replaced by a so-called art which is said to be 'abstract,' 'non-figurative,' or 'informal'; it consists of manipulating 'materials' on a surface with some degree of fantasy and conviction. But the function of painting is to make poetry visible, and not to reduce the world to its numerous materialistic aspects."[1] In a 1975 lecture, Artschwager argued that art is "thought experiencing itself," a somewhat more Teutonic analysis.[2]

Artschwager's first ten years in New York were strangely dysynchronous with its glory days as a hotbed of innovation. Predictably, abstract expressionism held limited appeal for him, and the financial constraints of supporting a family required a steady paycheck. First as a baby photographer, then as a lathe operator, then as a bank clerk, Artschwager's alienation from the art world grew. He wrote gloomily, "Studying the New York School (outside) and the School of Paris (inside) made some deep impressions, the telling one being an increasing conviction that nothing much could be added to these estimable bodies of art."[3] By 1953 he had begun to make furniture commercially; conceived in a modern style and well executed, this work found admirers, and three wood pieces were included in a 1957 show at the Museum of Contemporary Crafts in New York.

Artschwager's literal reversion to the object is congruent with the surrealist's obsession with the object as liberator of the psyche. André Breton early on defined surrealism's central ambition as the rehabilitation of the object, a rehabilitation that would allow inherent qualities to supersede utility. The subsequent surrealist landscape is littered with such objects, from de Chirico's glove to Roberto Matta's machines. Artschwager's early sculpture *Handle* (1962) sparely demonstrates such rehabilitative qualities: perfectly formed to receive our grasp, the three-dimensional tautology of the wall-mounted work gives form to the artist's assertion that sculpture is "felt space." *Handle* is ultimately nonfunctional, unless we are satisfied with its willingness to orient us to the blank wall behind. But this familiar rectangular shape further alludes to an important shared motif in Magritte's and Artschwager's work: the picture frame. Whereas Magritte's painstaking realism means he most often

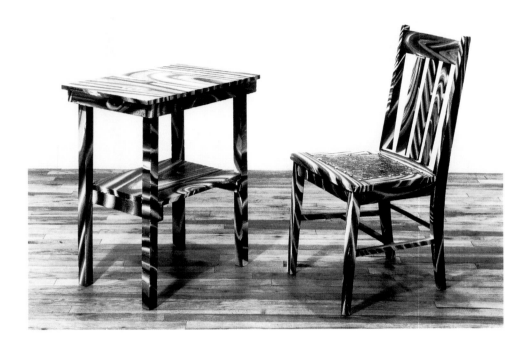

Richard Artschwager, *Table and Chair*, 1962–63, acrylic on wood, variable dimensions, Collection Paula Cooper

depicts the frame (and its related prosthetic device, the easel) as an encasement and delineator of meaning, Artschwager often chooses to fuse the frame with the mirror (another shared motif), surrounding paintings in a border that reflects ambient light as well as the peering, frequently puzzled viewers' faces.

In the hands of both artists the viewer participates in construing and assigning meaning, but the changes of the forty or so years that separate their production are telling. For all their rebus-like mystery, Magritte's paintings conform to conventions of scale and touch common to realist easel-sized paintings for centuries. Artschwager's pictures are less well-mannered: his concern for oblique significance, as well as the enormous shift in scale and imagery fostered by his peer pop artists, distinguishes Artschwager's work from Magritte's. To some extent this difference is underscored by Magritte's lifelong allegiance to surrealism, while Artschwager's preoccupations are nondogmatic and more empirically based. Artschwager's exploration of space, as both pictorial illusion and sculptural reality, lies at the heart of his *oeuvre*—itself comprised of both sculpture and painting. His concerted attempts at transmuting illusion to sculpture and tactility to painting are not unlike what Magritte sought in his late sculpture and in many of his *trompe l'oeil* pictures, particularly those of the 1950s. Again, the divide between the two artists is more than chronological; it is the radical incorporation of reality—through collage and commercial technique in the early works of Rauschenberg and Johns, followed by pop art—that cleaves them.

It is interesting to note that despite crucial friendships—Magritte with Breton and Dalí, Artschwager with Oldenburg—both artists had a contentious history with the dominant aesthetic of his early days: Magritte with surrealism, Artschwager with pop art. The latter's work proved ultimately uncongenial to pop's increasing extroversion, taste for high color, and uncritical fascination with the tone and

devices of postwar consumerism. Because Artschwager's work remains resolutely nonnarrative, it does not speak the era's lingua franca—one that seems deliriously overwhelmed by the material plentitude of the times. Now multiplied and quickly extended across a wider spectrum of the populace in a dramatically greater part of the world, such post-pop reactions to and digestions of plentitude via the media continue to animate much contemporary art.

Despite his warm reception by Johns, Rauschenberg, and other pop artists, Magritte maintained a calculated distance from this Anglo-American movement. In a 1964 interview, he stated his reservations about it:

> If we ignore the appearance nearly fifty years ago of dadaism, then pop art seems like a novelty. The humour of dadaism was violent and scandalous. The dadaists decorated the Mona Lisa, for example, with a moustache, or they exhibited a urinal as a work of art. The humour of pop art is rather "orthodox." It is within the reach of any successful window decorator: to paint large American flags with a star more or less does not require any particular freedom of mind and does not present any technical difficulty. . . . Are we permitted to expect from pop art anything more than a sugar-coated dadaism? Undoubtedly, anything is always possible. Provided we forget dadaism, and, since they claim a kinship with me, that we forget about me as well, the pop art people will one day show us, perhaps, unexpected images of the unknown, and thus they will satisfy our desire for efficacious poetry.[4]

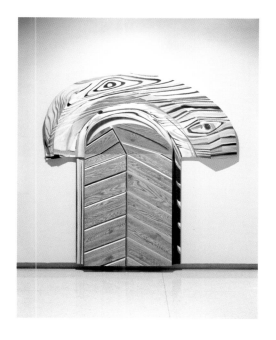

Richard Artschwager, *Low Overhead*, 1985, laminated plastic and latex paint on plywood, 243.8 × 236.2 × 236.2 cm, Walker Art Center, T. B. Walker Acquisition Fund, 1985

Like Magritte, Artschwager's paintings and his sculpture exhibit little interest in replicating the images and juxtapositions of found commercial imagery—one of the principal pursuits of pop—favoring instead invention and transformation toward lyrical ends. From his earliest furniture surrogates, Artschwager employed an exaggerated black-and-white painting technique that magnified and mocked fine wood grain, for example, *Table and Chair* (1962–63). The crudely swirling grain effectively renders these common objects (Artschwager's only use of the truly "found") thoroughly dysfunctional, so contravened by paint that their use becomes visual and catalytic rather than utilitarian. This painted caricature of wood grain reappears at intervals in Artschwager's work, perhaps most monumentally in the early 1980s in such pieces as *Low Overhead* (1985). His notes from this time even include citations of "Magritte oak" as his conceptual shorthand for this technique.

Artschwager's two favored surfaces, Celotex and Formica, suggest a further kinship with Magritte's sensibilities. As a compressed, patterned by-product of the refining of sugarcane, Celotex offers Artschwager a cheap and toothy surface that receives paint and charcoal with ease, and perhaps even suggests a material homage to his botanist father. Artschwager has employed this lowly building supply material for more than forty years for a wide range of imagery. His proto-photorealist technique is equally singular. Dissatisfied with the landscape imagery of his 1950s paintings, in the early 1960s Artschwager devised a grid system of transferring imagery to Celotex, a practice now more commonly associated with the work of Chuck Close. Using salvaged photos, and later newspaper and magazine clippings, he sought a dispassionate re-creation of reality—but always in grisaille. Even with the taste for veracity that Artschwager so deeply shares with Magritte, the younger artist avoids descriptive color in his paintings. His black, white, and gray

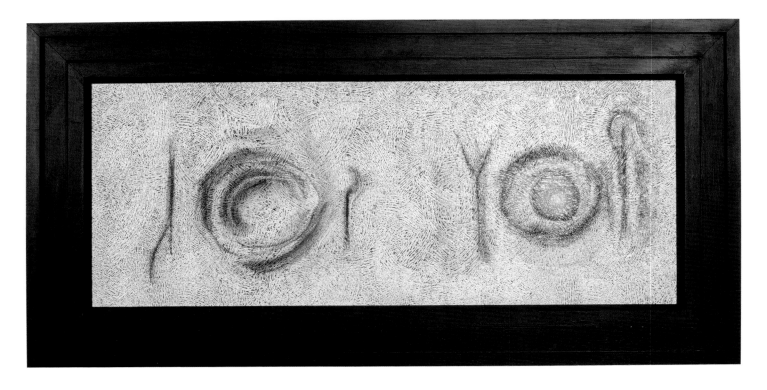

Richard Artschwager, *Dinner (Two)*, 1986

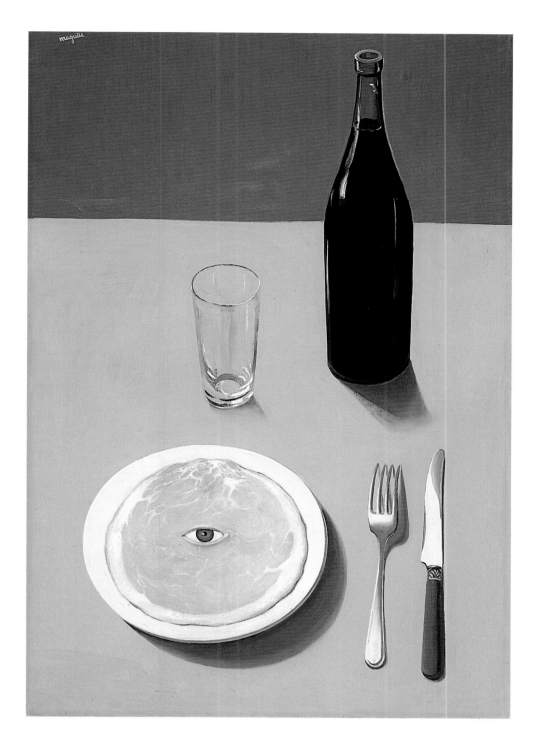

Magritte, *The Portrait*, 1935

universe operates as a ghostly parallel to what we see and, as a device for psychic liberation, can be seen as surrealist. Both artists' prodigious output of drawing offers another congruency, their strokes occasionally resembling one another in their staccato character. Magritte's evocative representations of hair—nature's drawn line—and pubic hair in particular, puts us in the mind of Artschwager's third favorite medium, rubberized hair. A dense and matted tangle of coated curlicues (one envies the Walloon slang for pubic hair, "canakrol"—coincidentally the nickname of Magritte's stepmother-in-law), the mildly repulsive material is cited by Artschwager as especially attractive for its "perfect imprecision." Not only useful as kin to the scratchy surface of Celotex, the rubberized hair artworks seem to be three-dimensional incorporations of Artschwager's drawings. For a long period through the 1960s and 1970s, their imagery was exclusively composed of door, table, basket, mirror, and rug—an echo, perhaps, of Magritte's door, window, table, basket, mirror, and bowler hat? In any case, the two artists share a taste for a relatively narrow class of images, sometimes permutating them, sometimes altering scale and perspective.

Depersonalized "portraits" resembling nothing so much as early black-and-white television images coexist in Artschwager's early years with simple illusionist exercises such as parallel or intersecting lines, for example *Bushes II* (1970), and oddly shaped concave depressions. Because they seem carved we are sometimes put in the mind of Magritte's frequent iterations of stone. The crucial point here is both artists' ease in exploiting illusion—the great and banished bane of modernist art in its quest toward abstraction. As one astute critic has noted, Magritte reverses responsibilities in his assertion (which might as easily be ascribed to Artschwager), "What matters is not that the copy should be similar to the model, but that the model should have the courage to resemble the copy."[5]

Artschwager's dependence on Formica—a laminate utilizing a photographically colored surface—seems distant from Magritte, but the Belgian's smoothly applied oil paint, done almost as if he wished to extract all sensation of application from the painting, frequently exudes a manufactured air not unlike that of the American's work. Artschwager recalls his attraction to Formica:

> Formica, the great ugly material, the horror of the age, which I came to like suddenly because I was sick of looking at all this beautiful wood. . . . So I got hold of a scrap of Formica—something called bleached walnut. It worked differently because it looked as if wood had passed through it, as if the thing only half existed. It was all in black and white. There was no color at all, and it was very hard and shiny, so that it was a picture of a piece of wood. If you take that and make something out of it, then you have an object. But it's a picture of something at the same time it's an object.[6]

Mirror/Mirror–Table/Table (1964) incarnates this duplicity. We see a pair of seemingly functional objects, clinically cited by name, occupying valuable wall and floor space. Cheery yellow and pink Formica synchronizes two kinds of space: the mimetic infinity of the mirror and the quantifiable, cubic bulk under the table. Brown Formica serves as frames as well as for the tables themselves. Such combinations of light and dark Formica are typical of Artschwager's desire to represent and enrich notions of light, its origins and reflections—typically a painterly pursuit (as with

Richard Artschwager, *Bushes II*, 1970

Richard Artschwager, *Mirror/Mirror–Table/Table*, 1964

Magritte) here manifested in three dimensions. While the endless metaphorical power of space is relentlessly empiricized in Artschwager's work (reaffirmed in his comment that "space is an abstraction that grows naturally out of our looking at, looking into, looking through, walking, opening, closing, sitting, thinking about sitting, passing by, etc."),[7] Magritte's renditions of space are at the service of his quest for the poetic *frisson*. In composing, Magritte seems to favor three variations of space: long views characterized by skies of various luminosities; close-ups which constrict, exaggerate, and detach subjects; and the more planar compositions that operate almost as an undisguised surface for the word-and-image pictures. Available oxygen diminishes from the first to the third of these varieties of invented context: from full-blown exhilaration, to choking compression, to logical mystification.

Magritte's most famous such an assertion, "Ceci n'est pas une pipe," is both literally true and intellectually puzzling. What else are we to call this tobacco-burning device, and how else could this "ceci" look? Comparably illogical queries surround *Mirror/Mirror–Table/Table* and its many furniture-derived siblings and progeny. Mirrors that do not reflect and tables that do not hold anything are symbols, paraphrases, miniature monuments to middle-class domesticity. In their willingness, even eagerness, to play with the hands dealt them, Magritte and Artschwager retain their status as contented skeptics. And like most outwardly bourgeois, we can say that in their worlds, everything is in its place—or rather that everything is irrefutably situated, made credible, and rendered somewhat familiar. Their joy and ours is in discovering what, if any of it, is true.

Notes

1. Suzi Gablik, *Magritte* (New York: Thames & Hudson, 1992), 145.
2. Richard Armstrong, *Richard Artschwager*, exh. cat. (New York: Whitney Museum of Art, 1988), 13.
3. Ibid., 15.
4. Gablik, *Magritte*, 73.
5. Marcel Paquet, *René Magritte, 1898–1967: Thoughts Rendered Visible*, trans. Michael Claridge (Cologne: Taschen, 2000), 89.
6. *Richard Artschwager* (New York 1988), 17.
7. Ibid., 25.

Alexander Iolas, Ed Ruscha, Magritte, Georgette Magritte, and Paniotas Skinnas at the Hotel Cipriani, Venice, Italy, June 1967

An Interview with Ed Ruscha

LYNN ZELEVANSKY

Numerous commentators have drawn comparisons between René Magritte and Ed Ruscha. According to David Bourdon, writing in 1971, "Ruscha's work combines the obvious and forthright literalism of pop with the wry and incongruous juxtapositions of surrealism. He appears to be a sort of cowboy Magritte gone Hollywood."[1] Ruscha has expressed some frustration with this comparison; he considers that the relationship between his work and Magritte's has not been a direct one. A few years after Bourdon's comment, Ruscha reflected on such comparisons by saying, "Yes, Magritte did influence me but it came the other way around, what I call 360-degree influence. That's influence from a person's thoughts and force and not from his pictures, which the person being influenced does not see until later on."[2]

Later, Bernard Blistène asked, "Do you think that sometimes your work refers to a certain kind of surrealism, I mean for example Magritte or Dalí?" To which Ruscha responded, "Not really. I saw Magritte and Dalí after they were forbidden. I saw them as art history. Artists always want to do things that are forbidden."[3] A few years later, Ruscha stated, "I like Magritte's work but it didn't have much influence on me."[4]

Lynn Zelevansky: It seems that you felt like your early comment had sort of pigeonholed you in a way you didn't want, because you never said Magritte was a source for you. You said that you were sympathetic to certain aspects of his work.

Ed Ruscha: Well, that's a good word, "source," because he wasn't a source for me. You know, I've painted pictures with light blue skies, and people would say, "Oh, that must have come from Magritte or it could have been influenced by Magritte," and I find that hard to believe myself; it's just too pat. I was more influenced by Duchamp and Kurt Schwitters and Max Ernst, but I recognized Magritte as a powerful figure. I first saw his work in a book on surrealism in the Oklahoma City library. I just sort of stumbled across it. I guess I didn't respond to his work as much as I did to the other artists. Only later on did I see something simpatico there, something that I might have shared with him. And you know, I don't feel like he's an outsider at all.

LZ: No?

ER: I think he was definitely part of the surrealist movement. They even photographed him, and documented him. He was never sidelined, but he lived out of the sphere of surrealism because he didn't live in Paris. And he had a habit of not appearing to be a bohemian character in the sense that he would dress up in a suit and tie and paint his pictures in his home. He looked more like a banker than an artist. Of course we all appreciate that, too.

LZ: You mean that kind of contradictory stance also has its appeal?

ER: Yes. Duchamp did the same thing. He dressed that way. I subsequently met Magritte shortly before he died.[5] It was in Venice, Italy. I spotted him in a gondola—he was with his dog LouLou and his wife Georgette and his dealer, who also happened to be my dealer at the time, Alexander Iolas. We waved and met up and had lunch together. We went to the Piazza San Marco and Magritte had his camera with him. He'd never been to Venice before.

LZ: Really?

ER: Never been to Venice. He was a little-traveled person. I asked him if he had ever been to the U.S. and he said, "Yes, Houston."

LZ: (Laughs)

ER: It's the only place in the states he had ever been besides New York.

LZ: Did he speak English?

ER: A little bit, yes. We went to the Cipriani to have lunch and they said, "I'm sorry, you can't bring dogs in here." And he said, "Well, then that's it. Wherever I go, LouLou goes." And then there was a little bit of chatter, and they ended up finding us a nice table outside in the garden. So we had lunch in the garden with LouLou and Georgette and Iolas and another man who worked for Iolas and my wife and me. In the Piazza San Marco he was photographing artists who were painting pictures of the Basilica. So he was actually photographing scenes that he had painted before—you know, a canvas on an easel with somebody in front of the painting and the scene continues behind the easel.[6] Talk about irony—there it was.

LZ: I wonder what happened to those photographs.

ER: I don't know, but I bet you they're in his archives, and I bet you could find them. His wife would have saved them because he had never been to Venice before and he was only there one time, so they would have been significant.

LZ: Were you all there for the Biennale?

ER: I don't think we were, but I forget what exactly the trip was for. I've been to Venice a few times outside of the Biennale and I think that was one of those times.

LZ: What was Magritte like?

ER: His demeanor was that of a total gentleman, a kindly man, and that was really impressive to me, knowing this man's work. I hadn't done an intensive study of it, but so many of his images by that time were known to the world, although actually he didn't become really popular until after he died. His work was well known and well collected before he died, but I think the main thrust of his exposure came afterwards. That's my opinion.

LZ: To me he had seemed not so much out of the mainstream as a surrealist, but until I saw the retrospective at the Met some time ago, I had the impression he was peripheral to the development of younger artists.[7] Clearly that was wrong, and it's interesting that you feel that it was after he died that he really came to the fore.

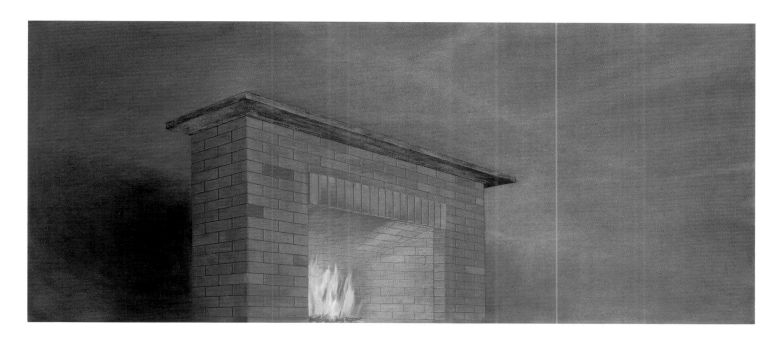

Ed Ruscha, *No End to the Things Made Out of Human Talk*, 1977

ER: Yeah. It's not just his images that we see reproduced here and there. It's not just that that makes him such a curious person. But the kind of life he lived, a sort of prosaic, so-called ordinary style of life. That combined with his pictures made him highly interesting.

LZ: There were a couple of things that struck me. One was that you had been a sign painter and I wonder whether there was any affinity with Magritte because so many of his paintings reference signage.

ER: No. Actually, his imagery involving writing never grabbed me. It was always secondary to his pictorial things, like *The Listening Room* or some of the pictures with paintings on easels with the scenes that are being painted in the background,[8] or the locomotive coming out of the chimney.[9] I was interested in the cryptic nature of his titles and how he got them. I'm still not sure how he did that. I wish Walter Hopps were sitting here with us now.

LZ: He would know the answer to that.

ER: Yes, he would. I've heard that Magritte had his friends make titles for him. That could be true or false but I took it as being the truth because I love the idea that he would release himself from the titles, even though his titles were very important. The titling of his work, I would say, had more effect on me than the pictorial aspects of his work.

LZ: Well, that's very interesting. And the pictorial aspects had more effect than the written aspects.

ER: I think so, yeah. I always doubted the importance of that work that says, "This is not a pipe." Other people will say that it's a turning point in art history. They point to it as being a particularly strong, profound statement, and I have doubts about that. His inscriptions on his paintings, whenever they become dominant, don't

really have much of an effect on me. I was more affected by abstract artists and people like—well, it's hard to believe—but Giorgio Morandi.

LZ: Really? Why Morandi?

ER: Well, maybe it's the isolated elements, and the plaintiveness and the loneliness of objects inside of a picture. Those things probably had more effect on me than Magritte's work.

LZ: That's fascinating because it's entirely unexpected and yet it makes perfect sense.

ER: You know the happy-go-lucky art world, they want to encapsulate what they think the world is all about so they throw these artists together, and they might put Magritte in there with a pop artist because they sometimes use related imagery and they use irony. So you get a kind of simplistic sifting of thoughts and realities into what they think art is all about. I see Magritte as more in line with surrealists like Salvador Dalí and André Breton. I think he's a very important artist but he didn't have the influence on me that someone like Jasper Johns or Rauschenberg did.

LZ: Maybe whatever is in your work of Magritte was sort of filtered through Johns.

ER: Could be, because I'm sure that Jasper looked at his paintings and saw some alternative way of thinking that was strong.

LZ: From what you've said, it sounds like certain artists have an impact on you as much for their attitude, for who they are, as for their work. You know, the notion of Morandi painting the same bottle over and over and over again; there's something almost noble about that.

ER: Yeah, there is. You know, the description you're laying out there is one that people in the world of art can attack. They can say, "Well, he just keeps doing the same thing over and over again." I've seen artists where that's troubling, but not Morandi. Morandi managed to paint the same bottles and cans all his life and still bring a different kind of vitality to his work. That I think is true greatness.

LZ: There's a difference between repeating yourself because you have nothing to say and working on a problem with such intensity.

ER: Now Magritte, I don't believe you can ever accuse him of repeating himself, although he made certain images over and over again. If you look at his work strictly from that angle, it is constantly renewed throughout his life, so he certainly shouldn't face that accusation.

LZ: You talk in various interviews about the notion of incongruity. At one point very early on, I think it's with Willoughby Sharp, you call it the "huh?" quality in art.[10] It's the idea that art has to be something that makes you scratch your head. Certainly Magritte has that quality.

ER: I think maybe that's one of the key protean things that the surrealists did. Not that you always have to put Magritte in that category. He's very independent but his thinking was aligned with those people who, back in the twenties and thirties, highlighted the randomness of things, like Jean Arp taking little shapes, throwing them up in the air, letting them fall down, and the way they fell, that's the way they

Ed Ruscha, *Give Him Anything and He'll Sign It*, 1965

Magritte, *The Liberator*, 1947

stayed. It's like you walk out the door, you're thinking about making a work of art and somehow the door hits you in the head and you say, "The edge of that door must go in my painting." It's like an act of blind faith. Maybe Magritte worked this way, maybe he didn't. But I think that the random nature of things is somehow involved in his work. Random in this case equals incongruity.

LZ: Yes, because it's coming from some unpredictable place.

ER: It's like several subjects within a given picture that don't ordinarily or necessarily need to be together, so they leave in doubt their existence.

LZ: Do you remember when you first saw Magritte's work?

ER: I think it was maybe like 1955, 1956.

LZ: This was Oklahoma City?

ER. Yeah, in Oklahoma City, the early book on surrealism that I stumbled across in the art section of the library. Not too many people knew about that, especially in Oklahoma in 1955. There were some reproductions inside the book, not many—it was mostly writing rather than pictures. Magritte had one of the images and Duchamp was there, and Max Ernst, and Dalí, and Tanguy—they were all in this book. I think maybe that's the first time I saw Magritte's work. I didn't see an original painting until maybe the late sixties.

LZ: I was going to ask what you could see in Los Angeles when you got here. What was available to you?

ER: There may have been examples of his paintings or drawings at the L.A. County Museum of Art.

LZ: Well, certainly not *The Treachery of Images*. That came into the collection in 1978. And then there's another painting by Magritte in the collection, a later one called *The Liberator*.

ER: But there may have been exhibits here. I don't think the Ferus Gallery ever had Magritte's work, but I know I had seen pictures of his through my dealer, Alexander Iolas. He had paintings of his in New York and Paris galleries because he was Magritte's dealer. In museums I really didn't see too many until maybe the late sixties, early seventies.

LZ: You probably could have seen stuff at MoMA in New York fairly early.

ER: I didn't get to New York until 1961, but I must have seen Magritte paintings there. Undoubtedly.

LZ: And why do you think Duchamp had such a strong impact?

ER: You know, it was simply the impact of all his work, and my continuing to see newer things in him; it just hammered home this idea that he was a great artist and that he possessed some kind of direct line of communication with me, especially. And then there were the stories that followed him, like the idea that he gave up painting. At a time in your life when you can't ever give up, he just very unceremoniously "gave up painting" or art making. It may not have been true throughout his life because he made art later on but it was a brave sort of statement. And I remember

all my friends, Joe Goode, Jerry McMillan, were very amused that this astute artist would do such a thing.

LZ: You must have been here for his retrospective in Pasadena?[11]

ER: Oh yeah. I went to the opening and I met Duchamp. That was a terrific exhibit organized by Walter Hopps. It was a tour de force to assemble all those works. It might have been his first one-man museum exhibit anywhere.

LZ: It was his first U.S. retrospective, for sure.

ER: He had been in the Armory Show of course, and he had been in maybe some group shows in commercial galleries in Europe but I think it was his first one-man show in a museum.

LZ: It's remarkable when you think about it. I was just wondering whether seeing him and not seeing Magritte would have made a difference in how much each one influenced you. Of course, there's been lots of stuff written about artists learning about art from reproductions. That happens as well.

Ed Ruscha, *The End No. 13*, 1993

ER: It sure happens for me. I didn't have to see an original work to be inspired by something. It was later on that I began to appreciate standing in front of an original work. I mean it wasn't a religious experience for me or anything—the imagery was equally as effective in a reproduction—but then finally I would say, "Yeah, I'd rather see the original."

LZ: What about the notion of an implied narrative? You've talked sometimes about looking for a way to tell a story in a different medium. That's what brought you to the books and the photographs. Is the notion of an implied narrative important for you, and is Magritte relevant at all for you in that way?

ER: I don't know. I don't always look for what you're calling a narrative or a story line but even if you do present something like that in a picture, it can be a little fragment. It can be a quick little, little thing. It doesn't have to have a beginning, middle, and end. It can be plotless.

Ed Ruscha, *Lion in Oil*, 2002

LZ: Right.

ER: So pictures are different in that respect. You know, when you study Magritte's works—let's say—you see all kinds of possibilities. It can fire off in many different directions, but he always manages to have a point of view. And the point of view is sometimes just a frozen statement, even if it's a rock in the shape of a chair, or something like that. So narrative is almost unimportant.

LZ: Is there anything that I haven't asked you about Magritte that you think is significant?

ER: You know his painting *Time Transfixed*—the one with the train coming out of the fireplace.

LZ: Yeah, that's an amazing picture.

ER: I have always held that to be maybe my favorite image of his.

LZ: Do you know why?

Ed Ruscha, *Man, Wife*, 1987

Magritte, *The Seducer*, 1950

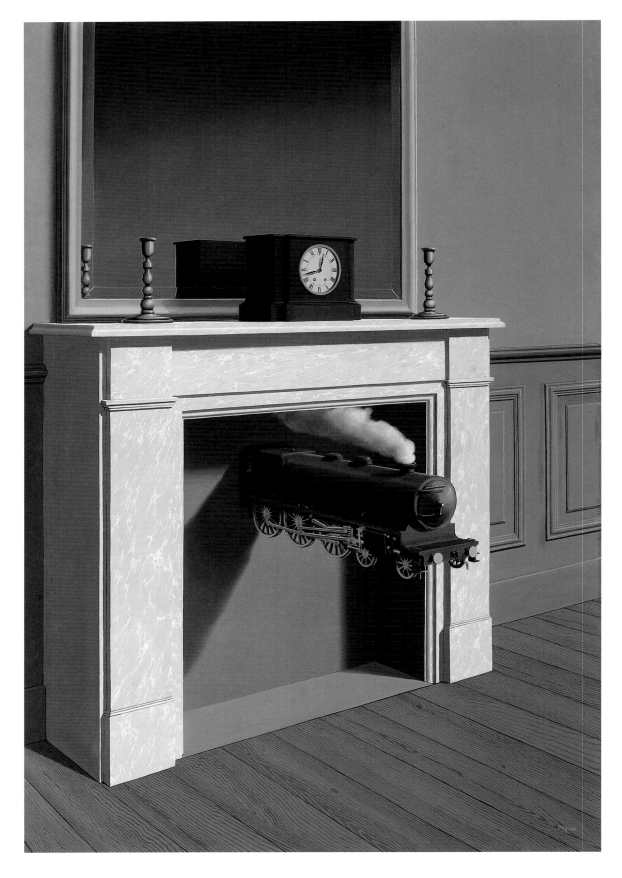

Magritte, *Time Transfixed*, 1938

ER: No, I don't, except that there is the unlikeliness of it. In our daily lives we don't see trains coming out of fireplaces. So that's a number one good thing for that picture. There's an unreality, or a misreality there. And then there's the reality of the exhaust that the train is pushing out. The smoke that comes out of the engine is going back up the fireplace, and that brings you to some sort of rigorous truth. I mean, isn't smoke supposed to go up fireplaces?

LZ: Yes, it is.

ER: The struggle between the unreality and the reality of the painting is the right kind of struggle to make a great picture, and I think maybe that's why it could be my favorite.

LZ: I think it's often interpreted in Freudian sexual terms.

ER: I hope it is. It better be. It is sexual. It is all those things. And there is the titling of the work, which leaves you somewhat baffled. *Time Transfixed*.

LZ: Your interest in Magritte's titles is fascinating, actually.

ER: It almost doesn't matter how he comes about his titles. But I like the idea, mistaken or not, that they could be created by friends of his in almost a random fashion.

Notes

This interview with Ed Ruscha took place at his studio in Venice, California, on November 21, 2005.

1. David Bourdon, "A Heap of Words About Ed Ruscha," *Art International*, November 20, 1971, 25.
2. Howardena Pindell, "Words with Ruscha," in Ed Ruscha, *Leave Any Information at the Signal: Writings, Interviews, Bits, Pages*, ed. Alexandra Schwartz (Cambridge: The MIT Press, 2002), 58. Originally published in *Print Collectors' Newsletter*, January–February, 1973, 125–28.
3. Bernard Blistène, "Conversation with Ed Ruscha," in Ruscha, *Leave Any Information at the Signal*, 304. Originally published in *Edward Ruscha: Paintings/Schilderijen*, exh. cat. (Rotterdam: Museum Boijmans Van Beuningen and Los Angeles: Museum of Contemporary Art, 1990), 126–40.
4. Walter Hopps, "A Conversation Between Walter Hopps and Edward Ruscha, Who Have Known Each Other Since the Early 1960s, Took Place on September 26, 1992" in Ruscha, *Leave Any Information at the Signal*, 324.

5. Magritte died on August 15, 1967.
6. Magritte typically eliminates the artist from these scenes. See, for example, *The Human Condition* (1933) and *The Fair Captive* (1935) (see David Sylvester et al., *René Magritte: Catalogue Raisonné*, vol. 2 [Antwerp: Mercatorfonds and Houston: The Menil Foundation, 1993], no. 375).
7. *Magritte* was co-organized by The Hayward Gallery, London; The Menil Collection, Houston; The Metropolitan Museum of Art, New York; and the Art Institute of Chicago in 1992. Jasper Johns, Robert Rauschenberg, and Saul Steinberg were among the lenders.
8. See also n. 6.
9. *Time Transfixed* (1938).
10. Willoughby Sharp, ". . . A Kind of Huh?: An Interview with Edward Ruscha" in Ruscha, *Leave Any Information at the Signal*, 65.
11. The Marcel Duchamp retrospective at the Pasadena Art Museum was held in 1963, curated by Walter Hopps. It was the artist's first museum retrospective.

Vija Celmins, *Train*, 1965–66

Freeze-Frame:
In Conversation with Vija Celmins

SARA COCHRAN

Vija Celmins has previously mentioned a youthful interest in René Magritte's work in interviews. However, Magritte is just one of a number of artists—including Giorgio Morandi, Diego Velázquez, and contemporary pop artists, most notably Jasper Johns—who prompted her to shift her painting in the early 1960s from large, semi-abstract canvases to objective renderings of objects. When she moved to Los Angeles in 1962 to study at UCLA, her attitude toward her work changed: the abstract expressionist style she had developed at John Herron School of Art in Indianapolis (1955–62) had lost its meaning for her and now seemed merely decorative. A visit to a Morandi show in New York in the early 1960s helped her decide to drop her previous large-scale work, quit her "action" technique, and return to a basic "look and paint" approach.[1] Grounding her new series of paintings against a rich gray background, she began making paintings (some have gone so far as to call them portraits) of the domestic objects in her studio, such as her fan, heater, hotplate, and lamp.

Vija Celmins, *Lamp #1*, 1964, oil on canvas, 62 × 89 cm, private collection

These early paintings grant their simple subject matter a presence and gravitas that belies their humble status. They also can be said to show certain influences—a calm that is certainly reminiscent of Morandi's work as well as an inherent strangeness that is suggestive of surrealism. However, Celmins points out that some of this "strangeness" is not necessarily inspired by outside sources. Rather, she has said that it can also be related to the way she chose to portray these household objects. She depicted them actual size, giving them an importance that they do not usually enjoy. Painted from life, her works were "overtly observed and isolated" and "active," she says. She made a conscious decision not to represent conventional still life subjects such as apples, flowers, and dishes, but rather modern electric appliances, sometimes shown in use, emphasizing their banal, functional nature.

Nevertheless, there is no denying that Magritte's painting did influence her work, and during our conversation in her studio it was obvious that Celmins had thought about this. She had laid out a number of Magritte catalogues as well as some about her own work, explaining that one of the things that most appealed to her about Magritte's painting was its quietness and deadpan quality balanced by his rather alarming images—as if to emphasize that the painting is one thing and the subject another. She also liked his play on the two-dimensional plane and three-dimensional images, evident in such works as *Where Euclid Walked* (1955), *The Field Glass* (1963), *Evening Falls* (1964), and *The Human Condition* (1933) as well as, not surprisingly, his images of objects. Early in her career, she even borrowed some of Magritte's objects when she ran out of things to paint in her own studio. She particularly liked *Personal Values* (1952) and appropriated the comb; she also

Vija Celmins, *Untitled (Cloud with Wire)*, 1969, graphite and acrylic ground on paper, 34.3 × 47.6 cm, private collection

used the train from *Time Transfixed* (1938) and considered using the bleeding rifle in *The Survivor* (1950) shown leaning against a wall. (Eventually she photographed her own revolver leaning against her studio wall and made three paintings of the gun being fired by an anonymous hand, though none of these used the pose from *The Survivor*.) All of these indicate how Celmins was intrigued by Magritte's way of juxtaposing the real and the imaginary: "[He] had so many ideas he illustrated in a clever way about the real and the illusionary. He pointed out that events in painting are not real events."

Attempting to resolve the illusion of three-dimensional image to the flat plane without recourse to single perspective (still an essential part of her work today), Celmins explained that she constructed an opposition between what she calls the "making" of the image and its subject in her graphite drawing *Untitled (Cloud with Wire)* (1969). This virtuoso work in grisaille juxtaposes a representation of a cloudy sky (an unquestionably important subject for Magritte's own work) with the depiction of a wire and its shadow drawn across the image of that sky. The realism of the wire highlights the single dimension of the drawing of the sky and undermines its sense of reality—but it is also, itself, manifestly just a drawing. In this way, *Untitled (Cloud with Wire)* is a perplexing double play on the idea of trompe l'oeil: although both parts of the image are representations, the viewer alternates in considering the veracity of the depiction of the sky and that of the wire, but is constantly confronted by the contradiction between these two elements.

The provocative construction of *Untitled (Cloud with Wire)* is akin to the concept behind *To Fix the Image in Memory I–XI* (1977–82)—another exploration of the real and the simulacrum. *To Fix the Image in Memory I–XI* is an assemblage of eleven

Vija Celmins, *To Fix the Image in Memory I – XI*, 1977–82, stones and painted bronzes, dimensions variable, private collection

stones paired with eleven painted bronze replicas that Celmins painstakingly made to resemble the originals. The piece has a tongue-in-cheek quality reminiscent of Duchamp's late sculptural reliefs illustrating French puns. Celmins's assemblage is, nevertheless, an illusion predicated on artistic notions of skill and making. After all, she chose to make her copies out of bronze—the fine art material par excellence—rather than of "lesser" casting materials such as plaster, clay, or even epoxy. The piece is premised on the viewer's ability to recognize and appreciate the deception, although some viewers have let her down on this account, asking naively: "How'd you find two rocks the same?"[2]

Celmins has been more comfortable talking about her process than about the interpretation of her work, explaining that a great deal of meaning is embedded in the medium and its feel.[3] Much critical writing has focused on her shifts between painting and rigorous drawing technique. However, one unifying aspect throughout Celmins's work is her use of photography, an element that was also of great importance to Magritte. This use of photography—both their own photos and found images—certainly accounts somewhat for the freeze-frame quality of their compositions, but it does not explain all aspects of it. For Celmins, the use of photography can also be seen as a distancing technique. The act of marking up photographic images to reproduce them on canvases allows her to concentrate on the material. In this way, it is the photograph as an *object* (with all of its contradictions of space and flatness), rather than the image that is its subject, with which she works. Nevertheless, even as Celmins says it was not part of her original intention, there is an undeniable tension (especially in her early work) between the significance of the materials that go into making her work and the highly charged

emotional content the work represents. This tension is most prevalent in her images of crashed cars, fighter planes, and firing guns.[4] Even Celmins's early gray paintings of domestic objects, despite a certain sense of nostalgia, contain a degree of menace by placing the viewer in a problematic and confrontational relationship with everyday objects that are not presumed to be disturbing in themselves.

For someone so interested in the process of making rather than questions of interpretation, it is ironic that Celmins's first interaction with Magritte's work was not with the paintings themselves but rather with reproductions, primarily those in the catalogue for the Museum of Modern Art's 1965–66 Magritte retrospective.[5] She did not see his paintings in person until much later; ultimately, she was disappointed by them because of their technique (particularly the thin, "scrubby" paint quality) and the extreme playfulness throughout his work. While Celmins's own work contains some playful elements—mostly the objects relating to childhood, such as puzzles, pencils, erasers, houses, and the comb—most of it is quite sober, and is composed of a tight paint surface built up over a longer time. Additionally, she found that she was uninterested in Magritte's use of collage and storytelling. Despite these reservations, Magritte's images still counted among the many influences of her early years. The inspiration for her painting *Train* (1965–66) is a mix of elements, in particular her early memories of fleeing on trains through war-torn Europe with her family, in combination with Magritte's iconic *Time Transfixed*. The genesis of her *Comb* (1970) piece is equally mixed. Part of a series of oversized objects, it took two years to produce and used various toxic lacquers and epoxies, representing an intense physical engagement on the part of the artist. In addition to the comb in Magritte's *Personal Values* (1952), Celmins remembers a real comb that belonged to her parents.[6] Nevertheless, she is emphatic about her appreciation of Magritte's painting: "By having snatched the comb out of it [*Personal Values*], I figured that when I showed [the comb] upright in a corner of a room, this painting would come to mind . . . always."

There were, of course, other sources for her early works. Celmins's comb and other oversized objects, such as *Pink Pearl Erasers* (1966–67) and *Pencil* (1968–70), are also indebted to pop art and its play on scale. Many critics have particularly cited the influence of the work of Claes Oldenburg, although Celmins's work avoids the jarring shift of materials, exemplified by Oldenburg's rendering of solid objects and machines as soft sculptures. For this reason, it is perhaps not so surprising that early critics were reluctant to discuss Celmins's relationship to Magritte or surrealism. In 1966, one critic defined the sense of isolation in her work as comedic rather than surreal, and thereby positioned it as closer to California pop than to any European tradition of painting.[7] Writing about Celmins's work more than ten years later, Susan Larsen referenced Magritte in relationship to Celmins but stated that the specificity of her imagery lent her paintings a sense of authenticity that exemplified the young painter's emotional involvement in her work. Larsen directly opposed this idea of Celmins's engagement to what she criticized as Magritte's slick manipulations.[8] Speaking recently, Celmins reflected on the relationship of her work to surrealism, and cited some important differences:

> My take on the surrealists is that they put together some sensational images just
> to surprise people and shock them . . . (Duchamp too). . . . By the time I came
> around no image was shocking anymore—those images were commonplace . . .

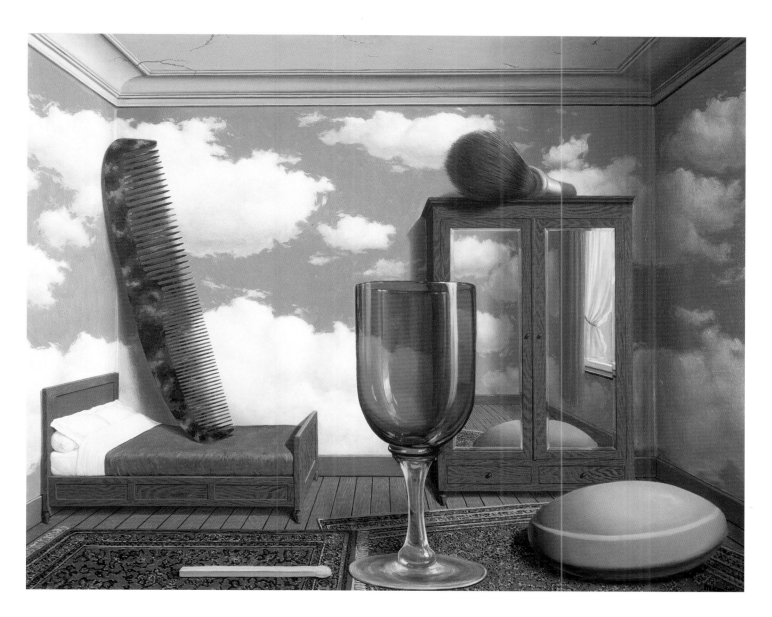

Magritte, *Personal Values*, 1952

Vija Celmins, *Untitled (Comb)*, 1970

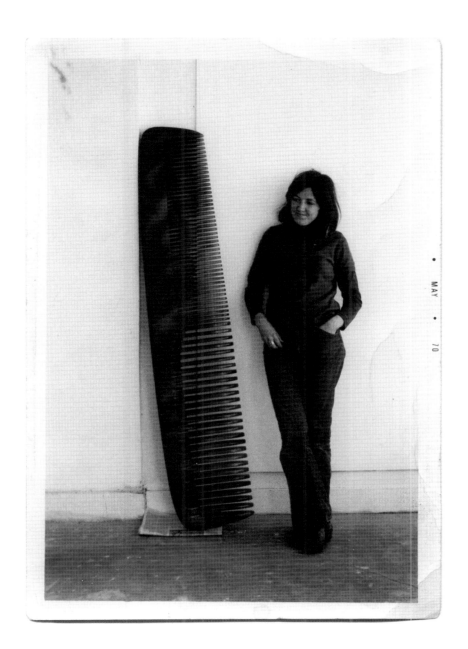

Vija Celmins with *Untitled (Comb)* in her Venice, California, studio, 1970

Magritte, *The Subjugated Reader*, 1928

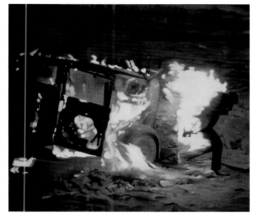

Vija Celmins, *Flying Fortress*, 1966, oil on canvas, 40.5 × 66 cm, private collection

Vija Celmins, *Burning Man*, 1966, oil on canvas, 51 × 57 cm, private collection

my interest in fires and steaming, turned-on appliances, and moving, falling planes was because I liked these things, and it was a challenge to paint them—to make paintings out of the "real images" we have around us. . . . My main interest was in how to make a painting—how to handle the paint and the image to make the complex object called a painting.

There is perhaps a larger argument to be made about the resonance between Celmins's and Magritte's work that has to do with childhood trauma. Both artists survived devastating events in their early lives: Celmins lived through the ordeal of World War II as a child in Latvia and Germany; more than a generation earlier, Magritte grew up with a mentally unstable mother who ultimately committed suicide by drowning herself when he was thirteen years old. But rather than focusing on and directly representing their individual memories, both artists draw from these personal experiences in their work through a sense of disjunction. As discussed above, photographic source material plays an extensive role for both artists. Magritte and Celmins (at the beginning of her career) were particularly interested in dramatic images that seem to be ripped from the middle of a narrative, like a freeze-frame from a film. These evocative and startling images—such as her pictures of a hand firing a gun (*Pistol*, 1964) and a burning man rushing from a crashed car (*Burning Man*, 1966) or Magritte's painting of a naked woman struggling with an invasive man (*The Titanic Days*, 1928) and his terrified reader (*The Subjugated Reader*, 1928)—represent moments of high drama taken from a larger narrative that the images themselves allude to but refuse to explain. They parachute viewers into the middle of a traumatic event and leave them there without explanation, escape, or any sense of closure.[9] As in a dream, Celmins's falling or exploding airplanes (*T.V.*, 1964 or *Flying Fortress*, 1966), destroyed cars, and firing guns are caught—trapped— in the very moment of disaster. They are doomed to eternally repeat this event, reinforcing its sense of trauma.

Vija Celmins, *Letter*, 1968, graphite and
acrylic ground on paper, 33.5 × 46 cm,
private collection

Letter (1968), her graphite and acrylic work of a letter from her mother, is an
extraordinary example of this. Part of the series reproducing objects in her studio,
this work exemplifies the underlying subjective nature of this project. It shows a
seemingly normal envelope addressed to Celmins from her mother, but the artist
has carefully replaced the stamps with tiny images of explosions and a burning
house. These changes are subtle and are not immediately apparent. They certainly
reflect the violent content in other paintings she produced at the time, but in the
context of a letter from her mother, such imagery would also appear to foreground
some significant emotions—emotions that I would suggest Celmins controlled by
focusing on the making of her art rather than its interpretation.

House #1 and *House #2* (both 1965) are similarly intriguing. As with other work
by Celmins, there is an undeniable link between these objects and the imagery
of Magritte. The reference here is his iconic *Dominion of Light* series of houses on
deserted streets viewed by lamplight. However, in discussing the sources of *House
#1* and *House #2*, Celmins first mentions fellow artist Tony Berlant's early house
artworks, which he made out of tin around the same time as she made hers, as well
as two specific houses—one house in her then-neighborhood of Venice, California,
and the other a type of traditional farm house in Indiana where she grew up after
emigrating from Europe. Nevertheless, neither Celmins's nor Magritte's houses
are examples of domestic bliss or safety. Both evoke a sense that their windows are
actually walls that exclude outsiders and imprison the inhabitants they are supposed
to protect. Celmins takes this one step further, superimposing violent images of
death and destruction on her domestic structures: a raging fire, a fast-moving steam
train, a crashing plane, a hand firing a gun. When asked about the juxtaposition
of these violent images with domestic spaces, Celmins explains that she never

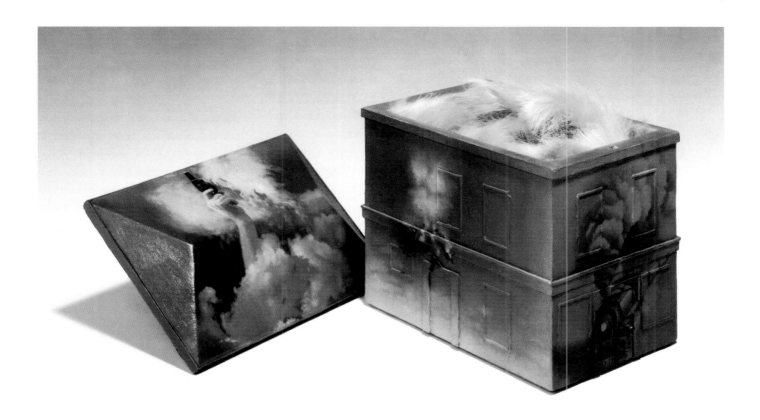

Vija Celmins, *House #1*, 1965

thought about how strange it could appear; in fact, she didn't think of these images as particularly violent and didn't choose them for their violent subject matter. As someone who had always collected images and who was working at the emotionally charged height of the Vietnam War, she found many pictures of violent events, but is adamant that she was not consciously trying to work with particularly shocking material: "I don't think I have ever done a work for any effect or sensationalism. All my work comes from the intuition, a brooding inwardness, my unconscious and an embarrassing true effort to build a form that 'feels right.'"

Of course, interpretation—including a critic's—is always influenced by its specific historical and cultural context. In this light, it seems obvious that the current renewal of interest in surrealism in general (and in individual surrealist artists such as Magritte in particular) has been largely driven by a contemporary interest in the idea of the uncanny, which Sigmund Freud defined as the outcome of denying memories and emotions. Freud explained: "It may be true that the uncanny is nothing else than a hidden, familiar thing that has undergone repression and then emerged from it."[10] The work of artists such as Mike Kelley, Robert Gober, and Damien Hirst speaks to this resurgence of interest in the Freudian concept, and this contemporary phenomenon may well affect the way we now look at Celmins's early paintings in comparison to earlier critical judgments made about them. The German word for "uncanny," *unheimlich* (literally, "un-homelike"), clearly implies its link to the domestic sphere—an inspiration fundamental to the development of Celmins's early career. However, as in Celmins's two *House*s, this idea of domesticity is not an easy or comfortable one. Although much of the recent work on the uncanny has primarily focused on the construction of the identity of the body through its inanimate alter ego of the mannequin, the idea is related to the fundamental

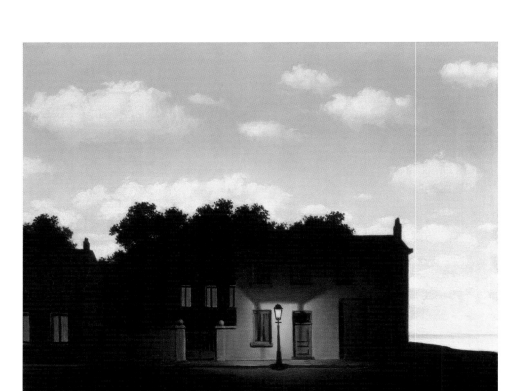

Magritte, *The Dominion of Light*, 1953

question of what is real and to our deep-seated fear of having our bodies, identities, or existences usurped.[11] Regarding the close connection between the concepts of the uncanny and the doppelgänger, I asked Celmins about the fact that many of her early paintings exist in two versions. Celmins explained that this doubling had a practical reason: often unhappy with the first version of a painting, she had a strong desire to get the work to feel "right" and would often quickly begin a second version. In this way, she painted a number of double images in a very short period of time.

This practical explanation highlights the need to be careful with such critical approaches, but I would still contend that there is an argument to be made in support of the correlation between the idea of the uncanny and Celmins's work. The uncanny constantly tests the division between authenticity and simulacra and probes the problem of self-identity by exploring the criteria we use to define ourselves. It is defined by the ambivalence it provokes as well as sudden shifts between delight and terror as our definition of the object and our experience evolves and changes. Mike Kelley has called it a physical sensation provoked by the act of remembering and, more personally for him, of viewing art.[12] In this, the uncanny is connected to perception and the tension between aesthetics and psychoanalysis. For the viewer and the artist, the idea of the uncanny as it is applied to art is one of ever-shifting interpretations and reactions. These ideas of openness and change certainly seem to resonate with many fundamental questions in Celmins's early work.

Ultimately, the question is not about the degree to which Magritte inspired early works by Celmins. Magritte did have a certain influence, but Celmins's involvement with his work, like that of Morandi, was short-lived, roughly from the mid-1960s to

1970. "After that," she recalls, "I changed my work and the medium (graphite and paint) became a bigger player (and recently the paint is probably the main player, as compressed, built up, sanded, and manipulated as it is). I became interested in the process and the image becoming closer, as if inseparable." However, for a brief period, Magritte's work served as a source of images and, more importantly, as a model of how to divorce the making of a painting from its image. This breakthrough allowed her to move beyond her initial abstract style; it also seems to have acted as a conduit for the powerful emotions of Celmins's war-torn childhood. While she concentrated on the making of her work, these disturbing and painful memories were quietly sublimated into her early controlled images of oddly glowing domestic appliances and guarded violence. Perhaps this is the essence of the openness that Celmins identified in Magritte's work and made her own: a way to channel these emotions into her early painting in abstract ways—without forcing her to focus on the anecdotal details of her own early life.

Notes

This essay is based on an interview with Vija Celmins that took place at her New York studio on November 21, 2005, as well as subsequent communications in early 2006. Unless otherwise noted, all Celmins quotes are derived from these conversations.

1. Celmins summed up Morandi's impact, saying: "In the fast-moving world of ideas and movements, political and conceptual, that drove the art world of the 1960s, I came across a painting that stopped me in my tracks . . . the painting was by Morandi. . . . [Objects] appeared both flat and dimensional, and were so tenderly painted that the paint itself seemed to be the subject. I was struck by the muteness of the work and by an odd psychological feel about it." In Donna De Salvo and Matthew Gale, *Giorgio Morandi* (London: Tate Publishing, 2001), 36.
2. "Interview: Robert Gober in Conversation with Vija Celmins," in Lane Relyea et al., *Vija Celmins* (London: Phaidon Press, 2004), 30.
3. "My work seems to communicate less about what I think and is more ambiguous. Sometimes I think the meaning is only in the material." Relyea, *Vija Celmins*, 11.
4. Although there is an argument to be made that Celmins's later paintings of horizonless seascapes, desert floors, starry night skies, and limitless galaxies also have a menacing edge to them, completely dwarfing the mortal realm and touching on subjects dear to the nineteenth-century ideal of the sublime.
5. The catalogue included black-and-white illustrations of *Time Transfixed* and *Personal Values.*

6. In his 2002 interview with Celmins, Robert Gober pointed out that Celmins has the exact same tortoiseshell comb in her bathroom—a fact that disturbed him because he said that given his use of sinks as subject matter, he could never live with a white porcelain sink in his kitchen. Relyea, *Vija Celmins*, 15.
7. Nancy Marmer, "Pop Art in California," first published 1966; reprinted in *Pop Art*, Lucy Lippard, ed. (New York: Praeger, 1996), 158.
8. Susan C. Larsen, *Vija Celmins: A Survey Exhibition*, exh. cat. (Los Angeles: Fellows of Contemporary Art, 1979), 23.
9. This sense of trauma without end is certainly one aspect that popular culture—especially an entire generation of rock album covers—picked up from Magritte's paintings, and explains why music companies and advertising agencies in the 1960s and 1970s embraced Magritte's particular sense of quiet realism that heightens the shock of his images.
10. Sigmund Freud, "The Uncanny" (1919), in *Sigmund Freud: Collected Papers*, vol. 4, trans. and ed. Joan Rivière (New York: Basic Books, 1959), 399.
11. Recent interest in the uncanny has also inspired a number of ground-breaking exhibitions like *Post-Human* (1992–93; curated by Jeffrey Deitch at the Musée d'Art Contemporain, Pully/Lausanne) and *The Uncanny* (2004; curated by Mike Kelley at Tate Liverpool).
12. Mike Kelley, "Playing with Dead Things," in *The Uncanny*, exh. cat. (Liverpool: Tate Liverpool, 2004), 26.

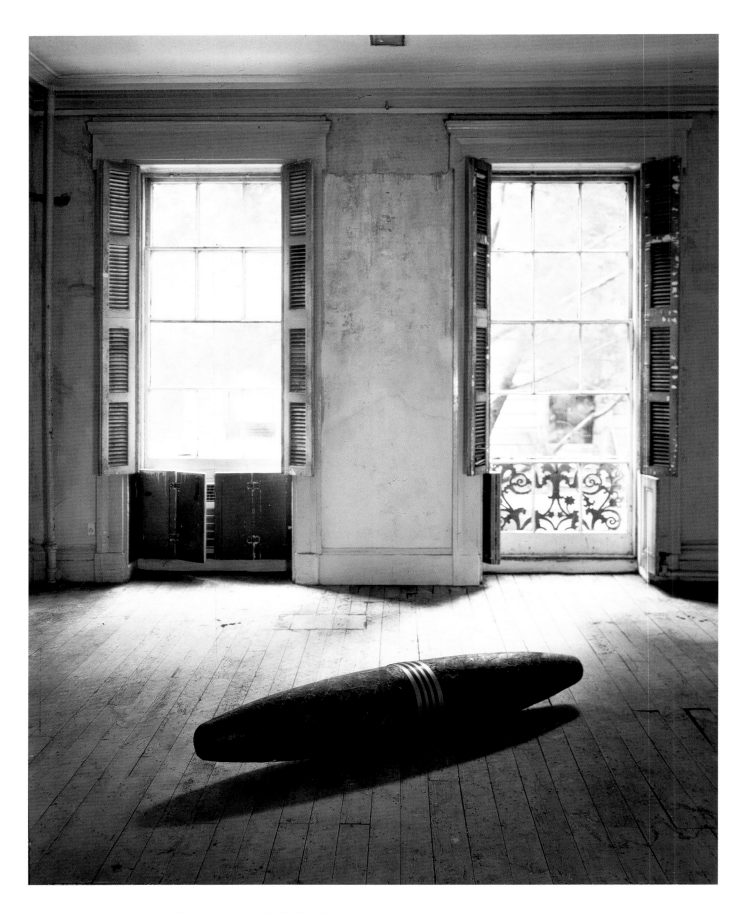

Robert Gober, *Cigar*, 1991, installed at his former New York studio

"Who You Are and Where You Come From": Robert Gober and René Magritte

PEPE KARMEL

Since 1980, surrealism has exercised an increasingly powerful influence on contemporary art, mingling in unpredictable ways with the legacies of more recent movements such as pop art and minimalism. These divergent tendencies are fused in the brilliantly disturbing work of Robert Gober. His sculptures and installations combine seemingly incompatible elements, "displaced in real space and time like a Magritte made real," as Joan Simon has written. What recalls Magritte in Gober's work is not just the juxtaposition of incongruous items, but also the obsessive attention to the material qualities of things and the revelation of an ominous aura surrounding everyday objects. Converting the literal space of the gallery into a symbolic arena, Gober extends and transforms the tradition of minimal and postminimal installation.[1]

Born in Wallingford, Connecticut, in 1954, Gober studied at the Tyler School of Art in Rome and at Middlebury College in Vermont. In 1984, he had his first solo exhibition at the Paula Cooper Gallery in New York. His sculpture and installations rapidly attracted worldwide attention. In 1991 and 1992, he was invited to create major installations for the Jeu de Paume in Paris, the Reina Sofia Museum in Madrid, and the Dia Center for the Arts in New York. In 2001, he represented the United States at the Venice Biennale. One of his most controversial installations was created in 1997 for the Museum of Contemporary Art in Los Angeles. Here, he depicted the Virgin Mary standing atop a sewer drain, flanked by open suitcases containing similar drains; a large culvert pierced the torso of the Virgin, as if to suggest that her endless clemency was extended only at the risk of damage to her purity. If the Catholic imagery of this installation derived from Gober's childhood experience as a choir boy, the radical disruption of conventional imagery reflected the influence of Magritte and surrealism.[2]

For an artist of Gober's generation, growing up in the 1960s and 1970s, Magritte was an inescapable presence, visible everywhere on posters and album covers as well as museum walls. Gober's original ambition was to be a painter rather than a sculptor. "In high school," he recalls, "I wandered into the Yale Art Gallery. I remember looking at my first Magritte painting—the one of a man in a bowler hat. I thought, 'I could do that.'" Years later, when he was preparing an installation for a 1991 exhibition at the Jeu de Paume, in Paris, he remembered Magritte's 1959 painting *State of Grace*, which depicts a cigar at the same scale as a bicycle. The centerpiece of his installation became a sculpture of a giant cigar, eight feet long. More recently, when Gober was invited to organize an exhibition in Houston at the Menil Collection by combining his own works with objects from the collection, he included three pictures by Magritte. However, the link between Gober's work and

Robert Gober, *Untitled*, 1995–97,
at the Museum of Contemporary Art,
Los Angeles, 1997

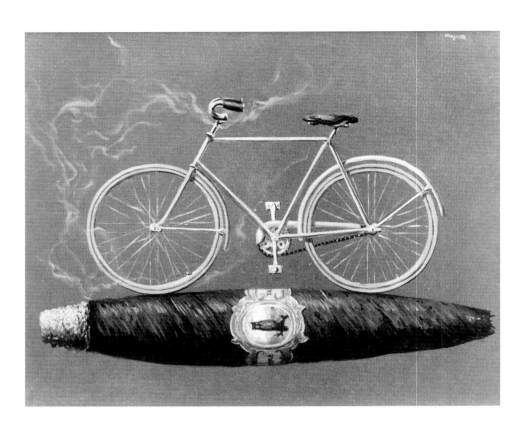

Magritte, *State of Grace*, 1959, oil on canvas, 50 × 61 cm, private collection

Magritte's cannot be reduced to a simple matter of "influence." The relationship is complex and often indirect.[3]

Beginning in 1982, Gober executed a series of sinks that became his first "trademark" images. These look as if he might have bought them at a plumbing supply store, much like the one where Marcel Duchamp bought the urinal for his 1917 readymade *Fountain*. But in fact Gober's sinks are sculptures, made from plaster over lathing and painted with enamel to simulate the look of porcelain. In some cases he has altered the shapes of the sinks, but even where they look perfectly "normal" there is something unsettling about them, beginning with the fact that they have no faucets or pipes attached. They are conspicuously nonfunctional in a way that makes us think twice (or three times) about everything they might recall or suggest.

Gober's sinks evoke a profound ambiguity. On one hand, they function as an architecture of purification, a setting in which dirty things are made clean again. By the same token, however, they are places where dirt is collected. Gober's first sinks, without taps or drains, were followed by sculptures of drains imbedded directly in the wall. It seems as if he wanted to focus the viewer's minds on different, contradictory moments in the process of purification. The pristine whiteness of the sinks is preserved or restored by gathering up the filth and sending it down the drain, which becomes a repository for everything we fear and reject.[4]

By 1986, Gober could sense that the image of the sink was "going away," and that the end of the series was in sight. He "laid the image to rest" by burying the sinks in the earth, so that their bowls were invisible while their backsplashes rose straight out of the ground like tombstones. The funereal association was reinforced

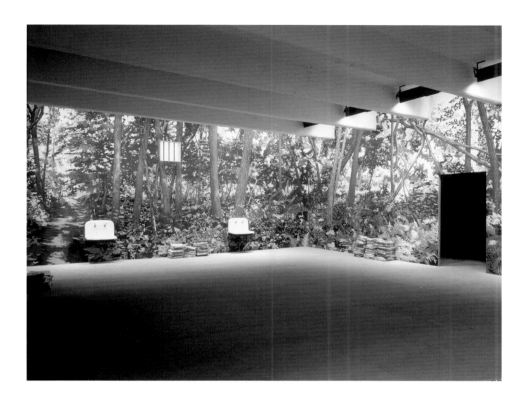

Robert Gober, site-specific installation at Dia Center for the Arts, New York, 1992–93

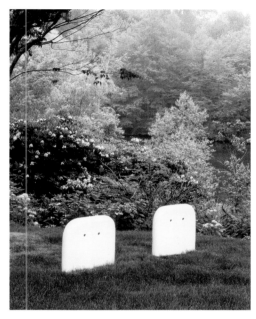

Robert Gober, *Two Partially Buried Sinks*, 1986–87, cast iron and enamel paint, 99.1 × 62.2 × 7 cm (left) and 99.1 × 64.8 × 6.4 cm (right), Institute of Contemporary Art, Boston

by the drawing he did for an exhibition announcement, where the words "ROBERT GOBER / new work" appear to be engraved on the backsplash like the name and dates on a slab.[5] Gober's allusion to the decorative architecture of death recalls Magritte's *Perspective* series of the early 1950s, where he repainted famous French paintings, substituting coffins for the "living" figures in the originals. In the right (or wrong) frame of mind, every box is simultaneously a coffin and every vertical slab is simultaneously a tombstone.[6]

Beginning in 1989, Gober's creative activity shifted increasingly from individual objects to more complex environments. His 1991 installation at the Jeu de Paume and his 1992 installation at the Dia Center for the Arts both incorporated elaborate paintings of forest settings, covering all four walls of the exhibition space. At first glance, this might have seemed like an updated version of the trompe l'oeil murals of gardens that decorated wealthy homes in ancient Rome.[7] However, Gober subverted the illusion of a forest by inserting a number of inconsistent elements. At Dia, for instance, there were piles of newspaper stacked around the room, sinks fastened to the sides of the room, and barred windows cut into the upper part of the walls. The sinks and the windows, in particular, had the disturbing effect of converting the "outside" (the forest view) into an "inside."

The painted walls in these installations recall an incident from Gober's childhood, when his family's house was repainted after a fire, and the painter, aspiring to be an artist instead of a mere craftsman, painted a trompe l'oeil scene in one room. Gober, still a boy, was very impressed. His adult decision simultaneously to re-create this trompe l'oeil view and to subvert it recalls the canvases in which Magritte depicted a landscape painting set on an easel in front of a landscape,

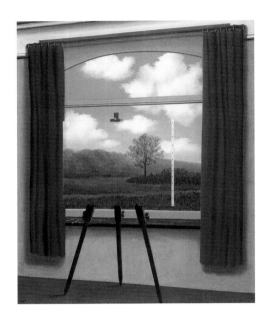

Magritte, *The Human Condition*, 1933

Diane Arbus, *A lobby in a building, N.Y.C.*, 1966, gelatin-silver print, 50.8 x 40.6 cm, The Museum of Modern Art, New York, Mrs. Armand P. Bartos Fund

with the view on the canvas merging seamlessly into the "real" view around it. The breakdown of the border between representation and reality induces a kind of mental vertigo.

A similar vertigo is induced by Diane Arbus's 1966 photograph, *A lobby in a building, N.Y.C.*, which reproduces a photomural of a river running through the countryside, framed by birch trees. What keeps Arbus's photograph from being simply a copy of the photomural (a Sherrie Levine before Sherrie Levine) is a series of small clues about the photomural's setting, in particular the strip of molding at the bottom of the image and the dark line rising through the image where it wraps around the corner of the room. These serve the same purpose as the legs of the easel and the raw edge of the canvas inside Magritte's painting, distinguishing between two levels of reality within the image. Gober clearly knew Arbus's photograph when he created his 1991 and 1992 installations. It is reproduced in the 1972 monograph of her work, which appears in one of his early still-life drawings.[8] Gober was deeply impressed by Arbus and her use of photography as a way of "being able to look at everything that you weren't supposed to."[9]

The barred windows of Gober's 1992 Dia installation not only subvert the "reality" of the surrounding environment but also pose an existential question: "Are you in nature that's a prison or are you in a prison cell that's a forest?"[10] Pressed for an explanation of this imagery, the artist refers to Jean-Paul Sartre's 1944 play, *No Exit*, in which a man and two women, all recently deceased, find themselves together in a windowless room stuffed with bourgeois furniture. At first they are surprised by the absence of the fires and instruments of torture that they expected to encounter in hell. But as they get to know one another, they realize that spending eternity with people they detest will be punishment enough. "Hell is other people," the man

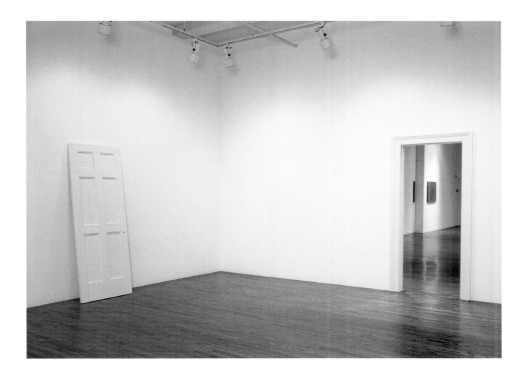

Robert Gober, *Untitled (Door and Doorframe)*, 1987–88, wood and enamel paint, 213.4 × 81.3 × 3.8 cm (door) and 228.6 × 109.2 × 14 cm (doorframe), installed at the Paula Cooper Gallery, New York (collection Walker Arts Center, Minneapolis)

famously concludes. Gober's installation suggests a corollary: that anyplace, even a pristine forest, can be a hell if you are imprisoned by your own imagination.

Within this disconcerting setting, the windows (which have also been exhibited separately) evoke a poignant ambiguity. Looking up through the bars, one sees a patch of wall painted and lit to evoke a beautiful blue sky. The high window creates a feeling of imprisonment, but at the same time a strange sensation of joy and liberation. The emotional tension of Gober's installation recalls Magritte's *The Dominion of Light*, showing a darkened street beneath a bright blue sky.[11] The obvious "joke" here lies in the combination of realistic but incompatible elements, but the picture's enduring popularity derives from its emotional complexity, its suggestion that depression and elation can—indeed *must*—coexist in our experience. If a forest can be a prison, a prison can also be a forest.

In 1987–89, before arriving at the window motif, Gober had created a series of sculptures of doors that art historian Sarah Whitfield has linked to Magritte's painting of the same motif.[12] Indeed, the door as a symbol of liminality—the transition from one state to another—can be traced beyond Magritte to Danish symbolist Vilhelm Hammershøi and the German romantic Caspar David Friedrich. If Gober's sinks and windows seemed to derive primarily from the surrealist tradition, his door sculptures demonstrate his ability to work simultaneously in the traditions of surrealism and of minimalism.

Gober's meticulous re-creation of an ordinary paneled door leans casually against the wall, echoing the work of minimal and postminimal sculptors of the 1960s. Traditionally, the vertical thrust of sculpture has served as a symbol for the vitality and independence of the human spirit. Sculptors such as John McCracken and Richard Serra jettisoned this rhetoric, making work that casually submitted

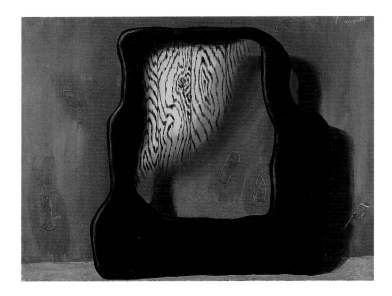

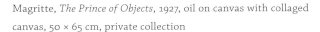

Magritte, *The Prince of Objects*, 1927, oil on canvas with collaged canvas, 50 × 65 cm, private collection

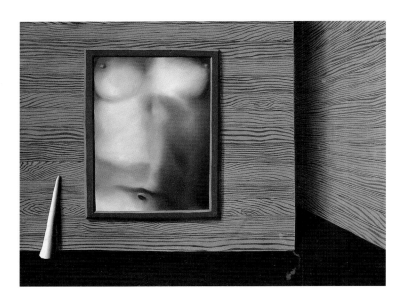

Magritte, *A Courtesan's Palace*, 1928, oil on canvas, 54 × 73 cm, The Menil Collection, Houston

to the force of gravity or struggled against it with obvious effort.[13] Nonetheless, they took care to differentiate their work from conventional sculpture: McCracken reduced his work to planes of pure color, polished to a transcendent gleam, while Serra crudely shaped his early sculptures from industrial materials such as rubber and lead.

Gober addresses the same sculptural issues using what seem to be everyday objects: a door or a sheet of plywood. But there is something deceptive about this ostentatious avoidance of "art." Gober's sculptures are not readymades but meticulous re-creations; a sheet of plywood, for instance, is made from plywood veneer wrapped around a chipboard core. It is, as Gober puts it, "a hyper-realistic sculpture of an abstract object." Gober was drawn to plywood, in particular, by its role in minimal art. In the 1960s, Tony Smith and Robert Morris had used plywood to construct geometric shapes, which they then painted black and gray. Later, Donald Judd constructed a long series of sculptures from raw plywood. In adopting this material, Gober was, as he puts it, "taking the available forms of minimalism and fusing them with other –isms."[14]

Gober's use of plywood also provides a link to Magritte, who was surprisingly interested in the role of wood as a traditional support for painting. In several 1927 pictures, including *The Prince of Objects*, it seems as if part of the image has been wiped away to reveal the striated lines of the wooden panel on which the picture is painted. The wavering lines of the wood grain echo the depicted forms even as they disrupt the illusion of realism. And the revelation of the material support is itself a deception: the pictures in question are painted on canvas.[15]

However, the most dramatic resemblances between Gober and Magritte occur in their treatment of the human body, and specifically their interest in the theme of "the body in pieces" (to borrow the title of a recent book by Linda Nochlin). In 1932, Magritte created a work consisting of five separate canvases depicting a woman's head, thorax, abdomen, knees, and feet. In a more typical work from this era, a woman's torso, cropped so that it extends only from breasts to belly, is presented as

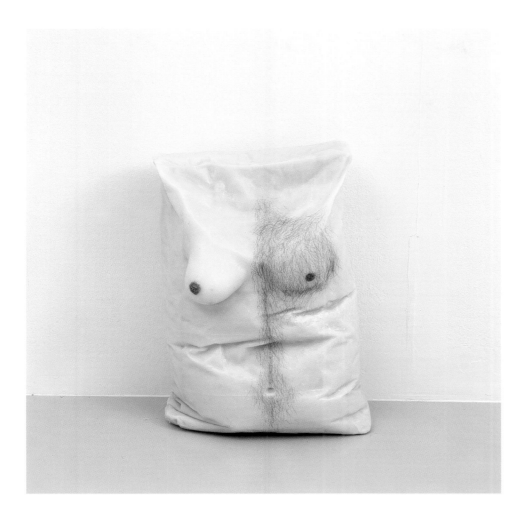

Robert Gober,
Untitled (Torso), 1990

an imaginary painting, hanging on the bare, wood-grained walls of a starkly modern interior.[16] A similar cropping of the torso occurs in one of Gober's best-known works, the *Untitled* torso of 1990. However, Gober has introduced an internal discrepancy between left and right sides of the body: one is feminine and the other masculine. The theme of psychological conflict, which had played a role in earlier works such as *The Split-Up Conflicted Sink* of 1985, here emerges in the conflict between masculine and feminine aspects of the human personality.[17]

Gober's attitude toward the body is very different from Magritte's. Magritte intended to shock his viewers and to disrupt their normal habits of perception, but when it came to the female figure he remained attached to conventional models of beauty. The nude torsos in his paintings are obviously modeled on casts of classical sculpture.[18] They have the firm, spherical breasts of the Venus de Milo, while the female breast in Gober's 1990 sculpture sags like the breast of a real woman. Furthermore, the body behind it is not a human torso at all, but a shape cast from a 100-lb. bag of plaster, inspired by the bags of cat litter that Gober had included in a 1989 installation at the Paula Cooper Gallery. Commenting on the cat litter, Gober said "The cat litter was to a large degree a metaphor for a couple's intimacy—that when you make a commitment to an intimate relationship, that involves taking care of that other person's body in sickness and in health."[19]

The male half of Gober's sculpture doesn't seem any sexier or more idealized than the female half—if anything, less so. The horizontal folds and puckers of the underlying bag suggest a kind of flabbiness that's miles away from the pumped-up

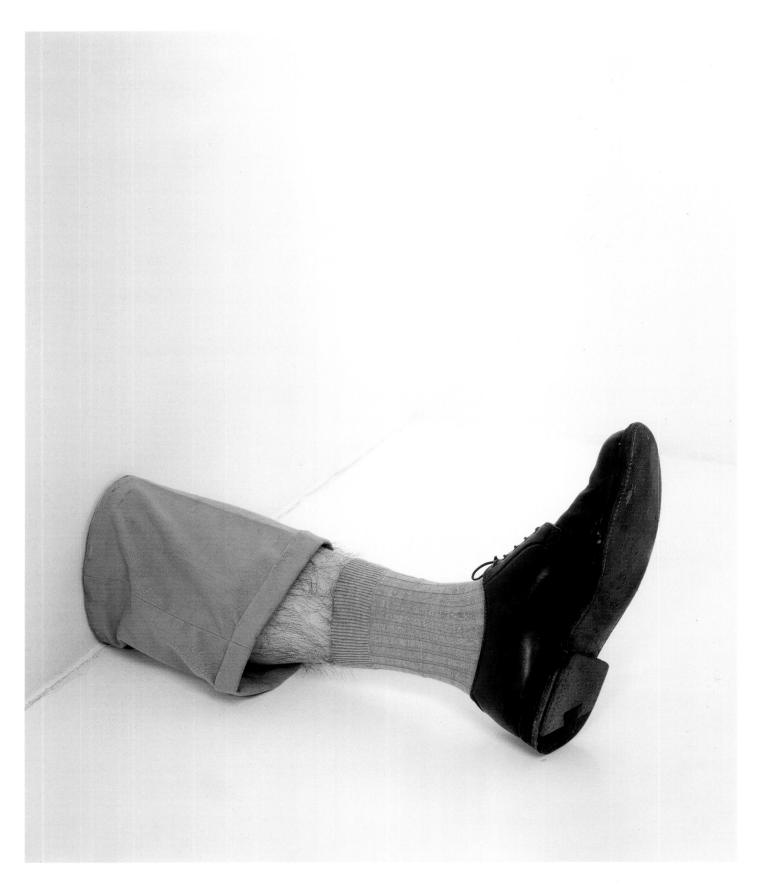

Robert Gober, *Untitled (Leg)*, 1990

muscles of Hollywood movie stars. The male half also has a thin pelt of hair very unlike the glistening, oiled skin of the classically posed models in, say, Robert Mapplethorpe's photographs.[20] Contrary to most artistic representations, this is a defetishized image of the body. It offers a reminder that we have at least two very different experiences of the body, whether male or female. There's the body as the subject of physical experience: eating and drinking, urinating and defecating, running and swimming, sweating and shivering, making love. Then there's the body as the object of visual delectation.

Obviously, there is some connection between these things. Physical activity can change the shape and therefore the image of the body. Conversely, the actual or desired image of the body can provide an incitement to activity—to sex, or to exercise. There are whole industries—advertising, publishing, film, pornography, gyms, spas—built around this fetishization of the body. Taking for granted the link between image and experience, we assume that the point of exercise is to look good, or that physical beauty will make us sexually desirable. In fact, there's no necessary linkage between these things. You might go to the gym purely for a cardiovascular workout. You might find someone insanely sexy because he emits the right pheromones, even if he is flabby and overweight. But we tend to assume that physical beauty is a desideratum, in others and in ourselves—we make it into a fetish.

Another series of sculptures by Gober, depicting an isolated foot and leg emerging from a wall, presents a similar challenge to conventional fetishism. Gober has explained that these sculptures were inspired by encounters in quasi-public situations: a glimpse of the leg of a businessman seated next to him on an airplane, or the portion of a leg glimpsed under the stall in a men's room. The image also recalls a terrifying story from his childhood. Gober's mother worked as a nurse in an operating room before having children; once, as a kind of sadistic joke, the doctor handed her a just-amputated leg. As Gober puts it, the leg is "just one body part, but it's conflicted." It is another example of his interest in "identities that fold in on themselves and merge."[21]

Desire runs headfirst into castration anxiety: it sounds like Freud's formula for fetishism. And yet Gober's sculptures don't conform to the usual clichés of bodily fetishism: tight jeans, cleavage, etc. On the contrary, the exposure of hairy flesh above a sock is usually seen as a sartorial embarrassment. Instead of admiring the image of a well-turned calf, sheathed in fabric so that it becomes a kind of living sculpture, we are confronted with the reality of bare flesh and curly hairs. The genital association of the image is underscored in another version of this piece, where a prone man's legs are ornamented with phallic candles. In effect, Gober represents desire without fetishism.[22]

At the same time, the image of a foot shod in a scuffed leather shoe serves as a synecdoche, not for desire but for the world of work: for the walking and standing that everyday work requires, as well as for the experience of fatigue, the desire to call it quits and slump to the floor.[23] Here, too, we find a counterpart in Magritte's image of a pair of men's boots whose front parts have taken on the shape and color of the toes that they conceal, while their leather heels and dangling laces retain their original character. (Gober included a version of this image in his exhibition at the Menil Collection.) In other compositions, Magritte explored the obvious sexual potential of transforming clothing to reveal the body it was meant to conceal, but in

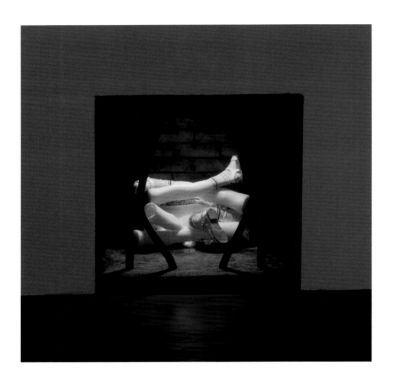

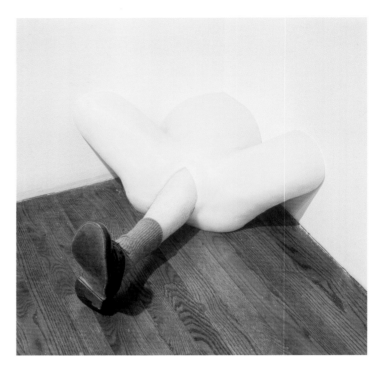

Robert Gober, *Untitled (Fireplace with Children's Legs)*, 1994–95, mixed media, 120.3 × 119.4 × 86.4 cm (overall), Robert Gober Studio

Robert Gober, *Untitled (Man Coming Out of the Woman)*, 1993–94, mixed media, 31.8 × 72.4 × 87.6 cm, Centre Nationale des Arts Plastiques, Paris

this instance the boots, like the famous worn boots painted by Vincent van Gogh, seem to stand in for an absent figure and its unspoken labor.[24]

Gober also created a series of truncated limbs, including a 1992 version that showed a child's leg, wearing a sock and sandal.[25] This then became the starting point for a new group of compositions involving multiple body parts. In one work, Gober created a fireplace with children's limbs stacked like pieces of timber atop an artificial fire. The front of the fireplace was closed off by iron bars like those of Gober's high windows, except that the central two bars were bent sideways, as if a strongman had pushed them apart to escape from the conflagration. Discussing this work with curator Richard Flood, Gober said that:

> It has a kind of storybook horror to it, a Hansel and Gretel-ish kind of horror. . . . Fireplaces are not exactly decorative. I think they're . . . a deep thing to have in your home. . . . Aside from warmth . . . fire is so powerful and its ability to destroy you so swift that I could understand why you would want to have a contained fire in your home. To sit and contemplate the beauty in something that has the ability to destroy you. So the legs enter into the story around that. . . . There are other stories of a kind of abuse . . . of children being used for other people's fuel.[26]

In another version of this composition, the firewood was replaced by a man's lower torso, with legs spread to reveal a child's leg emerging from its anus.

At first glance, there is no counterpart for such a work in Magritte's painting. However, discussing his varied leg sculptures, Gober has commented that they are "closer to Magritte's painting of a steam engine coming out of a fireplace than to

his pictures of literal body parts."[27] The fireplace setting for these sculptures thus seems to have been inspired by Magritte's *Time Transfixed*, while the protruding legs correspond to the miniature locomotive emerging mysteriously from the blank back wall of the fireplace. Magritte's painting invites a Freudian reading centered on the concept of castration anxiety. From this point of view, the dark aperture of the fireplace serves as a symbol for the vulva.[28] As Gober's comments suggest, it is simultaneously alluring (because of its warmth) and frightening (because of its destructive power). The locomotive is a mechanical phallus emerging triumphantly from its trial by fire, ejaculating white smoke as it advances.

Gober's sculpture of a child's leg emerging from a man's anus was in fact the sequel to another sculpture, which shows the leg of a grown man emerging from a woman's vulva. There is no fireplace frame. Instead, the woman's lower torso, with its legs spread and raised, is positioned in a corner.[29] Although the pose recalls Gustave Courbet's famous pornographic canvas, *The Origin of the World*, the effect of the sculpture is aggressively nonsexual. What is perturbing in this work is not primarily its anatomical explicitness, but the fact that a man's leg is emerging from the woman's vulva. It could be read as a visual statement of the Freudian theory of penis envy, with the leg serving the woman as a substitute phallus. However, the sculpture seems designed to remind us that the vulva is not just a site of sexual intercourse but is also (perhaps more importantly) a channel for giving birth. From this perspective, the work's slightly later pendant, Gober's sculpture of a child's leg emerging from a man's anus, seems to express a feeling of "womb envy": the desire that men, too, could give birth.

The strangeness of seeing a woman give birth to a full-grown man, with his leg already clothed in sock and shoe, derives not just from the implausibility of the image but also from its reversal of normal age relationships. It seems to go without saying that a mother must be older than her children. Here, however, we seem to be confronted with a son as old as—or older—than his mother. The inverted ages of Gober's mother and son recall the most famous couple in the history of Western sculpture: the mother and son in Michelangelo's *Pietà*. Michelangelo depicts the dead Christ as a grown man, while his mother, the Virgin, is depicted as a young woman, just barely old enough to have given birth to him. The sculpture telescopes and compresses the decades between infancy and maturity, between the Nativity and the Crucifixion. By bringing the Virgin and Son so close together in age, Michelangelo risks converting maternal into romantic love, tainting purity with sexual desire.

In this sense, *Man Coming Out of the Woman* looks forward to the radical reinvention of the Virgin in Gober's 1997 installation at MOCA. However, the earlier work avoids specifically Christian imagery in order to reflect on the ambiguities of the universal relationship between mother and child. As Gober himself puts it, it is "a rumination about who you are and where you come from."[30] Gober's sculpture continues Magritte's quest to explore the human condition by going beyond conventional reality.

Notes

1. As Sarah Whitfield points out in "Magritte and his Audience," Magritte's imagery anticipates the work both of pop and minimal artists such as Jim Dine and Robert Morris, and of younger artists such as Gober and Allan McCollum. See *Magritte*, exh. cat. (London: South Bank Centre, 1992), 11–23. For a more detailed discussion of Gober and Magritte, see Joan Simon, "Robert Gober et l'Extra Ordinaire," in *Robert Gober*, exh. cat. (Paris: Galerie Nationale du Jeu de Paume and Madrid: Museo Nacional Centro de Arte Reina Sofia, 1991), 9–10. (I am grateful to Whitney Museum of American Art curator Joan Simon, and to her assistant Stephanie Schumann, for providing me with a copy of this hard-to-find catalogue essay.) See also Gober's comments about Magritte in Craig Gholson, "[Interview with] Robert Gober," *Bomb*, no. 29, Fall 1989; reprinted in *speak art! the best of BOMB magazine's interviews with artists*, ed. Betsy Sussler (New York: G+B Arts International, 1997), 94. Regarding the influence of minimalism on contemporary art, see Lynn Zelevansky, *Sense and Sensibility: Women Artists and Minimalism in the Nineties*, exh. cat. (New York: Museum of Modern Art, 1994).

2. On Gober's childhood and his attitudes toward the Catholic Church, see Simon in *Robert Gober* (Paris 1991), 16.

3. Gober's recollection of discovering Magritte in high school is from an informal interview with the author on December 21, 2005. The link between Gober's cigar and Magritte's *State of Grace* is discussed by Simon in *Robert Gober* (Paris 1991), 11. For Gober's 2005 exhibition *The Meat Wagon*, which juxtaposed his own work with pictures by Magritte (including *The Survivor* [1950], *The Song of the Storm* [1937], and a drawn version of *The Red Model* [1964]) and a wide variety of objects from the Menil Collection, see *Robert Gober: The Meat Wagon*, exh. cat. (Houston: The Menil Foundation, 2006).

4. Another aspect of the meaning of Gober's sinks lies in their reference to the daily labor of housekeeping. This is something he alluded to in a painting from his student years, showing a woman washing dishes in a sink; see the *Untitled* picture reproduced in *Robert Gober: Sculpture + Drawing*, exh. cat. (Minneapolis: Walker Art Center, 1999), 57. The woman washing dishes is seen from above; only her forearms and a sliver of her torso are visible, so that attention is focused on the sink. Joan Simon notes how often the themes of housecleaning and toilets appear in the art of the 1980s work of artists such as Jeff Koons, Haim Steinbach, and Meyer Vaisman.

5. Robert Gober, *Untitled* (1991), reproduced in *Robert Gober*, exh. cat. (London: Serpentine Gallery and Liverpool: Tate Gallery, 1993), 20. Gober made a similar allusion to his own mortality in a 1991 multiple where he reproduced a page from a 1960 issue of the *New York Times*, including a fake story recounting his own death by drowning at the age of six.

6. It should be noted that the association between sinks and morbidity is not unique to Gober, but seems to be a part of the modern collective unconscious. For instance, the Brazilian artist Cildo Meireles used a sink in his installation *Red Shift* (1967–84). The viewer enters a room where all the furnishings are red—the carpet, the sofa, the bookshelves, the paintings on the walls. At the far end, there's a dark corridor where the red carpet becomes a puddle of red liquid. Around the corner, at the end of the corridor, the viewer discovers that the red liquid is coming from the drain of a spot-lit sink, with reddened water flowing out of the faucet. The installation is a reference to the military dictatorship that ruled Brazil in these decades: people continued making art, but in a sense everybody who participated in such bourgeois activities had blood on his hands. Meireles's political message seems very distant from Magritte's more abstract revolution in consciousness. See Dan Cameron's discussion of this work in Paulo Herkenhoff et al., *Cildo Meireles*, exh. cat. (London: Phaidon, 1999), 83–93.

7. Compare, for instance, the wraparound garden painted for the Villa Livia around 30 B.C., now on display in the Palazzo Massimo in Rome. It should be noted that the landscape of Gober's Jeu de Paume exhibition was based on "found" wallpaper patterns, so it functioned simultaneously as reality and as appropriation. See the wallpaper patterns reproduced in *Robert Gober* (Paris 1991), 9.

8. Robert Gober, *Untitled* (1976), reproduced in *Robert Gober* (Minneapolis 1999), 55.

9. Gober, interview with author, December 21, 2005.

10. Ibid.

11. There is a more literal antecedent for Gober's high windows in one of Magritte's lesser-known paintings, *Natural Encounters* (1945), which shows a pair of surreal figures standing in front of a wall pierced by two high casement windows revealing patches of blue sky. See David Sylvester et al., *René Magritte: Catalogue Raisonné*, vol. 2 (Antwerp: Mercatorfonds and Houston: The Menil Foundation, 1993), no. 595.

12. Whitfield, in *Magritte* (London 1992), 18–19, and see Magritte's *The Unexpected Answer* (1933).

13. Compare Richard Serra's *Doors* (1966–67), reproduced in Rosalind E. Krauss, *Richard Serra*, exh. cat. (New York: Museum of Modern Art, 1986), pl. 1.

14. In fact, there is a literal link between Judd's plywood work and Gober's sculpture. Gober was determined to use the coarsest commercial grade of plywood veneer for the surface of his work, but it turned out that none of the companies that produce such veneer were willing to sell it in anything less than industrial quantities. Finally, the intervention of Peter Ballantine, who had overseen the fabrication of Donald Judd's plywood sculptures, persuaded Judd's supplier to sell Gober a single truckload of veneer.

15. In addition to *The Prince of Objects*, see Sylvester, *Catalogue Raisonné*, vol. 1 (1992), nos. 183–87. Later, in a gouache from 1938 or 1939 (*Fortune Telling*, in Sylvester, *Catalogue Raisonné*, vol. 4 [1994], no. 1143), Magritte combines the door motif and the wood motif, depicting a door that fades imperceptibly from a bluish white to the textured brown of bare wood.

16. Magritte depicts the body on five separate canvases in *The Eternally Obvious* (1948); see also the 1930 version (Sylvester, *Catalogue Raisonné*, vol. 1, no. 327). For other examples of the isolated torso, see *The Six Elements* and *On the Threshold of Freedom* (Sylvester, *Catalogue Raisonné*, vol. 1, no. 326) and *Act of Violence* (Sylvester, *Catalogue Raisonné*, vol. 2, no. 345). On the general theme of bodily fragmentation in modern art, see Linda Nochlin, *The Body in Pieces: The Fragment as a Metaphor of Modernity* (London: Thames and Hudson, 1994).

17. Arguably, this conflict between masculine and feminine is anticipated by Magritte's *The Titanic Days* (1928). However, Magritte's rape imagery, with its suggestion of an experience simultaneously feared and desired, is a cliché of 1930s surrealism; Gober's non-narrative division of the body is far less conventional.

18. On Magritte's use of sculptural models, see the notes to *The Marches of Summer* in *Magritte* (London 1992), no. 82. Even Magritte's paintings from live models end up reproducing this conventional anatomy. Although Magritte's wife, Georgette, supposedly served as the model

for the nude figure in *Black Magic*, her body strongly resembles the statues in other canvases.

19. "Robert Gober: Interview with Richard Flood," in *Robert Gober* (London 1993), 10 and 14; reprinted (with modifications) in *Robert Gober* (Minneapolis 1999), 122–23 and 126–27.

20. Compare *Ajitto*, Mapplethorpe's 1981 photograph of a seated black model facing right (reproduced in Richard Marshall, *Robert Mapplelthorpe*, exh. cat. [New York: Whitney Museum of American Art, 1988], 97), with Hippolyte Flandrin's 1835–36 painting *Nude Young Man Sitting on a Rock* (reproduced in *Hippolyte, Auguste et Paul Flandrin: Une fraternite picturale au XIXe siecle*, exh. cat. [Paris, Musée du Luxembourg and Lyon: Musee des Beaux-Arts, 1984], no. 14).

21. *Robert Gober* (London 1993), 13; reprinted in *Robert Gober* (Minneapolis 1999), 126. Gary Indiana, "Success: Robert Gober," *Interview*, May 1990, 72; cited in Helaine Posner, *Corporal Politics*, exh. cat. (Cambridge: MIT List Visual Arts Museum and Boston: Beacon Press, 1992), 38. Quotations at end of paragraph from author's interview with Gober, December 21, 2005.

22. For Freud's analysis of fetishism as a reaction to the trauma of discovering the mother's "castration," resulting in the compensatory fantasy of a (disguised) maternal phallus, see Sigmund Freud, "Fetishism" (1927), in *Freud, Sexuality and the Psychology of Love*, ed. Philip Rieff (New York: Collier, 1963), 214–19. The prone legs with candles were part of Gober's 1991 installation at the Jeu du Paume; see the reproduction in *Robert Gober* (London 1993), 5. Gober discussed another version of the leg/candle sculpture in an interview with Richard Flood, transcribed in *Robert Gober* (Minneapolis 1999), 133.

23. On the sources of Gober's shoes, see Brenda Richardson, *A Robert Gober Lexicon* (New York: Matthew Marks Gallery and Göttingen: Steidl, 2005), 19.

24. The idea of a garment taking on the shape of the body parts it conceals seems first to have appeared in Magritte's 1936 painting *In Memory of Mack Sennett*, where the top of a woman's dress, hanging in an armoire, has taken on the shape of her classically shaped breasts. In his 1947 painting *Philosophy in the Boudoir*, Magritte combined the motifs of the dress-with-breasts and the shoe-with-toes to produce a more conventionally fetishistic image (see Sylvester, *Catalogue Raisonné*, vol. 2, no. 633). Freud's classic analysis of shoe fetishism appears in his essay "Fetishism"; see n. 22.

25. See the reproduction in Richardson, *A Robert Gober Lexicon*, 23.

26. Interview with Richard Flood, in *Robert Gober* (Minneapolis 1999), 132.

27. Interview with author, December 21, 2005.

28. The sexual symbolism of Magritte's 1938 fireplace might be compared to that of Edward Weston's contemporary (1937) photograph of his companion, Charis Wilson, lying nude in front of an old mud oven in New Mexico. (See the reproduction in Charis Wilson, *Edward Weston: Nudes* [Millerton: Aperture, 1977], pl. 96.) Weston juxtaposes the dark triangle of Wilson's pubic hair with the darkness of the oven right above her groin.

29. Gober here recalls the role of the corner as a symbolically charged space in minimal and postminimal art. On this topic, see Pepe Karmel, "The Corner as Trap, Symbol, Vanishing Point, History Lesson," *New York Times*, July 21, 1995, p. c25.

30. Interview with author, December 21, 2005.

Magritte, *The Ellipsis*, 1948

La Période Vache:
A Latter-Day Epidemic

NOËLLIE ROUSSEL

In the forty years since Magritte's death, we have witnessed the challenge to the modernist model, which has encouraged the reassessment of long-derided work by certain artists, for example, the recent reevaluation of Francis Picabia's late work (from 1933 on). This process has affected such popular figures as de Chirico (regarding his academic phase) and Dalí. And it has occurred, albeit more discreetly, in the case of René Magritte, with the rediscovery of two key moments in his production, when he deviated from the expected artistic norm of his time to introduce significant changes in his own style, first with his "sunlit surrealism" initiated during World War II, followed in 1948 by the brief but extremely significant *vache* period.[1]

Except for a few brief periods, Magritte lived at a distance from what, in his day, was the center of the art world: Paris. In Brussels he largely led a bourgeois life, quite unlike the bohemian existence that cliché associates with being an artist. During World War II, when many surrealists left Paris for exile in New York, Magritte remained in Nazi-occupied Brussels. Far from the artistic debates that raged on the other side of the Atlantic, Magritte drastically changed the style of his painting. First, he began using a technique derived from impressionism, producing an appearance influenced by the late Renoir. While this technique has been called "sunlit surrealism," in Magritte's case it actually corresponded to a desire to get away from orthodox surrealism, whose concerns struck him as untimely at best during the dark years of the Occupation. He intended his new style to inspire feelings of happiness and calm to help people forget the harsh realities of the war.

But the subjects of these paintings were still strange, demonstrating a powerful erotic charge. A small ballerina seems to replace the cellist's penis in *The First Day* (1943), where the apparent gaiety and peacefulness of the Renoiresque subject is contradicted by the incongruous absurdity of the detail. Other paintings returned to familiar subjects, as in *Freedom of Religion* (1946), with the artist's emblematic pipe seeming to float above a rural landscape, inundating it with rays of light. The works from this period remain little known, but they indicate a tendency toward a more nonlinear stylistic eclecticism that we find in such boldly innovative contemporary artists as Sigmar Polke and Martin Kippenberger. Here Magritte was signaling his desire to break with the norm, as well as with the perception the art world might have had of his work.

This change of style was followed in 1948 by another turnabout, the famous *vache* period, which, according to the historians who have studied it, lasted somewhere between a few weeks and a few months.[2] Magritte's intense activity in preparation for what was his first and last solo show in Paris saw him thumbing his nose at the city's art world, a city whose light as world capital of art was beginning

to flicker as New York increasingly laid claim to that title.[3] Magritte was not only confronting the limited circle of Parisian surrealists, but also going against what were then the current stereotypes of modernism. Rebuffing the rigid vision of his art maintained by critics anxious to keep in step with what seemed like the march of history, he presented paintings that were an anachronism: with loud and clashing colors, they were presented in a style that was deliberately infantile, aggressive, and awkward and that deliberately parodied his own paintings. Magritte was refusing to consider art in terms of the idealism that was then manifesting itself in the return to abstraction—in Europe with COBRA, and in the United States with various proponents of abstract expressionism.[4]

Organized by Kasper König in Cologne in 1981, the *Westkunst* exhibition's re-examination of Western art since 1949 included one of the first attempts to reconsider Magritte's *vache* period.[5] Martin Kippenberger was living in Berlin at the time, though it is impossible to say with any certainty whether he saw this show. However, there is no denying that *Westkunst* helped create a new context, a state of mind conducive to the favorable reception of the "mediocre"—as Philippe Vergne characterized it, "stupid, daubed, humorous, regressive painting."[6] Kippenberger, who died in 1997, evinced a healthily disrespectful and mocking attitude toward the established values of contemporary art, his work coinciding with a very specific moment in German artistic culture. Caught between such grand elders of German postwar art as Gerhard Richter and Joseph Beuys, the rise of a neoexpressionist style of painting, and the ascension of the neo-objectivist photography of Bernd and Hilla Becher and their followers (such as Thomas Struth and Andreas Gursky), Kippenberger had few alternatives if he was to escape the stifling weight of all this ambient gravitas.[7]

Living a nomadic life and interested in a broad range of styles and practices, Kippenberger set himself the task of destroying the prejudices of the contemporary art system of the early 1980s. He made absurd public sculpture devoid of social or redemptive function, as in the series of stations for subways that go nowhere (his one purposefully useful sculpture was his 1988 *Lamppost for Drunks*). In a famous show at the Pompidou, he exhibited as his own work objects—from laundry detergent to artworks—lent to him by dozens of friends. He also defied the seriousness and the pathos of "serious" art of the time (manifested most notably in Germany by Anselm Kiefer and Georg Baselitz) by giving his paintings absurd titles (e.g., *Guitar, You Who Are Not Called Gudrun*) and generally worked to desanctify painting, which he considered in danger of overglorification. One strategy he adopted in this quest was to add new paintings to a series left unfinished by Picasso at his death (*Ohne Titel, aus der Serie Jacqueline: The Paintings Pablo Couldn't Paint Anymore*, 1996), which "in a way completed the work," thereby substituting his own name for that of the most famous painter of the twentieth century.[8]

His most effective ploy in confounding contemporary expectations was to create a crude, colorful painterly style showing absurd situations or figures from popular culture and the collective vernacular. *Punch II* (1993) and *Punch VIII* (1993) feature a kind of variegated Punchinello reminiscent of the *Triumphal March* from Magritte's *vache* period. In *German Egg Banger* (1996) an egg in a Tyrolean or Bavarian costume brandishes what may be a weapon in a mix of colors dominated by a rather gloomy blue-green. Elsewhere, he used figures such as Santa Claus in his *Krieg Böse* series (started in 1983), whose title (using awkward German syntax to begin with)

Magritte, *The Stop*, 1948

Martin Kippenberger, *Punch VIII*, 1993

Martin Kippenberger, *The Philosopher's Egg*, 1996

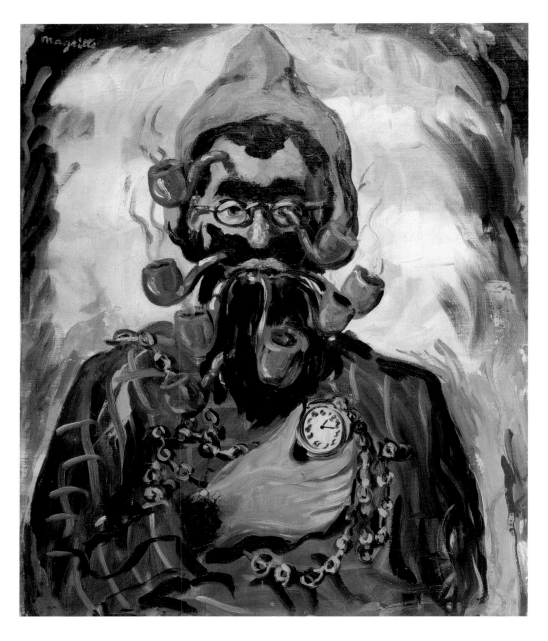

Magritte, *The Cripple*, 1948

translates roughly as "war wicked." The style of the painting seems approximate and unstable, and yet the composition is effective, without imbalance, despite its lack of conventional three-dimensional rendering. The subject is ridiculous—a cute little Santa raising his arm to stop a battleship—but the texture of the paint is revelatory. Like Magritte when he entered his *vache* period, Kippenberger's desire to create "bad" painting is manifest only in the subject and the touch—to sum up: in the attitude. The result is a body of work that is simultaneously legible, ferocious, and funny, work that skillfully undermines the expectation of "quality" and formal perfection attached to the long history of pictorial representation. Unlike Magritte's *vache* period, however, Kippenberger's work was more favorably received in a period open to the gust of fresh air that was his art.

In contrast, Magritte's determination to go against the main artistic currents of his day, his pessimistic and disenchanted irony, predictably met with incomprehension from both critics and the public. After the critical trashing he received for his one-person exhibition in Paris, made worse by the failure to sell one single painting, Magritte bitterly returned to his prewar style, which was also his wife's preference. For years afterward, the *vache* period lay forgotten, undisturbed and ignored, viewed as a moment of hallucinatory aberration by Magritte's most fervent exegetes, a malady that should not be recalled, lest it unleash a metaphoric bad case of mad cow disease that would alter forever the beloved master's good reputation. It was only toward the end of the 1980s, initiated by *Westkunst*'s presentation of the *vache* period, that this major stylistic change was reevaluated.[9]

Sherrie Levine, *Une Pipe*, 2001

Magritte was very much aware of the iconic association of much of his work, particularly the pipe and bowler hat, which he mocked in the *vache* paintings (for example, *The Cripple*, 1948) and in various photographic portraits of himself. In the 1980s, the pipe made a comeback when it was directly quoted by Sherrie Levine, one of the emblematic artists of the appropriation movement, in her *Une Pipe* (2001). And though this pipe is three-dimensional it is no more of a smoke than Magritte's; it is the materialization of a representation but still not the object itself. This piece, like almost all her work, is an heir of Duchamp's readymades, in their appropriation of twentieth-century icons.

Another artist from the same generation as Levine, Richard Prince, references Magritte in a less direct but nevertheless discernible way. His joke paintings, for example, share some sensibilities with the *vache* paintings in the sense that their subject matter is not serious; they also seem to be crudely executed. Additionally, in an ironic twist on the image/text relationship often seen in conceptual art, they reproduce jokes that aren't particularly funny. There is a discrepancy between the cartoon that is reproduced and its accompanying text, which is taken from a different joke. This incongruity means that the joke either fails to make sense of the content of the drawing or changes its meaning entirely. This is particularly evident in *The Salesman and The Farmer* (1989), in which two different texts—one handwritten, the other printed—frame a drawing of two women in a living room, a scene that doesn't appear to relate to the content of either of the two jokes. This underlines Magritte's lesson in representation: what is depicted is an illusion, and words are as powerless as images to make sense of the real.

Richard Prince, *The Salesman and the Farmer*, 1989

Magritte's best-known images are now so pervasive that many of them have been assimilated into the collective popular imagination; this may be one source for

Jim Shaw, *Bon Idée*, 1987

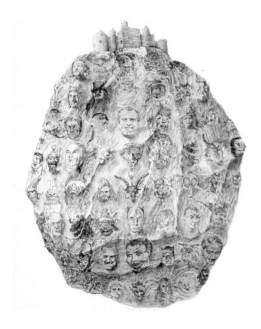

Jim Shaw, *Red Rock*, 1990

the cloudy skies accompanied by an incongruous text, often with narrative content, in the drawings of Raymond Pettibon, as in *Untitled (Little by Little)* (1992), or the gigantic eye of *Untitled ("Where was I?")* (1987). These recall Magritte's *The False Mirror*, and then there are the trains that frequently recur in Pettibon's drawings and inevitably bring to mind *Time Transfixed. Untitled (Rosetta Stone)* (1998) may look like a faithful representation of its subject, but its composition brings to mind Magritte's stones floating in space (as in *The Active Voice*). The same pervasiveness of Magritte's icons can be seen in the trompe l'oeil effects (the perfect flatness of the blue surface framed by the fake wood) in Mike Kelley's *Woodgrain #2*.

Jim Shaw has often referred to Magritte as a symptom of a culture in which reproductions and their spin-offs so saturate our mental and imaginary worlds that art eventually becomes part of our way of seeing reality. His *My Mirage* series (1986–91) centers on a fictitious teenager, Billy, whose thoughts and actions are transcribed in a variety of styles borrowed from famous artists, including Magritte. *My Mirage* documents Billy's coming of age in the 1960s and 1970s, his various encounters with the counterculture, his interest in visual art, his decline and fall through sex, drugs, and rock 'n' roll, and his redemption as a born-again Christian. *Bon Idée* (1987) and *Kryptonite Nixon* (1991) are formal fabrications whose style deliberately pastiches and parodies Magritte's. *Bon Idée* (which should be spelled *Bonne Idée*) is clearly derived from Magritte's word-and-image pictures, such as *The Interpretation of Dreams*, with their now-familiar dissociation between the image/representation and the meaning of the word associated with it; it is also simply an homage to a painter Shaw very much admired as a teenager. *Red Rock* is another obvious appropriation of Magritte's works (in this case *The Castle of the Pyrenees*, with its giant rock floating on an empty background), but it is appropriated with a twist. Rather than dwell on the visual trick of Magritte's levitating stone and its crowning castle embedded at the top, Shaw adds another illusion with several dozen devilish portraits (one of them resembling Richard Nixon); petrified and at the same time springing from the rock, they recall the imagery of horror movies in addition to the apparent nod to Magritte.

As derivative as these artworks by Shaw might seem, they are part of an ambitious ensemble of projects, including *My Mirage* and later the *Dream Drawings* and *Dream Objects* series (from 1995 to the present), that delve deeply into American popular culture. These examples of Magritte's iconography applied to 1980s and 1990s artworks by Shaw (and Pettibon) also reflect on the shifting status of Magritte in the contemporary telling of a "modern," New York-centric art history. From his position as a respected classic midcentury master honored by pop artists in the 1960s, two decades later Magritte was often considered a sellout—a characterization that stemmed from the Magritte posters, album covers, mugs, and umbrellas that flooded even the remotest outpost of the imagined Midwest where the Billys of the world lived, and where Magrittean imagery had been reduced to a window open for cheap escapism.

It was rather unfashionable for most artists in the 1980s to refer explicitly to surrealism in their work, and most particularly to Magritte. Magritte's *vache* period was virtually unknown in the United States, and if surrealism was discussed at all in intellectual and theoretical circles it was its pioneering use of photography that was most often considered, with the painters of the era still thought of as some kind of accidents stumbling on the road toward abstraction. Magritte was narrowly (and

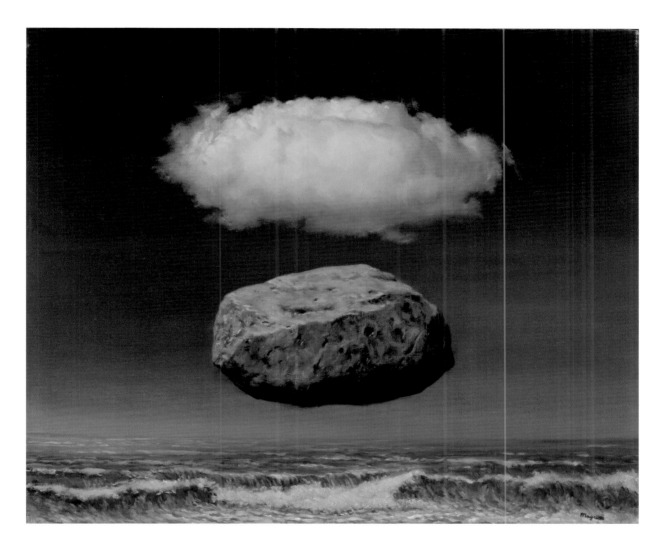

Magritte, *Clear Ideas*, 1958

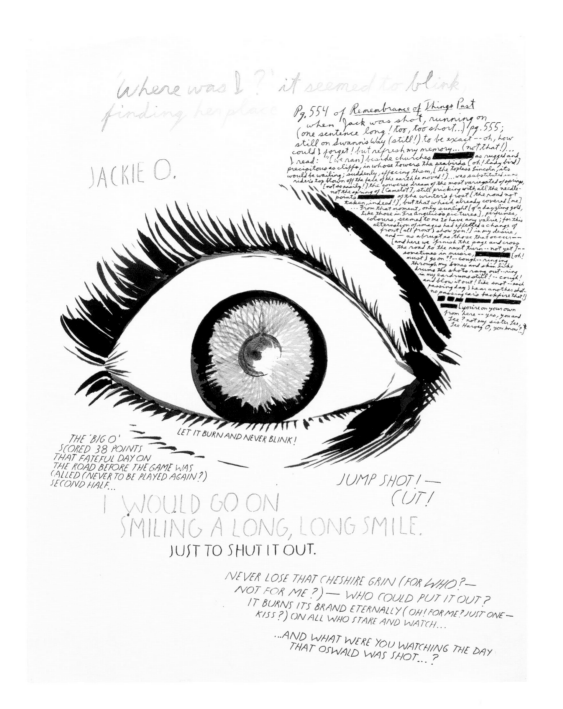

Raymond Pettibon, *Untitled ("Where was I?")*, 1987

somewhat grudgingly) exempted from the vilification unleashed on Dalí by the virtue of his early word-and-image paintings. Their intellectual and preconceptual qualities redeemed him in many theoretical, Foucault-influenced minds that might otherwise have viewed him with suspicion due to his posthumous commercial success.

For artists like Shaw and Pettibon, the significance of channeling a different Magritte—that is, the popular, "debased" one—whether directly or unconsciously, was multifold. First, it was a bit of an anachronism for people associated at the beginning of their careers with the Los Angeles punk scene (particularly Pettibon, who regularly designed flyers and record covers for such bands as Black Flag and the Minutemen) to draw on imagery pillaged by so many rock artists of the immediate past, such as Jackson Browne, Jeff Beck, and Styx—associations which carried the risk of undermining their punk credentials. For both artists, being based in Los Angeles (Pettibon as a native; Shaw as a transplant from Michigan) was important in the sense that the distance from the New York art world allowed them to work in comparative freedom, as their East Coast counterparts were more likely to submit to the pressure of having to discuss their postmodern art in terms still dependent on those of modernism. In other words, Shaw and Pettibon could experiment freely with tropes borrowed from the apparently outmoded Belgian, using them to build narratives and use figurative, seemingly old-fashioned media such as drawing and painting rather than photography, video, or installation.[10]

Both Pettibon and Shaw have used Magritte in only a few occasions in their work, and it would be overestimating his influence to state that their work shows a massive debt to the Belgian artist. But interestingly enough, their discreet, even subliminal, borrowing from his iconography can be seen as indicative of the almost-universal attraction Magritte's works still exert, and how his imagery can be used to examine various topics of American culture. What is most fascinating is the way his images have grown to be so pervasive, and how their initial gentleness (expressing what Magritte called *le mystère*) has transformed itself in contemporary artworks to serve as a common ground in expressing a sense of angst, irony, and despair that persists underneath the dominant cultural message of America's economic and political power.

Translation assistance by Charles Penwarden

Notes

1. Literally, "cow"; colloquially, "vache" is used to signify something mean, stupid, cruel, etc.
2. See *René Magritte: La période "vache,"* exh. cat. (Marseille: Musée Cantini, 1992).
3. The exhibition at the Galerie du Faubourg opened on May 11, 1948. The reception of Magritte's paintings was stormy, to say the least, and press cuttings from the time show the violence with which he was attacked by critics. On New York's rise as the capital of modern art, see Serge Guibault, *How New York Stole the Idea of Modern Art* (Chicago: University of Chicago Press, 1985).
4. It should be noted that Magritte was very much aware of what was happening in contemporary art and closely followed the artistic debates in Europe and in the U.S., which he often commented on in both private correspondence and public interviews.
5. It also included Picabia's late paintings.
6. Philippe Vergne, "Petit voyage au pays de la régression picturale," in *La période "vache"* (Marseille 1992).
7. It is worth noting that Sigmar Polke's work was acquiring a much more established status around the same time, providing a great precedent as an eccentric, eclectic model for the upcoming generation of German artists, including Kippenberger.
8. Quoted in *Kippenberger* (Cologne: Taschen, 1997), 200.
9. The chronology of the rediscovery of the *période vache* and the parallel with the organization of exhibitions of the "new" painting of the 1980s is analyzed by Vergne in "Petit voyage," 55–61.
10. Both Shaw and Pettibon have made a few videos, which were also narrative-based and not particularly influenced by the poststructuralist experimental film and video approach that still dominated new media in the early 1980s.

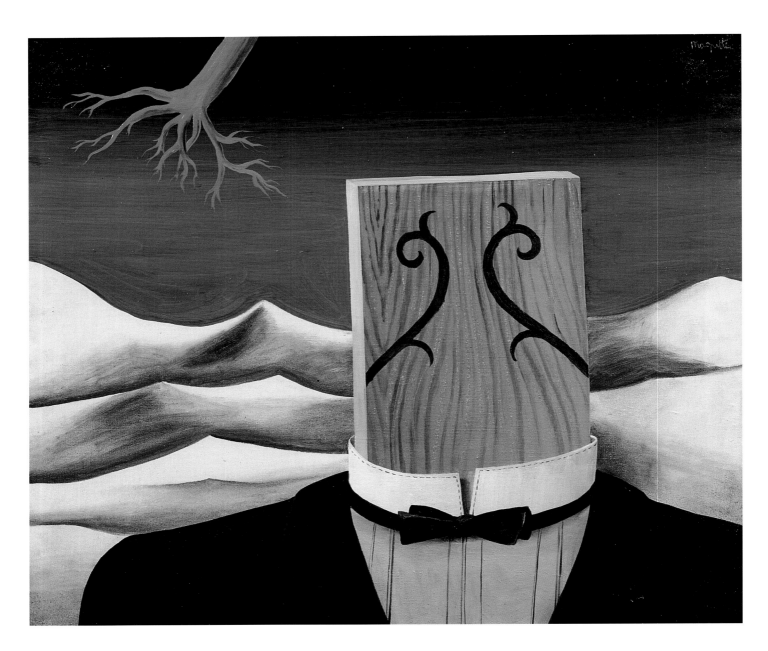

Magritte, *The Conqueror*, 1926

Checklist of the Exhibition

The checklist is accurate as of June 22, 2006.

René Magritte

Magritte object information is based upon David Sylvester, *René Magritte: Catalogue Raisonné* (Antwerp: Mercatorfonds and Houston: The Menil Foundation, 1992–97); any deviations are included in brackets on the following line. For each painting and gouache, the catalogue raisonné entry is indicated by a CR number following the credit line. Drawings by Magritte are not included in the catalogue raisonné, and so are listed without CR numbers.

The Conqueror (Le conquérant), 1926
Oil on canvas
65 × 75 cm
Leslee and David Rogath
CR 113

The Imp of the Perverse (Le démon de la perversité), 1927
Oil on canvas
81 × 116 cm
Musées Royaux des Beaux-Arts de Belgique, Brussels
CR 195
p. 59

The End of Time (La fin du temps), 1927
Oil on canvas
73 × 54 cm
Private collection
CR 179
p. 190

Attempting the Impossible (Tentative de l'impossible), 1928
Oil on canvas
116 × 81 cm
Toyota Municipal Museum of Art, Japan
CR 284
p. 230

The Lovers (Les amants), 1928
Oil on canvas
54 × 73 cm
Collection of the National Gallery of Australia, Canberra, purchased 1990
CR 251
p. 13

The Subjugated Reader (La lectrice soumise), 1928
Oil on canvas
92 × 73 cm
Private collection, courtesy of Ivor Braka Ltd., London
CR 230
p. 156

The Titanic Days (Les jours gigantesques), 1928
Oil on canvas
116 × 81 cm
Kunstsammlung Nordrhein-Westfalen, Düsseldorf
CR 247
p. 15

The Voice of the Air (La voix des airs), 1928
Oil on canvas
65 × 50 cm
Collection Albright-Knox Art Gallery, Buffalo, New York, Albert H. Tracy Fund by exchange; George B. and Jenny R. Mathews Fund, 1976
CR 241
p. 48

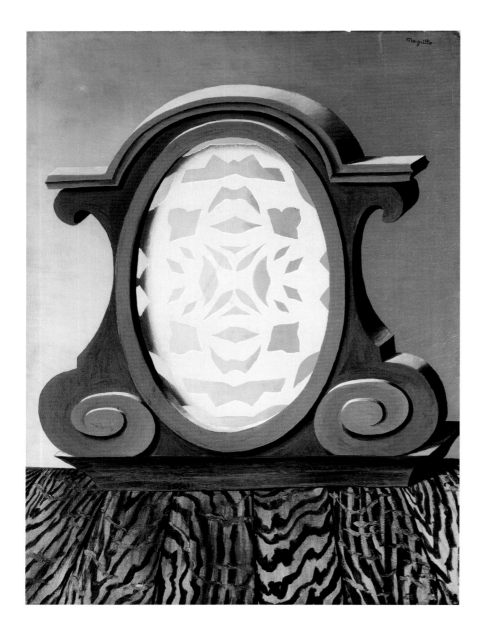

Magritte, *The End of Time*, 1927

Words and Images (Les mots et les images), 1928
Five sheets of paper with 18 original drawings
Each sheet: 27.2 × 28 cm
Private collection
pp. 32, 191

The Literal Meaning (Le sens propre), 1929
[The Literal Meaning IV]
Oil on canvas
73 × 54 cm
Robert Rauschenberg Foundation Collection
CR 309
p. 52

The Six Elements (Les six éléments), 1929
Oil on canvas
73 × 100 cm
Philadelphia Museum of Art, the Louise and Walter Arensberg Collection, 1950
CR 321
p. 55

The Treachery of Images (La trahison des images), 1929
[This is not a pipe/Ceci n'est pas une pipe]
Oil on canvas
60 × 80 cm
Los Angeles County Museum of Art, purchased with funds provided by the Mr. and Mrs. William Preston Harrison Collection, 78.7
CR 303
p. 28

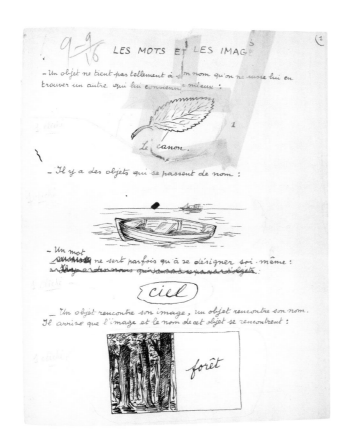

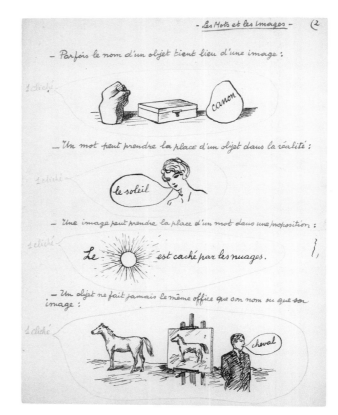

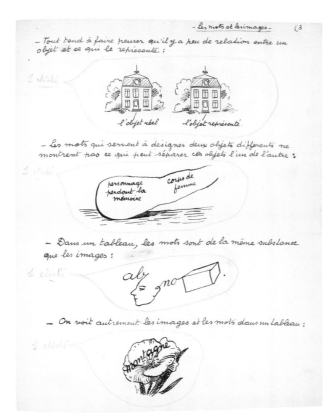

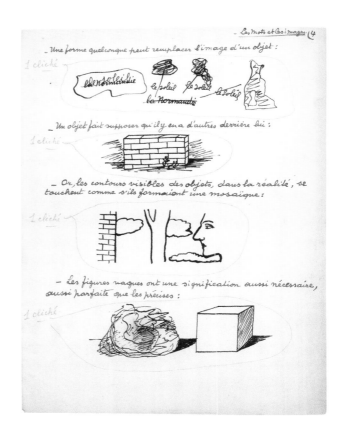

Magritte, *Words and Images*, 1928 (fifth sheet on p. 32)

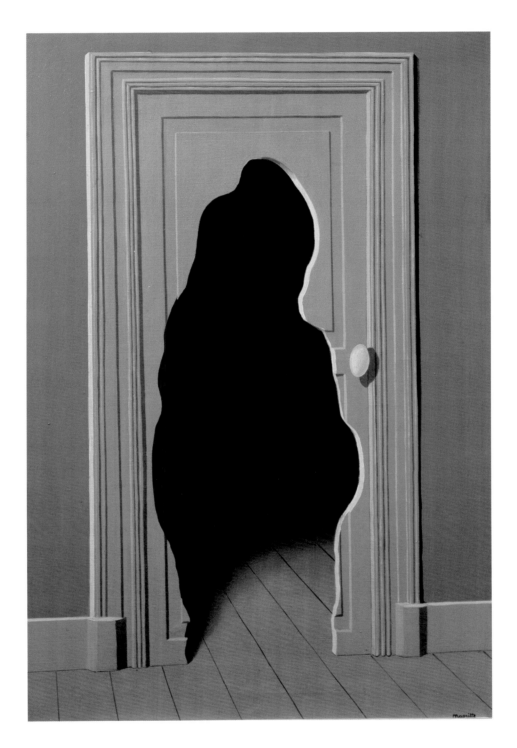

Magritte, *The Unexpected Answer*, 1933

The Annunciation (L'annonciation), 1930
Oil on canvas
114 × 146 cm
Tate, purchased with assistance from
the Friends of the Tate Gallery, 1986
CR 330
p. 20

*The Human Condition (La condition
humaine)*, 1933
Oil on canvas
100 × 81 cm
National Gallery of Art, Washington,
DC, gift of the Collectors Committee,
1987.55.1
CR 351
p. 8

*The Unexpected Answer (La réponse
imprévue)*, 1933
Oil on canvas
81 × 54 cm
Musées Royaux des Beaux-Arts
de Belgique, Brussels
CR 350

Black Magic (La magie noire),
first version, 1934
Oil on canvas
73 × 54 cm
Private collection
CR 355

The Ladder of Fire (L'échelle du feu), 1934
Oil on canvas
54 × 73 cm
Private collection, courtesy of
Guggenheim, Asher Associates, Inc.
CR 358
p. 194

The Rape (Le viol), 1934
Oil on canvas
73 × 54 cm
The Menil Collection, Houston
CR 356
p. 44

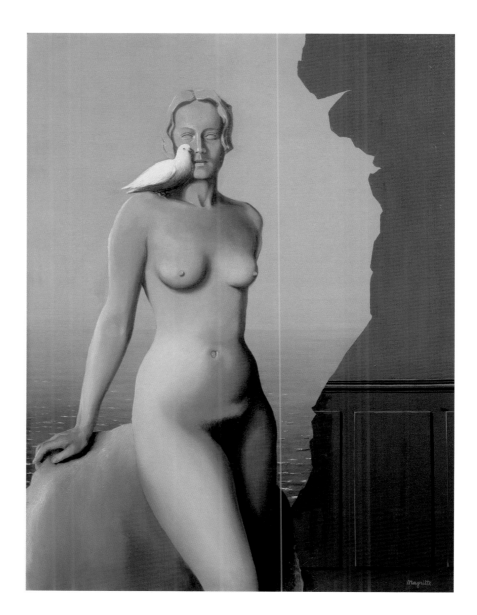

Magritte, *Black Magic*, 1934

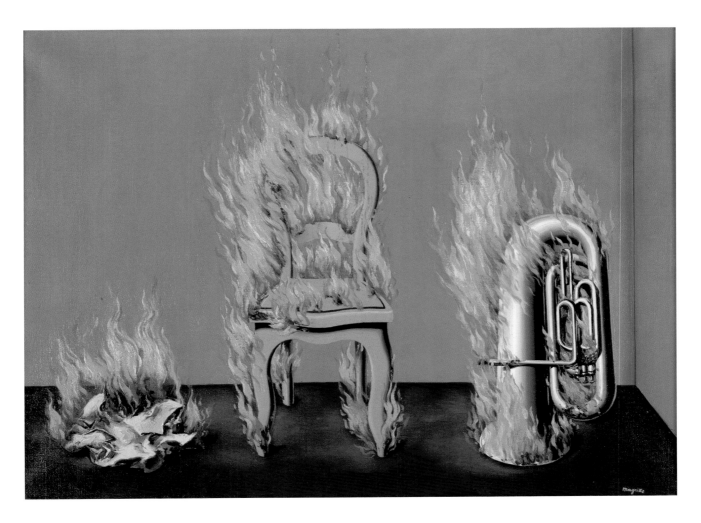

Magritte, *The Ladder of Fire*, 1934

The Discovery of Fire (La découverte du feu), 1934 or 1935
Oil on canvas
33 × 41 cm
Leslee and David Rogath
CR 359
p. 45

The Palace of Curtains (Le palais de rideaux), 1935
Oil on canvas mounted on board
27 × 41 cm
Collection Pierre Alechinsky
CR 368

The Portrait (Le portrait), 1935
Oil on canvas
73 × 50 cm
The Museum of Modern Art, New York, gift of Kay Sage Tanguy, 1956
CR 379
p. 131

The Treachery of Images (La trahison des images), 1935
Oil on canvas
27 × 41 cm
Private collection, Brussels
CR 369
p. 47

The Philosopher's Lamp (La lampe philosophique), 1936
Oil on canvas
46 × 55 cm
Private collection
CR 399
p. 16

The Curse (La malédiction), 1936 or 1937
Oil on panel
11.7 × 11.7 cm
J. Nicholson, Beverly Hills
CR 422

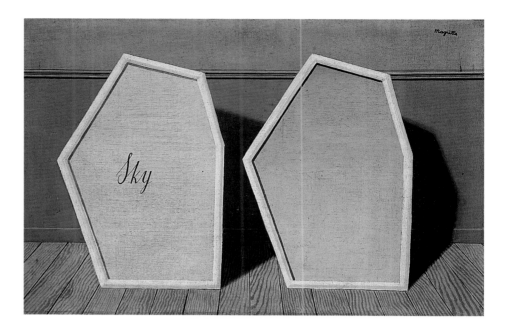

Magritte, *The Palace of Curtains*, 1935

Painted Object: Eye (Objet peint: œil), 1936 or 1937
Oil on panel glued in painted wooden box
Diameter: 15.3 cm;
base: 25.2 × 25.2 × 5.7 cm
Collection of Timothy Baum, New York
CR 685
p. 235

The Pleasure Principle (Le principe du plaisir), 1937
Oil on canvas
73 × 54 cm
Private collection
CR 443
p. 234

The Red Model (Le modèle rouge), 1937
Oil on canvas
183 × 136 cm
Museum Boijmans Van Beuningen, Rotterdam
CR 428
p. 71

Magritte, *The Curse*, 1936 or 1937

Magritte, *The Cut-Glass Bath*, 1946

*Time Transfixed (La durée
poignardée)*, 1938
Oil on canvas
147 × 99 cm
The Art Institute of Chicago (Joseph
Winterbotham Collection)
CR 460
p. 146

Deep Waters (Les eaux profondes), 1941
Oil on canvas
65 × 50 cm
Private collection
CR 491
p. 21

Untitled (Pipe), 1944
Pencil on paper
8.3 × 11.4 cm
Private collection
Not illustrated

A Stroke of Luck (La bonne fortune), 1945
Oil on canvas
60 × 80 cm
Musées Royaux des Beaux-Arts
de Belgique, Brussels
CR 579
p. 22

The Rape (Le viol), 1945
Oil on canvas
65 × 50 cm
Musée National d'Art Moderne,
Centre Georges Pompidou, Paris,
Legs de Georgette Magritte en 1987
CR 580
p. 66

The Cut-Glass Bath (Le bain de cristal),
1946
Gouache on paper
48.5 × 34 cm
Private collection, London
CR 1215

Magritte, *The Freedom of Worship*, 1946

*The Freedom of Worship (La liberté
des cultes)*, 1946
Oil on board
24 × 33 cm
Private collection, courtesy of Galerie
1990–2000, Paris
CR 605

The Liberator (Le libérateur), 1947
Oil on canvas
100 × 80 cm
Los Angeles County Museum of Art,
gift of William Copley, 52.31
CR 630
pp. 74, 142

The Cripple (Le stropiat), 1948
Oil on canvas
59.5 × 49.5 cm
Musée National d'Art Moderne,
Centre Georges Pompidou, Paris
CR 658
p. 182

Magritte, *The Human Condition*, 1948

The Ellipsis (L'ellipse), 1948
Oil on canvas
50 × 73 cm
Musées Royaux des Beaux-Arts
de Belgique, Brussels
CR 644
p. 176

*The Eternally Obvious (L'évidence
éternelle)*, 1948
Oil on canvas laid on board; five panels
framed and mounted on glass
25.5 × 19.5 cm; 19.3 × 32 cm; 27 × 20.2
cm; 20.5 × 26.6 cm; 26 × 18 cm
The Metropolitan Museum of Art, New
York, the Pierre and Maria-Gaetana
Matisse Collection, 2002
CR 640
p. 119

*The Human Condition (La condition
humaine)*, 1948
Gouache and pencil on paper
36 × 46.5 cm
Collection Jasper Johns
CR 1301a (1316)
p. 114

*The Human Condition (La condition
humaine)*, 1948
Pencil on buff paper
23.8 × 32.7 cm
Collection Jasper Johns

The Pebble (Le galet), 1948
Oil on canvas
100 × 81 cm
Musées Royaux des Beaux-Arts
de Belgique, Brussels
CR 656
p. 23

The Psychologist (Le psychologue), 1948
Oil on canvas
65 × 54 cm
Private collection
CR 645

Magritte, *The Psychologist*, 1948

Magritte, *The Active Voice*, 1951

Magritte, *Seasickness*, 1948

Seasickness (Le mal de mer), 1948
Oil on canvas
54 × 65 cm
Private collection
CR 654

The Stop (L'étape), 1948
Oil on canvas
55 × 46 cm
Private collection
CR 648
p. 179

Elementary Cosmogony (Cosmogonie élémentaire), 1949
Oil on canvas
80 × 100 cm
Private collection
CR 708
p. 58

Perspective: Manet's Balcony (Perspective: Le balcon de Manet), 1950
Oil on canvas
80 × 60 cm
Museum voor Schone Kunsten, Ghent
CR 721
p. 124

The Seducer (Le séducteur), 1950
Oil on canvas
50 × 60 cm
Virginia Museum of Fine Arts, Richmond, collection of Mr. and Mrs. Paul Mellon
CR 749
p. 145

Sheherazade (Shéhérazade), 1950
Oil on canvas
40 × 30 cm
Private collection
CR 729
p. 120

The Active Voice (La voix active), 1951
Oil on canvas
100 × 80 cm
Saint Louis Art Museum, gift of Mr. and Mrs. Joseph Pulitzer, Jr.
CR 758

Magritte, *Perspective: David's Madame Récamier*, 1951

*Perspective: David's Madame Récamier
(Perspective: Madame Récamier
de David)*, 1951
Oil on canvas
80 × 60 cm
National Gallery of Canada, Ottawa,
purchased 1997
CR 757

*The Interpretation of Dreams (La clef
des songes)*, 1952
Gouache on paper
19 × 14 cm
Collection of Timothy Baum,
New York
CR 1326
p. 17

Magritte, *Personal Values*, 1952

*The Listening Room (La chambre
d'écoute)*, 1952
Oil on canvas
45 × 55 cm
The Menil Collection, Houston,
gift of Philippa Friedrich
CR 779
p. 86

*Personal Values (Les valeurs
personnelles)*, 1952
Oil in canvas
80 × 100 cm
San Francisco Museum of Modern Art,
purchased through a gift of Phyllis Wattis
CR 773
pp. 25, 153

Magritte, *The Treachery of Images*, 1952

*Personal Values (Les valeurs
personnelles)*, 1952
Pencil on paper
20.3 × 27.9 cm
Collection Mr. and Mrs. Gilbert Kaplan

*The Treachery of Images (La trahison
des images)*, 1952
Ink on paper
19 × 27 cm
Private collection, London

Magritte, *The Intimate Friend*, 1960

The Dominion of Light (L'empire des lumières), 1953
[The Empire of Light]
Oil on canvas
38 × 46 cm
Private collection, courtesy of Pascal de Sarthe Fine Art
CR 796
p. 160

The Masterpiece or the Mysteries of the Horizon (Le chef d'œuvre ou les mystères de l'horizon), 1955
Oil on canvas
50 × 65 cm
Frederick R. Weisman Art Foundation, Los Angeles
CR 817
p. 60

Clear Ideas (Les idées claires), 1958
Oil on canvas
50 × 60 cm
Private collection
CR 885
p. 185

The Birthday (L'anniversaire), 1959
Oil on canvas
89 × 116 cm
Collection Art Gallery of Ontario, Toronto. Purchase, Corporations' Subscription Endowment, 1971
CR 906

The Glass Key (La clef de verre), 1959
Oil on canvas
130 × 162 cm
The Menil Collection, Houston
CR 899
p. 89

The Intimate Friend (L'ami intime), 1960
Gouache on paper
34.5 × 26 cm
Private collection, courtesy of Guggenheim, Asher Associates, Inc.
CR 1474

Magritte, *The Birthday*, 1959

Magritte, *One Fine Late Afternoon*, 1964

The Domain of Arnheim (Le domaine d'Arnheim), 1962
Oil on canvas
146 × 114 cm
Musées Royaux des Beaux-Arts
de Belgique, Brussels
CR 960
p. 19

The Granite Quarry (La carrière de granit), 1964
Gouache on paper
42 × 29.6 cm
Private collection, courtesy of
Guggenheim, Asher Associates, Inc.
CR 1557
p. 238

One Fine Late Afternoon (Par une belle fin d'apres-midi), 1964
Gouache on paper
34 × 53.5 cm
Private collection
CR 1571

A Taste for the Invisible (Le goût de l'invisible), 1964
Gouache on paper
35.4 × 26.4 cm
James and Debbie Burrows
CR 1555
p. 25

Decalcomania (La décalcomanie), 1966
Oil on canvas
81 × 100 cm
Collection Dr. Noémi Perelman Mattis
and Dr. Daniel C. Mattis
CR 1054
p. 24

Magritte, *The Shades*, 1966

The Shades (Les ombres), 1966
Oil on canvas
65 × 81 cm
San Diego Museum of Art, gift of
Mr. and Mrs. Norton S. Walbridge
CR 1037

The Two Mysteries (Les deux mystères),
1966
Oil on canvas
65 × 80 cm
Jane and Terry Semel
CR 1038
p. 115

TERMS MOST USEFUL IN DESCRIBING CREATIVE WORKS OF ART:

GIVE VISION	ENJOY	DISCIPLINE
DIRECTION	CHARM	DELICATE
FLAVOR	INFLUENCE	COMMAND ATTENTION
A NEW SLANT	INTEREST	EXALT
FORCE	DELIGHT	DEVELOP
UNIQUENESS	AROUSE	SATISFY
PERMANENCE	COMMUNICATE	BEAUTIFY
INSPIRATION	CULTIVATE	IDENTIFY
A GLOW	NURTURE	INSPIRE
MOTIVATION	PLAN INTELLIGENTLY	ORIGINATE
ENCHANTMENT	DETACH	CREATE
BLEND	TRANSFER	ASSOCIATE
ENLIGHTEN	CHALLENGE	CHERISH
INVIGORATE	ELEVATE	ALTER
ENTHRALL	SATIATE	REVISE
TAKE SERIOUSLY	IMPROVE	CRITICIZE
PRECISE CARE	VALUE	IMPRESS
OUT OF THE ORDINARY	FLAGRANCE	IMPART

John Baldessari, *Terms most useful in describing creative works of art*, 1966–68

Contemporary Artists

Eleanor Antin (United States,
born 1935)
This is not 100 BOOTS, 2002
Iris inkjet on Somerset satin
watercolor paper, ed. 4/10
88.9 x 120 cm
Los Angeles County Museum of Art,
anonymous gift, M.2006.67
p. 2

Art & Language (collective; England,
active 1968–late 1970s)
100% Abstract, 1968
Acrylic on canvas
61.5 × 68.5 cm
Collection Herbert, Ghent

Richard Artschwager (United States,
born 1924)
Handle, 1962
Wood
30 × 48 × 4 cm
Kasper König, Cologne
p. 127

Richard Artschwager (United States,
born 1924)
Mirror/Mirror–Table/Table, 1964
Formica on wood
Variable dimensions
The Museum of Contemporary Art,
Los Angeles, the Barry Lowen
Collection
p. 134

Richard Artschwager (United States,
born 1924)
Bushes II, 1970
Oil on Celotex
92.3 × 123.8 × 2.9 cm
Los Angeles County Museum of Art,
gift of Robert H. Halff through
the Modern and Contemporary
Art Council, M.2005.38.14
p. 133

Richard Artschwager (United States,
born 1924)
Dinner (Two), 1986
Acrylic on Celotex with wooden frame
70.5 × 141.6 cm
Ruth and William S. Ehrlich
p. 130

Richard Artschwager (United States,
born 1924)
RA-26, 1995
Fir plywood and spruce
186.7 × 121.9 × 55.9 cm
Courtesy Daniel Weinberg Gallery,
Los Angeles
p. 126

John Baldessari (United States,
born 1931)
*Terms most useful in describing creative
works of art*, 1966–68
Acrylic on canvas
288.9 × 243.8 cm
Museum of Contemporary Art
San Diego, gift of John Oldenkamp,
1970.21

Art & Language, *100% Abstract*, 1968

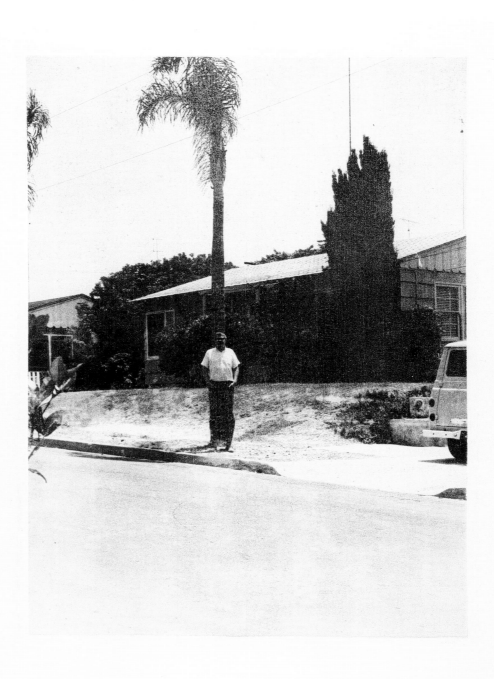

John Baldessari, *Wrong*, 1967

John Baldessari (United States,
born 1931)
Wrong, 1967
Photographic emulsion and acrylic
paint on canvas
149.9 × 114.3 cm
Los Angeles County Museum of Art,
Modern and Contemporary Art
Council, Young Talent Purchase Award,
M.71.40

Mel Bochner (United States, born 1940)
Language Is Not Transparent, 1970
Chalk on paint and wall
Template: 91.4 × 122.6 cm; installation:
182.9 × 122.6 cm
Los Angeles County Museum of Art,
Modern and Contemporary Art Council
Purchase, M.2001.61
p. 12

Marcel Broodthaers (Belgium,
1924–1976)
*Shelves with Jars and Eyes (Etagère avec
pots et yeux)*, 1966
38.3 × 49.5 × 11.2 cm
Wood, paint, glass, and paper
Private collection
p. 11

Marcel Broodthaers (Belgium,
1924–1976)
*A Magritte Picture (Un tableau
Magritte)*, 1967
Photographic image on canvas
176 × 120 cm
Collection Indivision Tob
p. 102

Marcel Broodthaers (Belgium,
1924–1976)
Rue René Magritte Straat, 1968
Molded plastic
85 × 120 cm
Musées Royaux des Beaux-Arts
de Belgique, Brussels
p. 94

Marcel Broodthaers, *The Clouds; The Dogs*, 1973

Marcel Broodthaers (Belgium,
1924–1976)
4 Pipes Alphabet, 1969
Four vacuum-formed plastic reliefs
with paint
84 × 120 cm each
Private collection, Brussels
p. 100

Marcel Broodthaers (Belgium,
1924–1976)
*René Magritte Written; Charles
Baudelaire Painted (René Magritte écrit;
Charles Baudelaire peint)*, 1972
Printed canvas; printed paper
64 × 80 cm; 84 × 55 cm
Private collection
p. 212

Marcel Broodthaers (Belgium,
1924–1976)
Magritte, 1972
China ink on canvas
9.2 cm × 18.2 cm
Private collection
p. 243

Marcel Broodthaers (Belgium,
1924–1976)
*The Clouds; The Dogs (Les nuages; Les
chiens)*, 1973
Ink on canvas
27 × 35 cm; 18.2 × 9.2 cm
Private collection

Marcel Broodthaers, *René Magritte Written; Charles Baudelaire Painted*, 1972

Vija Celmins (United States, born
Latvia, 1939)
House #1, 1965
Oil on wood, metal, fur, and plastic
House: 19.1 × 16.5 × 25.4 cm;
roof: 5.7 × 18.7 × 26.7 cm
The Museum of Modern Art, New York,
gift of Edward R. Broida, 2005
p. 159

Vija Celmins (United States, born
Latvia, 1939)
Train, 1965–66
Oil on canvas
30 × 30 cm
Collection of the artist, courtesy
McKee Gallery, New York
p. 148

Vija Celmins (United States, born
Latvia, 1939)
Untitled (Comb), 1970
Enamel on wood
195.6 × 61 cm
Los Angeles County Museum of Art,
Contemporary Art Council Fund,
M.72.26
p. 154

Robert Gober (United States, born 1954)
Half Stone House, 1979–80
Wood, stone, glass, stainless steel,
paper, paint, and linoleum block print
106.7 × 81.3 × 104.1 cm
Sue and John Wieland

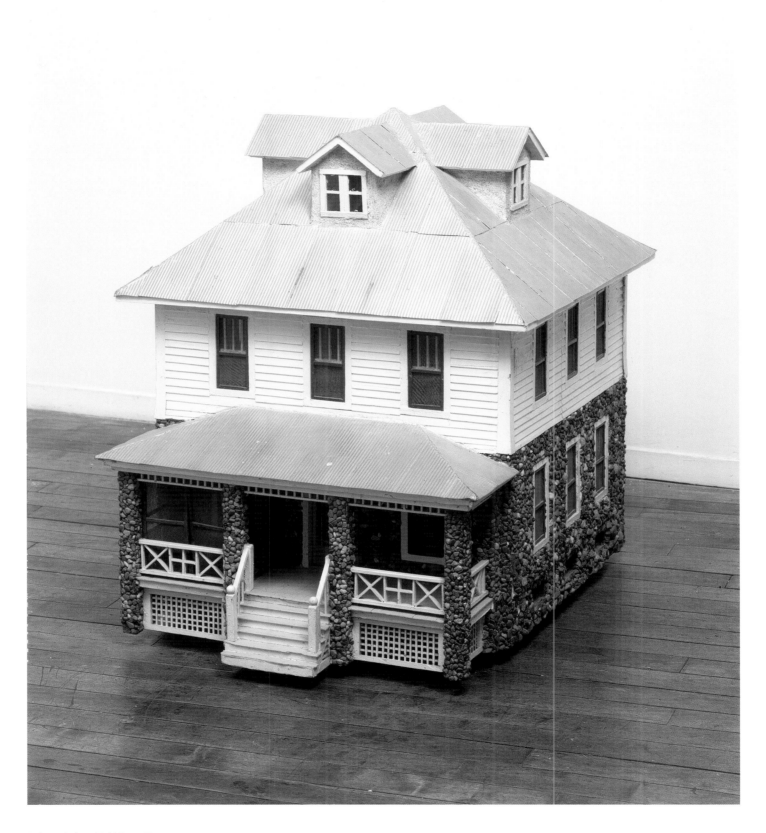

Robert Gober, *Half Stone House*, 1979–80

Philip Guston, *Blackboard*, 1969

Robert Gober (United States, born 1954)
Untitled (Leg), 1990
Beeswax, cotton, wool, human hair,
and leather shoe
27.3 × 52.1 × 17.5 cm
Hirshhorn Museum and Sculpture
Garden, Smithsonian Institution,
Washington, DC, Joseph H. Hirshhorn
Purchase Fund, 1990
p. 170

Robert Gober (United States, born 1954)
Untitled (Torso), 1990
Beeswax, human hair, and pigment
61.6 × 43.2 × 27.9 cm
Collection of the artist
p. 169

Robert Gober (United States, born 1954)
Cigar, 1991
Wood, paint, paper, and tobacco
Diameter: 40 cm; length: 180 cm
The Museum of Contemporary Art,
Los Angeles, purchased with funds
provided by the Collectors Committee
in honor of Marcia Simon Weisman
p. 162

Philip Guston (United States, born
Canada, 1913–1980)
Blackboard, 1969
Oil on canvas
201.9 × 248.5 cm
Estate of Philip Guston, courtesy
McKee Gallery, New York

Douglas Huebler (United States,
1924–1997)
*Crocodile Tears; Buried Treasure
(Magritte)*, 1985
Oil on canvas with panel with text,
photograph, and cartoon
Painting: 152.4 × 121.9 cm;
panel: 101.6 × 76.2 cm;
Darcy Huebler and Luciano Perna

Jasper Johns (United States, born 1930)
Figure 7, 1955
Encaustic and collage on canvas
44.5 × 35.6 cm
Los Angeles County Museum of Art,
gift of Robert H. Halff through the
Modern and Contemporary
Art Council, 2005.38.1
p. 112

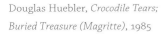

Douglas Huebler, *Crocodile Tears;*
Buried Treasure (Magritte), 1985

Jasper Johns (United States, born 1930)
Canvas, 1956
Encaustic and collage on wood
and canvas
76.2 × 63.5 cm
Collection of the artist, San Francisco
Museum of Modern Art
p. 108

Jasper Johns (United States, born 1930)
White Flag, 1960
Oil and newspaper collage over
lithograph
55.9 × 74.3 cm
The Eli and Edythe L. Broad Collection,
Los Angeles
p. 113

Jasper Johns (United States, born 1930)
Four Panels from "Untitled 1972," 1974
Lithograph, printed in color with
embossing on four sheets
Each sheet: 101.6 × 72.4 cm
Gemini G.E.L.
p. 118

Jasper Johns (United States, born 1930)
Montez Singing, 1989–90
Oil on canvas
193 × 127 cm
Collection of the artist
p. 121

Ray Johnson, *Untitled (Magritte)*, 1971

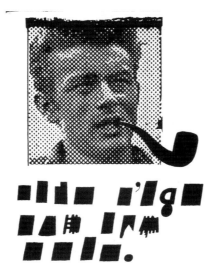

Ray Johnson, *Untitled (James Dean with Magritte's Pipe)*, c. 1980s

Ray Johnson (United States, 1927–1995)
Untitled (Magritte), 1971
Collage
8.6 × 13.3 cm
Collection of John Willenbecher

Ray Johnson (United States, 1927–1995)
Untitled (James Dean with Magritte's Pipe), c. 1980s
Mixed media collage
53.7 × 21.6 × 1 cm
Estate of Ray Johnson at Richard
L. Feigen & Co.

Mike Kelley (United States, born 1954)
Wallflowers, 1988
Acrylic on paper
Diptych: 182.2 × 152.4 cm each
Los Angeles County Museum of Art,
museum purchase with funds provided
by the Awards in the Visual Arts
Program, 1989, M.89.96a–b
Not illustrated

Mike Kelley (United States, born 1954)
Wood Grain #2, 2003
Acrylic on wood panel
183 × 122 cm
Courtesy Emi Fontana, west of Rome

Martin Kippenberger (Germany,
1953–1997)
Punch VIII (Kasperle VIII), 1993
Oil on canvas
180 × 150 cm
Private collection, courtesy Marc
Jancou Fine Art, New York
p. 180

Mike Kelley, *Wood Grain #2*, 2003

Jeff Koons, *Rabbit*, 1986

Jeff Koons, *Lifeboat*, 1985

Jeff Koons, *J. B. Turner Engine*, 1986

Martin Kippenberger (Germany,
1953–1997)
*The Philosopher's Egg (Des Philosophens
Ei)*, 1996
Oil on canvas
180 × 150 cm
Private collection, Berlin
p. 181

Jeff Koons (United States, born 1955)
Lifeboat, 1985
Bronze
30.5 × 203.2 × 152.4 cm
The Eli and Edythe L. Broad Collection,
Los Angeles
p. 219

Jeff Koons (United States, born 1955)
J. B. Turner Engine, 1986
Steel, edition of 3
Overall: 24.8 × 14 × 43.2 cm
Los Angeles County Museum of Art,
gift of Robert H. Halff through the
Modern and Contemporary Art Council,
M.2005.38.26.a-d

Jeff Koons (United States, born 1955)
Rabbit, 1986
Stainless steel
104.1 × 48.3 × 30.5 cm
The Eli and Edythe L. Broad Collection,
Los Angeles
p. 218

Joseph Kosuth (United States,
born 1945)
Definition ("Thing"), 1968
Photostat on Masonite
100 × 100 cm
Los Angeles County Museum of Art,
Modern and Contemporary Art Council,
AC.1994.14.1
p. 98

Barbara Kruger (United States,
born 1945)
*Untitled (It's a small world but not if you
have to clean it)*, 1990
Photographic silkscreen on vinyl
363.2 × 261.6 cm
The Museum of Contemporary Art,
Los Angeles, purchased with funds
provided by the National Endowment
for the Arts, a federal agency, and
Douglas S. Cramer

Sherrie Levine (United States,
born 1947)
Une Pipe (A Pipe), 2001
Cast copper alloy
6.4 × 13.3 × 3.8 cm
Los Angeles County Museum of Art,
purchased with funds provided by
Judy Henning and Richard Rosenzweig
and Linda and Jerry Janger through
the Modern and Contemporary
Art Council, M.2001.119
p. 183

Barbara Kruger, *Untitled (It's a small world but not if you have to clean it)*, 1990

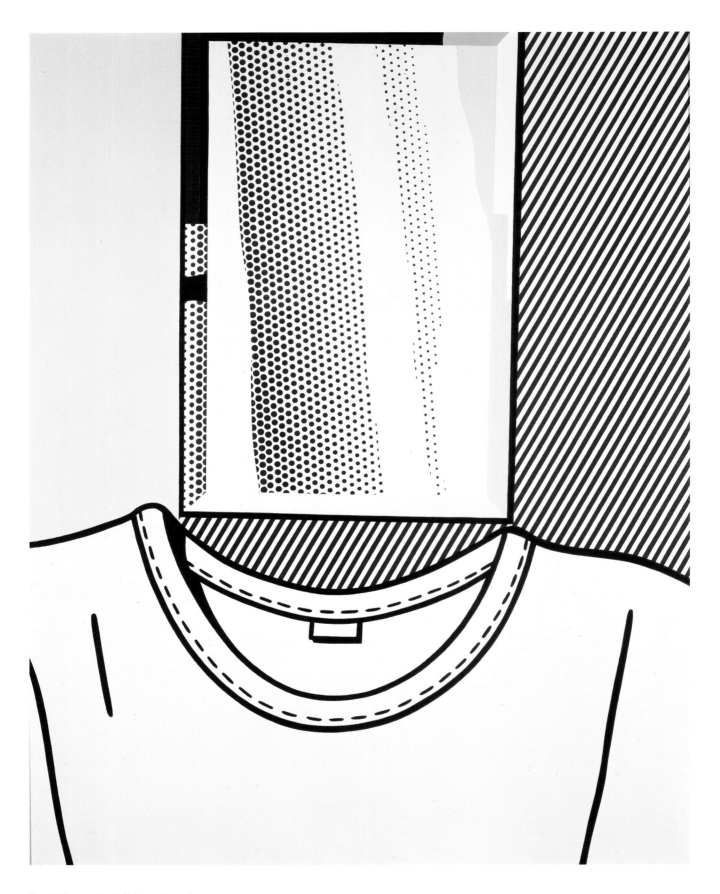

Roy Lichtenstein, *Self-Portrait*, 1978

Roy Lichtenstein, *Stretcher Frame*, 1968

Roy Lichtenstein (United States, 1923–1997)
Stretcher Frame, 1968
Oil and Magna on canvas
91.4 × 91.4 cm
Private collection

Roy Lichtenstein (United States, 1923–1997)
Self-Portrait, 1978
Oil and Magna on canvas
177.8 × 137.2 cm
Private collection

Claes Oldenburg (United States, born Sweden, 1929)
Baked Potato #1, 1963
Burlap soaked in plaster, painted enamel, jersey stuffed with kapok
Overall: 38.1 × 63.5 × 38.1 cm
Los Angeles County Museum of Art, gift of Robert H. Halff through the Modern and Contemporary Art Council, M.2005.38.30a–c

Raymond Pettibon (United States, born 1957)
Untitled ("Where was I?"), 1987
Ink on paper
58.4 × 39.4 cm
Collection Walker Art Center, Minneapolis, Miriam and Erwin Kelen Acquisition Fund for Drawings, 1998
p. 186

Claes Oldenburg, *Baked Potato #1*, 1963

Raymond Pettibon, *Untitled ("Little by little")*, 1992

Raymond Pettibon, *Untitled (Rosetta Stone)*, 1998

Raymond Pettibon (United States, born 1957)
Untitled ("Little by little"), 1992
Ink on paper
26 × 39 cm
Courtesy of Regen Projects,
Los Angeles

Raymond Pettibon (United States, born 1957)
Untitled (Rosetta Stone), 1998
Lithograph with watercolor
Image and sheet: 92.1 × 66 cm
Los Angeles County Museum of Art,
gift of Ed Hamilton and Pat Squires,
M.2000.202.2

Sigmar Polke (Germany, born 1941)
Candle before the Mirror, 1982
Oil and acrylic on canvas
181 × 150 cm
Amir Art Foundation

Richard Prince (United States, born 1949)
The Salesman and the Farmer, 1989
Acrylic, silkscreen, charcoal, and marker on canvas
61 × 46 cm
Courtesy of the artist
p. 183

Sigmar Polke, *Candle before the Mirror*, 1982

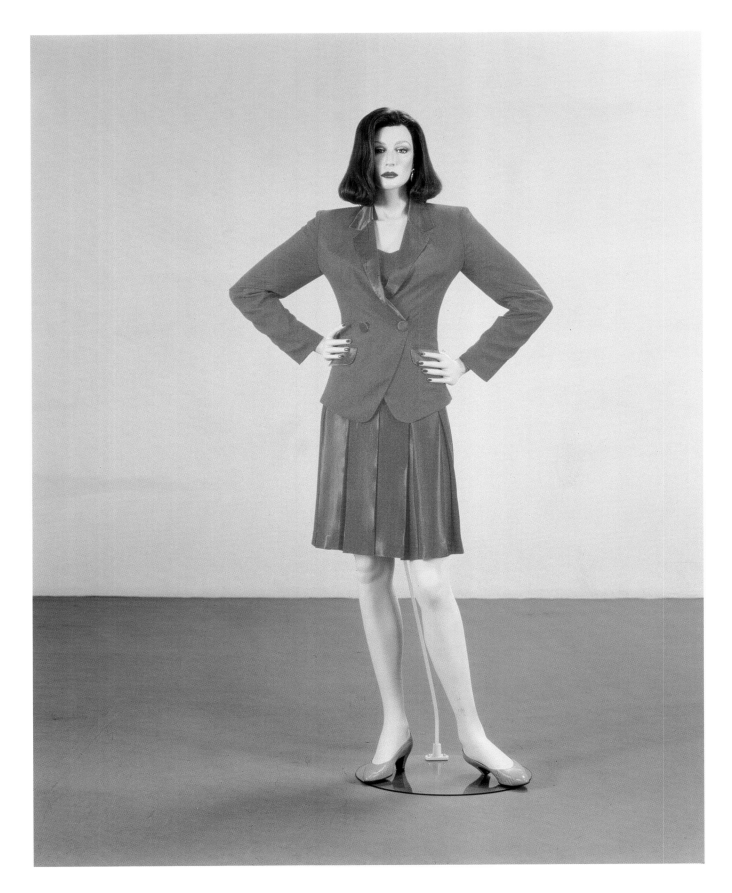

Charles Ray, *Fall '91*, 1992

Robert Rauschenberg (United States, born 1925)
193466, 1961
Combine: wire mesh, wood, and metal on wood, with cement-filled bucket
48.9 × 38.1 × 38.1 cm
Private collection

Charles Ray (United States, born 1953)
Fall '91, 1992
Mixed media
243.9 × 66 × 91.4 cm
The Broad Art Foundation,
Santa Monica

James Rosenquist (United States, born 1933)
Exit, 1961
Oil on canvas
76.5 × 83.8 cm
Barbara and Richard S. Lane, New York
p. 248

Ed Ruscha (United States, born 1937)
Actual Size, 1962
Oil on canvas
170.2 × 182.9 cm
Los Angeles County Museum of Art,
anonymous gift through the
Contemporary Art Council, 63.14

Ed Ruscha (United States, born 1937)
Give Him Anything and He'll Sign It, 1965
Oil on canvas
145.4 × 140.3 cm
Collection Emily Fisher Landau,
New York (Amart Investments LLC)
p. 141

Ed Ruscha (United States, born 1937)
No End to the Things Made Out of Human Talk, 1977
Oil and pencil on canvas
163.2 × 316.2 cm
The Broad Art Foundation,
Santa Monica
p. 139

Robert Rauschenberg, *193466*, 1961

Ed Ruscha, *Actual Size*, 1962

David Salle, *The Marionette Theater*, 1987

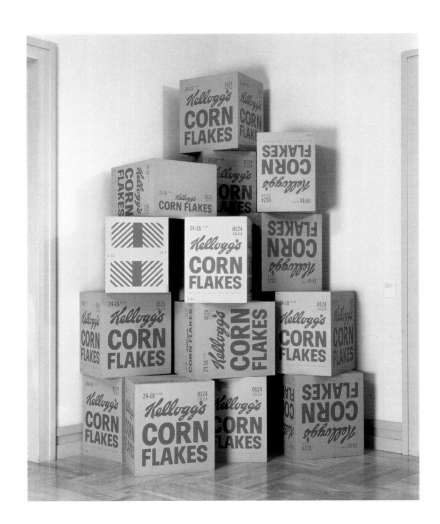

Andy Warhol, *Kellogg's Corn Flakes Boxes*, 1971

Ed Ruscha (United States, born 1937)
Man, Wife, 1987
Acrylic on canvas
137.2 × 304.8 cm
JP Morgan Chase Art Collection
p. 144

Ed Ruscha (United States, born 1937)
The End No. 13, 1993
Acrylic on paper
61 × 75.9 cm
Private collection, London
p. 143

Ed Ruscha (United States, born 1937)
Lion in Oil, 2002
Acrylic on canvas
162.6 × 183 cm
Fisher Landau Center for Art
p. 143

David Salle (United States, born 1952)
The Marionette Theater, 1987
Acrylic and oil on canvas
198.1 × 243.8 cm
Promised gift to the Los Angeles
County Museum of Art by Dorothy
and Richard E. Sherwood on the
occasion of the museum's twenty-
fifth anniversary. Lent by Dorothy R.
Sherwood

Jim Shaw (United States, born 1952)
Bon Idée, 1987
Oil on canvas
43.2 × 35.6 cm
James and Maureen Dorment
p. 184

Jim Shaw (United States, born 1952)
Red Rock, 1990
Pencil on paper
42.5 × 34.9 cm
The Museum of Contemporary Art,
Los Angeles, gift of Lannan Foundation
p. 184

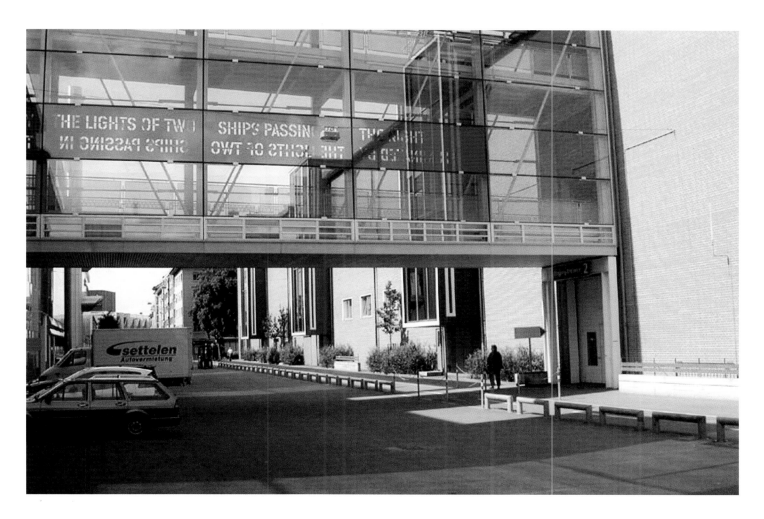

Lawrence Weiner, *Illuminated by the lights of two ships passing in the night*, 1998

Andy Warhol (United States, 1928–1987)
Two Marilyns, 1962
Acrylic and silkscreen ink and pencil
on linen
66 × 35.6 cm
Lou Thomas Trosclair
p. 37

Andy Warhol (United States, 1928–1987)
Kellogg's Corn Flakes Boxes, 1971
Silkscreen painted wood
68.6 × 61 × 48.3 cm
Los Angeles County Museum of Art,
gift of Andy Warhol through
the Contemporary Art Council,
M.69.107.1–100

Lawrence Weiner (United States,
born 1942)
*Illuminated by the lights of two ships
passing in the night*, 1998
Commercial lettering
Dimensions variable
Collection Glenn Fuhrman, New York

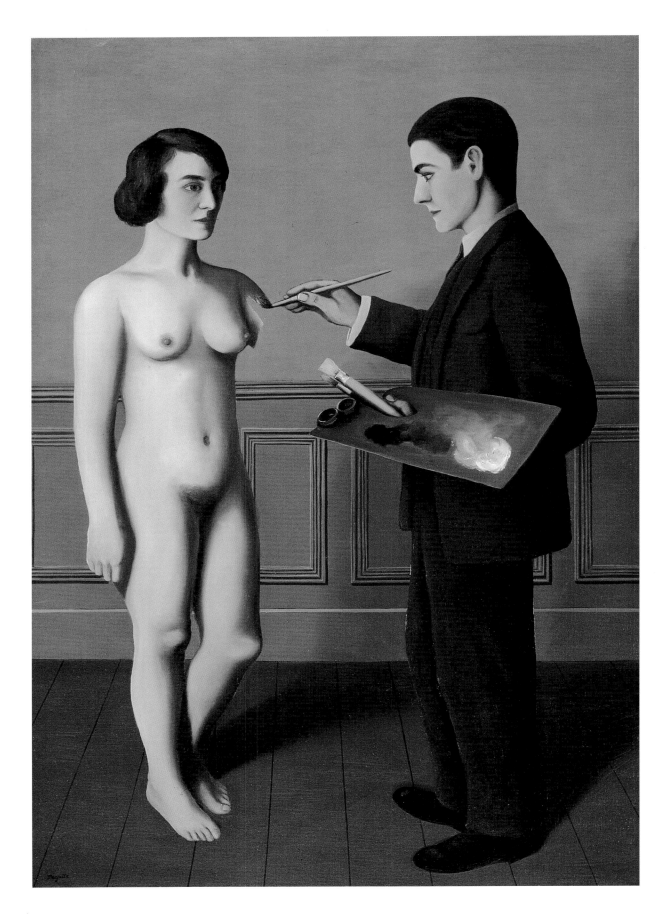

Magritte, *Attempting the Impossible*, 1928

Magritte Chronology

SARA COCHRAN

This chronology is drawn primarily from the extensive chronologies authored by Sarah Whitfield in *René Magritte: Catalogue Raisonné*, edited by David Sylvester (Antwerp: Mercatorfonds and Houston: The Menil Foundation, 1992–97) and in *Magritte*, edited by Daniel Abadie (New York: D.A.P., 2003).

For Magritte exhibitions, only significant ones up to the time of his death have been included; for significant exhibitions following his death, please refer to the exhibition catalogues listed in the selected bibliography.

November 21, 1898: Born in Lessines, Belgium
August 15, 1967: Dies in Brussels, Belgium

1910: Receives first painting lessons.

1912: Magritte's mother, Régina Magritte, commits suicide (February 24).

1916–20: Studies at the Académie Royale des Beaux-Arts and the Ecole des Arts Décoratifs in Brussels. Meets painters Pierre-Louis Flouquet and Victor Servranckx.

1920: Magritte and Flouquet hold a joint exhibition of abstract paintings and poster designs at the Centre d'Art, Brussels (January). Attends a lecture by Theo van Doesburg on de Stijl. Meets musician and artist E.L.T. Mesens, who later becomes his dealer. Participates in an international exhibition of modern art in Geneva (December). Enters military service (December 1920–September 1921).

1921: Works for manufacturer Peters-Lacroix in Haren creating wallpaper designs (through 1923).

1922: Marries Georgette Berger (1901–1986). Servranckx and Magritte write "L'Art pur: Défense de l'esthétique," heavily influenced by cubism and purism. Meets writer Marcel Lecomte.

1923: Participates in several group exhibitions in Belgium and abroad. Sees a reproduction of Giorgio de Chirico's *The Song of Love* (1914). Meets art dealer Geert Van Bruaene and Camille Goemans, one of the first Belgian writers involved in surrealism.

1924: Mesens and Magritte contribute to the final issue of Francis Picabia's *391*. Magritte, Mesens, Goemans, and Lecomte issue a prospectus for *Période*, a dada review; Mesens and Magritte continue with this project, while Goemans, Lecomte, and Paul Nougé publish the review *Correspondance*, which impresses André Breton's Paris surrealist group. Nougé becomes Magritte's mentor and dominates Belgian surrealism. Magritte designs commercial advertisements and posters and works for Brussels couture house Norine. Sells his first painting, a portrait of singer Evelyne Brélia.

1925: Rejects abstraction and adopts surrealist style inspired by de Chirico and Max Ernst. Contributes to *Little Review* at the invitation of Tristan Tzara. Collaborates with Mesens on the only issue of dadaist magazine *Œsophage*.

1926: Signs a contract with P.-G. Van Hecke's new Galerie Le Centaure, Brussels. Contributes to Mesens's magazine *Marie*. Creates commercial advertising for furrier S. Samuel et Cie. Forms the Belgian surrealist group with Mesens, Nougé, Goemans, and composer André Souris; group publishes three tracts (late 1926–early 1927), including two criticizing work by Jean Cocteau.

1927: First solo exhibition takes place at the Galerie Le Centaure (April–May). Press reaction is unfavorable. Meets writer Louis Scutenaire. Moves to Perreux-sur-Marne near Paris (September). Meets Breton, Paul Eluard, Benjamin Péret, Joan Miró, and Jean Arp; becomes active in Paris surrealist group. Begins incorporating words into his compositions.

1928: Second solo show held at Mesens's Galerie l'Epoque in Brussels (January). The accompanying catalogue's preface is written by Nougé and signed by Gaston Dehoy, Lecomte, Mesens, Nougé, Scutenaire, and Souris, signaling the relaunching of the Belgian surrealist group. Contributes to all three issues of Nougé and Goemans's review *Distances*. Though Magritte is not included in either Breton's book *Le surréalisme et la peinture* or the *Exposition surréaliste* at the Galerie au Sacred du Printemps in Paris, Breton acquires a number of Magritte's paintings.

1929: The Belgian surrealist group holds a one-day, solo exhibition of Magritte's paintings at the Salle de la Bourse in Charleroi (January). Participates in Breton's questionnaire (February) and meeting (March) regarding collective political action. Meets Salvador Dalí, who is filming *Un chien andalou* with Luis Buñuel in Paris. Contributes to special issue of the Belgian review *Variétés*, edited by Breton and Louis Aragon, and *Le sens propre* in collaboration with Goemans. Visits Cadaqués, Spain, with Dalí, Paul and Gala Eluard, Goemans, Buñuel, and Miró. Exhibits jointly with Arp, Dalí, and Yves Tanguy at Goemans's new gallery in Paris (October). Contributes four items to the final issue of *La révolution surréaliste* (December), including his text-image manifesto "Les mots et les images" (Words and Images). Following an argument with Breton (December 14), breaks with Breton and the Paris surrealist group.

1930: Participates in a group show of collages organized by Louis Aragon at the Galerie Goemans in Paris (March–April). Goemans closes his gallery for financial reasons; Magritte returns to commercial work. Returns to Brussels; establishes the Studio Dongo (with brother Paul Magritte) to produce posters and other commercial work.

1931: Exhibits in *L'art vivant en Belgique 1910–1930* at Galerie Georges Giroux (January). Solo exhibition of paintings at Salle Giso, a Brussels interior decorating firm (February). Participates in the major international exhibition *L'art vivant en Europe* at the Palais des Beaux-Arts in Brussels (April–May), the first of many times he would exhibit there.

1932: Signs Nougé's tract "La poésie transfigurée," setting out the Belgian surrealists' position regarding freedom of expression in response to Louis Aragon's indictment in France for his poem "Front rouge." Collaborates with Nougé on two short films.

1933: Radically alters the philosophy behind his art, defining his new method as an investigation into the specific "problems" posed by individual objects. Breton invites Magritte to contribute to *Le surréalisme au service de la revolution*, signaling a rapprochement. The final two issues include "Les images défendues," a long text by Nougé about Magritte, and a reproduction of Magritte's *On the Threshold of Freedom* (1930). Participates in the Paris surrealists' major group shows at the Galerie Pierre Colle (June) and the Salon des Surindépendants (October). Also contributes to the Parisian surrealist pamphlet *Violette Nozières*. Meets the poet Paul Colinet.

1934: Contributes to *Invention surréaliste*, a special issue of the Brussels quarterly *Documents 34*, edited by Mesens. Breton's lecture "Qu'est-ce que le surréalisme?," delivered in Brussels, is published with a drawing of Magritte's *The Rape* (1934) on its cover.

1935: Magritte's artistic production dramatically increases, thanks to the patronage of Claude Spaak. Though personally committed to communism, Magritte signs Parisian surrealist tract "Du Temps que les surrealists avaient raison," marking the split between Breton's group and the Communist Party. Publication in Brussels of the third issue of the *Bulletin international du surréalisme*, with Magritte's gouache *The Spoiler* (1935) on the cover. Paul Eluard publishes his poem "René Magritte" in *Cahiers d'art*. Magritte participates in the surrealist exhibition organized by Mesens at La Louvière (October).

1936: Magritte's first solo exhibition in the United States opens at Julien Levy Gallery in New York (January). Signs the tract "Le domestique zélé," announcing the expulsion of André Souris from the Belgian surrealist group. Participates in the *Exposition surréaliste objets*, organized at the Galerie Charles Ratton in Paris (May). Participates in the first major international surrealism exhibition at the New Burlington Galleries in London (June) and in *Fantastic Art, Dada, Surrealism* at the Museum of Modern Art, New York (December).

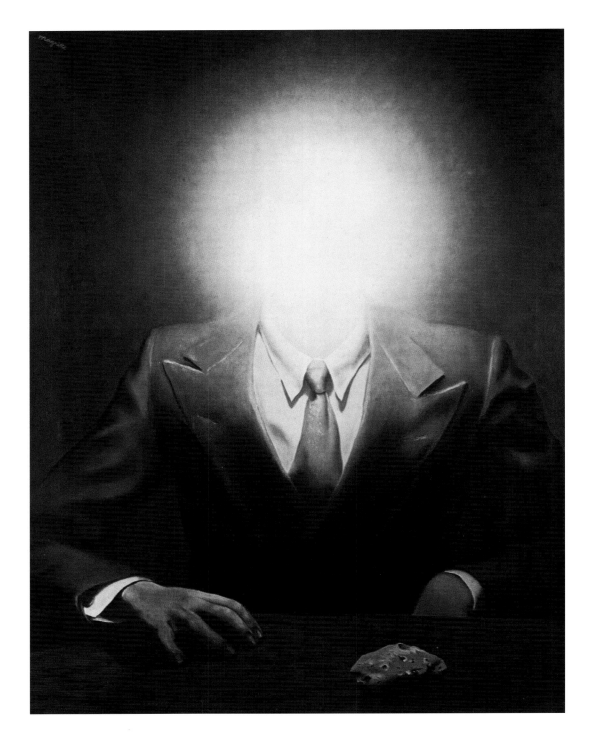

Magritte, *The Pleasure Principle*, 1937

1937: Meets the young artist Marcel Mariën. Visits London; stays with the English surrealist Edward James, paints three large commissioned paintings, and lectures at the London Gallery.

1938: Second solo show at Julien Levy Gallery in New York (January). Participates in the *Exposition internationale du surréalisme*, organized by Breton, Eluard, and Marcel Duchamp at the Galerie des Beaux-Arts in Paris (January–February). Mesens and Roland Penrose take over the London Gallery and open with a Magritte exhibition (April). Delivers his lecture "La ligne de vie" at the Koninklijk Museum voor Schone Kunsten in Antwerp (November).

1939: Designs a poster for the Vigilance Committee of Antifascist Intellectuals comparing Léon Degrelle, the leader of the Rexists (a Belgian fascist party), with Hitler.

1940: Belgian surrealist group publishes the magazine *L'invention collective*. Magritte briefly leaves for France (May–August) after Germany invades Belgium and Holland.

1943: Abandons his signature style over the next four years in favor of a brushy impressionist palette and technique known as his Renoir period or "sunlit surrealism." Publication of the first two monographs: Marcel Mariën's *Magritte* and Paul Nougé's *René Magritte ou les images défendues*.

1944: First public showing of Magritte's impressionist work, Galerie Dietrich, Brussels (January).

1945: Produces numerous book illustrations, including for Lautréamont's *Les chants de Maldoror* and a volume of Eluard poems. Joins the Belgian Communist Party. Highlighted in a largely Belgian surrealist exhibition at the Galerie des Editions La Boétie, Brussels (December–January).

1946: Corresponds with Alexander Iolas, director of the Hugo Gallery in New York. Magritte, Nougé, and Mariën publish a series of anonymous, subversive tracts (*L'imbéciles*, *L'emmerdeur*, and *L'enculer*), most of which are confiscated by postal authorities. Travels to Paris; reestablishes contact with Picabia and Breton.

1947: Solo exhibition at the Hugo Gallery, New York (April). In the catalogue for the international exhibition of surrealism at the Galerie Maeght in Paris (July), Breton condemns Magritte's concept of "sunlit surrealism." Publication of Scutenaire's monograph, *René Magritte*.

1948: Exhibits at the Galerie Dietrich in Brussels (January), Iolas's Hugo Gallery in New York (May), and the Copley Galleries in Beverly Hills (September). First solo exhibition in Paris at the Galerie du Faubourg (May), showing work from his *vache* period, which had all been completed in about five weeks. Exhibition is critically panned and commercially unsuccessful.

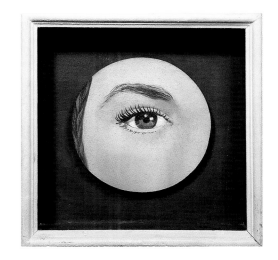

Magritte, *Painted Object: Eye*, 1936 or 1937

1952: First postwar retrospective held at Casino Communal in Knokke-le-Zoute (August). Ends friendship with Nougé. Founds the "miniature review" *La carte d'après nature* (1952–56).

1953: First exhibition in Italy held at the Gallerie dell'Obelisco in Rome (January–February), which is attended by Giorgio de Chirico. Commissioned to paint a large panoramic mural for Casino Communal in Knokke-le-Zoute.

1954: Exhibits a selection of word-and-image paintings from 1928 to 1930 in *Word vs. Image* at Sidney Janis Gallery, New York (March); exhibition is seen and appreciated by a younger generation of artists including Jasper Johns and Robert Rauschenberg, among others. Mariën breaks with Magritte. The Belgian pavilion at the Venice Biennale, which focuses on surrealism, includes a retrospective of twenty-four works by Magritte (June–October).

1956: Commissioned to create a mural for the Salle des Congrès in new Palais des Beaux-Arts, Charleroi. Meets Chicago attorney Barnet Hodes, who commissions more than fifty small-format gouaches and papier collés, representing Magritte's signature images, over the next ten years. Begins making surrealist home movies with friends.

1957: Exhibition at the Hugo Gallery (March). Elected to the Libre Académie de Belgique, an honorific group of artists defending artistic rights in opposition to the official Académie Royale de Belgique. Meets attorney and collector Harry Torczyner. Under the imprint La Tendance Populaire Surréaliste, Maurice Rapin and Mirabelle Dors begin publishing a series of tracts about Magritte based on his letters to them.

1959: Duchamp writes a short text for Magritte's exhibition at the Hugo Gallery (March). Luc de Heusch films Magritte for *La leçon des chose*, which premieres in 1960.

1960: Artist and critic Suzi Gablik spends eight months with the Magrittes and begins writing her monograph *Magritte*, which is published in London in 1970. Retrospective (*René Magritte in America*, curated by Jermayne MacAgy) held in Dallas and Houston (December 1960–March 1961).

1961: Collaborates with André Bosmans on the review *Rhétorique*, which includes texts by Scutenaire, Colinet, Achille Chavée, and van Bruaene. Paints a mural for the new Palais des Congrés in Brussels. Breton writes a brief but important text for the catalogue accompanying Magritte's exhibition at the Obelisk Gallery in London.

1962: Exhibits at the Hugo Gallery (April–May). Large retrospective opens at Casino Communal in Knokke-le-Zoute (June); to coincide with the retrospective, Mariën publishes a satirical pamphlet, *Grande baisse* (Great Bargain Sale), mocking Magritte's practice of painting several copies of the same image. A retrospective, *The Vision of René Magritte*, opens at the Walker Art Center in Minneapolis (September–October).

1964: *Magritte*, large retrospective curated by Dominique de Menil, held at the Arkansas Art Center, Little Rock (May–June).

1965: Travels to Italy. Travels to the United States for his retrospective at the Museum of Modern Art in New York (December), which travels to Waltham, Chicago, Pasadena, and Berkeley in 1966. After attending opening, Magritte travels to Houston. Patrick Waldberg's monograph, *René Magritte*, published in French, English, and Dutch.

1967: Retrospective at the Museum Boijmans Van Beuningen, Rotterdam, which travels to the Moderna Museet in Stockholm. Chooses eight of his signature images to be made into sculptures. Visits the Gibiesse foundry in Verona, Italy, to correct the models; the sculptures are cast after his death. Magritte dies suddenly of pancreatic cancer (August 15). Georgette telegrams Torczyner to announce Magritte's death: "René décedé."

Telegram from Georgette Magritte to Harry Torczyner, August 15, 1967

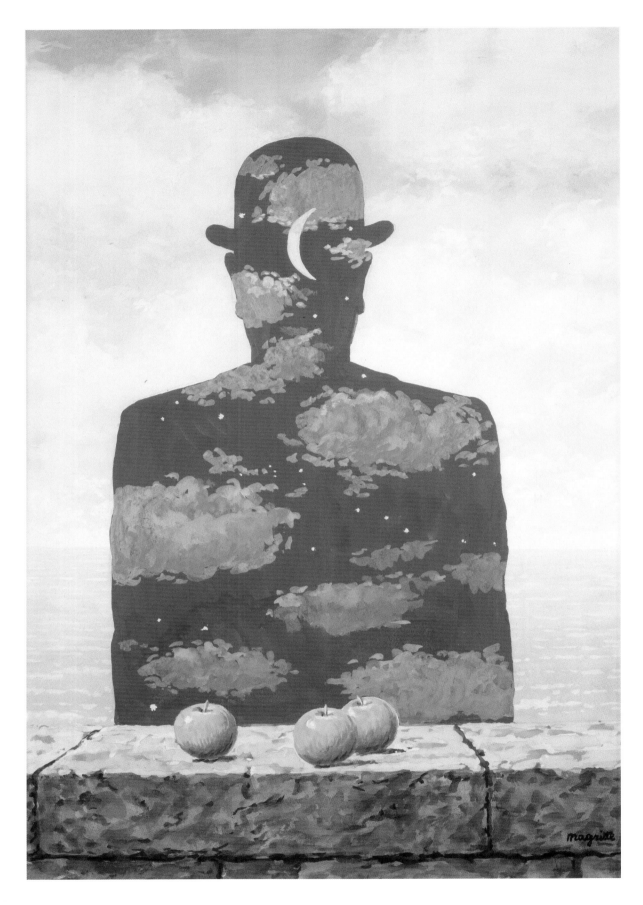

Magritte, *The Granite Quarry*, 1964

Selected Bibliography

Part I: René Magritte

The most comprehensive bibliography on Magritte covering publications through 1992 can be found in the catalogue raisonné:

Sylvester, David, Sarah Whitfield, and Michael Raeburn. *René Magritte: Catalogue Raisonné*. 5 vols. Antwerp: Mercatorfonds and Houston: The Menil Foundation, 1992–97.

Writings and Correspondence of Magritte

Magritte, René. *Manifestes et autres écrits*. Edited by Marcel Mariën. Brussels: Les Lèvres Nues, 1972.

———. *Écrits complets*. Edited and annotated by Andre Blavier. Paris: Flammarion, 1979.

———. *Lettres à André Bosmans (1958–1967)*. Edited by Francine Perceval. Paris: Seghers, 1990.

——— and Harry Torczyner. *L'ami Magritte: Correspondence et souvenirs*. Antwerp: Mercatorfonds, 1992.

———. *Magritte/Torczyner: Letters Between Friends*. Translated by Richard Miller. Introduction by Sam Hunter. New York: Harry N. Abrams, 1994.

Numerous texts and letters by Magritte may also be found in *Le fait accompli* (nos. 3, 6, 18, 28, 30, 32, 40, 49, 51–53, 55, 57, 58, 67, 76, 78, 81–95, 101, 107–113, 120, 127–29). Brussels: Les Lèvres Nues, April 1968–March 1975.

Works about Magritte

Blavier, André. *Ceci n'est pas une pipe: Contribution furtive à l'étude d'un tableau de René Magritte*. Verviers: Temps Mêlés, 1973.

Calvocoressi, Richard. *Magritte*. Rev. and enl. ed. Oxford: Phaidon, 1984.

Dopagne, Jacques. *Magritte*. Paris: Fernand Hazan, 1977.

Draguet, Michel. *Magritte*. Paris: Fernand Hazan, 2003.

Foucault, Michel. *This Is Not a Pipe*. Translated and edited by James Harkness. Berkeley: University of California Press, 1983. Originally published as *Ceci n'est pas une pipe: Deux lettres et quatre dessins de René Magritte* (Montpellier, France: Fata Morgana, 1973). First appeared as "Ceci n'est pas une pipe" in *Les cahiers du chemin 2* (January 15, 1968): 79–105.

Gablik, Suzi. *Magritte*. London: Thames & Hudson, 1970; New York and London: Thames and Hudson, 1985, 1992.

Hammacher, Abraham M. *René Magritte*. Translated by James Brockway. New York: Harry N. Abrams, 1974.

Hughes, Robert. *The Portable Magritte*. New York: Universe Publishing, 2002.

Kozloff, Max. "Surrealist Painting Re-examined." *Artforum* 5, no. 1 (September 1966): 5–9.

Masheck, Joseph. "The Imagism of Magritte." *Artforum* 12, no. 9 (May 1974): 54–58.

Meuris, Jacques. *Magritte*. Translated by J. A. Underwood. Woodstock, NY: Overlook Press, 1990.

———. *René Magritte*. Translated by Michael Scuffil. Cologne and New York: Taschen, 1998.

Michals, Duane. *A Visit with Magritte*. Providence: Matrix, 1981.

Müller-Tamm, Pia. *René Magritte: Les jours gigantesques*. Berlin: Kulturstiftung der Länder and Düsseldorf: Kunstsammlung Nordrhein-Westfalen, 1996.

Nougé, Paul. *René Magritte*. Brussels: Didier Devillez, 1997.

Paquet, Marcel. *René Magritte, 1898–1967: Thoughts Rendered Visible*. Translated by Michael Claridge. Cologne: Taschen, 2000.

Roegiers, Patrick. *Magritte and Photography*. Translated by Mark Polizzotti. Ghent: Ludion and New York: D.A.P., 2005.

Roque, Georges. *Ceci n'est pas un Magritte: Essai sur Magritte et la publicité*. Paris: Flammarion, 1983.

Rosenblum, Robert. "Magritte's Surrealist Grammar." *Art Digest* 28, no. 12 (March 1954): 16, 32.

Schneede, Uwe M. *René Magritte: Leben und Werk*. Cologne: DuMont Schauberg, 1973.

Scutenaire, Louis. *Magritte*. With a statement by René Magritte. Chicago: The William & Noma Copley Foundation, 1957 [?].

———. *La fidélité des images: René Magritte: Le Cinématographie et la photographie*. Brussels: Lebeer Hossmann, 1976.

———. *Avec Magritte*. Brussels: Lebeer Hossmann, 1977.

Shattuck, Roger. "On René Magritte." *Artforum* 5, no. 1 (September 1966): 32–35.

Soby, James Thrall. *René Magritte*. New York: The Museum of Modern Art, 1965.

Spector, Jack. "Magritte's La Lampe et Philosophe: A Study of Word and Image in Surrealism." *Dada/Surrealism* no. 7 (1977): 121 ff.

Sylvester, David. *Magritte*. New York: Frederick Praeger, 1969.

———. *Magritte: The Silence of the World*. Houston: The Menil Foundation and New York: Harry N. Abrams, 1992.

Torczyner, Harry. *Magritte: Ideas and Images*. Translated by Richard Miller. New York: Harry N. Abrams, 1977.

———. *Magritte: The True Art of Painting*. With the collaboration of Bella Bessard. Translated by Richard Miller. London: Thames & Hudson, 1979.

Waldberg, Patrick. *René Magritte*. Brussels: André de Rache, 1965.

————. *Magritte: Peintures*. Paris: L'Autre Musée, 1983.

Weschler, Lawrence. "Magritte Standard Time." In *Everything That Rises: A Book of Convergences*. San Francisco: McSweeney's, 2006.

Exhibition Catalogues

Exhibition catalogues are listed chronologically. For a complete list of Magritte exhibitions until 1990, see the catalogue raisonné.

René Magritte in America. Dallas: Dallas Museum for Contemporary Arts, 1960.

The Vision of René Magritte. Minneapolis: The Walker Art Center, 1962.

Magritte. Little Rock: Arkansas Art Center, 1964.

René Magritte. New York: The Museum of Modern Art, 1965.

Dada, Surrealism, and Their Heritage. William S. Rubin. New York: The Museum of Modern Art, 1968.

Magritte. David Sylvester. London: Tate Gallery, 1969.

Painters of the Mind's Eye: Belgian Symbolists and Surrealists. New York: The New York Cultural Center, 1974.

Secret Affinities: Words and Images by René Magritte. Houston: Institute for the Arts, Rice University, 1976.

Dada and Surrealism Reviewed. Dawn Ades and David Sylvester. London: Hayward Gallery, 1978.

Retrospective Magritte. Texts by Jean Clair, Louis Scutenaire, and David Sylvester. Paris: Centre George Pompidou and Brussels: Palais des Beaux-Arts, 1978.

Westkunst: Zeitgenössische Kunst seit 1939. Edited by Kasper König. Texts by Laszlo Glozer, Kasper König, and Marcel Baumgartner. Cologne: DuMont, 1981.

René Magritte et le surréalisme en Belgique. Texts by Marc Dachy, Marcel Mariën, and Uwe M. Schneede. Brussels: Musées Royaux des Beaux-Arts de Belgique, 1982.

René Magritte. Edited by Wieland Schmied. Texts by Wieland Schmied, Sabine Dorothée Lehner, Catherine De Croës, et al. Munich: Kunsthalle der Hypo-Stiftung, 1987.

The Dada and Surrealist Word-Image. Judi Freeman. Essay by John Welchman. Los Angeles: Los Angeles County Museum of Art and Cambridge: MIT Press, 1989.

Magritte 1898–1967. Text by Isy Brachot. Paris: Galerie Isy Brachot, 1989.

René Magritte: La période "vache." Edited by Bernard Blistène. Texts by Bernard Blistène, David Sylvester, Sarah Whitfield, et al. Marseilles: Musée Cantini, 1992.

Magritte. Sarah Whitfield. London: South Bank Centre, 1992.

Surrealism: Revolution by Night. Texts by Dawn Ades and Michael Lloyd. Canberra: National Gallery of Australia, 1993.

Magritte. Steingrim Laursen. Humlebaek, Denmark: Louisiana Museum of Modern Art, 1995.

Magritte. Edited by Didier Ottinger. Montreal: Museum of Fine Arts, 1996.

René Magritte: Die Kunst der Konversation. Edited by Didier Ottinger. Düsseldorf: Kunstsammlung Nordrhein-Westfalen, 1996.

René Magritte 1898–1967. Edited by Gisele Ollinger-Zinque and Frederik Leen. Texts by Alain Berenboom, M. Colin, Jef Cornelis, et al. Brussels: Musées Royaux des Beaux-Arts de Belgique and Ghent: Ludion, 1998.

René Magritte en de hedendaagse kunst/René Magritte and the Contemporary Art. Compiled by W. Van den Bussche. Ostend: Museum voor Moderne Kunst, 1998.

Surrealism: Two Private Eyes, The Nesuhi Ertegun and Daniel Filipacci Collections. New York: Solomon R. Guggenheim Museum, 1999.

Magritte. Text by Siegfried Gohr. San Francisco: San Francisco Museum of Modern Art, 1999.

La révolution surréaliste. Edited by Werner Spies. Paris: Centre Pompidou, 2002.

René Magritte. Edited by Daniel Abadie. Translated by Donald Pistolesi and Caroline Beamish. New York: D.A.P., 2003.

René Magritte: The Key to Dreams. Edited by Steingrim Laursen. Texts by Steingrim Laursen, Siegfried Gohr, and Michel Draguet. Ghent: Ludion, in association with Basel: Fondation Beyeler and Vienna: BA-CA Kunstforum, 2005.

Magritte tout en papier: Collages, dessins, gouaches. Michel Draguet. Paris: Hazan, 2006.

Part II: Contemporary Artists

For each artist, books and catalogues appear together chronologically.

Eleanor Antin

Eleanor Antin. Exh. cat. by Howard Fox. Los Angeles: Los Angeles County Museum of Art, 1999.

Art & Language

Art & Language: Now They Are Surrounded. Exh. cat. Texts by Paul Wood and Art & Language. Brussels: Galerie Isy Brachot, 1992.

Art & Language. Exh. cat. Paris: Galerie Nationale du Jeu de Paume, 1993.

Richard Artschwager

Richard Artschwager's Theme(s). Exh. cat. Buffalo: Albright-Knox Art Gallery, 1979.

Richard Artschwager. Exh. cat. by Richard Armstrong. New York: Whitney Museum of American Art, 1988.

Richard Artschwager: Public. Exh. cat. Texts by Germano Celant, Herbert Muschamp, and Russell Panczenko. Madison: Elvehjem Museum of Art and University of Wisconsin–Madison, 1991.

Schwartz, Dieter, ed. *Richard Artschwager: Texts and Interviews*. Winterthur: Kunstmuseum and Düsseldorf: Richter, 2003.

Marcel Broodthaers,
Magritte, 1972

John Baldessari
John Baldessari. Exh. cat. Texts by Marcia Tucker, Robert Pincus-Witten, and Nancy Drew. New York: New Museum, 1981.

John Baldessari. Exh. cat. by Coosje van Bruggen. Los Angeles: Museum of Contemporary Art and New York: Rizzoli, 1990.

John Baldessari: National City. Exh. cat. Edited by Hugh M. Davies and Andrea Hales. San Diego: Museum of Contemporary Art, 1996.

John Baldessari. Exh. cat. Vol. 1, *A Different Kind of Order*. Vol. 2, *Life's Balance*. Edited by Edelbert Köb and Peter Pakesch. Texts by Rainer Fuchs, Matt Mullican, Anne Rorimer, et al. Cologne: Walther König, 2005.

Mel Bochner
Mel Bochner, 1973–1985. Exh. cat. Texts by Elaine A. King and Charles Stuckey. Pittsburgh: Carnegie-Mellon University Press, 1985.

Mel Bochner: Thought Made Visible, 1966–1973. Exh. cat. by Richard S. Field. New Haven: Yale University Art Gallery, 1995.

Mel Bochner Photographs, 1966–1969. Exh. cat. Texts by Scott Rothkopf and Elisabeth Sussman. New Haven: Yale University Press and Cambridge: Harvard University Art Museums, 2002.

Marcel Broodthaers
Marcel Broodthaers. Exh. cat. by Marge Goldwater. Minneapolis: Walker Art Center and New York: Rizzoli, 1989.

Marcel Broodthaers: Oeuvres 1963–1975. Exh. cat. Text by Freddy De Vree. Brussels: Galerie Isy Brachot, 1990.

Marcel Broodthaers: Section Publicité du Musée d'Art Modern: Dt. des Aigles. Exh. cat. Edited by Benjamin H. D. Buchloh and Maria Gilissen. New York: Marian Goodman Gallery: 1995.

Vija Celmins
Vija Celmins: A Survey Exhibition. Exh. cat. Text by Susan C. Larsen. Los Angeles: Fellows of Contemporary Art, 1979.

Vija Celmins. Exh. cat. Edited by James Lingwood. London: Institute of Contemporary Arts, 1996.

Vija Celmins Interviewed by Chuck Close. Edited by William S. Bartman. New York: A. R. T. Press: 1992.

Relyea, Lane. *Vija Celmins*. Interview by Robert Gober. London and New York: Phaidon, 2004.

Robert Gober

Robert Gober. Exh. cat. by Joan Simon. Paris: Galerie National du Jeu de Paume, 1991.

Robert Gober. Exh. cat. by Lynne Cooke and Richard Flood. London: Serpentine Gallery and Liverpool: Tate, 1993.

Robert Gober. Exh. cat. by Karen Marta. New York: Dia Center for the Arts, 1993.

Robert Gober. Exh. cat. by Paul Schimmel. Los Angeles: Museum of Contemporary Art and Zurich: Scalo, 1997.

Robert Gober: Sculpture & Drawing. Exh. cat. by Richard Flood, Gary Garrels, and Ann Temkin. Minneapolis: Walker Art Center, 1999.

Robert Gober: The United States Pavilion, 49th Venice Biennale. Exh. cat. by James Rondeau and Olga M. Viso. Chicago: Art Institute of Chicago and Washington, DC: Hirshhorn Museum and Sculpture Garden, Smithsonian Institution, 2001.

Richardson, Brenda. *A Robert Gober Lexicon*. New York: Matthew Marks Gallery and Göttingen: Steidl, 2005.

Philip Guston

Philip Guston: Tableaux/Paintings, 1947–1979. Exh. cat. Bonn: Kunstmuseum and Ottawa: National Gallery of Canada, 2000.

Philip Guston Retrospective. Exh. cat. by Michael Auping. New York: Thames & Hudson and Fort Worth: Modern Art Museum of Fort Worth, 2003.

Douglas Huebler

Douglas Huebler. Exh. cat. by Ronald J. Onorato. La Jolla, CA: La Jolla Museum of Contemporary Art, 1988.

Douglas Huebler: Variable, Etc. Exh. cat. Texts by René Denizot, Robert C. Morgan, and Frederic Paul. Limousin, France: Fonds Regional d'Art Contemporain, 1993.

Jasper Johns

Bernstein, Roberta. "An Interview with Jasper Johns." In *Fragments: Incompletion and Discontinuity*. Lawrence D. Kritzman, ed. New York: New York Literary Forum, 1981.

Crichton, Michael. *Jasper Johns*. Rev. and exp. ed. New York: Harry N. Abrams in association with the Whitney Museum of American Art, 1994.

Jasper Johns: A Retrospective. Exh. cat. by Kirk Varnedoe. Texts by Kirk Varnedoe and Roberta Bernstein. New York: Museum of Modern Art, 1996.

Jasper Johns: Writings, Sketchbook Notes, Interviews. Edited by Kirk Varnedoe. Compiled by Christel Hollevoet. New York: Museum of Modern Art, 1996.

Johnston, Jill. *Jasper Johns: Privileged Information*. New York: Thames & Hudson, 1996.

Jasper Johns: *Numbers*. Exh. cat. by Carter E. Foster and Roberta Bernstein. Cleveland: Cleveland Museum of Art, 2003.

Ray Johnson

Ray Johnson: Questions by Clive Philpot; Answers by Ray Johnson. Roslyn, NY: Nassau County Museum of Fine Art, 1988.

Ray Johnson: Correspondences. Exh. cat. by Donna De Salvo and Catherine Gudis. Columbus: Wexner Center for the Arts, 1999.

Mike Kelley

Mike Kelley: Catholic Tastes. Exh. cat. by Elisabeth Sussman. Texts by Richard Armstrong, Howard N. Fox, et al. New York: Whitney Museum of American Art, 1993.

Welchman, John C., Isabelle Graw, and Anthony Vidler. *Mike Kelley*. London: Phaidon, 1999.

Kelley, Mike. *Foul Perfection: Essays and Criticism*. Edited by John C. Welchman. Cambridge: MIT Press, 2003.

Martin Kippenberger

Martin Kippenberger: I Had a Vision. Exh. cat. by John Caldwell and Jutta Koether. San Francisco: San Francisco Museum of Modern Art, 1991.

Koch, Uwe, ed. *Annotated Catalogue Raisonné of the Books by Martin Kippenberger, 1977–1997*. New York: D.A.P., 2003.

Martin Kippenberger: Das 2. Sein. Exh. cat. Texts by Ralph Melcher, et al. Cologne: DuMont and Karlsruhe: Museum fur Neue Kunst, 2003.

Martin Kippenberger. Exh. cat. Edited by Doris Krystof and Jessica Morgan, with Susanne Kippenberger and Gregory Williams. London: Tate Publishing, 2006.

Jeff Koons

Koons, Jeff, and Robert Rosenblum. *The Jeff Koons Handbook*. New York: Rizzoli, 1992.

Jeff Koons: Easyfun-Ethereal. Exh. cat. Texts by Rolf E. Breuer, Thomas Krens, and David Sylvester. Berlin: Deutsche Guggenheim Berlin and New York: Guggenheim Museum Publications, 2000.

Jeff Koons: Pictures, 1980–2002. Exh. cat. by Thomas Kellein. New York: D.A.P., 2002.

Jeff Koons: Retrospektiv. Exh. cat. Texts by Marit Woltmann and Arthur C. Danto. Oslo: Astrup Fearnley Museet, 2004.

Joseph Kosuth

Joseph Kosuth: Art as Idea as Idea, 1967–1968. Exh. cat. Brussels and Cologne: Paul Maenz, 1973.

Millet, Catherine. *Joseph Kosuth: Investigations sur l'art et problématique, 1965–1973*. Paris: Musee d'Art Moderne, 1974.

Joseph Kosuth: Interviews, 1969–1989. Stuttgart: P. Schwarz, 1989.

Barbara Kruger

Barbara Kruger. Exh. cat. by Ann Goldstein. Los Angeles: Museum of Contemporary Art, 1999.

Money Talks. Exh. cat. by Lisa Phillips. New York: Skarstedt Fine Art, 2005.

Sherrie Levine

Sherrie Levine. Exh. cat. by David Deitcher and Jeanne Siegel. Zurich: Kunsthalle Zurich, 1991.

Sherrie Levine: Sculpture. Exh. cat. Texts by Howard Singerman, Catherine Ingraham, and Sylvia Lavin. Cologne: Galerie Jablonka and Los Angeles: Margo Leavin Gallery, 1996.

Roy Lichtenstein

Cowart, Jack. *Roy Lichtenstein, 1970–1980*. New York: Hudson Hills Press, in association with Saint Louis Art Museum, 1981.

Roy Lichtenstein. Exh. cat. Liverpool: Tate Gallery, 1993.

Roy Lichtenstein. Exh. cat. by Diane Waldman. New York: Guggenheim Museum in association with Rizzoli, 1993.

Roy Lichtenstein: All About Art. Exh. cat. by Michael Juul Holm, Poul Erik Tojner, and Martin Caiger-Smith. Humlebaek, Denmark: Louisiana Museum of Art, 2003.

Roy Lichtenstein: Conversations with Surrealism. Exh. cat. Texts by Charles Stuckey and Frederic Tuten. New York: Mitchell-Innes & Nash, 2006.

Claes Oldenburg

Claes Oldenburg: Object into Monument. Exh. cat. by Barbara Haskell. Pasadena: Pasadena Art Museum, 1971.

Claes Oldenburg: An Anthology. Exh. cat. Texts by Germano Celant, Dieter Koepplin, et al. New York: Guggenheim Museum and Washington, DC: National Gallery of Art, 1995.

Claes Oldenburg and Coosje van Bruggen. Exh. cat. Text by Germano Celant. Milan: Skira and New York: Abbeville, 1999.

Raymond Pettibon

Temkin, Ann, and Hamza Walker, eds. *Raymond Pettibon: A Reader*. Philadelphia: Philadelphia Museum of Art, 1998.

Storr, Robert, Dennis Cooper, and Ulrich Loock. *Raymond Pettibon*. London and New York: Phaidon, 2001.

Raymond Pettibon: The Pages Which Contain Truth Are Blank. Exh. cat. Texts by Andreas Hapkemeyer, Luca Beatrice, and Peter Weiermair. Innsbruck: Skarabäus, 2003.

Sigmar Polke

Sigmar Polke. Exh. cat. by John Caldwell. San Francisco: San Francisco Museum of Modern Art, 1990.

Sigmar Polke: Illumination. Exh. cat. by Richard Flood. Minneapolis: Walker Art Center, 1995.

Sigmar Polke: Works & Days. Exh. cat. Texts by Bice Curiger, Hartmut Böhme, and Ulli Seegers. Cologne: DuMont, 2005.

Richard Prince

Richard Prince. Exh. cat. by Lisa Phillips. New York: Whitney Museum of American Art, 1992.

Richard Prince: Early Photographs, 1977–1979. Exh. cat. New York: Skarstedt Fine Art, 2001.

Richard Prince: American English. Exh. cat. Text by Sadie Coles. Cologne: Walther König, 2003.

Robert Rauschenberg

Robert Rauschenberg: The Early 1950s. Exh. cat. by Walter Hopps. Houston: Houston Fine Arts Press, 1991.

Robert Rauschenberg: A Retrospective. Exh. cat. by Walter Hopps. Texts by Walter Hopps, Susan Davidson, Trisha Brown, et al. New York: Guggenheim Museum, 1997.

Kotz, Mary Lynn. *Rauschenberg: Art and Life*. Rev. and exp. ed. New York: Harry N. Abrams, 2004.

Robert Rauschenberg: Combines. Exh. cat. by Paul Schimmel. Los Angeles: Museum of Contemporary Art and Göttingen: Steidl, 2006.

Charles Ray

Charles Ray: Interviews. Exh. cat. by Lucinda Barnes and Dennis Cooper. Newport Beach, CA: Newport Harbor Art Museum, 1990.

Charles Ray. Exh. cat. by Paul Schimmel and Lisa Phillips. Los Angeles: Museum of Contemporary Art, 1998.

James Rosenquist

Goldman, Judith. *James Rosenquist: The Early Pictures, 1961–1964*. New York: Gagosian Gallery and Rizzoli, 1992.

Brundage, Susan. *James Rosenquist: The Big Paintings—Thirty Years*. Interview by Craig Adcock. New York: Leo Castelli Gallery and Rizzoli, 1994.

James Rosenquist: A Retrospective. Exh. cat. Texts by Walter Hopps and Sarah Bancroft. New York: Guggenheim Museum, 2003.

Ed Ruscha

Ed Ruscha: New Paintings and a Retrospective of Works on Paper. Exh. cat. Texts by Neville Wakefield and Dave Hickey. London: Anthony d'Offay Gallery, 1998.

Engberg, Siri, Clive Phillpot, et al. *Edward Ruscha: Editions 1959–1999: Catalogue Raisonné*. 2 vols. Minneapolis: Walker Art Center, 1999.

Ed Ruscha. Exh. cat. Texts by Neal David Benezra, Kerry Brougher, and Phyllis Rosenzweig. Washington, DC: Hirshhorn Museum and Sculpture Garden, Smithsonian Institution, 2000.

Marshal, Richard D. *Ed Ruscha*. London and New York: Phaidon, 2003.

Ed Ruscha: Catalogue Raisonné of the Paintings. Vol. 1: 1958–1970, with texts by Walter Hopps and Yve-Alain Bois. Vol. 2: 1971–1982, with texts by Robert Dean, Erin Wright, et al. New York: Gagosian Gallery and Göttingen: Steidl, 2004–2005.

James Rosenquist, *Exit*, 1961

David Salle

David Salle. Exh. cat. Texts by Janet Kardon and Lisa Phillips. Philadelphia: Institute of Contemporary Art, University of Pennsylvania, 1986.

David Whitney, ed. *David Salle*. New York: Rizzoli, 1994.

Jim Shaw

Shaw, Jim. *Dreams*. Santa Monica, CA: Smart Art Press, 1995.

Jim Shaw, 1974–1999: Everything Must Go. Exh. cat. Texts by Amy Gerstler, Doug Harvey, Mike Kelley, et al. Santa Monica, CA: Smart Art Press, 1999.

Andy Warhol

Michelson, Annette, ed. *Andy Warhol*. Cambridge: MIT Press, 2001.

Frei, George, and Neil Printz, eds. *The Andy Warhol Catalogue Raisonné*. London and New York: Phaidon, 2002.

Andy Warhol's Time Capsule 21. Exh. cat. Cologne: DuMont, 2003.

Feldman, Frayda, and Jorg Schellmann. *Andy Warhol Prints: A Catalogue Raisonné, 1962–1987*. 4th ed., rev. and exp. New York: D.A.P., 2003.

Lawrence Weiner

Lawrence Weiner: A Selection of Works with Commentary. Exh. cat. Text by Rudolf H. Fuchs. Basel: Basel Kunsthalle, 1976.

Schwarz, Dieter. *Lawrence Weiner: Books, 1968–1989: Catalogue Raisonné*. Cologne: Walther König, 1989.

Acknowledgments

In the spring of 1978, my former colleague Maurice Tuchman and I opened the Sotheby's catalogue of forthcoming impressionist and modern paintings. We came upon an astonishing work being offered for sale: René Magritte's seminal *The Treachery of Images* (1929), previously owned by the artist William Copley. Copley, an important collector of surrealism, had briefly run a gallery in Beverly Hills in the 1940s where he showed surrealist and modern art. Commercially unsuccessful, Copley was himself his gallery's greatest client. Amassing an important collection, in 1955 he generously gave Magritte's *The Liberator* to what was then the Los Angeles County Museum of History, Science, and Art; in 1978, it was our only Magritte painting. Foucault's seminal text *Ceci n'est pas une pipe* (originally published in French in 1968) had not yet been translated into its English language version, with *The Treachery of Images* on its cover. Museums often find it difficult to acquire artworks at auction, but we were determined to try to acquire this remarkable painting. With acumen, pluck, and luck, LACMA was successful in acquiring *The Treachery of Images* for a relatively modest price. We quite simply couldn't believe our good fortune. Over the years, as the collections have grown, this Magritte has remained one of the hallmarks of the museum's collection, often requested to travel to faraway exhibitions. In 1990 my former colleague Judi Freeman organized a focused exhibition, *The Dada and Surrealist Word-Image*, locating the picture within a surrealist dialogue. The present exhibition takes as its impetus *The Treachery of Images*, and seeks to examine the role that Magritte and his work have played in the development of postwar art, with an emphasis on U.S. artists.

I am grateful to Michael Govan, LACMA's new Wallis Annenberg Director and CEO, for his enthusiastic embrace of this project and for his support of the invitation we extended to artist John Baldessari to collaborate with us on the design of this exhibition. It has been inspiring to work together on this project.

Special thanks for this effort are due to our partner and my co-curator of the exhibition, Magritte scholar Michel Draguet, who was named director of the Musées Royaux des Beaux-Arts de Belgique, Brussels, while we worked on the project. His new and complex administrative responsibilities naturally made his availability to us on a regular basis more difficult, but he has nonetheless been a real partner and contributed two texts for our catalogue. His insights into Magritte's work, his thoughtful suggestions about organizational structure and catalogue authors at the early stages of the exhibition, and his help in securing important loans are most gratefully acknowledged.

Without the tireless efforts of Charly Herscovici, president of the Magritte Foundation, this exhibition would not have been possible. Charly has been unfailing in his enthusiasm for our project, providing important contact information where needed and working tirelessly to assist in securing loans. His working visits to Los Angeles as we have organized this project have been both enjoyable and memorable.

There has been an increasing tempo to the organization of Magritte exhibitions, which of course rely upon the generosity of many of the same lenders. It is difficult to own hallmark paintings that are constantly sought after. Nevertheless we have been extremely fortunate and grateful to receive the cooperation of numerous

lenders in the United States and internationally. A few here and abroad simply could not part, once again, with their treasures. We have been gratified by the cooperation of the lenders of contemporary art, including many of the artists themselves to participate with us in this first-ever effort. All lenders, without whom we could not have organized this exhibition, have our deepest thanks. They are listed on page 252. Several lenders have made exceptions to expansion-enforced loan moratoria; others have been exceptionally generous to our project. My thanks to Neal Benezra, James Cuno, Jan Debbaut, John Elderfield, Marc Grossman, Josef Helfenstein, Kasper König, Pia Müller-Tamm, Didier Ottinger, Earl A. Powell III, Joe Rischel, David and Leslee Rogath, Alain Sayag, Ann Temkin, and Olga Viso for their support of this project with key loans. Our colleagues at the Museum of Contemporary Art in Los Angeles, Jeremy Strick, Paul Schimmel, and Ann Goldstein, and Joanne Heyler at the Broad Art Foundation, Santa Monica, have been exceptionally generous in responding to our requests. My thanks to Paolo Vedovi for his efforts on behalf of this exhibition. Numerous colleagues have been extremely gracious in sharing information about Magritte and thoughts about his connections with postwar artists, and many have provided invaluable leads to track down elusive works for the exhibition. We are grateful to Abigail Asher, Ida Balboul, Douglas Baxter, Roberta Bernstein, Susan Davidson, Emmanuel di Donna, Michael Findlay, Monica Moran, Ron Warren, and Alison Whiting in New York; Ernst Beyeler, Ulf Küster, and Christoph Vitali in Basel; Gisela Capitain and Regina Fiorita in Cologne; Evelyn Benesch in Vienna; Cynthia Burlingham, Barbara Guggenheim, Margo Leavin, Deborah McCloud, and Dawn Perlin in Los Angeles; Isy Brachot and Gisèle Ollinger-Zinque in Brussels; Daniel Malingue in Paris; Olivier Camu, Claire Coombs, and Frances Morris in London; and Steingrim Laursen in Copenhagen. Artists Pierre Alechinsky, Tony Berlant, Vija Celmins, Robert Gober, Darcy Huebler, Jasper Johns, Jeff Koons, Barbara Kruger, Robert Rauschenberg, Ed Ruscha, and John Willenbecher have all been enormously gracious with their efforts on our behalf. Thanks as well to Anders Bergstrom, Marie-Puck Broodthaers, Claudia Carson, Maria Gilissen, Susanne Kippenberger, Sarah Taggart, and David White for advice and help with specific loans from artists and artists' estates; and to Geraldine Aramanda at the Menil Foundation for archival assistance.

Many LACMA colleagues were very helpful to us in organizing this exhibition. My greatest thanks are to colleague Sara Cochran, assistant curator, modern art, who was a true partner on this exhibition. Her thoughtful suggestions, fluency in French, diplomatic skills, scholarship on surrealism, steadfast attention to detail over the past three years, and contributions to the catalogue have all been invaluable.

At the museum I am particularly grateful to Irene Martín, Beverley Sabo, Janelle Aieta, and Elaine Peterson of exhibitions programs, who help everything run more smoothly; to June Lomena in the department of modern art for her attention to myriad details with constant good cheer; to Roz Leader, champion sleuth volunteer, for tracking down elusive ephemera and checklist details; to Nancy Sutherland in the research library for supporting numerous requests for books with characteristic efficiency; to Tom Frick, Nola Butler, and Sara Cody for their heroic efforts to edit this book under great constraints; to Cheryle Robertson in rights and reproductions for always being on top of our needs for photography, and Peter Brenner in photographic services for ably shooting new photography for this book; to Renee Montgomery of collections management for deftly supervising the complicated

arrangements for shipping and insurance, and for the efforts of Alex Moran in the registrar's office; to Jeff Haskin and the staff of art preparation and installation for their careful handling of artworks; and to Toby Tannenbaum for working so imaginatively on educational components of the exhibition. Conservators John Hirx, Joe Fronek, and Virginia Rasmussen have been most helpful. We are grateful to designer Tony Waddingham, who worked closely with LACMA staff to produce the elegant volume you hold in your hands.

I thank Stephanie Dyas and Doug Rimerman in the development department for their efforts to find support for the show, and Christine Hansen and Gantry Jackson in communications and marketing for their imagination and zeal in promoting the show. Amy McFarland contributed to the graphic design for the show with her usual grace and skill. My thanks to Bernard Kester for bringing his customary elegance to the design process. I am grateful to Carol Eliel and Howard Fox, my curatorial colleagues in modern and contemporary art, for their support, and to colleague Lynn Zelevansky for undertaking the interview with Ed Ruscha for this catalogue at a time when she was extremely busy. Noëllie Roussel, 2004–2006 Wallis Annenberg Curatorial Fellow, was very helpful in the early stages of the project and has contributed an essay to this catalogue. My colleague Patrice Marandel has been helpful in securing loans.

All of the artists who have participated with us in the exhibition, through their cooperation with loans, information, opinions, and suggestions, have enriched this project. I am grateful to John Baldessari for the opportunity to collaborate with him on the unique design of this exhibition. I would like to thank our authors: Richard Armstrong, Roberta Bernstein, Sara Cochran, Michel Draguet, Thierry de Duve, Pepe Karmel, Theresa Papanikolas, Noëllie Roussel, Dickran Tashjian, and Lynn Zelevansky, who have written a group of revealing texts that together offer new insights into the work of Magritte, his reception in the United States, and the effect his work has had on a number of key artists.

Certainly no exhibition can be mounted without financial support. We are very grateful to Lexus for their generous sponsorship of the exhibition and the installation. It is a pleasure to acknowledge the National Endowment for the Arts and the NEA's Arts and Artifacts Indemnity Program, the Wallis Annenberg Director's Endowment Fund, and the Frederick R. Weisman Philanthropic Foundation for their support of the exhibition.

This exhibition has been an adventure to organize, and I am grateful to the partnership of Michel Draguet, Charly Herscovici, and the artists who have enthusiastically encouraged us in our efforts. I also want to thank my son, Max, who demonstrated enormous curiosity, patience, and enthusiasm for the art of Magritte and surrealism while I worked on this project; his support is appreciated more than he can ever imagine.

STEPHANIE BARRON
Senior Curator, Modern Art
Los Angeles County Museum of Art

Lenders to the Exhibition

Albright-Knox Art Gallery, Buffalo
Pierre Alechinsky, Bougival, France
Amir Art Foundation
Art Gallery of Ontario, Toronto
The Art Institute of Chicago
Timothy Baum, New York
Ivor Braka Ltd., London
The Broad Art Foundation, Santa Monica
The Eli and Edythe L. Broad Collection, Los Angeles
James and Debbie Burrows
Vija Celmins, courtesy of McKee Gallery, New York
James and Maureen Dorment
Ruth and William S. Ehrlich
Fisher Landau Center for Art
Glenn Fuhrman, New York
Galleria Emi Fontana
Gemini G.E.L., Los Angeles
The Getty Research Institute, Special Collections
Robert Gober, New York
Estate of Philip Guston, courtesy McKee Gallery, New York
Collection Herbert, Ghent
Hirshhorn Museum and Sculpture Garden, Smithsonian
 Institution, Washington, DC
Darcy Huebler and Luciano Perna, Los Angeles
Jasper Johns
Estate of Ray Johnson, courtesy Richard L. Feigen & Co.,
 Inc., New York
JP Morgan Chase Art Collection
Mr. and Mrs. Gilbert Kaplan
Kasper König, Cologne
Kunstsammlung Nordrhein-Westfalen, Düsseldorf
Emily Fisher Landau, New York
Barbara and Richard S. Lane, New York
Christie Mayer Lefkowith
Los Angeles County Museum of Art
Dr. Noémi Perelman Mattis and Dr. Daniel C. Mattis
The Menil Collection, Houston
The Metropolitan Museum of Art, New York
Musée National d'Art Moderne, Centre Georges
 Pompidou, Paris
Musées Royaux des Beaux-Arts de Belgique, Brussels
Museum Boijmans Van Beuningen, Rotterdam
The Museum of Contemporary Art, Los Angeles

Museum of Contemporary Art, San Diego
The Museum of Modern Art, New York
Museum voor Schone Kunsten, Ghent
National Gallery of Art, Washington, DC
National Gallery of Australia, Canberra
National Gallery of Canada, Ottawa
J. Nicholson, Beverly Hills
Philadelphia Museum of Art
Richard Prince
Robert Rauschenberg Foundation
Regen Projects, Los Angeles
Leslee and David Rogath
Saint Louis Art Museum
San Diego Museum of Art
San Francisco Museum of Modern Art
Joel Selvin
Jane and Terry Semel
Dorothy R. Sherwood
The Trustees of Tate Gallery, London
Collection Indivision Tob
Toyota Municipal Museum of Art, Toyota City, Japan
Lou Thomas Trosclair
University of California, Berkeley Library
University of California, Los Angeles Libraries and
 Collections
Virginia Museum of Fine Arts, Richmond
Walker Art Center, Minneapolis
Daniel Weinberg Gallery, Los Angeles
Frederick R. Weisman Art Foundation, Los Angeles
Sue and John Wieland
John Willenbecher
And several lenders who wish to remain anonymous

Illustration Credits

Most photographs are reproduced courtesy of the creators and lenders of the material depicted. For certain artwork and documentary photographs we have been unable to trace copyright holders. We would greatly appreciate notification of additional credits for acknowledgment in future editions. Works by René Magritte illustrated in this catalogue are licensed and copyright protected under © 2006 C. Herscovici, London, Artists Rights Society (ARS), New York.

front cover, p. 146: © 2006 C. Herscovici, London, Artists Rights Society (ARS), New York, photo © The Art Institute of Chicago (1970.426)

back cover, p. 170: © Robert Gober, photo © Hirshhorn Museum and Sculpture Garden, Smithsonian Institution (HMSG 90.15), by Lee Stalsworth

p. 2: © Eleanor Antin, photo courtesy of Lumiere

pp. 8, 13, 15, 16, 19, 20, 21, 22, 23, 24, 29, 32 top, 32 bottom, 35, 36, 38, 44–47, 49, 53–55, 58, 59 left and right, 60, 61 bottom, 66, 68, 71, 80, 82, 83, 89, 97, 110, 114, 119, 120, 124, 127 right, 131, 142, 160, 164, 166 left, 168 left and right, 176, 179, 182, 185, 188, 190–94, 195 top and bottom, 196, 197, 199, 201, 202, 203 bottom, 205, 230, 234, 238: © 2006 C. Herscovici, London, Artists Rights Society (ARS), New York

p. 10: © 2006 Marcel Broodthaers/Artists Rights Society (ARS), New York/SABAM, Brussels, photo © D. James Dee, courtesy of Peter Freeman, Inc., New York

p. 11: © 2006 Marcel Broodthaers/Artists Rights Society (ARS), New York/SABAM, Brussels, photo courtesy of Peter Freeman, Inc., New York

p. 12: © Mel Bochner, photo courtesy of the artist

p. 14: © 2006 Giorgio de Chirico, Artists Rights Society (ARS), New York/SIAE, Rome, photo © The Museum of Modern Art/Licensed by SCALA/Art Resource, New York

p. 17, 235: © 2006 C. Herscovici, London, Artists Rights Society (ARS), New York, photo courtesy of the lender

p. 25 top, 28, 115: © 2006 C. Herscovici, London, Artists Rights Society (ARS), New York, photo © Museum Associates/LACMA

p. 25 bottom: © 2006 C. Herscovici, London, Artists Rights Society (ARS), New York, photo © SFMOMA (98.562) by Ben Blackwell

p. 26: cover illustration © Ed Ruscha, photo by Danna Ruscha

p. 33: © 2006 Succession Miró/Artists Rights Society (ARS), New York/ADAGP, Paris, photo © 2003 The Metropolitan Museum of Art (2002.456.5)

p. 37: © 2006 Andy Warhol Foundation for the Visual Arts/Artists Rights Society (ARS), New York

p. 40: © 1974 Elektra/Asylum/Nonesuch Records, A Division of Warner Communications, Inc., front cover photograph and package design by Bob Seidemann, front cover lettering by Rick Griffin, cover concept by Jackson Browne

pp. 42, 92: photo by Adelaide de Menil Carpenter, courtesy of The Menil Archives

p. 48: © 2006 C. Herscovici, London, Artists Rights Society (ARS), New York, photo © Albright-Knox Gallery

p. 50 top and bottom: © 2006 C. Herscovici, London, Artists Rights Society (ARS), New York, photo by John Kiffe, courtesy of Special Collections, Getty Research Institute

p. 52: © 2006 C. Herscovici, London, Artists Rights Society (ARS), New York, photo courtesy of Robert Rauschenberg Foundation Collection (98.F010)

p. 56 left and right: photo © N. Bleecker Green, courtesy of Dallas Museum for Contemporary Arts, Timeline Photos

p. 61 top: photo courtesy of CBS Broadcasting, Inc.

p. 62: photo © Duane Michals, courtesy of Pace MacGill Gallery, New York

p. 72 right: photo courtesy Iolas Archives

p. 72 left: photographed by Steve Schapiro for *LIFE* magazine

p. 74: © 2006 C. Herscovici, London, Artists Rights Society (ARS), New York, photo © 1993 Museum Associates/LACMA

pp. 76 left and right, 77 bottom: photo courtesy Nolan/Eckman Gallery, New York

p. 77 top: © William Copley, photo courtesy of Sammlung Klewan, München

p. 85: Cover art © 2006 C. Herscovici, London, Artists Rights Society (ARS), New York, publication © 2006 Harry N. Abrams, Inc. All rights reserved.

p. 86: © 2006 C. Herscovici, London, Artists Rights Society (ARS), New York, photo by Paul Hester, Houston, courtesy of The Menil Collection

p. 88 left and right: photo by Paul Hester, Houston, courtesy of The Menil Archives

p. 94: © 2006 Marcel Broodthaers/Artists Rights Society (ARS), New York/SABAM, Brussels, photo by Speltdoorn

pp. 95 top and bottom, 105: © 2006 Maria Gilissen/Artists Rights Society (ARS), New York/SABAM, Brussels

p. 98: © 2006 Joseph Kosuth/Artists Rights Society (ARS), New York, photo © Museum Associates/LACMA

pp. 99, 102, 106: © 2006 Marcel Broodthaers/Artists Rights Society (ARS), New York/SABAM, Brussels

p. 100: © 2006 Marcel Broodthaers/Artists Rights Society (ARS), New York/SABAM, Brussels

p. 108: Art © Jasper Johns/licensed by VAGA, New York, photo by Zindman/Fremont, courtesy of the Jasper Johns Collection

pp. 109, 111: © 2006 C. Herscovici, London, Artists Rights Society (ARS), New York, photo courtesy of the Jasper Johns Collection

p. 112: Art © Jasper Johns/licensed by VAGA, New York, photo © Museum Associates/LACMA

p. 113: Art © Jasper Johns/licensed by VAGA, New York, photo courtesy of the Eli and Edythe L. Broad Collection, Los Angeles

pp. 116, 117: Art © Jasper Johns/licensed by VAGA, New York, photo courtesy of the Jasper Johns Collection

p. 118: Art © Jasper Johns/licensed by VAGA, New York, photo courtesy Gemini G.E.L.

p. 121: Art © Jasper Johns/licensed by VAGA, New York, photo courtesy of Jasper Johns Collection

p. 122: © 2006 C. Herscovici, London, Artists Rights Society (ARS), New York, photo by Malcolm Varon

p. 125: photo © Musee d'Orsay, Paris, France, by Erich Lessing/Art Resource, NY

p. 126: © 2006 Richard Artschwager/Artists Rights Society (ARS), New York, photo courtesy Daniel Weinberg Gallery, Los Angeles

p. 127 left: © 2006 Richard Artschwager/Artists Rights Society (ARS), New York, photo courtesy of Kasper König, Cologne

p. 128: © 2006 Richard Artschwager/Artists Rights Society (ARS), New York

p. 129: © 2006 Richard Artschwager/Artists Rights Society (ARS), New York, photo © Walker Art Center (1985.714)

p. 130: © 2006 Richard Artschwager/Artists Rights Society (ARS), New York, photo © Museum Associates/LACMA by Danny Bright

p. 133: © 2006 Richard Artschwager/Artists Rights Society (ARS), New York, photo © Museum Associates/LACMA

p. 134: © 2006 Richard Artschwager/Artists Rights Society (ARS), New York, photo by Brian Forrest, courtesy of the Museum of Contemporary Art, Los Angeles

p. 136: © Ed Ruscha, photo © Danna Ruscha, courtesy of Ed Ruscha Studio

p. 139: © Ed Ruscha, photo courtesy of The Broad Art Foundation, Santa Monica

p. 141: © Ed Ruscha, photo by Dorothy Zeidman, courtesy of Fisher Landau Center for Art (FL 338)

p. 143 bottom: © Ed Ruscha, photo courtesy of Gagosian Gallery, New York

p. 143 top: © Ed Ruscha, photo courtesy of C. Herscovici

p. 144: © Ed Ruscha, photo by Brady Behrens, courtesy of The JPMorgan Chase Art Collection

p. 145: © Ed Ruscha, photo by Paul Ruscha

p. 153: © 2006 C. Herscovici, London, Artists Rights Society (ARS), New York, photo © SFMOMA (PS98.497), by Ben Blackwell

p. 154: © Vija Celmins, photo © Museum Associates/LACMA

p. 155: photo courtesy of Vija Celmins and McKee Gallery, New York

p. 156: © 2006 C. Herscovici, London, Artists Rights Society (ARS), New York, photo courtesy of Ivor Braka Ltd., London

pp. 148–51, 157 left and right, 158, 159: © Vija Celmins, photo courtesy McKee Gallery, New York

pp. 162, 165 right: © Robert Gober, photo by Andrew Moore, courtesy of the artist

p. 163: © Robert Gober, photo by Joshua White, courtesy of the artist

p. 165 left: © Robert Gober, photo by Bill Jacobson, courtesy of the artist

p. 166 right: © 1966 Estate of Diane Arbus LLC, photo courtesy of Mr. John Pelosi, Esq. and Robert Miller Gallery

p. 167: © Robert Gober, photo by Geoffrey Clements, courtesy of the artist

p. 169: © Robert Gober, photo by Jan Engsmar, Malmö, courtesy of the artist

p. 172 left: © Robert Gober, photo by D. James Dee, courtesy of the artist

p. 172 right: © Robert Gober, photo by Russell Kaye, courtesy of the artist

pp. 180, 181: © Martin Kippenberger

p. 183 bottom: © Richard Prince, photo courtesy Barbara Gladstone Gallery, New York

p. 183 top: © Sherrie Levine, photo © Museum Associates/LACMA

p. 184 top: © Jim Shaw, photo © Museum Associates/LACMA by John Acara

p. 184 bottom: © Jim Shaw, photo by Brian Forrest, courtesy of the Museum of Contemporary Art, Los Angeles

p. 186: © Raymond Pettibon, photo © Walker Art Center, Minneapolis (1998.3)

p. 198: © 2006 C. Herscovici, London, Artists Rights Society (ARS), New York, photo courtesy of the Jasper Johns Collection

p. 200: © 2006 C. Herscovici, London, Artists Rights Society (ARS), New York, photo © Saint Louis Museum of Art

p. 203 top: © 2006 C. Herscovici, London, Artists Rights Society (ARS), New York, photo courtesy Mr. and Mrs. Gilbert Kaplan, New York

p. 204: © 2006 C. Herscovici, London, Artists Rights Society (ARS), New York, photo courtesy of Guggenheim, Asher Associates, New York

p. 206: © 2006 C. Herscovici, London, Artists Rights Society (ARS), New York, photo courtesy of Sotheby's, New York

p. 207: © 2006 C. Herscovici, London, Artists Rights Society (ARS), New York, photo © San Diego Museum of Art

p. 208: © John Baldessari, photo by P.S. Ritterman © Museum of Contemporary Art, San Diego

p. 209: © Art & Language, photo courtesy of lender

p. 210: © John Baldessari, photo courtesy of Museum Associates/LACMA

p. 211, 212: © 2006 Marcel Broodthaers/Artists Rights Society (ARS), New York/SABAM, Brussels, photo courtesy of Maria-Puck Broodthaers, Brussels

p. 213: © Robert Gober, photo by D. James Dee, courtesy of the artist

p. 214: © Philip Guston, photo courtesy of McKee Gallery, New York

p. 215: © 2006 Estate of Douglas Huebler/Artists Rights Society (ARS), New York, photo courtesy Darcy Huebler and Luciano Perna

p. 216 top: © Estate of Ray Johnson, photo by Kevin Noble

p. 216 bottom: © Estate of Ray Johnson

p. 217: © Mike Kelley, photo courtesy of Galleria Emi Fontana, Milan

p. 218: © Jeff Koons, photo © Douglas M. Parker Studio, Los Angeles, courtesy The Eli and Edythe L. Broad Collection, Los Angeles

p. 219: © Jeff Koons, photo courtesy The Eli and Edythe L. Broad Collection, Los Angeles

p. 220: © Jeff Koons, photo © Museum Associates/LACMA

p. 221: © Barbara Kruger, photo courtesy of the Museum of Contemporary Art, Los Angeles

pp. 222, 223 top: © Estate of Roy Lichtenstein

p. 223 bottom: © Claes Oldenburg, photo © Museum Associates/LACMA

p. 224 top: © Raymond Pettibon, photo courtesy of Regen Projects, Los Angeles

p. 224 bottom: © Raymond Pettibon, photo © Museum Associates/LACMA

p. 225: © Sigmar Polke

p. 226: © Charles Ray, photo courtesy of The Broad Art Foundation, Santa Monica

p. 227 bottom: © Ed Ruscha, photo © Museum Associates/LACMA

p. 227 top: © Robert Rauschenberg, photo by Sally Ritts

p. 228 bottom: © 2006 Andy Warhol Foundation for the Visual Arts/Artists Rights Society (ARS), New York, photo © Museum Associates/LACMA

p. 228 top: © David Salle, photo © Museum Associates/LACMA

p. 229: © 2006 Lawrence Weiner/Artists Rights Society (ARS), New York, photo courtesy of Marian Goodman Gallery, New York

p. 243: © 2006 Marcel Broodthaers/Artists Rights Society (ARS), New York/SABAM, Brussels, photo courtesy of Maria-Puck Broodthaers, Brussels

p. 248: © James Rosenquist, photo courtesy of Acquavella Galleries, New York

Index

Page numbers in **bold** refer to illustrations